ENGLISH MEDIEVAL SCULPTURE

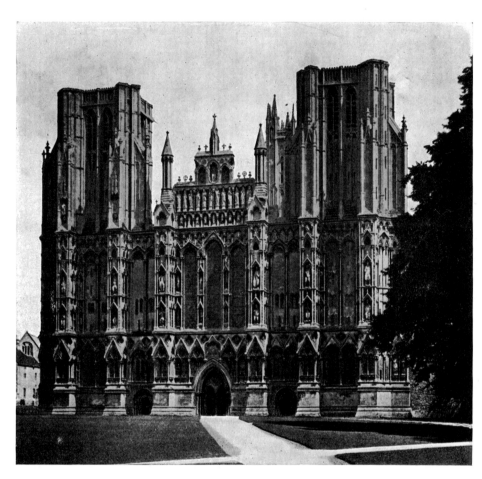

1. *Wells Cathedral. West Front*

ENGLISH
MEDIEVAL SCULPTURE

BY

ARTHUR GARDNER
M.A., F.S.A.

THE
ORIGINAL HANDBOOK
REVISED AND ENLARGED
WITH
683 PHOTOGRAPHS

Hacker Art Books
New York

First edition 1935.
This is a reprint of the revised
and enlarged edition of 1951,
published by Cambridge University Press.

Reissued 1973 by
Hacker Art Books, Inc.
New York, New York

Library of Congress
Catalogue Card Number 78-171421
ISBN 0-87817-110-X

Printed in the
United States of America

PREFACE TO THE
NEW AND ENLARGED EDITION

Since the publication of *A Handbook of English Medieval Sculpture* in 1935 various things have occurred which add to our knowledge of the subject, and a number of new publications have thrown light on some of the problems or revealed the results of patient research. Perhaps the most important event has been the exhibition at the Victoria and Albert Museum of the sculptures from Westminster Abbey, which had been temporarily removed from their places for security reasons during the war. Close examination of these has helped to increase our knowledge and appreciation of the work of the last period of medieval sculpture. Dr Hildburgh's donation of his great collection of alabaster carvings to the Museum also enables us to study another remarkable phase of the later developments of the subject. A few early carvings of Saxon date have also come to light, and there seems, therefore, to be room for a new edition, including some 180 fresh illustrations, which will enable a more up-to-date and comprehensive view of the subject to be obtained.

In view of the availability of such works as Mr Cave's *Roof Bosses*, Mr Crossley's *English Church Monuments* and Mr Bond's *Fonts* and *Misericords*, as well as my own *Alabaster Tombs*, I have not felt it necessary to go into these subjects in quite such full detail as in some others, and have been content to include only such outstanding or typical examples as are required for them to take their proper place in a general account of medieval sculpture.

Finally I have to thank the clergy, vergers and curators of our churches and museums for giving facilities for the collection of the vast amount of photographic material from which the illustrations have been selected.

A. G.

HARROW
January 1951

v

PREFACE TO THE FIRST EDITION

Some twenty-two years have passed since the publication of *Medieval Figure Sculpture in England*, in which I had the honour of collaborating with the late Professor Edward S. Prior, and the book has been accepted as the standard work on the subject. It is now out of print, and in view of the growing interest in the subject as evidenced by the increasing provision for the study of art history in various universities, and above all by the Courtauld Institute associated with the University of London, there seems to be room for something in the nature of an abridged edition to serve as a text-book for students if such a volume can be produced at a price within the means of the modern purse.

The enterprise of the Cambridge University Press has enabled me to attempt to supply this need, and the fact that most of the blocks for the original work are available has made it practicable. Some 110 new photographs have been added, including several composite blocks from my paper 'Alabaster Tombs of the Gothic Period' in the *Archaeological Journal* for 1923, in order to bring the story up to date and to add fresh interest. The plan has also had to be altered in order to bring the matter into smaller compass, so that it is really a new work rather than an abridgment, though still to a great extent based on the research, the results of which are set forth in the original book.

I must take this opportunity of paying a tribute to my late colleague, Professor Prior. It was a great privilege for me when quite a young man to have been associated with him in collecting and arranging the material for such a work. His wide knowledge and original mind were an inspiration and guide which I hope have kept me on a right course in these studies, and have certainly added a fascinating interest to my life.

A. G.

HARROW
January 1935

CONTENTS

CHAPTER I

INTRODUCTORY

(1) GENERAL REMARKS

Some American writers have treated English architecture as a mere provincial offshoot of that of France. Such an idea is both ill-informed and superficial. Even if we allow France a certain hegemony in art in the thirteenth century, our English work is no mere importation or copying of the French. No doubt there was frequent interchange of ideas and inspiration, but English church building took a line of its own which manifested our national characteristics and advanced by experiment on its own lines until it finally evolved the stately Perpendicular style, which has no counterpart on the other side of the Channel. All through we notice a strain of conservatism, a hesitation to carry principles to an extreme, and a loving attention to craftsmanship of detail, which differentiate an English cathedral with its wealth of mouldings and modest proportions from such a monument of overwhelming French ambition and logic as Beauvais Cathedral.

So, too, in the sculpture, while we can discern suggestions from abroad from time to time, the work on the whole follows its own course, fighting its own local battle against difficulties and overcoming them in its own way. Our sculptors seldom attained the complete mastery of technique which we admire in the splendid statues of Rheims, but sometimes the very struggle against technical difficulty, and the loving care bestowed on detail by primitive artists who are learning their art as they go along, are of more interest and charm than the more perfect productions of the experienced master.

We also have to face the difficulty that our English sculpture is in a much more fragmentary state than that of France, and we have to piece together our evidence of what it must have been like from broken and mutilated scraps or from the lesser carvings originally looked upon as of minor importance. In France much damage was done by Puritanic reformers, but it was not systematic, and many of the great porches have come down to us almost intact, apart from a certain amount of modern restoration, but in England all religious carving was deliberately and thoroughly destroyed under Acts of Parliament, and what we have owes its preservation to its inaccessibility or to its real or imagined secular intention. In one case, however, we are more fortunate than the French; the rage of the French revolutionaries was directed more against the aristocracy than the Church, and the tombs of the nobles were everywhere broken up and cast out, and usually have to be studied now in museums or in such collections of effigies and much restored fragments as may be found at S. Denis. In England the aristocracy never earned such violent unpopularity, and the tombs scattered all over the country, in parish church as well as cathedral, are a mine of wealth to the student of sculpture, costume and armour. They have suffered from neglect and careless mutilation, and more rarely from ill-judged restoration, but on the whole afford a very valuable guide to our subject in the absence of the religious sculpture.

The material for our study, therefore, consists mainly of the architectural sculptures and those of the monuments. We must not, however, forget that much of the sculpture

I

most prized in the middle ages was to be found in the altar furniture and the decoration of the shrines of the saints, the productions of goldsmiths and metal-workers, or of the ivory- and in humbler places the wood-carvers. This was especially the case in the earlier periods down to the middle of the twelfth century, for it was largely to the productions of what we may call the *cloister crafts*, made for and preserved in the monasteries, that the stone sculptors looked for their models when the growing ambition of the great church-building era led to the demand for larger and more effective sculptural decoration in stone. A few bronze tomb figures, some small ivory statuettes, a few broken wood figures and a number of late alabaster panels, helped out by some fine medieval seals, are all we have by which to judge of the vast riches which once decorated our cathedrals and abbeys, and it is tantalising to read of the gold and jewels removed from Becket's shrine at Canterbury

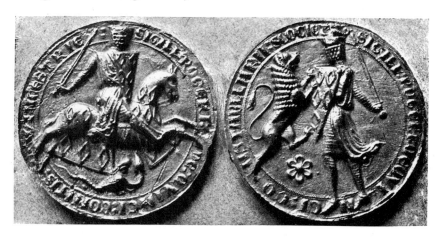

2. *Seal of Roger de Quinci, Earl of Winchester*

by Henry VIII's commissioners, which filled twenty-six carts, or of Henry III's magnificent golden shrine of the Confessor at Westminster, surrounded by statues of gold and studded with precious stones.[1] The magnificent seal of the Earl of Winchester (Fig. 2) may serve to give some idea of the skill of the metal-worker of the middle of the thirteenth century, and a reference to the ivory carvings (Fig. 437) and the bronze or laton effigies illustrated later on will also give some evidence as to the quality of the numerous priceless works of art which fell victims to the avarice of Henry VIII and the misguided zeal of the Puritan reformers.[2]

Although this volume, for the sake of convenience, is devoted to the history of *sculpture*, we must beware of isolating it as the art of a specialist in the modern sense. Medieval art was a comprehensive whole with all its branches closely associated. In the greatest period sculpture was part of the mason's trade, and it was only as his technical skill increased that the *imager* became a specialist. Medieval sculpture should, therefore, be regarded as part and parcel of the building trade, just as in the darker ages which preceded the great twelfth- and thirteenth-century renaissance it had been mainly part of the craft of the gold- and silversmith, and architectural sculpture must not be too rigidly separated from its con-

[1] Descriptions exist of Bishop Stigand's great silver cross at Winchester in 1070, and in 1326 Bishop Stapledon set up a silver reredos.

[2] A number of brass eagle lecterns of the fifteenth century still survive (see C. C. Oman, *Arch. Journ.* 1930).

structural surroundings if its full value is to be properly appreciated. The best figure work is mainly in building stone, not marble, and was usually intended to be finished in gesso and colour in order to be effective in its place in the building: it loses considerably, therefore, if transplanted to a museum and placed beside statues of marble meant to stand alone or finished with the delicacy of a Greek chisel.

It is, perhaps, something of a shock to those who have not studied medieval art to realise that all the sculpture, like that of the Greeks, was originally coloured. The fact that when the Classical marbles were first dug up the colour had faded led the connoisseurs of the Renaissance period to assume that statues should be left in the natural colour of the material. We must, however, realise that this was by no means the view in the middle ages. Modern attempts to restore the original colour have not always been successful, either through coarse craftsmanship, or a mere copying of what was left of the ground colour without the gilding and brilliant finish in bright pure colours of the original, and we shall best be able to gather an impression of the scheme adopted by turning to the illuminated manuscripts of the period. The recent cleaning of the interior of Westminster Abbey has brought out vivid traces of colour and gilded patterns on the tombs and other sculptures, and there can be little doubt that the exterior carvings of porch and façade were treated in the same way. When Sir W. St John Hope and Prof. Lethaby[1] examined the front of Wells Cathedral from a scaffolding they found traces of a colour wash over the whole surface and signs of painting and gilding over it. The whole façade must have resembled a colossal reredos glowing with brilliant colours and a splendour we can hardly imagine. The chapter-house doorway at Westminster is known to have been painted and gilded, and in fact in our climate this protective covering of the surface is almost necessary if the sculpture is to survive. It is not uncommon to see a bit of modern restoration crumbling away more quickly than the older work beside it, and this may be due more to its never having had this protective wash than to any lack of experience in selecting the stone. As soon as the masons had completed their work the *whiteners* were put on, and they were followed by the painters and gilders.[2]

(2) THE SUBJECTS OF THE SCULPTURES

The study of the art of the past has other interest beside the purely historical and aesthetic appeal. It usually casts light on the conditions of life of the men who produced it, and, above all it enshrines their ideals and embodies the thoughts and aspirations which occupied their minds. The first thing to notice is the way in which the Church dominated the whole life of the middle ages. In the absence of all the distractions of modern work and play, without newspapers or facilities for travel, with books scarce and difficult to read, men's thoughts turned mainly to religious topics when not occupied with war or the struggle for subsistence. It is mainly, therefore, in the churches that we find the art of the day best exhibited, and the subjects with which it deals are mainly religious or connected in some way with ecclesiastic teaching.

Owing to the wholesale destruction of our more serious sculptures we have few such complete summaries of theological ideas as are found in the great porches of Chartres or Amiens, but at Wells, though the loss of attributes makes the identification of individual

[1] See Hope and Lethaby in *Archaeologia*, LIX, 1904.
[2] See Lethaby, *Westminster Abbey Re-examined*, chapters IV and XI.

figures difficult, a few of the statues can be at least tentatively named and a general idea of the plan embodied in the great façade can be made out. The whole front of the cathedral is a vast theological scheme, worked out, no doubt, by Bishop Jocelin himself, grouped round the Coronation of the Virgin over the west door. The Apostles and Prophets who must have occupied the niches of the lower tiers are now missing, but the quatrefoils above them are occupied on the south side by scenes depicting the Old Testament from the Creation to the Flood, and on the north side by scenes from the New. Above them are two tiers of niches filled by large statues, among which Sir W. Hope and Prof. Lethaby[1] succeeded in identifying the Saxon martyr kings Oswald, Edward, Kenelm and Ethelbert, while St Eustace, St Thomas of Canterbury (Fig. 253), and possibly St George can be picked out. As these are all on the north side and are grouped with a number of female saints, it is a probable suggestion that we have here the martyrs and virgins, while the bishops, monks and hermits on the south side represent the confessors. We find this same classification in the south porch at Chartres. At the base of the north tower the statues of the lowest tier have survived and comprise a group of grave bearded figures who might do for Evangelists or doctors of the Church (Fig. 258), another of female statues, one of them carrying a pot of ointment, who are probably the holy women witnesses of the Resurrection (Fig. 259), and a set of deacon saints (Fig. 260), probably representing St Stephen and his associates. Above the statues is a cornice of foliated niches all round the front containing reliefs of the General Resurrection—little naked figures rising from their tombs. The central gable has two tiers with figures of a somewhat later date representing the nine orders of angels, the twelve Apostles, and in the central niche at the top the broken figure of Christ in Majesty, the lord and master of them all.

Here, as elsewhere, the Bible scenes are mainly the story of the Fall, of how sin came into the world, and of the Redemption, concentrating on the Nativity and the Passion more than on the life story of our Lord, though there are one or two scenes at Wells dealing with the latter. A king and queen may, like the early statues at Rochester, be identified as Solomon and the Queen of Sheba, well-known types of the Old Law prefiguring the coming of the Magi to worship the new-born Christ under the New Dispensation.

At Exeter, in the fourteenth century, we have another great series of statues grouped round the Coronation of the Virgin, in which an absurd restoration has replaced the missing figure of Our Lady by a seated king. The upper tiers have a series of Prophets and Apostles, and the lower kings and warriors, who are probably Old Testament heroes placed here as ancestors of Christ, and not English kings as they have usually been called.

The bosses of the vault at Norwich illustrate the Old and New Testaments in a very numerous set of scenes, and the beautiful bosses of the cloister include a remarkable set of the Apocalypse. At Tewkesbury the nave bosses are devoted to the New Testament story, dealing with the Nativity and Passion scenes. These last are also common in the alabaster retables of our last period, where, if we restore the scattered panels of their proper sets, we shall find the Passion scenes, the Last Judgment, the Nativity forming part of a set devoted to the Virgin as the commonest subjects chosen, though others picturing favourite saints, and especially a series of martyrdoms, are fairly common also.

The legends of the Virgin are carved in great detail, though unfortunately, sadly mutilated, in the Lady Chapel at Ely, which have been elaborately described in his monograph by the late Dr M. R. James (Fig. 3).

[1] *Archaeologia*, LIX, 1904.

4

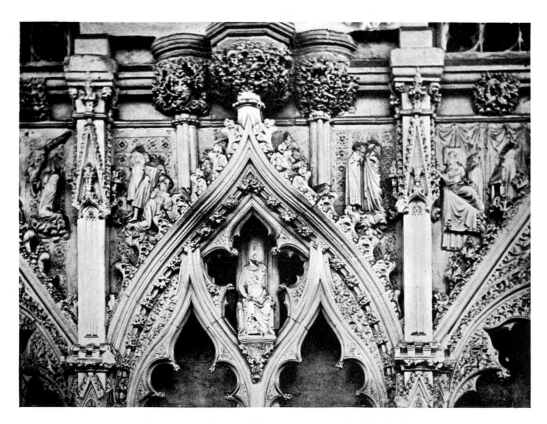

3. *Ely. Lady Chapel. Life and legends of the Virgin Mary*

It is to Westminster that we must turn for the best illustration of the ideas of the last period before the Reformation. Henry VII's Chapel contains what is probably the most complete series of saints in Europe, and their excellent preservation, with symbols and attributes complete, enables almost all of them to be identified with certainty. The selection may have been made by Henry himself, and besides the Apostles, Evangelists, Holy Women and the universally accepted Saints of Christendom, like Sts. Catherine, Dorothy, Barbara, George, Martin, Christopher, Nicholas, Antony, Giles and Lawrence, a number of specially English saints are included, such as the royal figures of Edward the Confessor and St Edmund, St Thomas of Canterbury, St Dunstan holding the devil by his nose in his tongs, St Hugh of Lincoln with his swan, St Cuthbert and St Oswald. Saints who had special powers of intercession in cases of plague and other troubles, like St Sebastian and St Roch (Fig. 5), are given prominence. The latter has his garments turned aside to show the plague spot on his leg; he wears a large traveller's hat with crossed keys on it to indicate his labours among the sufferers in Rome. Welsh saints are represented by St Winifred with her head on a stool beside her, and St Armil (or Armgilius) (Fig. 494), a Breton saint leading a dragon by his stole, appears as one whose acquaintance Henry had made in his younger days of exile abroad. But the most extraordinary figure is that of St Wilgefort (Fig. 4), or Uncumber as she was sometimes called, a virgin saint who was so pestered by lovers that she begged Heaven to allow her to grow a beard to disgust them. Her legend was probably derived from an ignorant person who saw a draped crucifix of the ancient

5

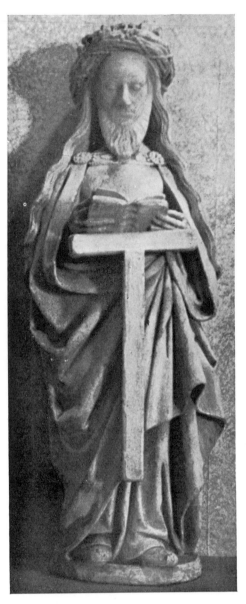

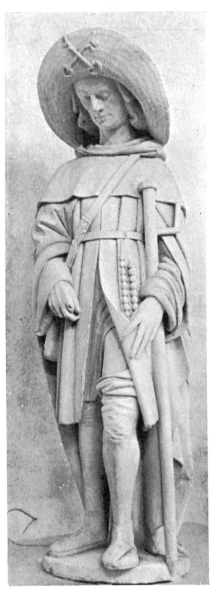

4. *Westminster. Henry VII's Chapel.*
St Wilgefort

5. *Westminster. Henry VII's Chapel.*
St Roch

Lucca type for the first time and mistook the figure for a woman. St Uncumber was in favour with unhappy wives who wished to be relieved of their husbands.

St Martin is represented as a young soldier holding a bishop's mitre in his hand as a symbol of his future destiny.

Even in the lesser carvings, where theological supervision was less strict, and more was left to the individual fancies of the mason-carvers, such as the bosses and gargoyles or misericord seats of the stalls, many of the subjects which appear at first to be merely legend and fancy had a theological or moral signification attached to them in the medieval mind. The strange monsters in the bestiaries were all given a somewhat far-fetched religious

6

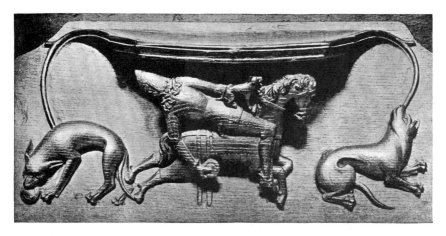

6. Chester. Misericord. The tiger

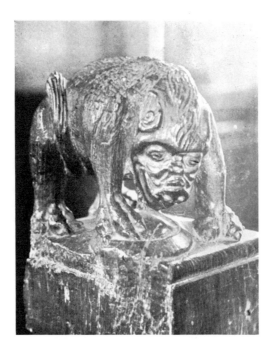

7. Wendens Ambo (Essex). Tiger and mirror

signification; thus the lion, who was supposed to bring to life his cubs, which had been born dead, by roaring over them, becomes a well-known symbol of the Resurrection, or the hunter pursuing the tiger and carrying off her cubs is said to distract the mother by strewing mirrors in the path, and thus becomes typical of the Devil who carries off our souls by setting before us the vanities of this world (see the misericord from Chester, Fig. 6).

Another version of the tiger admiring herself in a mirror is to be found at Wendens Ambo (Fig. 7). The strange creature called a Skiapod, who uses his enormous single foot as a sunshade, occurs on a bench at Dennington (Fig. 8), and the jejune way in which the

7

carver ventured to represent a creature he had never seen merely from a description may be seen in the ostrich from a misericord at Windsor, which can only be recognised by the horseshoe it is holding in its beak, for it was well known that this bird was able to digest old iron! (Fig. 9).

A very remarkable set of bestiary subjects may be found round a twelfth-century doorway at Alne (Yorks), where a number of the creatures are identified by inscriptions, those in our illustration (Fig. 10) being the fox, panther, eagle, hyena, caladrius and another with a defaced name.[1]

Medieval humour is chiefly displayed in gargoyles and the lesser wood sculptures. It consists to a great extent in the invention of strange monsters and fanciful combinations of parts of various creatures, birds with human heads or other fantastic animals. The fables

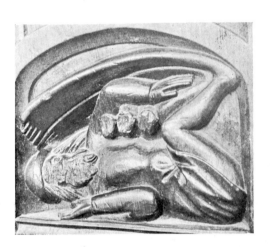

8. *Dennington (Suffolk). 'Skiapod'*

9. *Windsor. Ibis and ostrich*

about Renard the fox from the bestiaries were supplemented by caricatures even of the monks and clergy, who were represented in the guise of foxes (e.g. at Christchurch) in the pulpit, preaching to the geese (Beverley (Fig. 556), Boston, etc.), or as foxes in full vestments attended by cocks or apes as acolytes.

An early tympanum at Stanley St Leonard's (Fig. 11) has an ape handing an apple to another, apparently a skit on the story of Adam and Eve, a curious anticipation by some 700 years of the Darwinian theory of the descent of man!

The reversal of the established order of things and attribution of human characteristics to animals seems to have appealed to the medieval sense of humour. As early as the twelfth century we find animals playing musical instruments in the crypt capitals at Canterbury and in the doorway (Fig. 140) and quaint frieze at Barfreston (Fig. 143), which certainly display a love of the comic. Usually the humour is of the childish knock-about Punch and Judy type, the confusion of the fox raid on the farmyard, or the

[1] For description see Romilly Allen's *Christian Symbolism*, p. 47.

10. *Alne (Yorks). Bestiary subjects*

hen-pecked husband being beaten by his wife (Fig. 551), but considering the primitive state of society indecent carvings are rarer than might have been expected.[1]

In the fifteenth century the wood carver came into his own with the elaborate furnishing of the parish churches with rood screens and bench ends. He was given free play for his imagination, and there are many examples of his sense of fun. At Wiggenhall St German are a series of the Seven Deadly Sins, in which the rake, the miser (Figs. 12, 13), and so on are seen with their feet sinking into the gaping mouth of hell, while opposite is an angel pointing a warning finger at them. In the west country carving of bench ends continues even after the Reformation, though it becomes coarser and tinged with Flemish detail.

[1] Some rather coarse carvings of devils may be found in the late stalls of Windsor, but what can be expected of devils?

11. *Stanley St Leonards (Glos). Ape with apple*

12. *Wiggenhall St German (Norf). The miser*

13. *Wiggenhall St German. The adulterer* 14. *South Brent (Devon). Renard the fox*

15. *Norwich. Misericord. The schoolmaster. c. 1420*

16. Westminster. Henry VII's Chapel. Boys at play

17. Windsor. Misericord. Edward IV at Piquigny

The set at South Brent illustrating the legend of Renard the fox, preaching to the geese, and finally hanged by them, is quite entertaining (Fig. 14).

In these small wood carvings we are brought more into touch with everyday life. The farmer's year and works of the months or seasons (e.g. at Worcester or Ripple, Fig. 568), the schoolmaster birching his boys (Norwich, Fig. 15; Sherborne, Boston, etc.), boys playing at school with one of them wielding the birch rod (Westminster, Fig. 16), or 'cock-fighting' (Windsor and Westminster), the University lecture and sermon (New College, Oxford, Fig. 553), the priest before the altar (V. and A. Museum, from King's Lynn), the tourney (Worcester, Fig. 550) and many other scenes referred to again in our chapter on woodwork (pp. 277 sqq.).

Scenes from contemporary history are very rare. Besides the Coronation scenes in Henry V's chantry at Westminster, practically the only one of importance is the misericord of the King's stall at Windsor on which is carved the meeting of Edward IV with Louis XI on the bridge at Piquigny in 1475 (Fig. 17).

(3) THE SCULPTORS

Most art histories follow the lines laid down by such writers as Pliny and Pausanias in dealing with Classical art, or Vasari with that of the Renaissance in Italy, and allow the story to centre round the lives and personalities of a succession of famous artists. Their characters and styles, the influence they had on their pupils and the ascription to them of certain works, or an attempt to reconstruct others which have perished, form the main theme of such histories. But when we come to the medieval period this method will not work. Until quite the end of the middle ages no great individual artist seems to emerge head and shoulders above his contemporaries; we only know a few of the producers of the sculptures or paintings by name, and then only by accident where such names have been preserved as the recipients of payments in the royal or other accounts. We shall be dealing with the work of humble goldsmiths, masons, carpenters and shopkeepers, who were paid little more than their fellows who were working on the plain walls and roofs of the buildings they were employed to adorn. As we proceed to deal with the successive periods we shall see that the functions of these various workers gradually change and develop, and researchers have dug out of the records and building accounts a certain amount of information which enables us to picture, at any rate vaguely, the conditions under which the medieval art we admire to-day came into being.

Down to the twelfth century the demand for art had chiefly come from the monasteries, and all through the dark ages the monasteries had been the main power to keep alive such technical and artistic traditions as survived the barbarian invasions and Moslem conquests. But the idea, once current, that the churches and all the works of art they contained were the work of monks can no longer be sustained. No doubt monasteries frequently maintained workshops and when the great revival came they were the chief patrons of the arts, but most of the work seems to have been done by lay workmen employed either as permanent servants or hired for the special occasion. It is true that in the early period monks are sometimes described as specially skilful in the arts, but this must probably be taken as indicating that it was an unusual accomplishment worthy of note. Where names are mentioned they are usually those of monks employed on what we may call the *cloister crafts*, such as metal work, ivory carving, book illumination, supplying shrines and altar furniture rather than the larger architectural sculpture. Great ecclesiastics like St Eligius and St Dunstan were famous metal-workers in their younger days, and in 1050 an abbot of Abingdon is recorded as 'in auri et argenti fabrificio operator mirificus'. In the thirteenth century Matthew Paris describes one Anketell, 'monachus et aurifaber incomparabilis', as the maker of St Alban's shrine. One of the most famous of these monkish craftsmen was Walter of Colchester, a fellow-monk with Matthew Paris at St Albans. He started life as a goldsmith, but was brought to the abbey about 1200 to work on its treasures. He eventually became a monk and was appointed sacrist about 1213, finally becoming a brother. He is said to have worked with Elias de Dereham, afterwards Canon of Salisbury, on the superb shrine of St Thomas à Becket at Canterbury, completed in 1220.

13

Similarly in France we read of a monk 'Guinamundus in architectura et sculptura peritissimus', and the shrine of St Lazare at Autun, of which three stone statues remain in a museum there, was signed by a monk by name Martinus, 'lapidum mirabilis arte'. On the other hand the finely sculptured porch at Carennac has a capital signed by 'Girbertus Cementarius',[1] evidently a lay mason, employed on the church.

In England the fine twelfth-century font at Bridekirk is signed by one Richard, but he gives no description of himself (Fig. 18).[2]

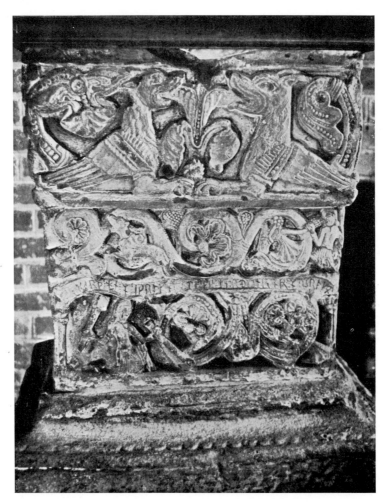

18. *Bridekirk (Cumb). Font. Inscription by Ricardus. c.* 1150

After the twelfth century signatures are almost unknown, and the best information about the sculptors has to be extracted from the royal accounts. Prof. Lethaby has given a most useful and detailed account of the masons and other artists employed on Westminster Abbey[3] in the middle of the thirteenth century. By this time there appears to have been

[1] See A. Gardner, *Medieval Sculpture in France*, fig. 16.

[2] A bronze censer-cover found at Pershore, dating probably from the beginning of the eleventh century, is signed '*Godric me Wworht*'.

[3] Lethaby, *Westminster Abbey and the King's Craftsmen*, and *Westminster Abbey Re-examined*. See also G. G. Scott, *Gleanings from Westminster Abbey*.

14

a regularly organised lay trade in building. Henry of Westminster, the king's master-mason, Alexander the king's carpenter, and Fitz Odo, the clerk of the works, were in charge of a large body of men. In one week in the year 1253 wages were paid to 39 cutters of white stone, 15 marblers, 26 stone-layers, 32 carpenters, the famous painter John of St Albans, his partner with an assistant, 13 polishers of marble, 19 smiths, 14 glaziers, and 4 plumbers, besides 176 inferior workmen. Special jobs were often done by task-work, or as we should call it piece-work, and large sums were entrusted to those in charge of the works.

This seems to indicate that men specialised in their own particular job, and important figure work may have been frequently entrusted to specially skilled sculptors. Thus we read that in 1253 William Yxwerth was paid for two images wrought by task-work costing 53s. 4d., and, as this date is that of the completion of the chapter-house, Prof. Prior suggested that these were the famous Annunciation group still extant (Figs. 270, 271).[1] They were painted by Warinus the painter for 11s. The names which have survived are chiefly those of the clerks of the works, sometimes important ecclesiastics, and the master-masons, who were apparently men of some position. Though the latter had started life as ordinary masons, beginning perhaps in the quarries, they had risen by their skill and had evidently acquired a certain amount of education, so they were often made jointly responsible for the accounts, and were given special board and robes of office. As time went on they were often small contractors and evidently men of some substance, and in 1436 a contract between the Abbot of Bury St Edmunds and John Wode of Colchester, mason, provides that 'the seyd John Wode schall haue hys bord in the Couentys halle for hym and hys man, for hymself as a gentilman and for his servaunt as for a yoman'.[2]

There is, however, no evidence that the master-masons did the sculpture, though they may sometimes have had a hand in this as the most skilled part of the work. Makers of statues and tombs gradually began to specialise, just as the marblers of Corfe who provided the Purbeck marble were separated from the freestone masons, and as time went on they contracted for tombs or kept regular shops for the provision of sculptured wares.

The earliest names of London sculptors known to Prof. Lethaby were Thomas the image-worker and Richard his son in 1226. In 1257–8 John of St Albans, 'sculptor to the king's images', received a robe of office along with Peter of Spain the painter, and Alexander the carpenter. Lethaby therefore assigns to him the credit of having carved the splendid angels of the Abbey transepts (Figs. 208, 209, 210). He also suggests that in a fine bearded head there (Fig. 19) in a rounded cap we may have a contemporary portrait either of John of Gloucester the master-mason, or of John of St Albans the sculptor himself. John's masterpiece was no doubt the sculpture of the great north porch of the Abbey, of which we only have scanty records.

Half a century later we find the imagers separating themselves still more from the building masons, and we shall see the effect of this when we come to deal with their works in detail. Light is thrown on this period by the accounts of the Eleanor Trustees dealing

[1] J. G. Noppen in *Antiq. Journ.* July–Oct. 1948. The same record says that Robert of Beverley was paid 32s. for four bosses. Can that illustrated in Fig. 208 be one of these?

[2] *Archaeologia*, XXIII, 330–2. A careful study of the position and wages of the masons is to be found in *The Mediaeval Mason* by Douglas Knoop and G. P. Jones. See also R. E. Swartwout, *The Monastic Craftsman*.

John of Gloucester, the King's master-mason, in 1255 received fur robes from the Royal Wardrobe, such as Knights of the Household receive (Lethaby, *Westminster Abbey Revisited*, p. 94).

15

with the erection of the famous crosses in 1292–4, which were published in *Archaeologia* as far back as 1842. Alexander of Abingdon, 'le imaginator', was paid for the statues of the queen at Waltham (Fig. 318) and Charing. It is possible that the statues of Charing Cross were of metal, in which case he must have been a master of several crafts, for he was also paid for painting and iron-work. At Waltham he was associated with Dymenge de Leger 'operarius'. On the Northampton Cross, which still survives, the statues were made by

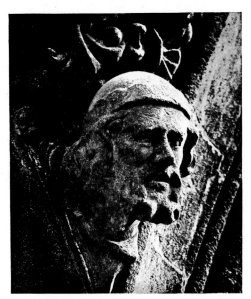

19. *Westminster. Transept. The master mason.*
c. 1250

William of Ireland (de Hibernia) 'imaginator' and 'caementarius' who was paid 'pro quinque imaginibus ad crucem Northamptoni et alibi' (Fig. 319).

In the Abbey itself the beautiful bronze, or laton, effigy of Queen Eleanor was made by Master William Torel, goldsmith of London (Fig. 422). He also made similar figures for Blackfriars and Lincoln, and received £113. 6s. 8d. for the three, a large sum in those days. He was also responsible for the bronze effigy of Henry III (Fig. 424), placed on the inlaid marble tomb made by Peter of Rome. Of course it has been suggested by those who would belittle our English art that Torel was the Anglicised name of an Italian Torelli, but his family has been traced back for three generations of goldsmiths settled in London, and it should be realised that at this date Italy had not yet produced artists capable of so fine a work.

In the fourteenth century we have records of the makers of the royal tombs. Queen Philippa's effigy was made by a famous foreign sculptor, Hawkin (or Hennequin) of Liège, who has sometimes been identified with Jean de Liège, one of the leading sculptors at the court of Charles V in Paris, where the individual masters of the Franco-Flemish school were beginning to receive more recognition than the old mason-craftsmen. Some little figures for this tomb were made by John Orchard, 'latoner', or bronze-worker, and it is possible that he was responsible for the laton effigies of Edward III at Westminster and the Black Prince at Canterbury. He was also paid for the two small alabaster figures of the infant son and daughter of the queen, now in the Abbey, and this indicates that he was a versatile artist in varied materials unless he was head of an establishment which employed several workers and supplied tombs and other works of art to order. This was certainly the case later on, but at this period the contracts are usually made with a number of workers each of whom was to supply his own particular contribution.[1] In 1395 Nicholas Broker and Godfrey Prest, citizens and coppersmiths of London, contracted to make the effigies of Richard II and Anne of Bohemia for the large sum of £400. The features of this were laid down in detail in accordance with the 'patron' which they had shown to the king. The whole was to be richly engraved and enamelled, and little figures of saints and angels were to be provided. The marble work was to be provided by Henry Yevele and Stephen

[1] The famous stalls of Winchester Cathedral were begun in 1305 by William of Lyngwode, carpenter (*Arch. Journ.* 1927).

20. *Lowick (Northants). Alabaster monument of Ralph Green by Thomas Prentys and Robert Sutton of Chellaston. c. 1419*

Lote, citizens and masons of London, for a sum of £250 besides a gratuity of £20 if it gave satisfaction.[1] These masons also received payment for the tomb of Archbishop Langham, whose effigy is of alabaster. Yevele was the king's chief mason, and superintended the building of the nave of the Abbey, and is perhaps the nearest approach to what we should now describe as an architect to be found in the middle ages.[2]

For the fifteenth century we have the contract for the noble monument of Richard Beauchamp, the great Earl of Warwick, who died in 1439. Here again a number of different craftsmen undertake to carry out their several functions. John Essex, marbler, Thomas Stevyns, coppersmith, and William Austen, founder, covenant to make a plate of finest 'latten' to lie under the image and a herse over it. William Austen also covenanted to cast and make an image of a man armed according to patterns,[3] as well as the weepers about the tomb. John Bourde of Corfe was to supply the marble and bring it to Warwick and polish it. Bartholomew Lambspring, Dutchman, was to polish and gild the great image and the rest of the laton work. Roger Webb, Warden of the Barber-Surgeons was also called in, presumably to advise on anatomical details.

We also have the contract for the Green monument at Lowick of 1418–19 (Fig. 20), between Katharine the widow with two clerks and Thomas Prentys and Robert Sutton, of Chellaston, 'kervers'. This is one of the fine alabaster tombs which are the chief feature of the sculpture of this period, and we thus see that it was provided by carvers working on

[1] Scott's *Gleanings from Westminster Abbey*, p. 174. [2] J. H. Harvey, *Henry Yevele*.
[3] The wood patterns were supplied by John Massingham, one of the leading imagers of the day (see p. 235). Under modern conditions we might give him the chief credit as the sculptor.

17

the actual spot where the alabaster was quarried.[1] There was a regular trade in the fifteenth century in alabaster tombs and retables, and these were exported even to the Continent. Names of these 'alabaster-men', as they were called, are known, and have been located in London, Norwich, York and other cities, but the chief centre of the trade was in Nottingham. As we shall see when we come to study their productions, the work was largely shop-work showing constant repetitions of types and technical mannerisms, but splendid in effect and sometimes attaining a high standard of workmanship, especially in the tombs.

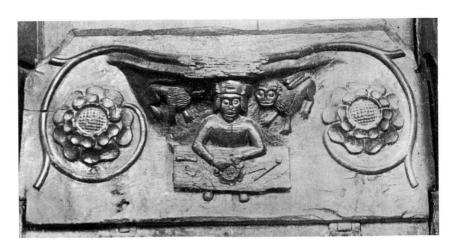

21. *Great Doddington (Northants). Misericord. The wood-carver*

St John Hope[2] suggests that the tombs of Henry IV and his queen at Canterbury and the Nevill tomb at Staindrop came from the Chellastin workshop, as well as that of the Earl of Arundel at Arundel. Similar details, such as the traceried 'gablettes' at the ends, occur in all of them. Dr John Bilson[3] published a record of a purchase of alabaster by a French mason sent from Fécamp in 1414, who got it from Thomas Prentys.

More individuality, perhaps, was shown by the wood-carvers at this period, and the little figures on bench ends in the fifteenth-century parish churches or the misericords of the stalls of cathedral and collegiate churches display a spirit and invention which are rare in the larger sculptures. One or two of them have left us self-portraits. Thus at Great Doddington the carver is seated with the board across his knee on which he is working at a Tudor rose exactly like those on each side of him on the misericord (Fig. 21). Another example at Wellingborough, close by, is so like this that it must be by the same hand, and there is another carpenter at work with his tools about him at St Nicholas, Lynn.[4]

A bench-end at Altarnun in Cornwall (Fig. 22) has an inscription on a shield held by an angel, which begins 'Robert Daye, maker of this worke'. The date appears to be *c.* 1520–30, at which time the wood-carvers of Devon and Cornwall were very active in fitting out the churches with richly carved screens, pulpits and benches. Daye's figures of

[1] A convenient abbreviated version of these contracts is given by F. H. Crossley, in his magnificently illustrated *English Church Monuments*. The original was preserved by Dugdale.
[2] *Arch. Journ.*, Dec. 1904. [3] *Arch. Journ.*, March 1907.
[4] Figured by F. Bond in *Woodcarvings in English Churches*, pt. I, 'Misericords', p. 96. These are now in the Victoria and Albert Museum, South Kensington.

a fiddler (Fig. 548) a fool and dancers, etc., are on a bolder scale than usual, and one or two bench ends at St Winnow, not far away, might be ascribed to him owing to similarity of treatment.

Finally, we find the citizen shopkeeper growing into a contractor, or business man working on a large scale. Thus Drawswerd, the imager of York, gave an estimate to Henry VIII for his father's tomb, which was never finished on the original lines. Now Drawswerd was mayor of York and a member of Parliament, and must therefore be regarded as the head of a considerable establishment, in which the actual carving was done by his shopmen and apprentices.

The elaborate structure of Henry V's chantrey at Westminster was provided by John Thirsk, master-mason, but he is not mentioned anywhere as a sculptor. Mr John Harvey suggests John Massingham's name[1] as a possible sculptor of the images. He seems to have been the most distinguished sculptor of his day. His chief work was the provision of the images for the great reredos of the Chapel of All Souls at Oxford. These have perished, but the statues of Henry VI and Archbishop Chichele on the Gatehouse may with some probability be attributed to him. These were replaced in 1939 by modern figures, but the old ones are preserved in the Cloister. The similarity between these and the Westminster statues, however, is hardly sufficient to justify an ascription to the same hand (Figs. 458, 459).

The names of a number of imagers working for Henry VII are known, but there is nothing to connect them with any particular surviving work. Lawrence Ymber made the patterns for the little bronzes of the grill round the tomb of the king. John Hudde, Robert Bellamy, Nicholas Delphyn and others are also mentioned, and may have been among the sculptors of the great array of statues in Henry VII's Chapel, described in Chapter VI, but this is pure conjecture. John Hudde's name occurs among carvers working on the architectural details of the north tower and porch at Bourges c. 1510. This seems to show that English masons travelled to France as well as foreigners to England.[2]

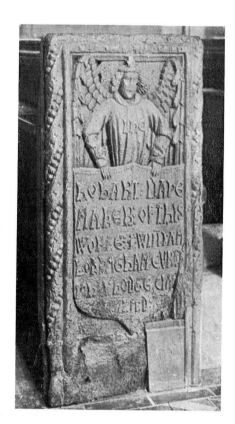

22. *Altarnun (Cornwall). Bench-end with signature of Robert Daye*

William Brownfleet of Ripon made the fine stalls at Ripon, Manchester and Beverley, though Mr Harvey[3] is perhaps a little rash in ascribing the well-known Jonah misericords (Fig. 560) to his own hand. He may have been merely the head of a wood-carving establishment with a number of good men working under him. In fact, by this time conditions were approaching those of more modern commercial practice.

[1] *Gothic England*, p. 100.
[2] Jean Verrier, *La Cathédrale de Bourges.* [3] *Gothic England.*

19

There is very little evidence of any elaborate guild organisation among masons and imagers during the medieval period. Master-masons seem to have sometimes had apprentices, and in the fifteenth century the masons had representatives on city councils, but the organised guild does not seem to have been really established before the sixteenth century. In fact Messrs Knoop and Jones[1] describe the stone-building industry as having a capitalistic organisation from the outset, not easily reconciled with the democratic craft-guild system of the fourteenth or early fifteenth centuries.

This is not the place to deal with the problems of the medieval mason and the conditions under which he worked, as we are here dealing with only one phase of his activities, but this brief sketch of the development of the sculptor's position from the stone-mason striving to translate into stone the traditional subjects and types set him by his monastic employers, to the skilled mason or marbler of the thirteenth century, the specialised imager of the fourteenth, and finally to the shopkeeper or contractor of the fifteenth, is necessary to the full understanding of our subject. As we study the sculptures themselves we shall see these changing conditions reflected in the character of the art produced by each succeeding generation.

[1] D. Knoop and G. P. Jones, *The Mediaeval Mason*, p. 159 and *passim*.

CHAPTER II

PRE-CONQUEST SCULPTURE

The period treated in this volume is from the earliest introduction of Christianity into these islands down to the Reformation—from the seventh to the first quarter of the sixteenth century. For the earlier part records are scarce and dating uncertain, but by comparing one thing with another we are able to make out a tolerably logical story of development. When we come to the post-Conquest period the steady advance of style makes classification easier and dating more certain.

Pre-Conquest sculpture in England may be roughly divided into three main categories, the Anglian cross-carving of Northumbria, the rougher crosses and more architectural sculpture of Mercia, and the later monastic style of Wessex. Fragments of carved crosses are found all over the northern counties and spreading into the northern midlands and the south of Scotland, and can be numbered by the hundred. The most conspicuous examples are the famous Bewcastle Cross standing in its original position on the moorland of Cumberland near the border, and the Ruthwell Cross in Dumfriesshire reconstructed from the original fragments in a little chapel near the spot where it had been thrown down by the Puritans in 1670. There has been considerable dispute as to the date of these monuments, as they stand entirely by themselves, unlike anything produced elsewhere in Western Europe at this early date. French critics until recently dubbed them as fine works of the twelfth century, while English critics have claimed them for the seventh. Recent research, however, has narrowed the possible dating to a period of about eighty years, from 670 to 750, which accords well with the history of the time.

The Northumbrian kingdom flourished from the middle of the seventh to the middle of the eighth century, and is made very real to us by the delightful picture presented to us in the writings of the Venerable Bede, who lived from 674 to 735. The Synod of Whitby, at which King Oswy rejected the Scottish rites, took place in 664, and Theodore of Tarsus (669 to 700) became primate of the united English Church. By the year 750 the Northumbrian kingdom was beginning to break up, and Mercia under Offa, 757 to 796, took the lead. In the ninth century the Viking incursions became more serious, and York was captured by the Danes in 867. Alfred (871 to 901) checked their advance and saved the southern and western parts from their ravages, but was compelled to hand over to them all the country north and east of a line drawn from London to Chester.

Alfred's successors gradually drove back the Danes, and Athelstan's victory at Brunanburgh in 937 and the recovery of York in 954 made England once more a single kingdom. Edgar's reign, 959 to 975, was a comparatively prosperous one, and was notable for the great monastic revival under the influence of St Dunstan, whose formidable figure dominates the scene until his death in 988. Fresh Danish incursions led to the supplanting of the old Wessex dynasty by Canute in 1017, but he was soon converted to Christianity and showed considerable zeal in restoring the churches he had burnt. He reigned as an English king and was succeeded by Ethelred's son Edward, known as the Confessor. He had strong

Norman sympathies and was much under the thumb of the Church, and paved the way for the Norman Conquest of 1066.

Bearing these facts and dates in mind let us return to the sculptures and see how their development fits in with the course of history. It is now generally accepted that the best and most refined crosses date from the end of the seventh to the middle of the eighth century, corresponding to the bright interlude of Northumbrian civilisation so delightfully described by Bede. Rather less skilful work is then found in the Midlands under the Mercian supremacy, and in the latter part of the ninth century Danish influences affect the style. The later work in the north is poor and decadent, but in the south art schools arose in the monasteries reformed by Dunstan, which were in touch with Carolingian developments on the Continent. We will take these several schools in order.

(1) THE ANGLIAN CROSSES

The Bewcastle Cross (Figs. 23, 24), to take the most striking of these monuments first, is a monolith shaft, some $14\frac{1}{2}$ feet high, to which a cross-head was apparently attached, but is now missing. On the front are three sunk panels containing figures, in fairly bold relief, of Christ and the two St Johns, on the back is a vine scroll with birds and beasts pecking at the grapes, and on the sides are further delicately wrought vine scrolls and chequer and interlacing patterns. There is a runic inscription, so worn as to be hardly decipherable, but said to contain the names of several persons known to have been living about the year 670,[1] whence it has been suggested that the cross was erected to commemorate the conquest of Cumbria by the Northumbrian Christians. At Ruthwell the cross (Figs. 25, 26), which had been thrown down by the Puritans in 1670, has been re-erected, and a few missing parts restored, in a new church built round it. Here again are large figures of Christ in sunk panels on both back and front, in one case treading on the asp and basilisk and in the other with a clumsily wrought figure of Mary Magdalene wiping his feet with her hair. There are also smaller groups of two figures each representing the Annunciation, Visitation, and a scene of Eastern origin, St Paul and St Anthony meeting in the desert, very rarely found in the West. There is a vine scroll with pecking birds very like that at Bewcastle. In both crosses the figures are quite well-proportioned and, if the execution looks a little coarse and heavy, this effect is partly due to the decay of the finer details caused by the storms and frosts of over 1200 winters. At Ruthwell there is a poem, the Dream of the Holy Rood, in runic letters, which must be one of the earliest specimens of the English language known, and also Latin inscriptions round the scenes. Prof. Lethaby has pointed out the similarity of certain letters in this last to forms found in MSS. of about the year 700.[2]

That work of such merit could have been produced in such a remote region, only recently converted to Christianity, comes as a shock to Continental students, but we need not take seriously the opinion of even so distinguished a critic as Rivoira who assigns them to the twelfth century. It is sufficient to point out that they do not stand by themselves,[3] but that

[1] The usual reading makes it a monument to Alchfrith, son of Oswy, and the names of his wife and other contemporaries seem to confirm this interpretation. See note on p. 28.

[2] *Burlington Magazine*, June 1912.

[3] The splendid cup found at Ormside, now in the York museum, must be dated to this period, and the MSS. like the Lindisfarne Gospels, which are more certainly dated *c.* 700, display a calligraphic skill in lineal ornament which has never been surpassed.

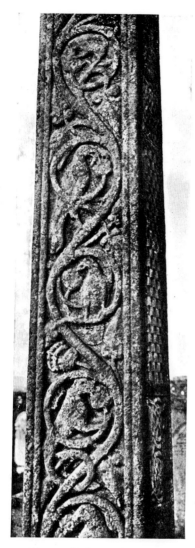

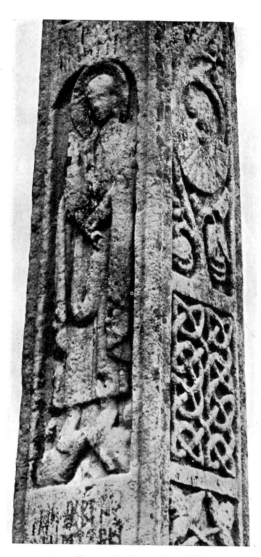

23. *Bewcastle Cross (Cumb). c.* 670 24. *Bewcastle Cross. The Christ*

there are many hundreds of fragments of more or less similar monuments scattered about the northern counties—there are said to be 500 in Yorkshire alone—and many of them already weather-worn and discarded were used as building material when churches were being rebuilt in the eleventh and twelfth centuries, as, for instance, at Kirkdale in Yorkshire where the church is dated by an inscription to the reign of Edward the Confessor, *c.* 1060. Now we have seen that the ninth century was one of turmoil and Danish invasions, so that we are thrown back to the end of the seventh and the eighth centuries as the one period of prosperity in which such numerous works of art could be produced. Bede, writing of the archbishopric of Theodore, says: 'Nor were there ever happier times since the English came into Britain.'[1] How then are we to account for this accomplished sculpture, for these vine scrolls—a plant which could hardly have been common in our bleak north-eastern counties—at this remote date? It can only be accounted for as a foreign importation, and

[1] *Ecclesiastical History*, bk. IV, ch. II.

23

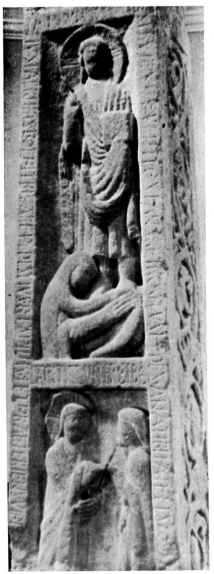

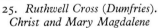

25. *Ruthwell Cross (Dumfries).*
Christ and Mary Magdalene

26. *Ruthwell Cross. Vine scroll*

there are records of the importation of foreign craftsmen. Eddius tells us that Wilfrid introduced masons, and when in Rome in 680 'obtained from men especially expert a goodly store of sacred relics...and possessed himself after his wont of precious things too numerous to mention for the adornment of the house of God'.[1] William of Malmesbury and Prior Richard of Hexham,[2] writing in the twelfth century, state that he brought masons from Rome, and Acca, his successor at Hexham, 'enriched the church with manifold

[1] Baldwin Brown, *Arts in Early England*, 1925, gives long extracts with translations from Eddius, set side by side with the later descriptions of Wilfrid's church at Hexham by the twelfth-century writers, Prior Richard of Hexham, Symeon of Durham and Aelred of Rievaulx.

[2] Prior Richard, *c.* 1140, describing Wilfrid's church, built *c.* 672–4, and remained to his day, tells us it was adorned 'hystoriis et ymaginibus et variis coelaturarum figuris ex lapide prominentibus.'

24

adornments and marvellous workmanship'.[1] Benedict Biscop, when building the abbey of Wearmouth, of which the porch still survives, went over to Gaul and brought back masons to build a stone church 'juxta morem Romanorum'. He also sent for workers in glass, and went on journeys to Rome more than once to procure sundry fittings.[2]

Here then we have ample evidence of the importation of skilled workers from contemporary as well as later sources just at the period suggested by the Bewcastle inscriptions. The only puzzle then is that nowhere in Western Europe can any similar works be found dating from this period. Several observers have noted that the resemblance in style of these Anglian crosses is much closer to that of eastern than western models. We have already referred to the scene of SS. Paul and Anthony on the Ruthwell Cross, and the vine scrolls may be compared with those of Syrian mosaics, or such ivory works as the chair of Maximian at Ravenna, which is held to be a Syrian or Alexandrian production of the sixth century. There are also strong resemblances to Coptic ornaments, such as certain limestone reliefs of the fifth century in the Cairo Museum, where vine scrolls with birds pecking at the grapes bear a remarkable likeness to those on the Northumbrian crosses. Mr Dalton in his *Byzantine Art and Archaeology*[3] also illustrates a wooden post with figures carved in panels dating from the fifth century in the same museum, which suggests the Anglian scheme. This eastern flavour is not so surprising when we consider the state of the world at the time. Gaul and Italy itself had been overrun by barbarian invasions and Rome was only a shadow of its former greatness kept alive by the moral authority of the popes. The seventh century was marked by the Mahommedan conquests of Syria, Egypt, Africa and Spain, which wiped out what had by then become the most civilised portion of the ancient world. Refugees no doubt had fled in great numbers into Italy and Gaul, and it is likely that when Wilfrid and Benedict Biscop came to search for craftsmen to build their churches exiles looking for work to support themselves would have been more disposed to follow them than natives of Gaul or Rome. Such men too would have been more skilled and therefore more welcome. There seem to have been Syrian colonies in southern Gaul, and in Rome itself at the end of the seventh and beginning of the eighth centuries four Syrians and three Greeks occupied the papal throne. Theodore, the first archbishop to exercise full authority over the whole English Church, after the defeat of the Scots at the Synod of Whitby, came from Tarsus, and his friend and right-hand man, the Abbot Hadrian, was an African and had presided over a monastery near Naples. These men reformed the northern Church in England, introduced Roman doctrines and music and no doubt also objects of art of the types with which they were familiar. Monastic institutions were of very high repute in the days of Bede and it must be remembered that the monastic idea first arose in the deserts of Egypt and the near East, where the hermits banded themselves together into groups for mutual protection.

The form of the monuments themselves seems to have been of native origin. The idea of erecting tall crosses may have been Celtic, but there is no evidence of Irish sculpture which could have influenced the Northumbrian carvers. The Irish crosses are later in date and, like the Book of Kells which seems to have been derived from such works as the Lindisfarne Gospels, must have been inspired by the English monuments. As Sir A. Clapham remarks,[4] the Irish monks from Iona and Lindisfarne seem to have brought

[1] Bede, *Hist. Eccl.* v. 20. [2] Bede, *Historia Abbatum*, c. 5. [3] Fig. 85, p. 148.
[4] A. W. Clapham, *English Romanesque Architecture before the Conquest*, p. 59. This book contains the best summary of our knowledge of the art of this period brought up to date.

with them little but piety and learning, and it was only when the Greco-Italian element came into power after the Synod of Whitby that the great outburst of cross-carving comes into being. At Whithorn, the ancient Candida Casa, and at Kirkmadrine, in Galloway, there are some early crosses, some of which may go back to St Ninian's mission at the end of the fourth century, but their ornamentation consists merely of the sacred monogram with nothing which can be called sculpture. In the life of St Willibald, born about 700, it is stated that it was the custom of the Saxon race that 'they are wont to have, not a church, but the standard of the Holy Cross, dedicated to our Lord and reverenced with great honour', and William of Malmesbury describes two crosses as standing in his day at Glastonbury, one of which bore the names of a seventh-century king and bishop. Preaching crosses, often probably of wood, seem to have been set up by the Columban monks, and we therefore appear to be justified in assuming that the great outburst of stone cross-carving of the seventh and eighth centuries resulted from the calling in of Wilfrid's and Biscop's eastern craftsmen to decorate the native type of monument. How far the surviving crosses were actually made by the foreign craftsmen, or how far by native pupils taught by them or working under their supervision, is a matter of conjecture. In the case of Bewcastle, Baldwin Brown thought the runic inscription pointed to native Anglian carvers, though the excellence of the figure-work might suggest the presence of a master doing some of the more important parts himself.

Under these circumstances it would be natural to expect the earliest crosses made by the foreigners or their pupils to be the finest, and that the quality of the work should deteriorate as time went on and the native carvers were further removed from their teachers, especially as the Northumbrian kingdom began to decline by the middle of the eighth century. And this is exactly what we find. Prof. Brøndsted, the distinguished Danish antiquary, has made a careful survey and classification of the crosses in accordance with the development and decline of the foliage ornament, and especially the vine scrolls,[1] and his book enables us to arrange them in a more or less logical sequence. At the same time it would be wise to avoid falling into the temptation, so attractive to many continental critics, of expecting too logical a sequence of development or deterioration. The general position seems fairly clear within certain limits, but the classification of individual objects must be more or less tentative and conjectural.

A panel at Hexham (Fig. 27), with the lower part of what looks like a naked Cupid running among delicately twined vine tendrils, is probably part of the decoration of Wilfrid's church, wrought by his imported craftsmen. Brøndsted illustrates the Otley cross-shaft (Fig. 30) side by side with a very similar pattern from Maximian's ivory chair at Ravenna. There is considerable variety in the birds and beasts set in the vine scroll, and he is probably right in placing this cross in the first category, though the linear treatment of the drapery in the busts on the other side has not quite the modelling of that on the Bewcastle Christ. Side by side with this we may place the Easby cross-shaft, the various fragments of which are now safely collected in the Victoria and Albert Museum, South Kensington. Here the vine scrolls are exceptionally well wrought and the birds and beasts (Fig. 29) are full of life and vigour, while the grouped heads of the Apostles (Fig. 28) in

[1] J. Brøndsted, *Early English Ornament* (English translation). The most complete treatise on these crosses is W. G. Collingwood's *Northumbrian Crosses*. This is illustrated by hundreds of careful drawings by the author, which bring out the patterns more clearly than photographs of much weathered and decayed stones, though less reliable for detailed examination of the actual handling.

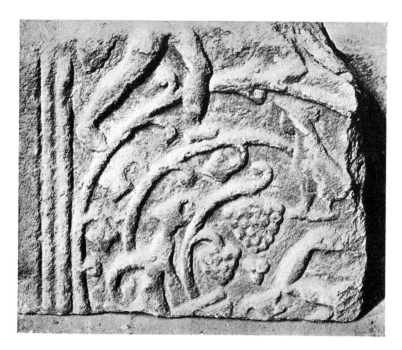

27. *Hexham (Northumb). Panel*

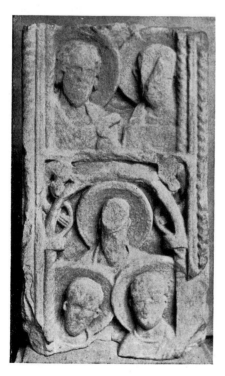

28. *Easby Cross (Victoria and Albert Museum). Heads of the Apostles. c. 680*

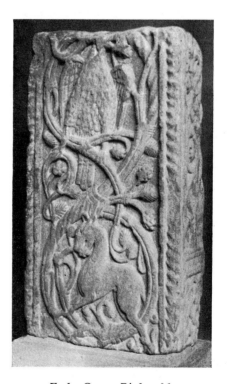

29. *Easby Cross. Bird and beast*

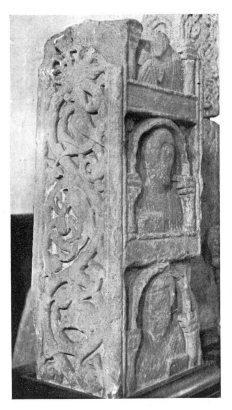

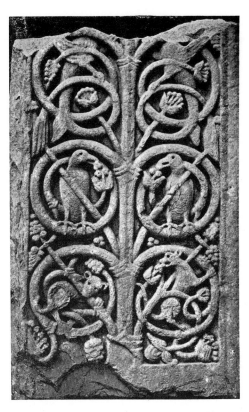

30. *Otley (Yorks). Cross-shaft. c. 680* 31. *Jedburgh (Roxburgh). Base of cross(?) c. 700*

spite of their worn condition suggest a level of attainment not reached again for 500 years. Brøndsted, accordingly, places this group at the end of the seventh century, and attributes them to the imported craftsmen, but he thinks that the scrolls at Bewcastle and Ruthwell (Figs. 23, 26) are a little coarser and should be placed in a second category early in the eighth century. It seems, however, unnecessary to separate them by more than ten, or even five years, which is a considerable period in the working life of a man, especially as the work of a master and his pupil, even if contemporary, might show considerable variety in quality.[1] Without stronger evidence to the contrary, therefore, it does not seem necessary to reject the evidence of the inscription which points to about 670 to 680 as the date of these famous crosses. A stone at Jedburgh, possibly forming the base of a cross, is a little coarser with birds pecking vigorously at the grapes (Fig. 31), and may be placed c. 700. Two crosses, one of which has a bird and vine scroll and the other a single vine scroll without animals, have been found at Abercorn, near Linlithgow, and as an Anglian see was established here for the short period 671–6, this seems the most likely date for the crosses (Fig. 48).

[1] Baldwin Brown devotes the greater part of the fifth volume of his *Arts in Early England* to a minute and careful analysis of every detail of these crosses at Bewcastle and Ruthwell, with the collaboration of Prof. Blyth Webster in dealing with the runic inscriptions. He is satisfied that the latter part of the seventh century is historically the most likely period for their erection. He is also convinced that the reading of the runes to the effect that the Bewcastle Cross was set up in memory of Alcfrith, son of Oswy, may be accepted, especially as Alcfrith's wife's name Cyneburga also occurs. Alcfrith was under-king of Deira, and took a prominent part in organising the Synod of Whitby. He was a friend of Wilfrid, and is not heard of after 664, so that a date of 670–5 for the cross seems indicated.

32. *Hexham (Northumb, now in Durham Library).*
Acca's Cross. c. 740

33. *York Museum. Huntsmen*

The above is the most widely accepted theory, but it is fair to mention that W. G. Collingwood, whose lifelong study of the subject entitles his opinion to respect, places the whole series half a century later. He begins with a cross from Hexham, now at Durham, which has been identified with the one placed over Acca's grave on his death in 740 (Fig. 32). This has very refined vine scrolls, both single and double, but no figures or birds. A cross in private possession at the Spital, Hexham, is very like it, but has a much worn Crucifixion on the back, and there are other fragments in the Durham Library from Hexham of similar style. Under this scheme the whole of the finest group of the Northumbrian crosses is brought into the second half of the eighth century, but this is not really necessary since, as Sir A. Clapham[1] points out, it is easy to suppose a second introduction of foreign craftsmen, especially as there is a record that Acca, who was Wilfrid's pupil, companion and successor, also did much to embellish the church at Hexham. The style is different from the bird and beast scrolls and looks like a separate inspiration.

Whatever theory we adopt there is little doubt about the subsequent course of events, even if there may be a little controversy about the exact dates. As the foreign school died out there was a progressive decline in the quality of the work. A cross at Rothbury, of which we illustrate a portion now in the museum at Newcastle, shows a slight coarsening in treatment and a rendering of the drapery by parallel ridges (Fig. 34). A stone in the York museum (Fig. 33) has two huntsmen, one with a sword and the other girt with a horn,

[1] A. W. Clapham, *English Romanesque Architecture before the Conquest*, p. 65.

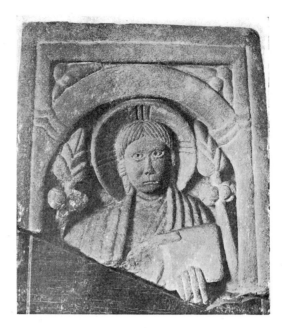

34. *Rothbury (Northumb). Part of cross.*

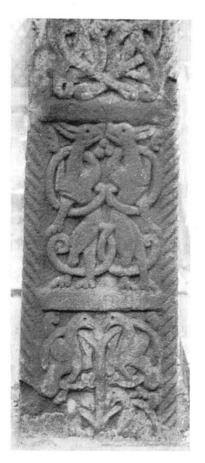

35. *Ilkley (Yorks). Cross-shaft with pair of beasts*

36. *Aycliffe (Durham). Cross-shaft*

37. *Dacre (Cumb). The Anglian beast. c. 800*

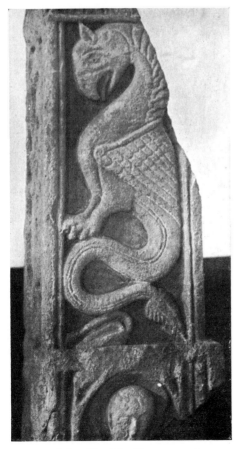

38. *Otley (Yorks). Dragon. c. 800*

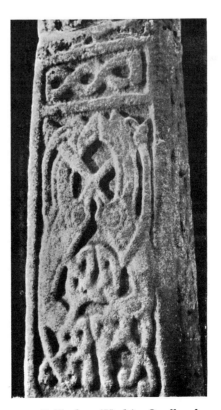

39. *Collingham (Yorks). Scroll and monsters. c. 840*

and a bold but rougher foliage scroll at the side. A good example of what has been called the 'Anglian beast' may be found on a cross fragment at Dacre (Fig. 37). As time goes on the scrolls become more and more formal, the beasts tend to become less natural and their extremities melt off into meaningless interlacements. There is a tendency to divide up the face into panels, each containing one beast, or sometimes a pair of beasts arranged almost heraldically, as at Ilkley (Fig. 35). Norse inspiration begins to be felt, and becomes stronger after the Danish conquests of the middle of the ninth century. A fragment at Otley has some finely carved busts, reminiscent of Easby, but accompanied by a bold dragon which

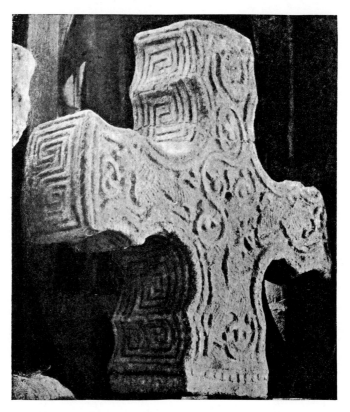

40. *Cropthorne (Worcs). Head of cross. c.* 800

suggests a first infiltration of Norse ideas (Fig. 38). A cross-shaft at Collingham (Fig. 39) preserves a reminiscence of the Anglian scroll, but mixes it with nondescript strap-like monsters derived from Norse wood-carving, and worked flatly in two planes, with rings marking the joints, characteristic of Danish work.

A cross-head preserved at Cropthorne (Worcestershire) of late Anglian type (Fig. 40) shows the shape of head adopted in all these early crosses, the wheel-head type familiar in tenth-century Irish crosses being mainly Celtic and later in date. The degradation to which sculpture fell as the Northumbrian kingdom dwindled away may be seen at Aycliffe, where the figures are little more than patterns (Fig. 36), or still more strikingly in a fragment from Gainford now in the Durham Library (Fig. 41).

A number of roughly carved crosses at Durham, of which we give one example (Fig. 42), must be mainly of the early eleventh century, as the see was only established there in 995.

32

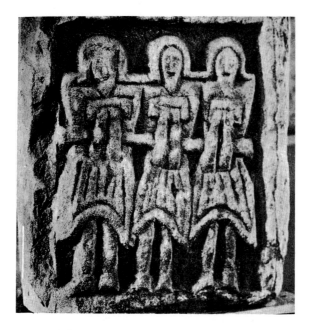

41. *Gainford (now in Durham Library). Part of cross*

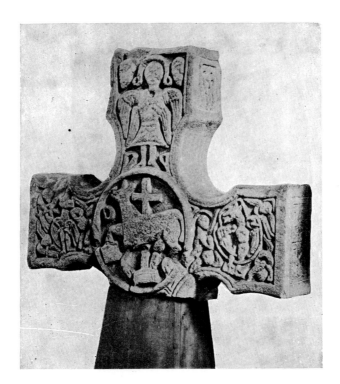

42 *Durham Library. Roughly carved cross. c.* 1000

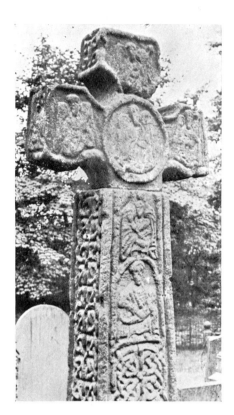

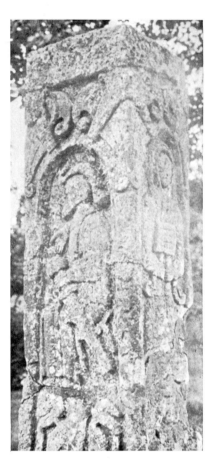

43. *Eyam (Derby). Cross*
44. *Nunburnholm (Yorks). Madonna and warrior. c. 900*

(2) THE MERCIAN SCHOOL

There are a few crosses scattered about the rest of England, but they are rare in the south. A fragment showing well-executed drapery at Reculver probably dates from the erection of the church at the end of the seventh century, but most of the others seem later and have little figure-sculpture.

In the northern midlands, however, there are a number remaining which there is reason to believe derive from the rise of Mercia to the leading position under Offa in the second half of the eighth century. The crosses at Eyam (Fig. 43) and Bakewell in Derbyshire may be cited as examples. In these the interlaced patterns continue, but the vine scroll has become little more than a bold spiral, while the figures are very rough and primitive.

Work of a purely Danish character may be found in the tall cross (Figs. 45, 46) at Gosforth on which episodes from Norse sagas are mixed with scenes of Christian origin. As good an example as can be found anywhere of early eleventh-century Danish style is in Southwell Cathedral; it is a kind of tympanum now placed over a doorway in the north transept, and represents St Michael and the Dragon. The flat treatment and strap-like monster are very typical of a technique derived from wood-carving (Fig. 47).

34

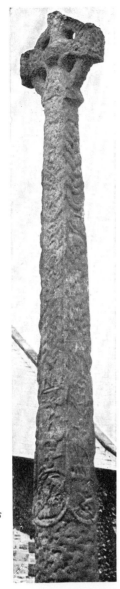

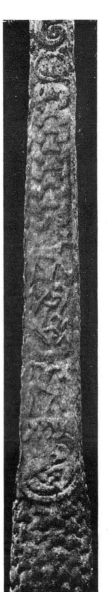

45. *Gosforth Cross*
 (Cumb). *c.* 900

46. *Gosforth Cross*

47. *Southwell. St Michael and the Dragon.* *c.* 1000

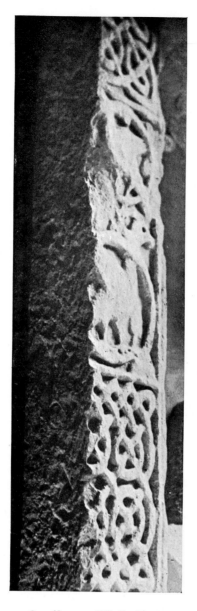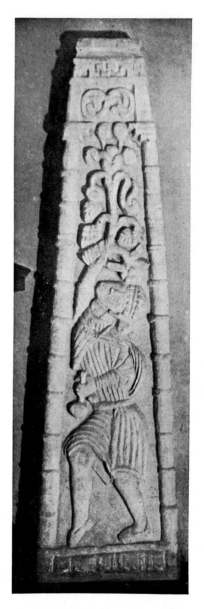

48. *Abercorn (W. Lothian).*
Cross-shaft. c. 675

49. *Codford (Wilts). Cross-shaft*

A cross at Nunburnholm is a good example of the Danish period. On one face is a seated Madonna and on the other a helmeted warrior, whose tomb-stone it appears to be. The carving is very coarse and stylised, with little attempt at modelling (Fig. 44).

A few examples of sculptured decoration other than that of cross carving have survived in the Midlands, some of which may go back to the second half of the eighth century or beginning of the ninth. The following century was too much taken up by the struggle with the Danes to have given much opportunity for church decoration. At Breedon-on-the-Hill some eighty feet of narrow carved friezes have been set in the walls of the later church. They have various interlacings and fretwork patterns, together with Anglian beasts

36

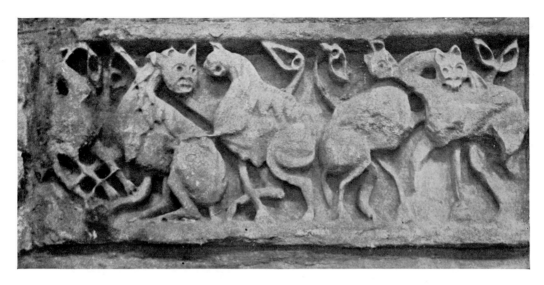

50. *Breedon-on-the-Hill (Leics). Anglian beasts. c. 800*

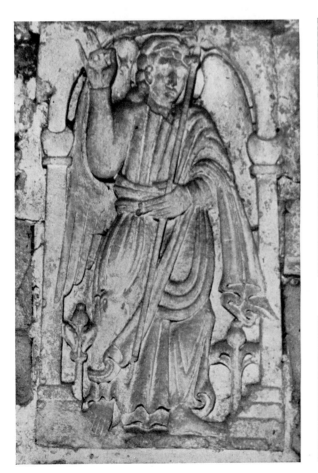

52. *Breedon-on-the-Hill. Half figure*

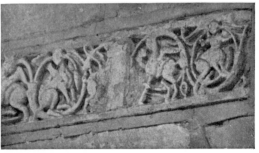

51. *Breedon-on-the-Hill. Christ*

53. *Breedon-on-the-Hill. Figures in vine tendrils*

37

(Fig. 50) and figures set in vine tendrils (Fig. 53). Most important of all are two larger reliefs, one of a Christ and another a half figure, set under arches with bulbous capitals and raising their hands to bless in the Greek manner (Figs. 51, 52). This is a feature found in English MSS. of 750 to 850.[1] Some similar pieces, together with two figure-panels, are preserved at Fletton. It has been suggested that they came from Peterborough, from the church destroyed by the Danes c. 870. Several pieces of a frieze of interlacements and animals are set in the south buttress of the chancel, and a row of busts reminiscent of those of the Easby Cross (Fig. 55). The panel figures have the eyes hollowed to receive some kind of filling (Fig. 56) which is found in other Saxon work at Breedon, Wirksworth or Chichester. The Monks' Stone at Peterborough (Fig. 57) is a shrine-shaped block with a row of figures under an arcade, derived ultimately from the design of a Roman sarcophagus.[2] The coped top is decorated with interlacing patterns which suggest a late eighth century date. Closely allied to this is a stone recently discovered at Castor, not far off (Fig. 58). The details of the arcade are very similar, but the attitudes are more vigorous and the drapery rendered by finer lines. The seated figure of Christ in a sunk panel at Barnack (Fig. 59) looks like an altar-piece, and may have been more influenced by Carolingian efforts in the south. This probably belongs to the post-Danish period of the latter part of the tenth century, to which the tower at Barnack may be assigned. Ruder and perhaps earlier work is to be seen in the remarkable slab at Wirksworth (Fig. 60). The subjects are difficult to identify, but include the washing of the disciples' feet, a symbolical cross with the lamb affixed instead of the sacred figure and

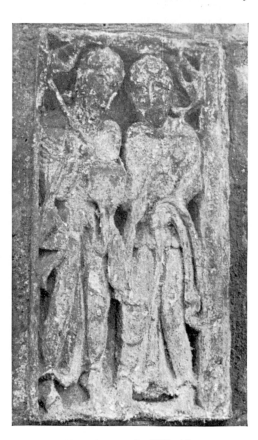

54. *Breedon-on-the-Hill. Figures*

the four Evangelists with human bodies and beasts' heads, the Entombment, the Ascension, etc. This curious treatment of the Evangelists occurs also on a cross at Ilkley and probably at Edenham, and like the Greek blessing occurs in MSS. of 750 to 850.[3]

The coped tombstones with the figure of a bear at each end, known as hog-backs, of which good examples may be found in the Durham Library, Brompton (Fig. 61) and at Gosforth, appear to belong to the Danish period.

[1] For full description of the Breedon sculptures see A. W. Clapham in *Archaeologia*, LXXVII, 1927. He gives strong reasons for dating them before the destruction of the churches of this district by the Danes in 874, and is inclined to favour the second half of the eighth century as most likely.
[2] A panel with two figures in curious head-dresses is also preserved in the cathedral at Peterborough, and evidently belongs to the same series.
[3] Clapham, *English Romanesque Architecture before the Conquest*, p. 70.

55. *Fletton (Hunts). Frieze. c. 800* 56. *Fletton. Figure with hollowed eyes*

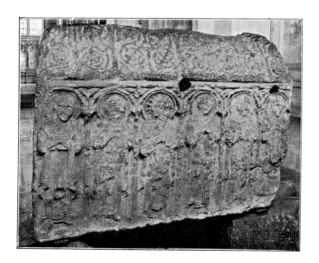

57. *Peterborough. The Monks' Stone*

39

58. *Castor (Northants). Stone fragment* 59. *Barnack (Northants). Christ*

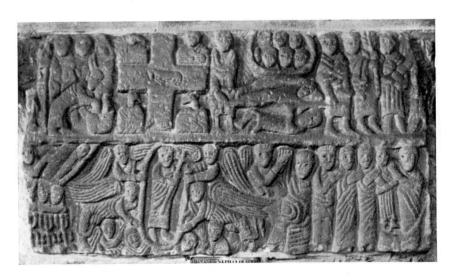

60. *Wirksworth (Derby). Slab*

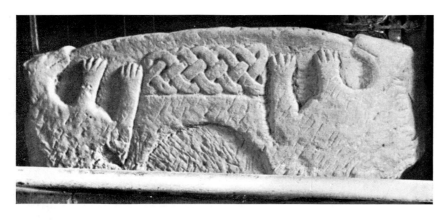

61. *Brompton (Yorks). Hog-back*

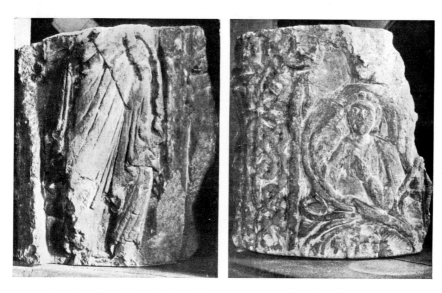

62, 63. *Canterbury Crypt. Fragments of cross from Reculver. c.* 670

(3) THE WESSEX SCULPTURE

There is very little in the south in the way of sculpture which can claim such remote antiquity as the crosses we have been discussing in Northumbria. The Reculver fragments (Figs. 62, 63) have been mentioned as almost certainly going back to the end of the seventh century, and are remarkable even in their mutilated condition as showing a high quality of workmanship. This cross stood inside the church in front of the apse, and the foundation on which it stood is contemporary with the pavement dating from about 670.[1] It was round in section, and the fragments now preserved in the Crypt at Canterbury show that it was not a monolith like the slab-crosses of the north. The figures in the scrolls are human, not birds and beasts, and the elaborate zigzag folds of the draperies, the careful rendering of the feet and variety of attitudes combine to give this cross exceptional distinction.

[1] Fully described and illustrated by Sir Charles Peers in *Archaeologia*, LXXVII, 1927.

41

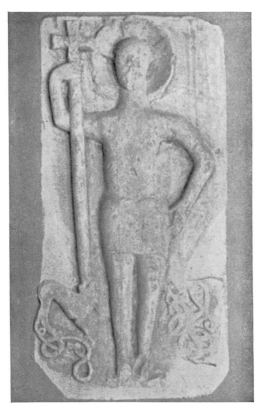

64. *Jevington (Sussex). Figure with cross staff* 65. *Deerhurst (Glos). Angel*

A slab at Jevington (Fig. 64) has a figure with the cruciferous nimbus and holding a cross staff. This is shown by the curious interlacements of Danish character to be work of the tenth or eleventh century, while an angel slab set in a niche on the exterior of the chancel at Deerhurst (Fig. 65) appears to be contemporary with the building which is assigned by Baldwin Brown to the earlier part of the tenth century. The strangely well-preserved relief at Codford St Peter has some reminiscences of the earlier cross sculpture (Fig. 49). A little carving of St Michael and the Dragon at Seaford may belong to this period (Fig. 66).

Mention has already been made of the early 'pyramids' seen by William of Malmesbury at Glastonbury. He also records that crosses were put up to mark the progress of the funeral of St Aldhelm at each seven miles from Doulting to Malmesbury, in 709.

At Britford (Wiltshire) there are arches opening into porch-chapels with the jambs ornamented with a rough vine scroll which may be dated to the beginning of the ninth century (Fig. 67). Crosses are scarce and the collection at Ramsbury have decadent ornament which cannot be very early. There is a tombstone at Whitchurch to a lady called Frithburga, with inscription, and a bust of Christ on one side, which might be early tenth century, but the most important remains seem to derive from the period of monastic reform under St Dunstan. Under his influence a brilliant school of MS. painting arose, in touch with the Carolingian schools on the Continent, and by the end of the tenth and

42

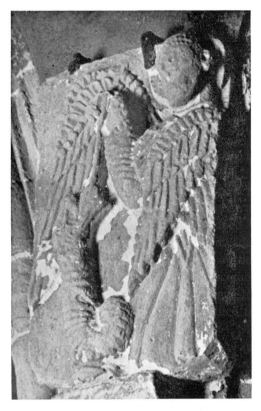

66. *Seaford (Sussex). St Michael and the Dragon*

67. *Britford (Wilts). Vine scrolls. c. 800*

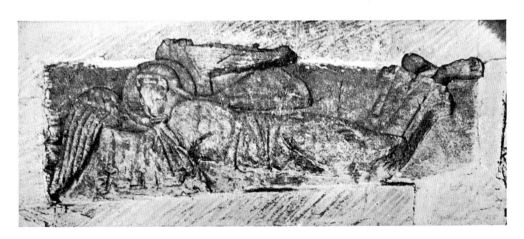

68. *Bradford-on-Avon (Wilts). Flying angels. c. 1000*

43

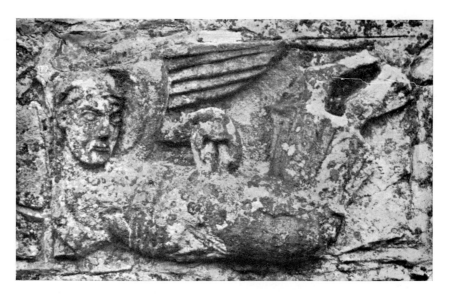

69. *Winterborne Steepleton (Dorset). Angel. c.* 1000

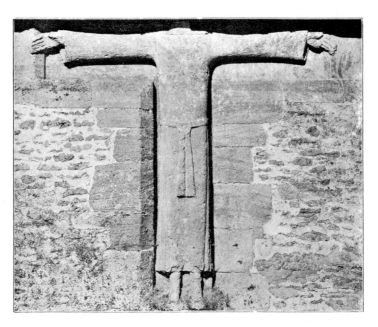

70. *Langford (Oxon). Draped crucifix. c.* 1000

beginning of the eleventh century the Winchester manuscripts had become famous all over Europe. Henceforth ornamentation is based more on a kind of semi-classical acanthus pattern, which takes the place of the Syrian vine scroll.

The little church at Bradford-on-Avon, now usually assigned to the tenth century, has two flying angels (Fig. 68) with napkins over their hands, a piece of Byzantine court ritual; these must have been placed on either side of a crucifix, or a sacred symbol, like the lamb bearing the banner. They resemble Byzantine ivories, and proportions are fairly natural. There is an angel in a very similar attitude built into the tower at Winterborne Steepleton

44

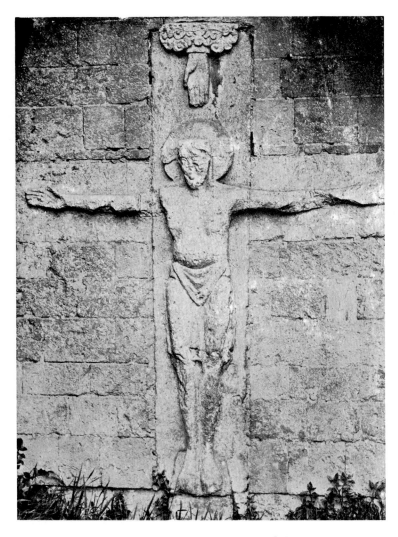

71. *Romsey (Hants). Rood by south door*

(Dorset), which must have come from a similar group (Fig. 69), and at Deerhurst there is another figure over the west porch from which all the projecting features have been cut away.[1]

The Rood, or crucifix flanked by Mary and John, without the flying angels, seems also to have been fairly common. At Langford (Oxon), a late Saxon church, there is one over the porch, and there is also a very remarkable Crucifix, now headless, draped in a long straight garment, with the hands very delicately rendered (Fig. 70). At Headbourne Worthy the outline of a huge Crucifix can be traced on the west wall, now inside the tower, and in the north traces of a similar Rood can be seen over the porch at Monk Wearmouth. The well-known Romsey Rood (Fig. 71) is the finest of these carvings; the proportions are correct and the whole a work of great dignity. It is far superior to anything produced in the half-century following the Conquest, and so seems to be rightly placed here, the

[1] Illustrated by Baldwin Brown, *Arts in Early England*, 1925, fig. 87.

45

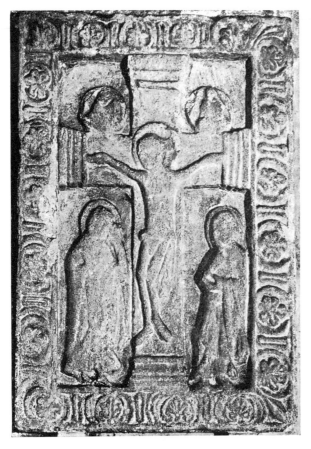

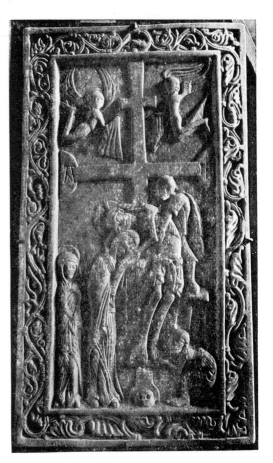

72. *Stepney. Stone slab. Crucifixion* 73. *Victoria and Albert Museum. Ivory Deposition*

only possible alternative being the end of the twelfth century. The feet are separate and not crossed, and the hand of God appearing from a cloud is an early feature, which is found in eleventh-century MSS. A stone slab at Stepney (Fig. 72) may be placed *c.* 1000 with more probability. When it is set beside such a Saxon ivory as the Deposition we illustrate from the Victoria and Albert Museum (Fig. 73) there can be little doubt as to a common inspiration if allowance is made for the different materials. The border is clearly an attempt to translate into stone the acanthus borders of the Winchester MSS.

A remarkable little relief in a smooth hard stone of the Madonna and Child at York (Fig. 74) is so unlike any of the rough Anglo-Norman sculpture that the pre-Conquest date seems probable. In spite of its mutilation it is a work of great delicacy, and the cushion and style of the drapery is more like late eleventh-century sculpture at Toulouse than anything else in this country.[1] It is stated to be carved in Tadcaster stone, which proves it a local work in spite of its Byzantine feeling. Sir A. Clapham makes a strong claim for a pre-Conquest date, basing his arguments strongly on the style of the inscription (*Arch. Journ.* CV, 1948).

[1] Another Madonna at Inglesham and some rough figures of Christ and Apostles at Daglingworth (Glos) seem to be the work of rustic masons.

46

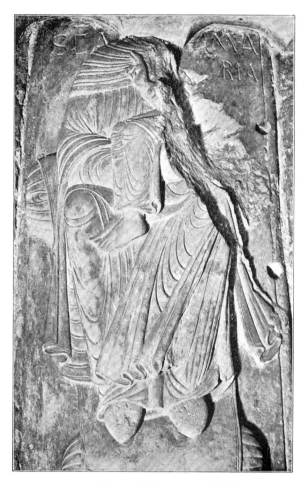

74. *York. Madonna and Child*

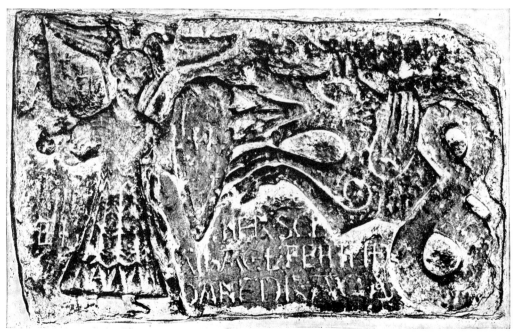

75. *Ipswich. St Nicholas, St Michael. c.* 1000

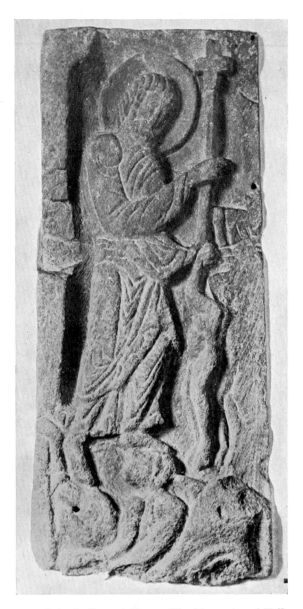

76. Bristol. Canons' Vestry. The Harrowing of Hell

In St Nicholas' Church, Ipswich, several fragments of early sculpture are set in the wall of the present building. One is a tympanum carved with a wild boar, and another a panel with St Michael and the Dragon and an inscription in Anglo-Saxon describing the subject (Fig. 75). These show Danish influence in the spiral joints and other details, and are probably not earlier than the eleventh century.

Some of these early reliefs are difficult to date exactly. For instance, the slab of the Harrowing of Hell preserved in the Canons' Vestry at Bristol has no distinct feature to point to a date before or after the Conquest, and we shall be safer merely to label it eleventh century (Fig. 76).

77. *Chichester. Christ coming to Mary's house. c.* 1000–1050

We have left till last the most important examples of Saxon sculpture. Two slabs carved on built up blocks of Caen stone, suggesting local execution, are set in the south aisle of the choir of Chichester Cathedral (Figs. 77, 78), and are supposed without any positive evidence to have come from the ancient Saxon cathedral at Selsey. They represent Christ coming to the house of Martha and Mary, and the raising of Lazarus. In style they do not fit into any later period, and certain early features seem to justify us in assigning them to a date *c.* 1000–1050. One panel has a rough acanthus-type cresting very like that on the rood at Stepney, and the way of emphasising the importance of the persons represented by grading them according to size points to an early date. The hair and other details are rendered with more care and variety than in Anglo-Norman work, and the high-shouldered attitudes and eyes hollowed out in order to be filled with crystals or jewels also occur in Saxon sculpture elsewhere. The architecture of the house and capitals suggesting those of late Saxon date at Sompting, the zigzag folds of the draperies recalling those of the Winchester MSS. of *c.* 1000, the attempt to give expression to the faces, especially those of the weeping Martha and Mary, the use of the three-quarter profile, are all refinements which we shall not find again until we come to a period when art was so different that there could be no question of assigning these slabs to it. Moreover, the resemblance to such an

49

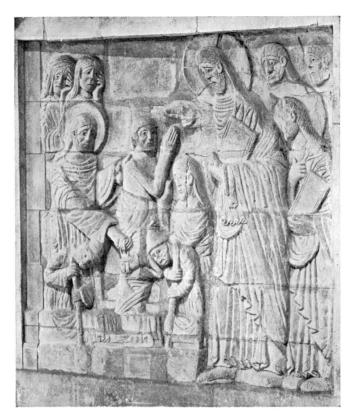

78. *Chichester. Raising of Lazarus. c.* 1000–1050

object as the walrus ivory Adoration of the Magi at South Kensington (Fig. 79),[1] work of some northern school, probably English, of the early eleventh century, provides another work of the same type, which we may reasonably assume to have had its origin in the monasteries reformed by St Dunstan, and in touch with the Carolingian schools of the Continent. A tomb slab at Bishopstone with doves pecking at a vase, a lamb and a cross, reminds us strongly of Byzantine motives and may, therefore, be placed here, though with less certainty (Fig. 80).[2]

[1] It must be recorded that Miss Longhurst in her book on ivories assigns this to the twelfth century. Most authorities, however, consider it pre-Conquest work as suggested in the text.

[2] Some rather coarse figures at Daglingworth and a Majesty and a bishop at Sompting, must be classified as local productions of this eleventh-century school.

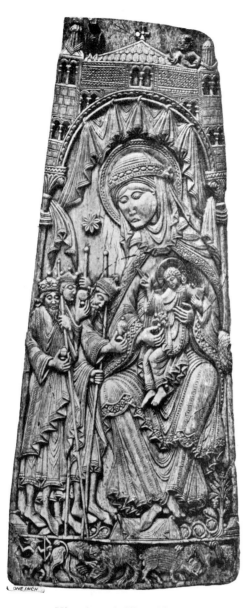

79. *Victoria and Albert Museum.*
Saxon ivory

80. *Bishopstone (Sussex).*
Tomb slab

51

CHAPTER III

THE NORMAN PERIOD

(1) ANGLO-NORMAN SOURCES OF STYLE

The effect of the Norman Conquest on sculpture may easily be exaggerated. We must remember that the Normans were of the same stock as Saxons and Danes, though for a generation or two they had been in contact with Frankish civilisation. What we owed to the Normans was not the introduction of Continental refinement, but the impulse of vital energy backed by the spoils of the conquered race. This expressed itself in covering

81. *Durham Castle. Capital in chapel. c.* 1070

England with great churches on a scale hitherto undreamed of, but these at first were extremely plain and relied for their ornamentation on paintings or such barbarous, though effective, enrichments as the zigzag or billet patterns which are employed to decorate door-head, window or arch-mould. In Normandy itself there is even less early sculpture than in England, and when in course of time the stone-carver was called in to enrich the great buildings growing up on all sides he really had to begin afresh and look for new sources of inspiration instead of carrying on from such examples as the Chichester slabs. The first efforts of the Norman sculptor were of the crudest possible description, and such works as the capitals of the chapel in Durham Castle, *c.* 1070, are absurdly childish in comparison with the Saxon productions of the Winchester school (Fig. 81).

In one indirect way, however, the Conquest introduced a lasting and decisive element into the history of English art; the Norman Kings, in spite of their violence and excesses—perhaps partly because of them—were pious churchmen, and it was part of their policy to settle the country by founding monasteries to be centres of light and learning in the conquered territory. The eleventh century had witnessed a great expansion in the reputation

and power of the Benedictine foundations, and especially of the reformed branch under the leadership of Cluny, and in the twelfth we see them at the height of their wealth and prosperity, housing themselves magnificently and showing themselves bountiful patrons of the arts. Their great churches, to a great extent, still serve as the basis of many of our cathedrals to-day, and it was their demand for architectural sculpture which stimulated the movement which developed into the Gothic building sculpture of the following century. Their influence, however, in this direction was not fully felt until the second quarter of the twelfth century, and may therefore be left to a separate section.

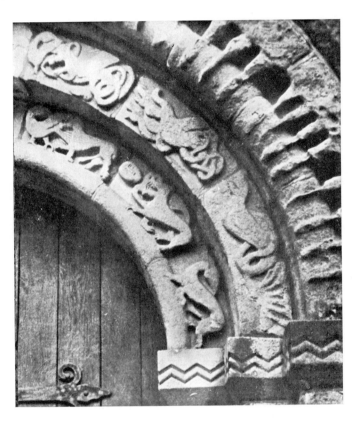

82. Bradbourne (Derby). Beasts with interlacing tails

Although the first big abbeys and cathedrals were very plain we find a tendency in the smaller country churches to favour more elaborate doorways and fonts, and these, especially in the tympanum over the doorway, or in the mouldings round the door-head, seem to be inspired more by the old Norse carving of the later crosses than by Continental fashions. Such wild imaginations as the beasts with tails running off into interlacements, and carved practically in two planes, as we find at Bradbourne (Fig. 82), can only be derived from Norse wood-work technique, and even the more accomplished tympanum at Dinton (Fig. 83), with its beasts representing the souls of the righteous battening upon the 'tree of life' and its St Michael fighting with the Dragon, or of Moreton Valence with its vigorous combat between a bearded long-robed St Michael and a dragon of true Danish type, carry on the old Viking tradition though amplified by the increasing technical skill

53

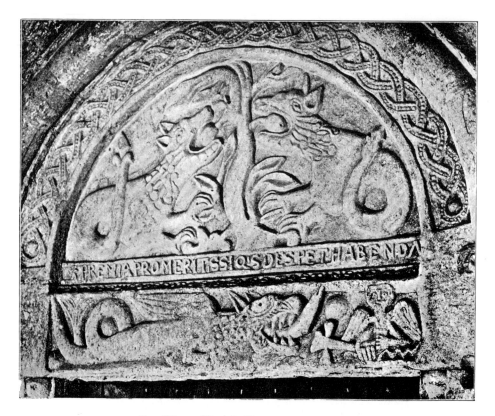

83. *Dinton (Bucks). Tympanum. c. 1125*

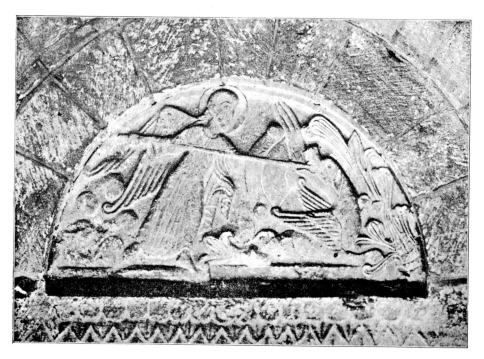

84. *Moreton Valence (Glos). St Michael. c. 1120*

54

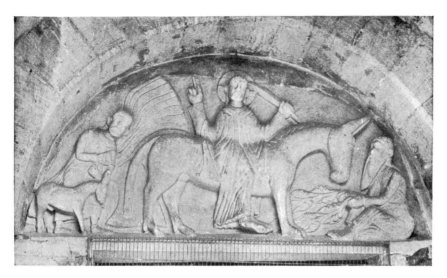

85. *Aston Eyres (Salop). Entry into Jerusalem*

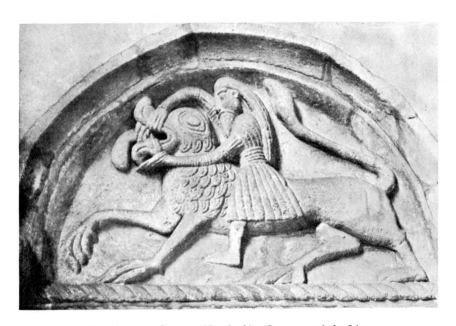

86. *Stretton Sugwas (Herefords). Samson and the Lion*

of the carvers (Fig. 84). Mr Keyser noted over 240 of these tympanum carvings scattered all over the country, but most numerous in the western counties, and varying in style from quite accomplished work to the crudest village productions.[1] The reader must be referred to his book if he wishes to follow up this fascinating subject, as it is impossible to illustrate here more than two or three examples, such as the Entry into Jerusalem at Aston Eyres (Fig. 85) or the Samson and the Lion from Stretton Sugwas (Fig. 86), which

[1] C. E. Keyser, F.S.A., *Norman Tympana and Lintels*, 2nd edition, 1927, with 188 illustrations.

55

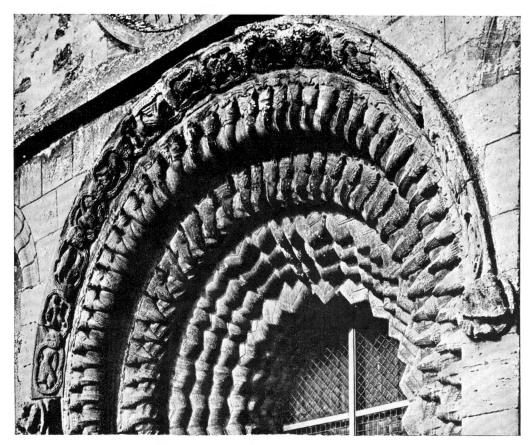

87. *Iffley (Oxon). Beak-head ornament. c.* 1160

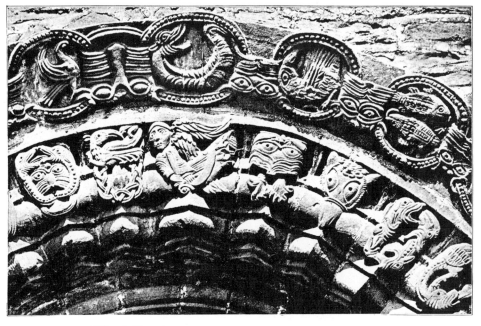

88. *Kilpeck (Herefords). Voussoir carving over west doorway. c.* 1140

56

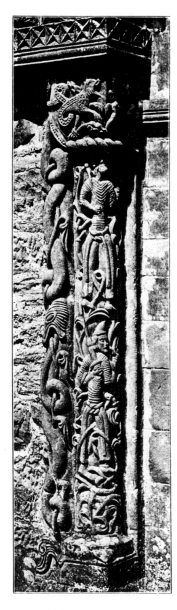

89. *Kilpeck. Jamb of west doorway*

90. *Victoria and Albert Museum. The Gloucester candlestick*

show the rapidly increasing story-telling power that is such a feature of the later Norman carving. The beak-head ornament, of which that at Iffley (Fig. 87) may be taken as typical, also seems to derive from the bird and beast heads which were such a favourite termination of Danish patterns in wood or metal, as well as in stone or MS. drawing.

A remarkable group of these wild carvings is to be found in Herefordshire and neighbouring counties, and is of sufficient distinctiveness to deserve special mention as a local school. It seems to be based on metal-work designs with convoluted wire-drawn lines, while roughly-worked interlacing patterns of great boldness can be traced back to Saxon

91. *Kilpeck. Side of chancel arch.*
St Peter

92. *Castle Frome (Herefords). Font*

or Norse prototypes.[1] The most conspicuous example of this school is the little church at Kilpeck. Here the voussoir carving on the doorway (Fig. 88), besides beak-heads, birds and beasts, has the signs of the zodiac set in circles joined by grotesque heads, which seem copied from a metal chain. The jambs of the same doorway have shafts carved with a most astonishing collection of writhing dragons and weirdly drawn-out human figures (Fig. 89) set in foliage scrolls, which must have been inspired by such a piece of monastic craftsmanship as the famous bronze candlestick from Gloucester, now in the Victoria and Albert Museum (Fig. 90). The shafts of the chancel arch are composed each of three figures of Apostles standing on one another's heads, in the same wire-drawn technique (Fig. 91).

The extraordinary fonts at Eardisley, Chaddesley Corbett and Castle Frome (Fig. 92), the latter standing on prostrate figures and carved with the Baptism of Christ and the signs of the Evangelists, are among the most effective productions of this school.

Other notable examples may be found in the tympanum carvings at Rowlstone (Fig. 93), Ruardean (Fig. 94), Brinsop, Fownhope (Fig. 95) and Shobdon. The last mentioned is now a ruin and the once elaborate carving is much decayed, but it is of special interest as

[1] Sir Alfred Clapham, however, in his *English Romanesque Architecture after the Conquest*, pp. 141, 142, seems to regard this group as of purely Norman type.

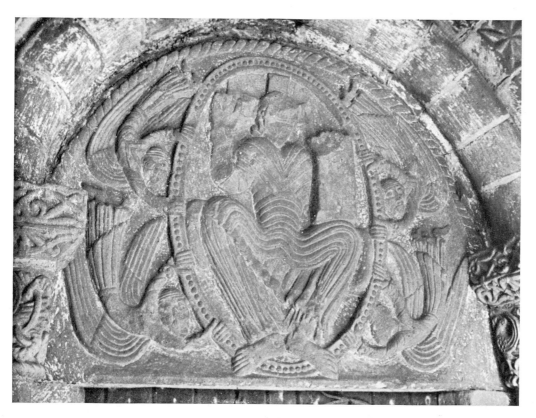

93. *Rowlstone (Herefords). Tympanum. c.* 1140

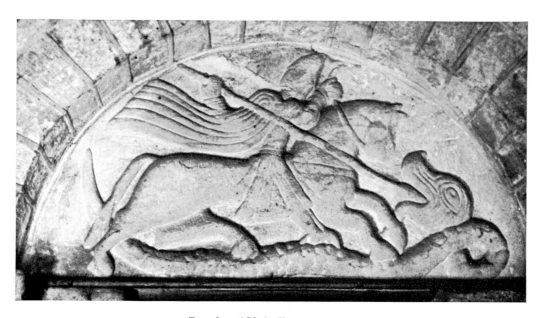

94. *Ruardean (Glos). Tympanum. c.* 1140

59

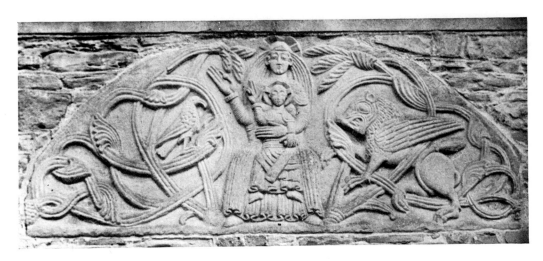

95. *Fownhope (Herefords). Virgin and Child. c.* 1150

96. *Hallaton (Leics). St Michael*

there is a record that it was finished before 1148, which points to a date round 1140 for this remarkable group. At Rowlstone there are also strange friezes of angels and birds, some of which are now placed upside down.

These early Norman tympanum carvings occur all over the country, witness the lively charging St Michael at Hallaton (Leics.) (Fig. 96), or the flying serpent at Netherton (Worcs.) (Fig. 97), which last shows considerable power of design and composition.

Rather more advanced work, which has lost some of the characteristic wildness of this school, can be found at Leigh (Worcs) and Rouse Lench, where niches are placed over

60

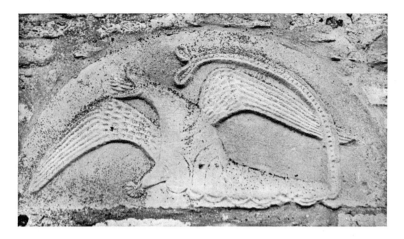

97. *Netherton (Worcs). Flying serpent*

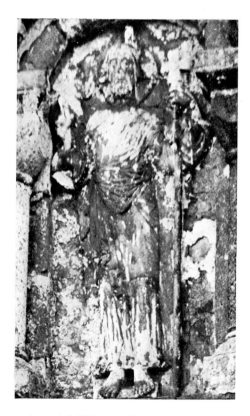

98. *Leigh (Worcs). Figure over doorway*

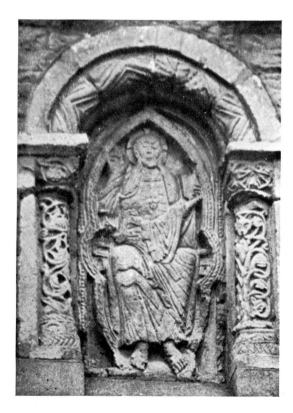

99. *Rouse Lench (Worcs). Figure over doorway*

the doorways containing standing figures of Christ. Though on a small scale they are precursors of the more ambitious statues of the following period (Figs. 98, 99).

In dealing with the Kilpeck carving it has been suggested that the sculptors were copying a metal-work model. This point is worth emphasising as it must be remembered that it was what have been called the cloister-crafts—works in metal, ivory, manuscripts, etc.—

that kept alive the artistic tradition through the dark ages. Shrines, reliquaries, altar furniture, vestments and books were needed in the monasteries, and brought away by monks flying before the Moslem conquests in Asia, Africa and Spain. When the twelfth century renaissance of art called for larger stone carvings to decorate the splendid new churches rising on all sides these smaller models were no doubt set before the masons to copy. Primitive art does not look to nature for models at first, but works in accordance with tradition, and we may therefore turn to such lesser arts for the origins of conventions which at first seem unaccountable and strange. Another excellent example of inspiration from goldsmith's work may be found in the richly carved capitals of St Peter's Northampton, c. 1140 (Fig. 100).

100. *Northampton. St Peter's. Capital in nave. c.* 1140

It is a pity that the intrinsic value of the shrines and other products of the cloister-crafts in the precious metals have led to their being often melted down in times of stress, while the remainder fell victims to the greed of Henry VIII. It is difficult therefore to set concrete examples side by side to demonstrate the point made above, but the few remaining objects in our museums, or the rather more numerous survivals in treasuries or museums abroad, enable us to form some idea of what they must have been like. We have already seen, when studying the later Saxon sculpture, how the drawing of the zigzag folds of the Chichester slabs (Figs. 77, 78) was influenced by the style of the drawings in the Winchester manuscripts, and such a monument as the Monks' Stone at Peterborough (Fig. 57) must be a stone copy of a metal shrine, while the birds drinking from a vase on the Bishopstone slab (Fig. 80) repeat a motive of great antiquity, probably introduced by Eastern woven stuffs.[1]

It has also been pointed out that the early Norman plain building relied to a great extent on painting for its decorative features. Traces of painting still survive on the extremely simple capitals of the transept at Ely, and it is almost certain that many of the plain cushion capitals of the period were decorated with painting, which would in some cases have

[1] A beautiful little ivory figure of a king in the Dorchester museum is a rather later example, and seems inspired by such works as the western porches of Chartres.

101. *Westminster. Judgment of Solomon c. 1100*

102. *Romsey (Hants). Capital in choir*

included figures. It was soon realised that such pictures could be emphasised by outlining the figures by cutting back the ground, or by strengthening the lines by incised grooves, and we thus get such results as we see in the capitals at Westminster illustrating the story of Solomon and the Queen of Sheba and the Judgment of Solomon (Fig. 101), which probably came from the original Norman cloister. Fragments preserved at Hereford suggest derivation from a similar source, as also do the crude carvings on some of the capitals at Romsey (Fig. 102),[1] and even the more advanced capitals of the crypt at Canterbury—which were carved in position some time after erection, though this was not the usual medieval practice—betray some signs of painter's technique.[2] Here, however, the stone-

[1] Other examples may be found on the capitals of the tower arches at Southwell, Melbourne, Castor, at Adel and Bugthorpe in Yorkshire and Stanley St Leonard in Gloucestershire.

[2] One capital is only finished on one face, another being merely blocked out, and the other side is still plain.

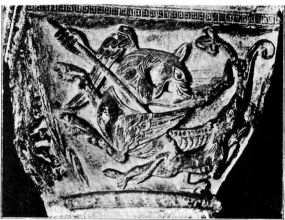

103. *Canterbury Crypt. Samson*

104. *Canterbury Crypt. Flying dragon and dog*

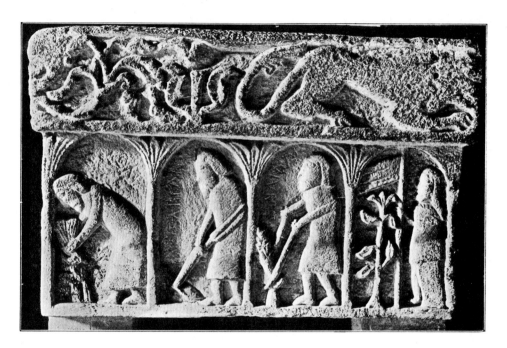

105. *Burnham Deepdale (Norfolk). Works of months*

carver was beginning to feel his way to a style of his own more suited to his material, and there are more attempts at modelling in the round in the Samson (Fig. 103) and a feeling for composition which displays itself in the curious attempt to give symmetry by providing Samson with what looks like a floriated tail to balance that of the lion! The combat between the flying dragon and a dog on the other capital we illustrate is also a very vigorous composition (Fig. 104) and still retains some of the old Norse vitality in its new guise.

The painting technique of the capitals is also sometimes reflected on the fonts, and the shrine motive with figures under an arcade may be found at Hereford or at Burnham

64

106. *Hook Norton (Oxon). Font*　　　107. *Brookland (Kent). Lead font*

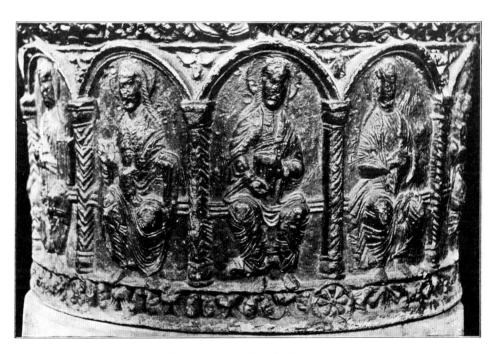

108. *Dorchester (Oxon). Lead font*

Deepdale, on the last of which each compartment is assigned to one of the agricultural labours of the successive months (Fig. 105). Fonts vary in quality from the crudest village workmanship like that at Hook Norton (Fig. 106), to quite accomplished productions like that at Burnham Deepdale or those to which we shall return in our second section at Coleshill (Fig. 132) or Southrop (Fig. 131).

A number of lead fonts form an interesting series: it is usual to find groups of them in which the same mould has been used,[1] though sometimes the figures and patterns are used

[1] F. Bond, *Fonts and Font Covers*, illustrated by 426 photographs and drawings, should be consulted by all those interested in this subject.

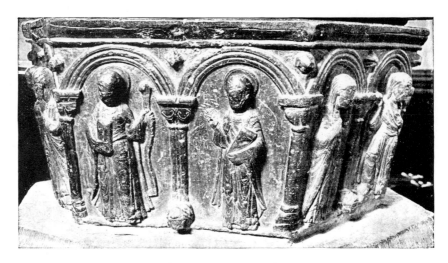

109. *Wareham (Dorset). Lead font. c.* 1170

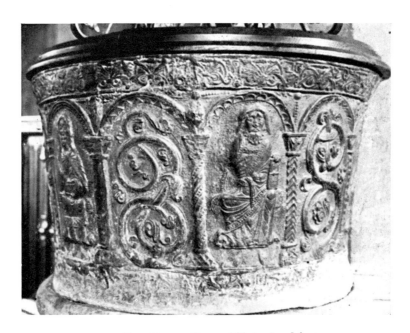

110. *Frampton-on-Severn (Glos). Lead font*

in a different order. These may be illustrated from Dorchester (Oxon), where a number of seated figures resembling types found on twelfth-century seals are ranged under an arcade (Fig. 108), and from Wareham, where the font is hexagonal instead of round and the figures are in bolder relief and standing[1] (Fig. 109). Some of these seem to date from the middle or even the end of the twelfth century: one of the earliest examples would appear to be that at Brookland in the Romney Marsh, where there is a double arcade containing the signs of the zodiac above and the works of the months below (Fig. 107). Mr Bond

[1] Mr P. M. Johnston, F.S.A., thought these were carved, not cast, and that this font may be an importation from France.

66

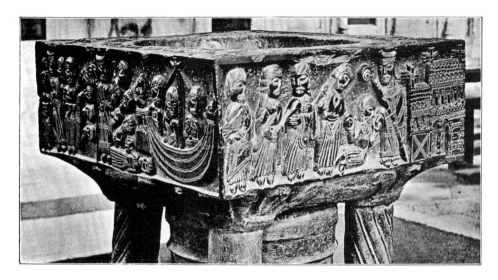

111. *Winchester. Black marble font (from Tournai)*

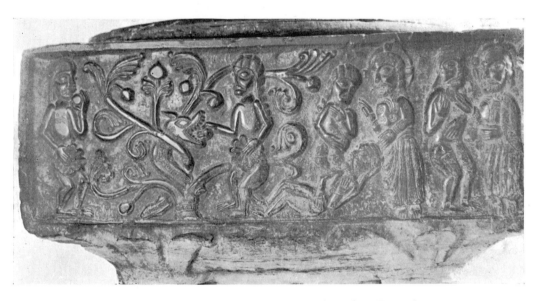

112. *East Meon (Hants). Black marble font (from Tournai)*

noted 29 lead fonts, of which those at Frampton-on-Severn (Fig. 110), Siston, Oxenhall, Tibenham, Lancaut and Sandhurst are all from the same mould. These are all in Gloucestershire. Warborough and Long Wittenham (Berks) are both from the same pattern. Ashover, Walton-on-the-Hill and Childrey are among the more interesting variations in type.

Mention must also be made of the fonts of black marble from Tournai in Belgium, though these were no doubt imported from abroad ready carved. There are seven of them[1] in this country, the most important being that in Winchester Cathedral with scenes from the legend of St Nicholas (Fig. 111). The style is firm but harsh, and as figure-work is not in

[1] Winchester, East Meon (Fig. 112), St Mary Bourne, St Michael's, Southampton (all in Hants), Lincoln, Thornton Curtis and Ipswich, St Peter's.

67

113. *Romsey (Hants). Corbel-table*

114. *Kilpeck (Herefords). Corbel-table*

advance of our native productions of the same date, *c.* 1150. That at East Meon has a quaint scene of the Fall of Man (Fig. 112).

Corbel-tables, formed of a series of heads or grotesques, arranged beneath the eaves, are a feature of enriched Norman work. Good examples may be shown from Romsey and Kilpeck. In these the fancy of the sculptors has full scope and the old Norse imagination comes out again (Figs. 113, 114).

(2) THE LATER ROMANESQUE

As we approach the middle of the twelfth century we find a more advanced type of work, influenced to some extent under cosmopolitan monastic inspiration by what was going on abroad, but at the same time retaining many of the old native characteristics. A gradual simplification of the elaborate conventions derived from the goldsmith and painter begins to show itself, though complete freedom is not reached until the following century. A more architectural feeling begins to appear in the sculpture, and the use of figure-work on a larger scale tends to become more frequent, and as it is produced by the building masons it fits naturally into the architectural scheme, and leads the way towards the great development of Gothic building sculpture which was to follow.

We have seen figure-sculpture reaching considerable attainment on the capitals of the Canterbury crypt, and no doubt many of the monastic cloisters had a wealth of carved capitals. With the exception, however, of a few fragments like the Dark Entry at Canterbury, none of them have survived to compete with those of southern France or Spain, most

68

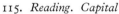
115. *Reading. Capital* 116. *Norwich. Capital*

117. *Winchester. Capital in Lapidary Museum*

having been destroyed at the Dissolution or replaced by later and more ambitious building. A few fragments survive to give us some notion of what they must have been like. We have already had occasion to refer to the primitive capitals from Westminster, and illustrate here one which came probably from Reading Abbey, now in the museum there (Fig. 115), which displays rather crude figure-drawing with fine decorative effect, and another from Norwich, now preserved in the triforium of the cathedral (Fig. 116), which shows great delicacy of treatment and vigour of action, though the old linear handling of the drapery has not been altogether discarded.

Others at Winchester display vigorous handling (Fig. 117), and at Stoke Dry there is a remarkable column with little figures carved all up the shaft, one of which is a bell-ringer. Could this be a clumsy reminiscence of certain famous shafts which a pilgrim had seen at Santiago de Compostella (Fig. 118)?

Some remarkable capitals, which seem to have come from the cloister of Hyde Abbey, are preserved in the church of St Bartholomew, Hyde, Winchester. Well-carved heads coming out of foliage, and vigorous griffins almost reminiscent of the Saxon crosses, show

69

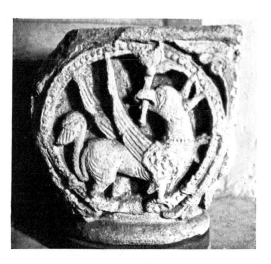

119. *Winchester. St Bartholomew.*
Capital from Hyde Abbey

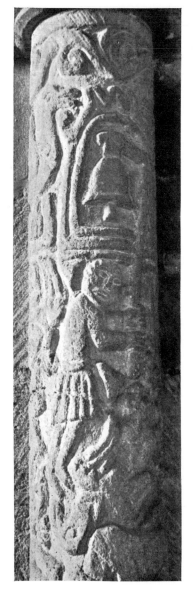

118. *Stoke Dry (Rutland).*
Column

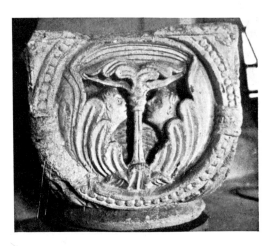

120. *Winchester. St Bartholomew.*
Capital from Hyde Abbey

that England once had some cloisters to compare with those of southern France and Spain (Figs. 119, 120).

One of the most ambitious efforts is to be found in the Prior's Door at Ely, leading into the cloister. It is surrounded by arabesques and foliage scrolls, with birds and beasts of the old Anglian cross tradition, but treated in a new way. The scrolls are no longer based on the vine pattern but on the acanthus, or still more on a trefoil leaf which afterwards developed into the Early English stiff-leaf foliage. Heads with staring eyes form brackets for the lintel, and the whole effect is rich and sumptuous. The tympanum (Fig. 121) has a beardless Christ in an aureole supported by angels, which still retains evidence of its

70

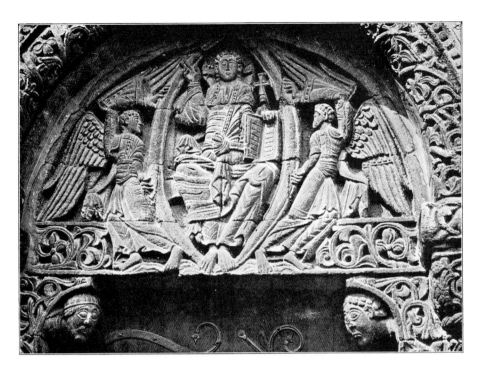

121. *Ely. Prior's Door. Tympanum*

122. *Ely. Detail of doorway in cloister*

manuscript origin. The lines of the drapery and little groups of tossed-up folds at the ends are still those of the Winchester drawings, and the extraordinary distortion of the angels' arms shows the inexperience of the sculptor in dealing with the problems of perspective when translating the drawing set before him into stone.

Another doorway into the cloister at Ely has a figure of an abbot in a spandrel of considerable attainment (Fig. 122).

71

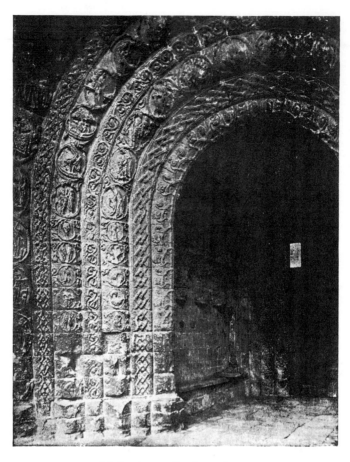

123. *Malmesbury. South porch. c.* 1170

At the period we have how reached three main schools of building-sculpture may be distinguished, though the boundaries between them should not be too closely defined. They are the West-midland, the South-eastern and the North-eastern.

The *West-midland* is perhaps the most typically English in developing in its own way from the origins discussed above. The most impressive monument is the great south porch at Malmesbury (Fig. 123). There seems to be no definite record of the date, but it must be in the neighbourhood of 1160–70. The outer door has no tympanum, and is surrounded by eight orders of mouldings carried right round the arch without a break for capitals or shafts. These mouldings are richly carved with foliage scrolls and interlacements, and three of them contain a large series of medallions with scenes from the Old and New Testaments. Here then for the first time we are confronted with a connected religious scheme evidently dictated by a learned ecclesiastic in accordance with the scholastic theology of the day in which events in the Old Testament were regarded as types or symbols of others under the new dispensation. Thus Samson carrying off the gates of Gaza corresponds to Christ breaking through the gates of the tomb (Fig. 124). This sculpture is weather-worn, and many of the subjects difficult to make out, but the old cloister-craft technique is still in evidence. If we place such a figure as the Resurrected Christ (Fig. 125) beside a con-

72

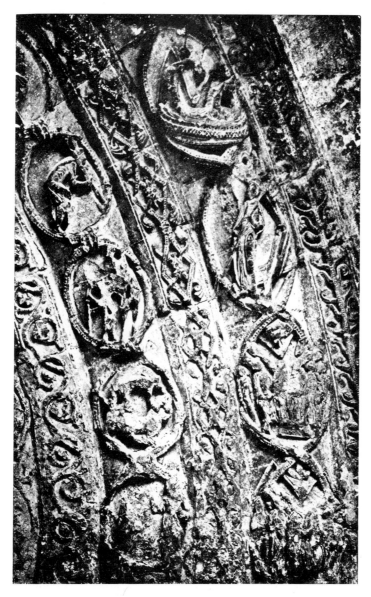

124. *Malmesbury. Detail of south door*

temporary manuscript drawing (Fig. 126) we cannot fail to be struck by the similarity of treatment in the folds of the drapery, the double lines and smooth round patches over projecting portions of the anatomy like knees or thighs.

The inner door has a tympanum with Christ in Glory supported by two angels, but this is insignificant in comparison with the groups of Apostles ranged six on each side of the porch with a flying angel over their heads in the lunettes formed by the vaulting of the porch (Fig. 127). These are on a large scale, and some attempt is made to vary their attitudes as they turn to converse with one another, but the folds of the draperies are still partially rendered by incised lines, only the main masses being modelled over the figure and the pearled borders are a reminiscence of metal-technique. The bearded and closely-

73

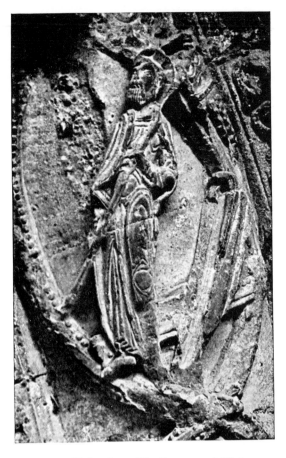
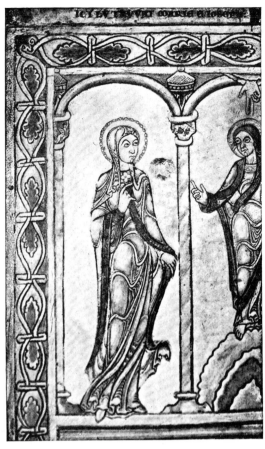

125. *Malmesbury. The Resurrected Christ* 126. *Twelfth-century MS. c.* 1160

swathed angel is still rather clumsy, even as compared with his Saxon predecessor at
Bradford-on-Avon, but in spite of a certain stiffness, and quaint details such as the way
one of the Apostles has to bend his head to make room for the angel, the general effect of
the group is quite impressive and there is a rough vigour in the design and execution
which has more promise than the quieter elegance of the Saxon prototypes.

The next stage can be well seen in the doorways of the Lady Chapel at Glastonbury,
built to replace the long-cherished wooden 'Vetusta ecclesia', attributed to Joseph of
Arimathea according to the legend, which was burnt in the disastrous fire of 1184. The
new chapel was built in the most ornate late Romanesque style, in contrast to the choir
begun at about the same time which is definitely in the Transitional style with pointed
arches throughout. The north doorway[1] is very much of the same design as the Malmesbury
door, except that shafts have been inserted in the jambs in two of the orders. The others
are carried down to the ground and contain elaborate scrolls of foliage and figures, now too
much broken to be clearly made out. The second order from the outside is slightly better
preserved and shows a series of medallions enclosing scenes from the nativity cycle. Those
of the Magi and Massacre of the Innocents (Fig. 128) show a definite advance in modelling

[1] Described by W. H. St John Hope in *Archaeologia*, LII, 1890.

74

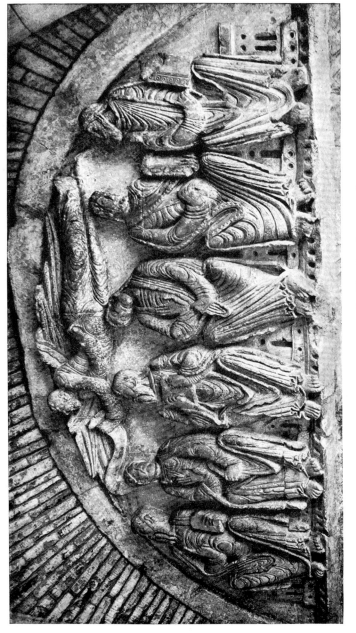

127. *Malmesbury. South porch. The Apostles. c. 1160–70*

75

128. *Glastonbury. Massacre of the Innocents. c. 1185*

129. *Wenlock Abbey (Salop). Lavatory in the cloister. Apostles*

130. *Wenlock Abbey. Lavatory in the cloister. Christ walking on the water*

and freedom of style; the metal-worker's technique and painter's tracings have been discarded, and we are well on the way to thirteenth-century style.

Some interesting reliefs are preserved in the Cluniac abbey of Much Wenlock from the lavatory in the centre of the cloister. One has two prophets or apostles under arches in the old shrine tradition, which are interesting to compare with a similar arrangement on

76

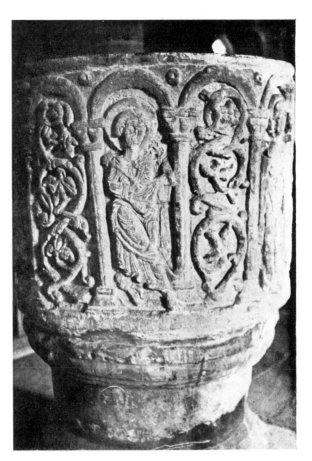

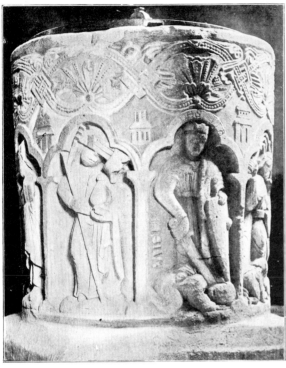

131. *Southrop (Glos). Font. Virtues and Vices.*
c. 1160

132. *Coleshill (War). Font*

the capitals of the great Cluniac abbey of Vézelay of half a century earlier date, though the actual handling is different (Fig. 129), and the other has Christ walking on the water (Fig. 130). The figures are short and heads too large, but they have just that mild suggestion of caricature which gives so much life and story-telling power to work of this date.

Monastic or ecclesiastic supervision is also to be seen in the subjects treated on some of the more elaborate fonts. At Southrop (Fig. 131), for instance, and on a very similar one at Stanton Fitzwarren, not far off, the Virtues are represented in human form trampling on or chastising the Vices, a subject taken from a poem, the *Psychomachia* of Prudentius, which was popular in the middle ages. Another font at Coleshill, near Birmingham, is based on the design of the Gloucestershire lead fonts, but is interesting in having one of the figures in the cross-legged semi-dancing attitude fashionable in the southern French school of Toulouse (Fig. 132) and familiar to many pilgrims to the shrine of Santiago de Compostella in several of the statues in the famous porch built by Matteo in 1183. One side of the Coleshill font has a fairly advanced Crucifixion enclosed in a circle which still retains some reminiscence of goldsmith's work. Finally, in an elaborate doorway at Lullington we see the figure of Christ removed from the tympanum and placed in a niche

133. *Lullington (Som). Relief over doorway. c. 1170*

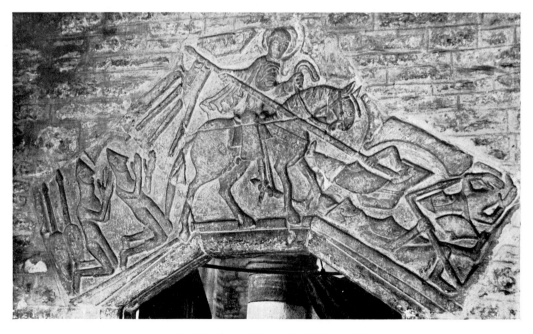

134. *Fordington (Dorset). St James (?)*

135. *Rochester. Capital of west door*

136. *Rochester. Capitals of west door (before restoration)*

79

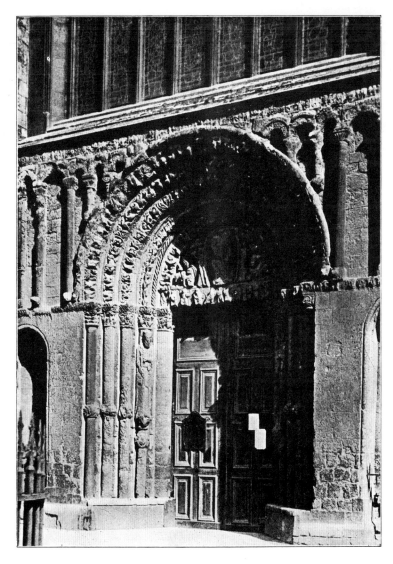

137. *Rochester. West door*

in the gable above, a development of the scheme shown at Leigh and Rouse Lench (Figs. 98, 99); in this case the bas-relief has almost developed into the large statue of the next generation (Fig. 133).[1]

A tympanum at Fordington, a suburb of Dorchester, Dorset, has a more skilful representation of a knight on horseback overthrowing armed foot-soldiers. He is nimbed and usually described as St George, but more probably is St James, who appeared according to the Spanish legend and helped to rout the Moorish host in the great battle of Clavijo in 939 (Fig. 134).

[1] A rather more crude effort in this direction may be found in a slab-figure of a bishop in a niche over the north-transept door at Norwich; this must be earlier in date. It is illustrated by A. W. Clapham, *English Romanesque Architecture after the Conquest*, pl. 31.

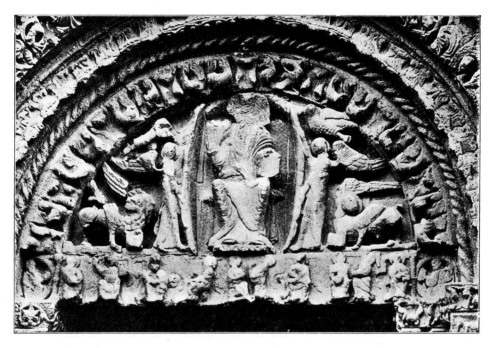

138. *Rochester. Tympanum of west door*

The *South-eastern* district of Kent was apparently more in touch with continental developments, though these influences are mixed and do not altogether efface the indigenous characteristics. The central monument of this group is the west front of Rochester Cathedral. The Norman church was consecrated in 1130, but the front shows signs of a reconstruction, probably after a fire in 1137. There was also a fire in 1177, but it is difficult to put any of the work as late as that. The capitals of the central doorway (Figs. 135, 136) are decorated with foliage scrolls and animals of a type not unusual in rich Romanesque carving, but those of the archivolts are of a more peculiar type; in the inner ring especially there is a kind of ornament (Fig. 138), half leaf and half bird, which is common not in Normandy or immediately across the Channel but in Poitou and Charente, notably on the façade of Nôtre-Dame-la-Grande at Poitiers.[1] We must remember that Henry I married his daughter Matilda to the Count of Anjou, and their son, Henry II, owned more territory in the west of what is now France than the King of France. It is not surprising therefore to find close relations between England and western France in the middle of the twelfth century. The tympanum has a Christ in Majesty supported by angels and surrounded by the Four Beasts (Fig. 138). This is in higher relief than we have hitherto seen, and in style the central figure is not unlike the seated statues in the arcades at Poitiers. In that region, however, tympanum carvings on a large scale are rare, and the general idea is more akin to those at Chartres or Le Mans, where we find the same scheme and the same lintel with the little figures of the Apostles. We also have at Rochester (Fig. 139) statues of a king and queen, probably·Solomon and the Queen of Sheba, attached to shafts on the jambs of

[1] See the author's *Medieval Sculpture in France*, Fig. 131. A drawing exists of a window which once ornamented a building at Colchester which shows figures on the jambs on each side, and is extraordinarily like work at Civray in south-west France.

81

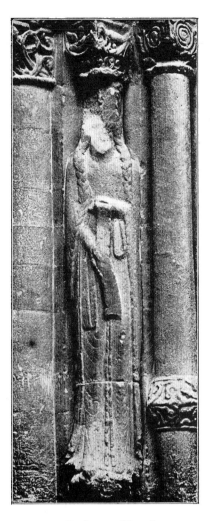

139. *Rochester. West door.*
Queen of Sheba

140. *Barfreston (Kent).*
South door. c. 1170

the doorway. This is a feature which became common in France and Spain after the middle of the century. The origin of the column figure is obscure; the earliest dated examples at S. Denis, if we may judge of them by drawings made before their destruction at the Revolution, were set up *c.* 1140, but look too far developed to have been the first experiments in the type. The Rochester queen has the same costume and long plaits of hair as the famous statues of Chartres and Le Mans, but the rendering of the lesser folds of the draperies by mere incised lines looks more primitive. As the knops of foliage on the shafts have been cut away to make room for these statues it is possible they were an afterthought added in emulation of the French works. If so they may be a little later than 1140, the date suggested by the fire, though they do not look as late as 1180, after the later fire.

A flatly treated statue, called Gundulf, is preserved in the cathedral, and seems to have come from a niche on the north turret. The drapery is very shallow in treatment, the richly ornamented vestments being incised rather than modelled, but it is interesting as one of

82

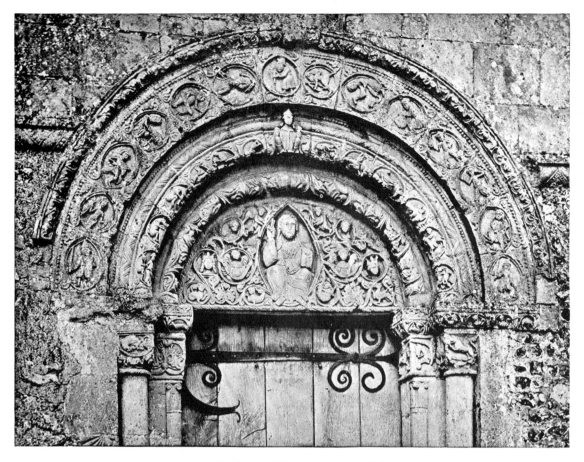

141. *Barfreston. Tympanum of south door*

the first of the great series of statues in niches which afterwards became one of the chief features of a cathedral façade.[1]

Rather later, in the third quarter of the century, we have the little church at Barfreston, which in general effect recalls the richly decorated churches of the Charente, south of Poitiers. The south doorway shows the international monastic type of decoration modified by what may be regarded as the English tradition. The tympanum has a seated figure of Christ in a vesica embowered in twining foliage in the loops of which are the heads of a king and queen, angels, and fanciful monsters (Fig. 141). The capitals with more monsters and tilting knights are effective (Fig. 142) and the medallions surrounded by foliage tendrils in the arch-moulds are occupied by quaint fancies and grotesque groups of animals playing musical instruments (Fig. 143) and so on, instead of the serious religious subjects of Malmesbury or Chartres. The keystone of the arch has a half figure of an archbishop, and inside the church is an amusing panel of a monkey and a donkey carrying a rabbit in a pail suspended on a stick (Fig. 143).

More serious sculpture is to be found on a white stone font at Brighton. It has a relief of the Last Supper (Fig. 144) of considerable attainment, and a Baptism and two scenes

[1] Another statue of about this date has been dug up at Sibertswold, near Canterbury. It is unfortunately in private possession and rather jealously guarded.

83

142. Barfreston. Capitals of south door. c. 1170

143. Barfreston. Carving in interior

referring to St Nicholas on the other. The style cannot be matched by anything else in England, but bears some resemblance to that of the Tournai fonts, in which case it may have been a direct importation from Flanders.

A few fragments still survive of the sculptured decoration of some of our most important abbeys. Besides the reliefs already referred to at Wenlock (Figs. 129, 130) a figure of a king in a quatrefoil about 15 inches high preserved in the Library at Canterbury (Fig. 145) is thought to have come from some screen in the Refectory. A stone lectern at Crowle, Worcs (Fig. 146) with a crouching figure amid foliage must date from about 1200, and probably came from a ruined abbey. A similar one slightly later remains at Norton near Evesham.

144. *Brighton. Font. Last Supper. c.* 1170

The *North-eastern Sculpture* may best be studied at Durham, Lincoln and York.

At Durham there is very little figure-sculpture in the great cathedral, but the vault corbels from the chapter-house, infamously destroyed by the Dean in 1796, are preserved in a somewhat damaged condition in the library (Fig. 147). They take the form of 'atlantes' supporting the weight on their shoulders, and their contorted attitudes would have been better appreciated looked up at from below than in their present position on the floor. A block with decayed figures about five feet high set back to back (Fig. 148) might have formed a corner post or shaft from a cloister, like those at S. Bertrand de Comminges in the Pyrenees. The most delicate work at Durham consists in some reliefs built up in the canons' houses and now removed to the library (Fig. 149). They represent the appearances of Christ in the garden after the Resurrection, and though there are still reminiscences of manuscript conventions in the folds of the garments and of goldsmith's technique in the beaded edges, the proportions and gestures are fairly correct, and the figures stand out from the background in true boldness of relief. It is suggested that these came from the original twelfth-century rood screen of the cathedral.

A delicately carved cross of late twelfth-century date at Kelloe (Fig. 150) forms an interesting contrast in style to the early crosses of this district, and is an obvious proof of the impossibility of accepting the arguments of the foreign critics who have assigned our seventh and eighth-century crosses to the twelfth century. The reliefs illustrate the story of the Invention of the Cross by St Helena.

The west front of Lincoln, like that at Rochester, is a composite monument of various

85

145. *Canterbury Library. Relief from refectory (?)*

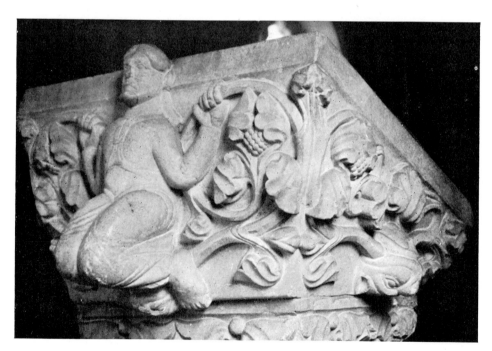

146. *Crowle (Worcs). Stone lectern*

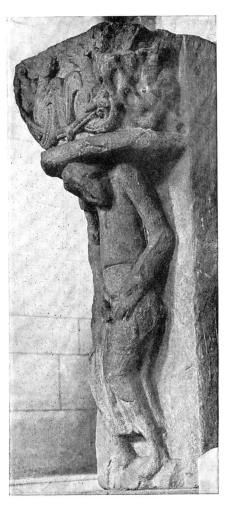

147. *Durham. Corbel from the chapter-house. c.* 1150

148. *Durham. Block with decayed figures*

dates. The severe eleventh-century façade of Remigius was reconstructed by Bishop Alexander, *c.* 1140–50, when the sumptuously carved western doors were inserted. The shafts of this door are elaborately sculptured with writhing figures in foliage and little scenes of heraldically grouped pairs of beasts, of Byzantine inspiration. Most of the lower parts, however, have been renewed. Further alterations and additions took place in the thirteenth and fourteenth centuries. The most interesting feature is the series of reliefs forming a more or less continuous band over the doorways. These may not be in their original position as the order of the subjects is confused, Daniel in the Lions' Den being interpolated in the middle of the Scenes of the Flood, but they suggest that Bishop Alexander had planned an elaborate scheme of sculpture with bands in relief like those at Ripoll in Spain or Modena in Lombardy. Remains of a 'Majesty' are preserved in the cloister, and may have formed part of such a scheme, as also, perhaps, a St John also preserved in the cloisters (Fig. 151).

The long frieze, which is the chief interest to us, is composed of two series, one of which

87

recounts the story of Genesis, and the other seems to be connected with the Last Judgment. The cloister fragments might have been part of a centre-piece to the last. The story of Dives and Lazarus (Figs. 152, 153) is in two panels; in one Dives feasting with his two friends, and in the other devils pitchforking their souls into the yawning mouth of Hell, while angels bear up Lazarus to Heaven. There are also representations of the Descent of Christ into Limbo, trampling Satan under foot, of Satan presiding over the tortures of Hell, of the Apostles seated as assessors and of the Souls of the righteous in Abraham's bosom. The Old Testament scenes include the Expulsion from Paradise (Fig. 154), the

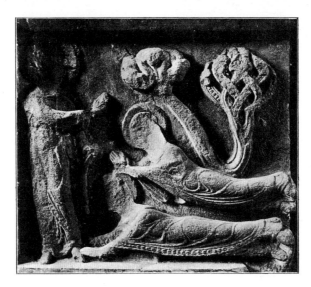

149. *Durham. Cathedral Library. Christ's appearance after the Resurrection. c. 1170*

Building of the Ark, Noah and family in the Ark (Fig. 156), God's Promise to Noah (Fig. 155), Daniel in the Lions' Den (out of order interpolated among the Flood Scenes), Noah cultivating the Vine, and inside the present western transept on what was once the exterior of the Norman tower, three men clinging to the trees up to their waists in the flood. The style is bold and effective, and if the modes in the Expulsion scene are a little stiff, the whole is full of vigour and expression. The twelfth-century power of telling a story is here to the full, and the policeman-like gesture of the angel ordering Adam and Eve to move on, and the look of intense indignation on the face of Adam are altogether delightful.[1]

Here again we see the connected scheme of medieval theology worked out in detail, in spite of missing portions, and notice how the power and learning of the churchman gradually ousted the semi-pagan motives of combats between good and evil symbolised by Samson and the lion, St Michael and the dragon and all the monstrous imaginations of the northern forests.

York has preserved little *in situ*, but the museum in the ruins of St Mary's Abbey

[1] There is also a fragment of the lower part of a figure showing that the series must originally have been longer. Were these reliefs meant for a position inside the building, and put up by Bishop Alexander when he inserted the west doors? They have been claimed as Saxon, but have little in common with anything else which can be assigned to a pre-Conquest era.

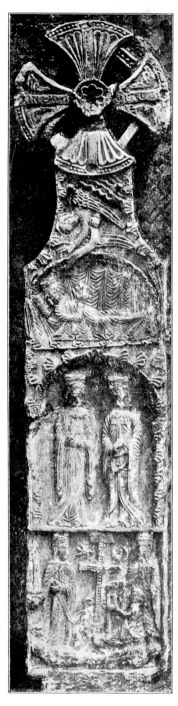

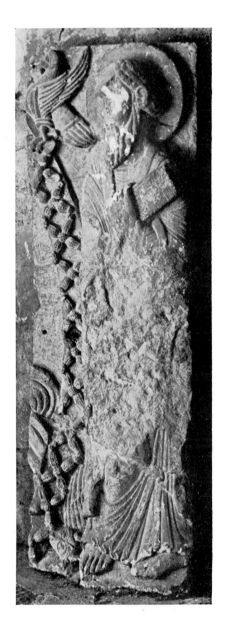

150. *Kelloe (Durham). Cross.*
Invention of the Cross

151. *Lincoln. Cloister.*
St John

89

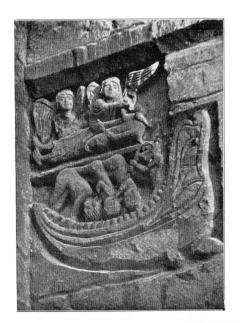 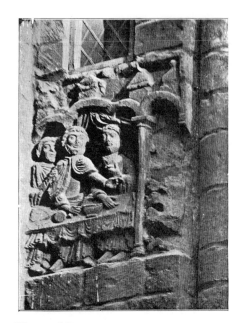

152, 153. *Lincoln. West front. Dives and Lazarus*

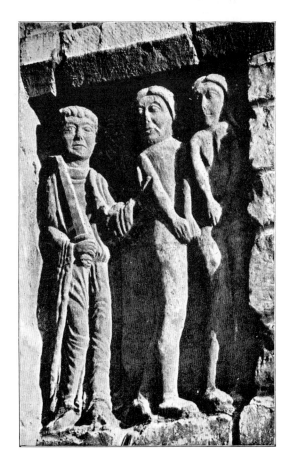 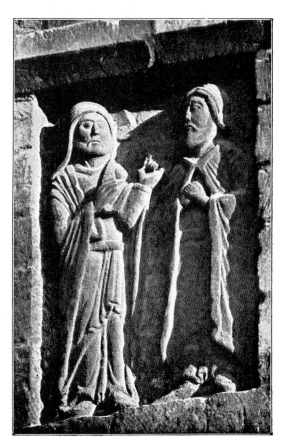

154. *Lincoln. West front. The Expulsion*

155. *Lincoln. West front. God's promise to Noah*

90

contains some important pieces, and the remains of a great Doom subject have been unearthed in the Deanery and are now in the Cathedral Library. The latter consists of a shallow tympanum, considerably worn, with devils extracting the soul from the mouth of a corpse, and a large slab representing the tortures of Hell (Fig. 157). Gaping jaws at the side exhibit varied horrors, while inside a huge cauldron full of chained souls is resting on the flames which are stirred up by hideous demons at the bottom. At no other period have the devils been so formidable as in the twelfth century, and these fearful imaginings help to explain the enormous power of the Church over the violent kings and nobles of the time.

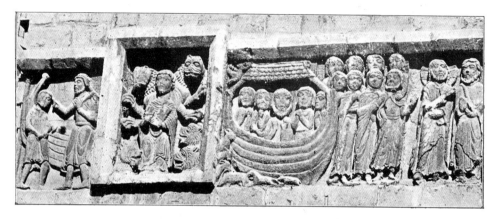

156. Lincoln. West front. Noah and Daniel

A finely carved corbel in the Yorkshire Museum in the grounds of St Mary's Abbey shows a struggle between a man and two dragons (Fig. 158)—the old symbolic combat, but treated with new power. The stone is deeply undercut, the subject is conceived in the round, not drawn on the flat, and we are now in the presence of a real stone-carver's technique.

More important still are a number of large statues of Apostles and Prophets found buried on the site of the south aisle of the abbey church. These may have come from a big doorway from the cloister to the church, or more likely to the chapter-house, and their date must be the end of the century. They include the few real column-statues existing in England, and show a great advance over the Rochester king and queen of half a century earlier. Heads are large and rather coarsely treated, hands and feet skilfully rendered and draperies well adjusted to the figure. The folds are boldly modelled, with a tendency to rounded forms which might have developed from those of such figures as the Promise to Noah at Lincoln (Fig. 155). More than one hand could perhaps be distinguished as working on them, the bold handling of the Moses (Fig. 159) and the St John (Fig. 160) being rather different from the more refined and elaborated treatment of one or two headless statues which appear to have been set against the wall at the side of the doorway, but all must have been contemporary. There are also the remains of a Virgin and Child (Fig. 161) which may have formed part of a seated figure in the central tympanum; the elaborate brooch and long plaits of hair falling over the shoulders are those of Chartres, but the big-headed broad prophets come from a very different school, and appear to be a native development.[1] Several voussoirs from the same door have also been found, of which we show one

[1] The large heads and general proportions are perhaps more like the statues of the west portal at Angers, but the York draperies are bolder and more rounded.

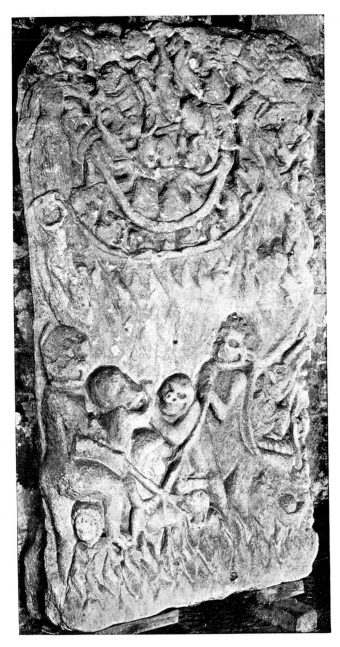

157. *York. Minster Library. Hell*

depicting Herod giving instructions to his soldiers for the Massacre of the Innocents (Fig. 162). Others appear to represent the Baptism of Our Lord and the Raising of Lazarus, and we have here, therefore, the débris of a great portal on the continental model, though it is difficult to trace foreign influence in the handling. It was, no doubt, easier to import general ideas than craftsmen to carry them out. This brings us to the threshold of the thirteenth century, which must be the theme of the following chapter.

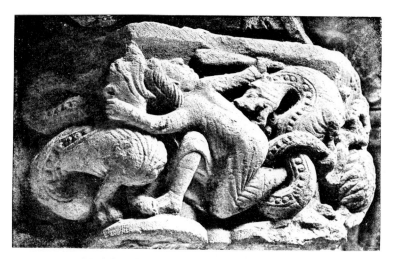

158. *Yorkshire Museum. Man and two dragons. c. 1170*

159. *Yorkshire Museum. Moses. c. 1200* 160. *Yorkshire Museum. St John. c. 1200*

161. *Yorkshire Museum. Fragment of Madonna. c.* 1200

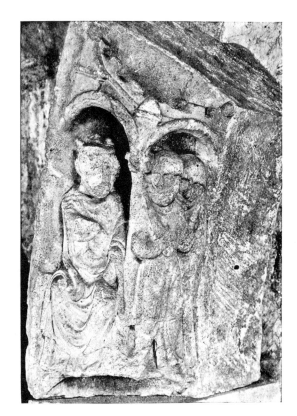

162. *Yorkshire Museum. Herod. c.* 1200

94

CHAPTER IV

THE THIRTEENTH CENTURY
(OR EARLY ENGLISH PERIOD)

(1) ARCHITECTURAL SCULPTURE

The statues from St Mary's, York, brought us to the threshold of, if not actually into, the first years of the thirteenth century, and in them we recognise a vital change in the spirit of the work which henceforward is to be the characteristic feature of medieval sculpture. It is no longer applied decoration, such as it had been even when attached to the porches and doorways of the Romanesque period: it is now definitely architectural in character and definitely stone-carving, suited to the material of which it is composed, and no longer carrying on the conventions and tricks of the ancient goldsmiths' and painters' traditions. It was the work of the stone-masons engaged on the building, and seems to grow naturally out of the surrounding structure, marking points where emphasis is desired but not disguising structural features. It is this union of the sculpture with the architecture, this thorough understanding of material and suitability of purpose, which gives our thirteenth-century sculpture its unique charm. There is, too, an evenness of attainment which makes it difficult to separate local schools, though certain differences may be detected between east and west, but even these are mainly dependent upon the variety of materials available in the local quarries.

The storied capitals of the Romanesque period go out of favour in the thirteenth century. At the beginning we have at Wells a fine series of figures mixed with foliage, but the tendency was for foliage to be used more and more by itself for capitals, or even for simple moulded capitals to be substituted for more elaborate designs, though heads and beasts occur occasionally, and figures are used rather more in corbels. The use of heads as stops for mouldings, or even as corbels, becomes a great feature, much more frequent than in France, though superb examples occur at Rheims.

Wells Cathedral provides us with some of the best examples of these features for the first half of the thirteenth century. The choir and eastern side of the transepts were begun *c.* 1185–90 and the work was gradually carried westward. The next section to be taken in hand was the west side of the transepts and the eastern part of the nave, down to and including the north porch, the date of which would seem to be about 1210 to 1220, though there may have been an interval during the Interdict from 1208 to 1213. The western bays of the nave followed soon after, and the whole church, including the west front, seems to have been completed in time for the consecration of 1239, though it is possible some of the more advanced statues of the front may not have been added before the middle of the century. Bishop Jocelin, in a charter of 1242, speaks of the work as finished, so that there cannot have been much left to add.[1]

[1] The chronology of Wells Cathedral has been carefully worked out by Dean Armytage Robinson and Dr John Bilson in the *Archaeological Journal*, LXXXV, 1930. It is possible that the Interdict in John's reign, 1208–13, may be the explanation of the break in the style of the nave.

95

The earliest work at the east end has been largely overlaid with fourteenth-century alterations, but the capitals are of the simple crocket type with little elaboration. Most of the figure-carving is in the capitals of the west side of the transepts and the earlier section of the nave. As the piers are of moderate height, these delightful carvings can be well seen, and have just that touch of caricature which gives such life and interest to the work. In some, fanciful heads or fighting dragons stand out among the foliage (Fig. 163), in others, serious Biblical subjects, such as the prophet Elias with head on hand and holding a scroll on which his name is inscribed, or Moses with the Tables of the Law (Fig. 164). The most famous of all are the man with a thorn in his foot—a subject which goes back to the days of ancient Greece—a man with the toothache[1] (Fig. 165), and a capital with thieves robbing a vineyard on one side and captured and punished by the owners on the other (Fig. 166).

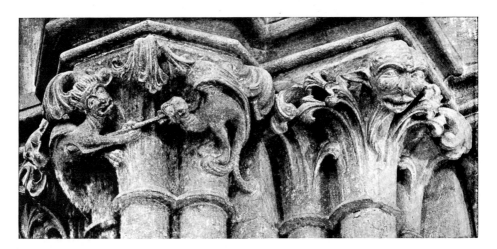

163. Wells. Nave capitals. c. 1220

The continuous triforium arcade has a series of heads forming the stops of the dripstone moulding, a somewhat illogical feature inside a building, characteristic of English as opposed to French work, but usually very effective. These heads offer a useful guide to the progress of the work and the increasing skill of the local school of masons, those at the east end of the nave being small and often retaining something of the archaic grin (Figs. 167, 168), while those to the westward are considerably larger and more accomplished works of art (Fig. 169).

Leaving the sculptures of the famous west front for separate treatment a little farther on, mention should be made of the pretty little capitals in the small parish church of St Paul's Cray, Kent, with well-carved heads peeping out of the stiff-leaf foliage (Fig. 170). We must now go back a little and trace the story of head, capital and corbel elsewhere. In the latter part of the twelfth century heads begin to emerge from the stage of the hideous masks of the Norman corbel-table, and such a head as that over the cloister door at Ely,

[1] It has been suggested that these capitals had been damaged by the fall of the tower in 1248, and were re-carved *c.* 1280, because Bishop Bytton, who died in 1274, gained a reputation for curing the toothache, and this capital was re-cut to mark his tomb. The style, however, is entirely that of *c.* 1220, and it is more likely that the capital suggested the attribution of the miracle-working power to the tomb of the sainted bishop placed near it, than that the miracles suggested the capital.

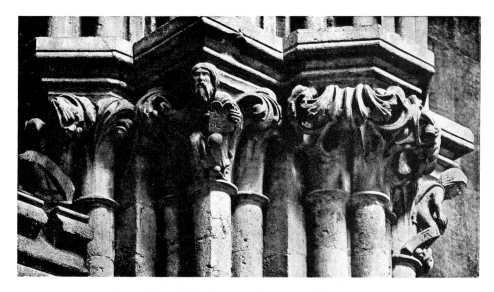

164. *Wells. Capitals in north transept. Moses. c. 1220*

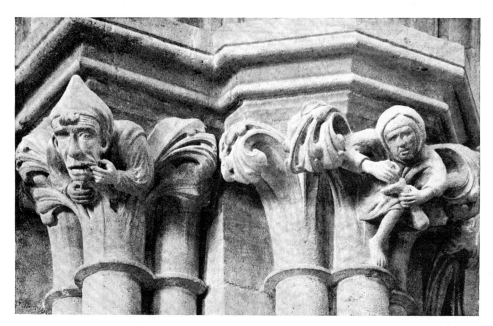

165. *Wells. Capitals in south transept. Toothache. c. 1220*

or the severe heads in Oakham Hall (Figs. 171, 172) give some promise of better things to come.

At Old Shoreham in the elaborately carved tower arches of the second half of the twelfth century are heads of a king and queen (Figs. 174, 175) which seem to indicate some purpose beyond mere caprice. The long beard of the king suggests Edward the Confessor, as the Normans were usually clean shaven, if we may trust the evidence of the Bayeux tapestry.

97

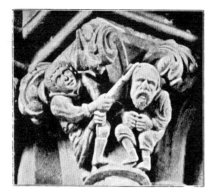

166. *Wells. South transept. The robber caught. c. 1220*

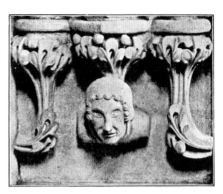

167. *Wells. North transept. Head. c. 1200*

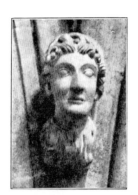

168. *Wells. East nave. Head. c. 1200*

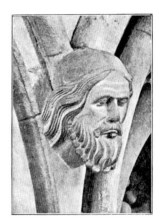

169. *Wells. West nave. Head. c. 1230*

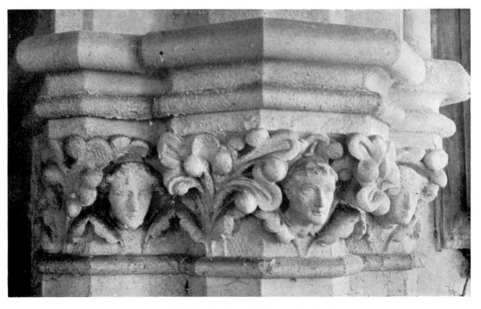

170. *St Paul's Cray (Kent). Capital*

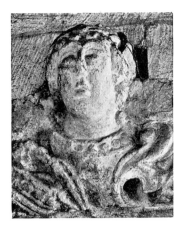

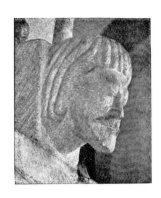

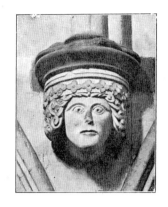

171. *Ely. Cloister door.*
Head. c. 1150

172. *Oakham Hall (Rutland).*
Head. c. 1170

173. *Boxgrove.*
Choir head

174. *Old Shoreham (Sussex).*
Queen

175. *Old Shoreham. King. Edward the*
Confessor(?)

176. *Salisbury. East nave.*
Head. c. 1225

177. *Salisbury. South-east*
transept. Head. c. 1230

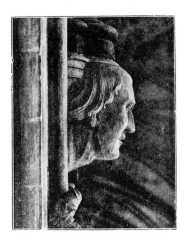

178. *Salisbury. West nave. Head. c. 1240*

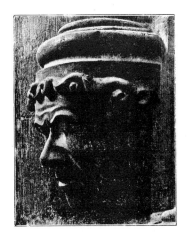

179. *Salisbury. Purbeck head*

180. *Lincoln. Purbeck head*

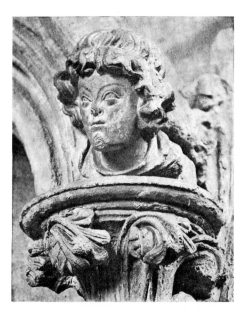

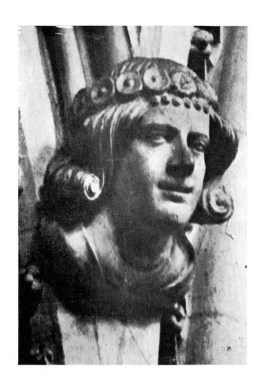

181. *York. Archbishop Gray's monument.*
c. 1255

182. *Lincoln. Angel Choir. Head.*
c. 1270

Heads from the eastern part of the nave at Salisbury (Figs. 176, 177), *c.* 1225, are almost contemporary with those at Wells, and here again slightly later examples from the clearstory at the west end show a rapid advance in skill (Fig. 178).

The introduction of Purbeck marble begins about this time to exercise a great influence on English work. A regular craft of marblers based on the quarries at Corfe, Dorset, and working both on the spot and in London and other big towns, exported shafts, capitals, tombs and other fittings to all parts of the country. In 1206 King John gave licence to the Bishop of Chichester to bring to his cathedral 'marmor suum per mare a Purbic'. Elsewhere it is spoken of as 'marmor regis', and if, as seems likely, the quarries were a royal possession, this may account for the rapid development of the trade. The absence of good building stone in London, and the ease of water carriage as compared with that over the bad roads of medieval England, also helped its popularity. Under Henry III a large body of marblers was working beside the free-stone masons at Westminster, but the evidence of misfits at Chichester proves that shafts and capitals were also imported ready made from the quarries. The Purbeck marble is a dark shell limestone, not a crystalline marble, but takes a polish, and probably first came into use as a native substitute for the dark marble of Tournai. The difficulty of working a hard intractable material like this produced a bold firm style of treatment, which set a good example for the free-stone cutters to follow. The heads here illustrated from Salisbury and Lincoln (Figs. 179, 180) will serve to show the fine quality of this school, while the strange harsh faces and conventional hair treatment from Boxgrove (Fig. 173), *c.* 1210–20, and a rather later and more florid head from Archbishop Gray's monument at York (Fig. 181), *c.* 1255, may show the influence of the

183. *Lincoln. South-east transept. Head* 184. *Lincoln. South-east transept. Mason*

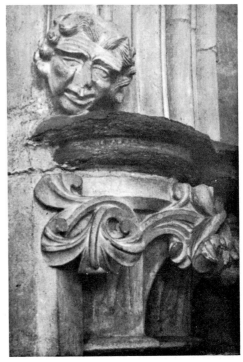

185. *Lincoln. Angel Choir. Head. c. 1270* 186. *Lincoln. Nave. Head. c. 1240*

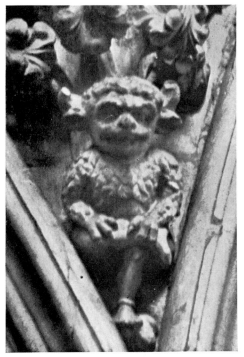

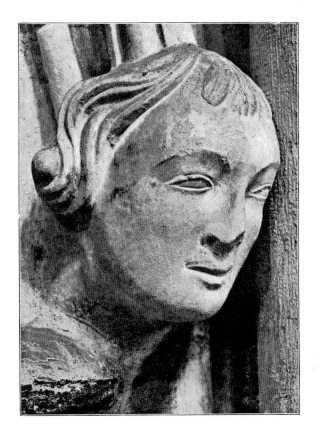

187. *Lincoln. Angel Choir. Imp* 188. *Lincoln. Angel Choir. Head*

marblers on their contemporaries working in more tractable materials. The high quality of the free-stone heads of the middle of the century may be seen in the examples given from Lincoln (Figs. 182 to 188) and Salisbury (Figs. 189, 190). A head in the triforium at Westminster has already been referred to (p. 15) as possibly a portrait of the master-mason of the day, or even of the sculptor himself.

The habit of carving heads in every possible place all over the building is a particularly English one, and they are used more frequently as stops or corbels here than anywhere else. At Lincoln, for instance, there are hundreds of them used separately or in conjunction with the exuberant stiff-leaf foliage in all sorts of positions both inside and outside the building. They range from minute faces an inch or so across placed capriciously on the tip of a cusp, up to almost life size, and vary from comic masks (Fig. 185) to ideal heads or portraits of great beauty (Fig. 182). In the upper parts of the interior of the Cathedral, where they have been out of reach of the iconoclasts, the splendid Lincoln stone is usually as fresh and clean-cut as when first carved. One in a round cup in the triforium of the south-eastern transept might be a portrait of the master-mason or one of his assistants (Fig. 184).

At this period wood-carvers were much influenced by the stone-masons, and in a photograph it is difficult to say whether such a head as that from the sedilia at Westminster (Fig. 191) is of wood or stone, especially as both were painted.

103

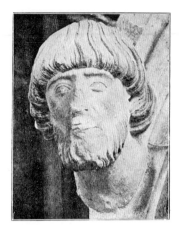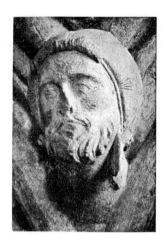

189, 190. *Salisbury. Old choir screen. Heads*

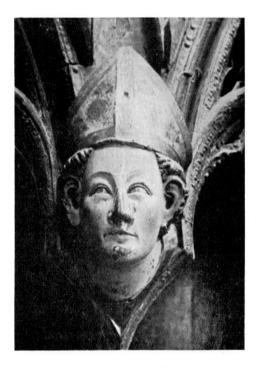

191. *Westminster. Wooden head on sedilia* 192. *Westminster. Transept triforium*

Corbels follow very much on the same lines as the heads. A late twelfth-century Moses, with a long plaited beard and holding the Tables of the Law, from Wimborne (Fig. 193), and a pair of angels censing the head of Christ, from Lincoln (Fig. 194), *c.* 1230, show the enterprise and imagination of their authors, even if they are less architecturally satisfying than the more conventional angel patterns of the following centuries. Such fanciful figures as the famous Lincoln Imp (Fig. 187) or the grinning devil in the apex of a triforium arch at Westminster (Fig. 192) are often inserted into the lovely foliage of the period.

193. Wimborne (Dorset).
Moses

194. Lincoln. South-east transept.
Christ and angels. c. 1230

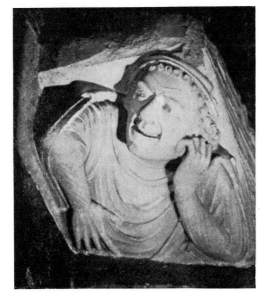

195. Westminster. Choir triforium.
Head of a youth

196. Westminster. Choir triforium.
Caricature of mason

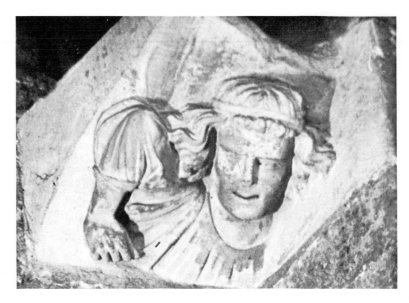

197. Westminster. Choir triforium. Youth

198. Worcester. East chapel. Masons

Some strange corbels have recently been revealed from the encrusting dirt at the back of the choir triforium at Westminster. One of them, a beautiful head of a youth with his head resting on his hand, in the attitude of thinking, is worthy of the sculptor of the great angels of the transept (Fig. 195). Another of a youth with arm raised in a rather cramped attitude belongs to the same workshop as the worn and mutilated reliefs of the wall arcades below (Fig. 197). Besides these there are some striking caricatures so lifelike that some hesitation has been expressed as to whether they could be genuine thirteenth-century work, but it is difficult to see when they could have been inserted at any other time. We illustrate one in

106

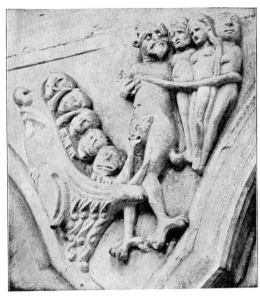

199. *Worcester. South-east transept.*
The Redeemed

200. *Worcester. South-east transept.*
The Damned

a mason's cap (Fig. 196), which must have been a study from the life of one of the masons working there. Some hideous or boldly cut faces are savagely wrought, or even unfinished, but they may be compared with some vigorous, or even sinister heads in St Faith's Chapel, and show the versatility and powerful handling of the carver of the middle or later part of the thirteenth century.

The spandrels of the wall arcades of our more sumptuous buildings also provided a useful field for relief sculpture, and deserve attention both for their technical qualities and for the subjects illustrated. The eastern transepts and choir of Worcester Cathedral were reconstructed after the fall of the tower in 1175 and a fire in 1202, and were consecrated in 1218. The spandrels here, where they have escaped restoration, are of great interest as showing the first experiments of the thirteenth-century carvers in this class of work. In one scene a lady patroness (Fig. 198) is instructing a master-mason, indicated by his pair of compasses, and in the next one a monk is supervising the working mason, while in a third a bishop is presenting the model of his church at the altar. A very spirited series in the south-east transept depict the Last Judgment, with the Judge enthroned, the Last Trump, the Resurrection of the Dead, St Michael weighing souls, an angel joyfully escorting the redeemed to Heaven (Fig. 199), a devil escorting the damned chained together, apparently by his tail, to be cast into the mouth of Hell (Fig. 200), and devils roasting a condemned soul over a hot fire. Draperies are rather tightly drawn and meagre and the whole treatment dry and angular, but the excited gestures and vigour of the attitudes show that none of the twelfth-century story-telling power has been lost, and the vigour shown in the Expulsion of Adam and Eve from Paradise (Fig. 201) is unsurpassed. New Testament scenes, such as the Visitation (Fig. 202) and Presentation, in the north-east transept, are quieter and more restrained, though the affectionate greeting in the former is quite delightful. There are here some slight traces of the original colouring, and no doubt when this was new and fresh it disguised some of the harshness now apparent.

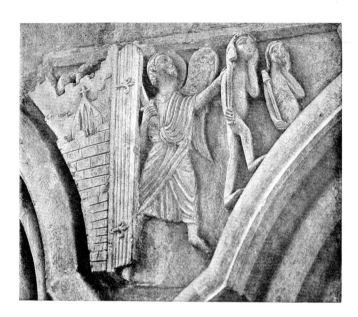

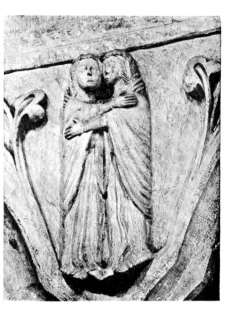

201. *Worcester. South-east transept.*
The Expulsion

202. *Worcester. North-east transept.*
The Visitation

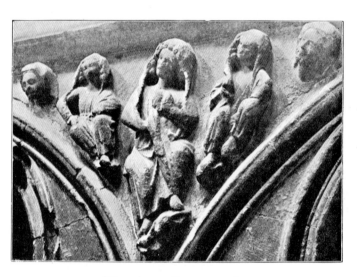

203. *Westminster. Transept wall arcade*

The wall arcades of the transepts at Westminster contained a number of these little reliefs of mid-century date, unfortunately much cut into and destroyed to make room for later monuments, and where they survive much decomposed by the London atmosphere. We illustrate one of the better preserved examples, showing a curious cramping of the little figures to get them into the triangular space (Fig. 203), as evidence that even at this date some sculptors were still in the experimental stage.

The chapter-house at Salisbury has a series of the next period, *c.* 1270, but here the work has suffered severely from restoration. This was much more skilfully done than usual,

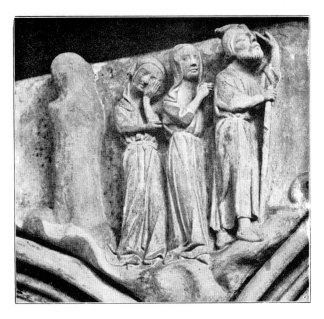

204. *Salisbury. Chapter-house. Lot's wife*

205. *Salisbury. Chapter-house. Pharaoh's Dream*

and as the whole was painted and then the paint scraped off again, it is difficult to trace the genuine work without the description left by Burges of what he had done when he undertook the restoration. The scenes illustrated here are selected from the more genuine pieces, and show that the balance and grouping are now very efficient and the whole full of liveliness and charm. The group of Lot and his daughters turning their backs on the pillar of salt (Fig. 204), in spite of Lot's new head, is a spirited version, and Pharaoh's Dream with the lean kine eating the fat ones and the thin ears of corn consuming the good ears (Fig. 205), and Noah's Ark which combines two parts of the story in one picture (Fig. 206), are fairly genuine, with the exception of Noah welcoming the dove.

109

206. *Salisbury. Chapter-house. Noah's Ark. c.* 1270

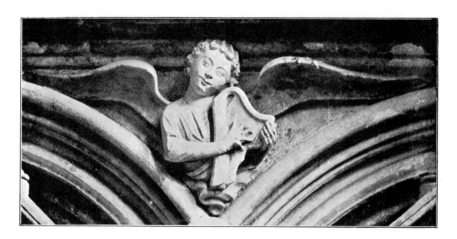

207. *Salisbury. Old choir screen. Angel. c.* 1260

The difficulty met by the Westminster sculptor in fitting in his figures is really met in the most satisfactory manner by the use of a half figure of an angel, whose wings fill the narrow corners of a spandrel in a most effective way. The most charming examples of these may be found in the old choir screen at Salisbury, turned out by Wyatt but fortunately preserved in a side chapel. The sculpture is untouched and much of the original colour and gilding remains, and the coy expression of the angels (Fig. 207), the well-arranged draperies and fine heads below, combine with the knots of foliage and lovely capitals to make this screen one of the most perfect pieces of decorative architecture and sculpture that have come down to us.

Lincoln also had a fine series of angels in the elaborate wall arcades of the choir, but unfortunately they are badly mutilated or restored.

Angel sculpture reaches its climax in the great figures in the triforium spandrels of the Westminster transepts and of the Angel Choir at Lincoln. The former are the earlier and the finest, and may be dated 1250–5. Those of the north transept are slightly more severe (Fig. 208), those in the south more gracious (Figs. 209, 210). In all the composition,

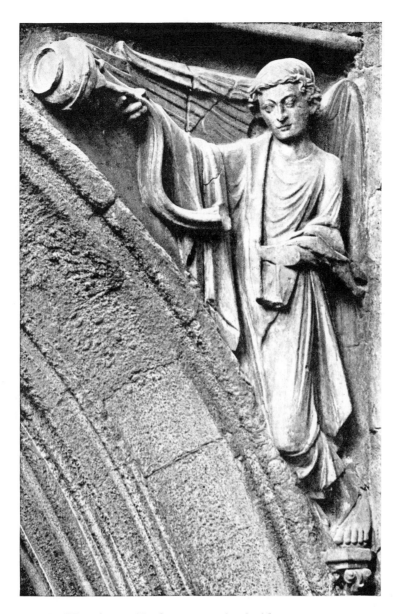

208. *Westminster. North transept. Angel with censer. c.* 1250–5

with swinging censer to occupy the corner and fluttering wings and draperies to fill the backgrounds, is masterly, while the firm treatment of the folds, and noble pose of the heads, make these angels the supreme masterpieces of English medieval art, fit to rank beside anything produced abroad. Like much thirteenth-century sculpture, they seem an incarnation of a new and noble type—the ideal which, as opposed to the sensuous, the trivial or merely pretty, may be called 'monumental'. They have something of the quality of Greek fifth-century art, when allowance is made for the difference in material and surroundings. They have recently (1933–4) been cleaned and considerable traces of the original colours and gilded star patterns have been revealed. Reference has already been

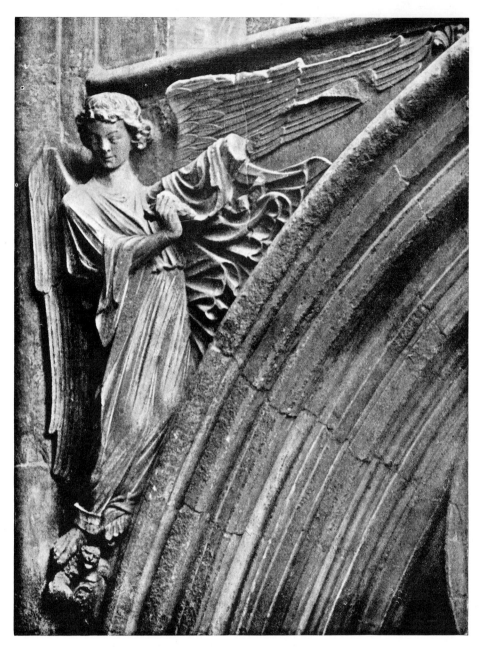

209. *Westminster. South transept. Angel. c.* 1250–5

made to Prof. Lethaby's suggestion (p. 15) that they may be attributed to John of St Albans, the king's imager at this period.

In the Muniment Room, adjoining the south transept, some exceptionally fine vault-bosses have recently been cleaned, revealing much colour though it is uncertain how much of it is medieval (Fig. 211). The quality of the work and style of the draperies prove them to have come from the same workshop as the angels. They represent lively combats with monsters and dragons. Vaulting bosses play a more and more important role in the history

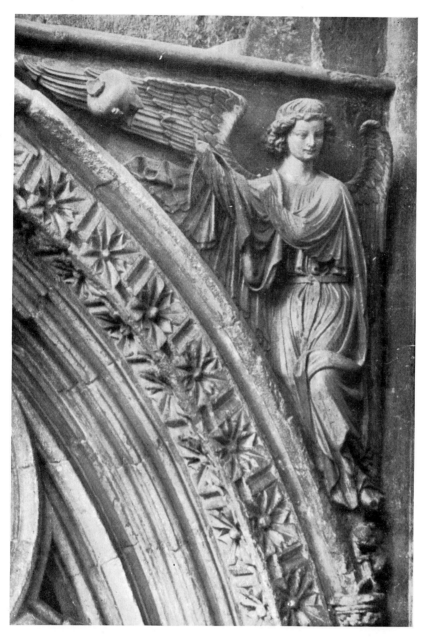

210. *Westminster. South transept. Angel with censer. c.* 1250–5

of English sculpture as vaults become more elaborate. The earliest series of importance are those of the choir at Canterbury *c.* 1180; these are mostly confined to foliage, though here and there little figures and faces are introduced. Heads, dragons and fanciful subjects become increasingly common as time goes on, and by the last quarter of the thirteenth century some very beautiful and important figure-subjects appear.

Besides those in the Muniment Room there are a number of other thirteenth-century bosses at Westminster, but they are difficult to see in the darkness of the aisle vaults, and they are too decayed for their quality to be appreciated. The finest examples of the last

113

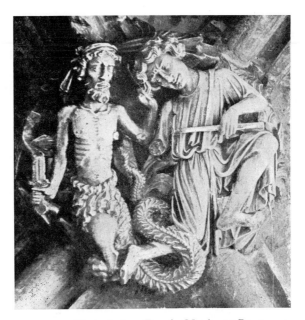

211. *Westminster. Boss in Muniment Room*

212. *Lincoln. Boss in south aisle of Angel Choir. Coronation of the Virgin*

213. *Lincoln. Boss in south aisle of Angel Choir. Queen with pet dogs*

214. *Lincoln. Boss in south aisle of Angel Choir. Nathan and David*

115

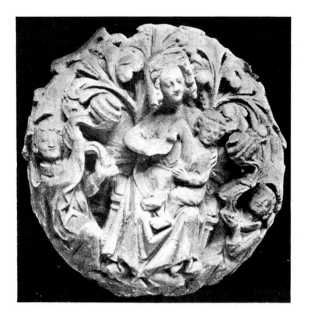

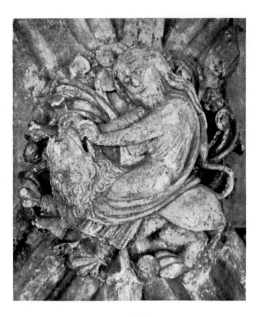

215. *Chester. Lady Chapel. Madonna and Child*
(from a cast)

216. *Hailes Abbey. Boss.*
Samson

217. *Lincoln. Angel of the Expulsion. c. 1270*

116

218. *Lincoln. St Michael with scales*

quarter of the thirteenth century can be found in the Angel Choir at Lincoln (1256–80). Those in the main vault are confined to foliage, some of the regular stiff-leaf variety, and others showing the new naturalistic treatment then coming into fashion. In the south aisle, however, are a series of lovely figure subjects, including a Coronation of the Virgin (Fig. 212), a queen and her attendant playing with her pet dogs (Fig. 213), Nathan and David (Fig. 214), David with his harp, part of a Jesse tree, a prophet and apostle and a number of more fanciful scenes.[1]

There are some very beautiful bosses in the Lady Chapel at Chester, the most notable ones being a Holy Trinity and a Madonna and Child (Fig. 215). Other examples of this period may be found in the presbytery at Ely, and from destroyed vaults at Abbey Dore and Hailes (Fig. 216).

The Angel Choir of Lincoln was begun in 1256 to accommodate the shrine of St Hugh and the pilgrims who flocked to it. It seems to have been completed by 1280, when the relics were translated to it in the presence of King Edward I, Queen Eleanor, and many of the leading personages of the realm. It is the most ornate building in any of our cathedrals.

There are five bays each containing one central and two half spandrels on each side. The work appears to have been begun at the east end with the bays which could be built outside St Hugh's apse, and then completed in a second campaign after the apse had been removed. The first idea seems to have been merely to house a series of heavenly musicians each

[1] For a fuller treatment of this subject the reader must be referred to Mr C. J. P. Cave's *Roof Bosses in Medieval Churches*, with its magnificent series of photographs (see note on p. 196).

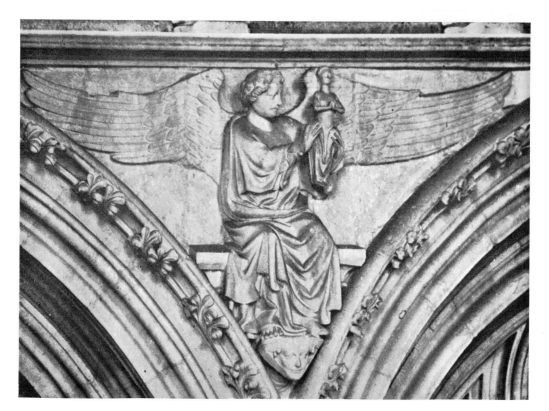

219. *Lincoln. Angel with soul*

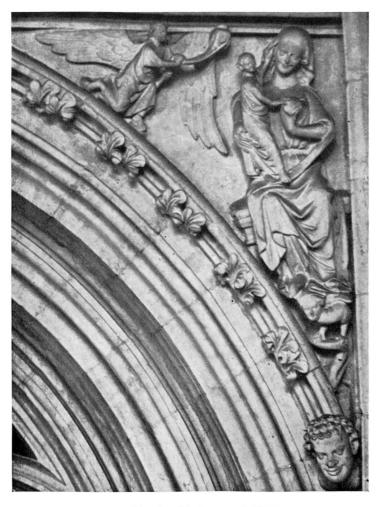

220. *Lincoln. Madonna and Child*

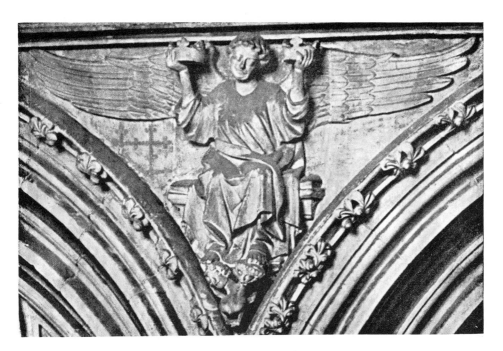

221. *Lincoln. Angel with crowns*

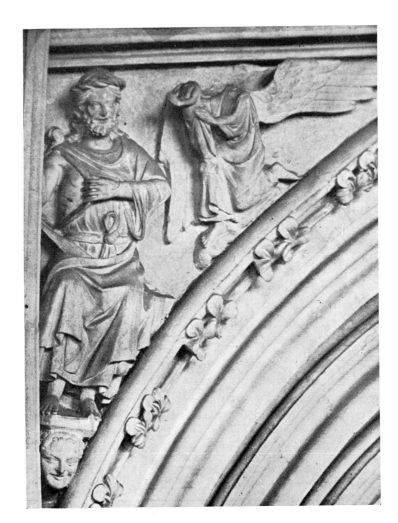

222. *Lincoln. The Christ*

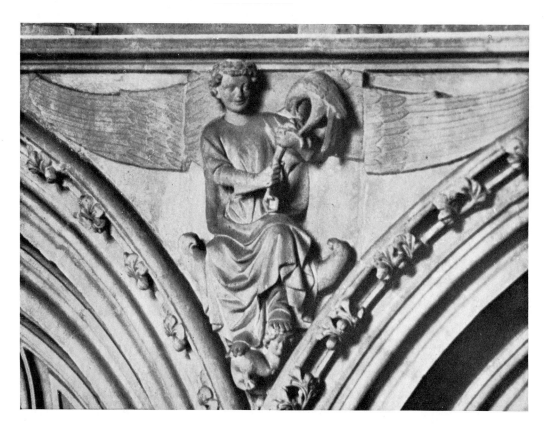

223. *Lincoln. Angel with hawk*

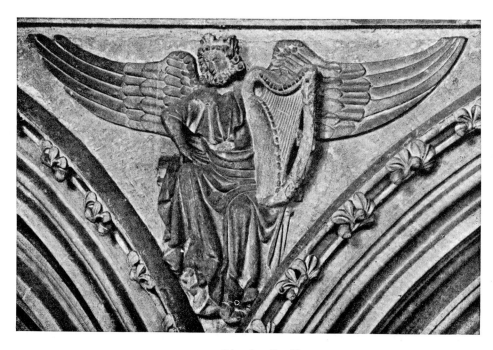

224. *Lincoln. David*

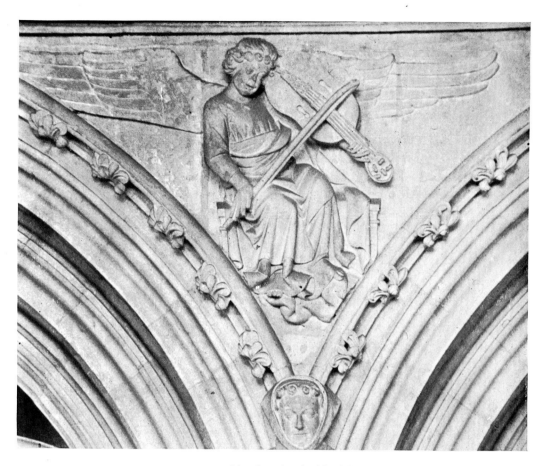

225. *Lincoln. Angel with viol*

playing a different instrument, but as the work proceeded westward a more solemn scheme was introduced and the objects held indicate the more serious activities of the angelic host. We thus have the angel of the Expulsion (Fig. 217), St Michael with the scales (Fig. 218), an angel holding up a little naked soul, probably St Hugh's (Fig. 219), another censing a charming Madonna (Fig. 220), and another holding up the victors' crowns (Fig. 221). There is also a Christ showing his wounded side, to whom a little angel brings a soul (Fig. 222). But what are we to make of the splendid angel with hawk on wrist, which seems hardly in place in this august company (Fig. 223)? David, too, crowned and winged and holding a harp, finds his place in the heavenly choir (Fig. 224).

The angels were carved before erection in the usual manner, as is proved by certain misfits, especially in the wings (Fig. 223), and so were ready to be put in position when the building reached the required stage. The work of three or four different hands can be distinguished in them. Those at the east end who merely hold musical instruments or scrolls are evidently the earliest and are not very distinguished in character (Figs. 225, 226). Figures and attitudes are sometimes clumsy and draperies soft and less tense than that of the magnificent work at Westminster. There is a much more serious expression in the great angels of the western bays, and in spite of a little awkwardness in the perspective of the raised arms in the Expulsion and St Michael, which is less obvious when looked up at

121

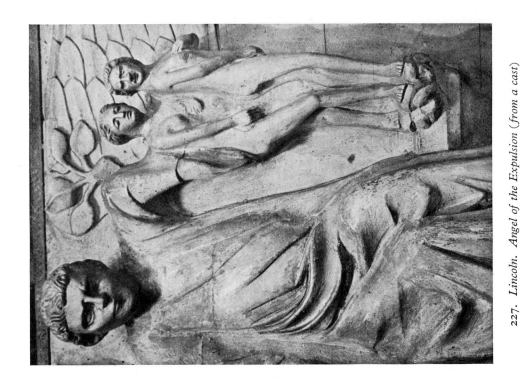

227. *Lincoln. Angel of the Expulsion (from a cast)*

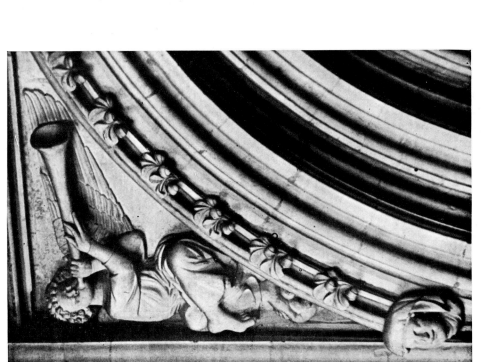

226. *Lincoln. Angel with trumpet*

122

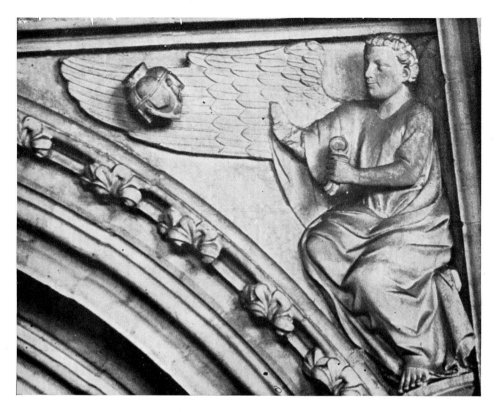

228. *Lincoln. Censing angel (N6 in plan)*

from below, as intended, they are fine and forceful compositions. A close-up view taken from the cast now placed in the transept shows the remarkable expression on the faces of Adam and Eve, while the somewhat unequal treatment of the two sides of the angel's face gives it a stern and severe look (Fig. 227). The flanking angel swinging a censer, which we illustrate (Fig. 228), has a large head and is well composed, while the smaller heads and slighter figures in the Christ and Madonna seem to indicate the hand of another carver. Few traces of colour survive, but the stars on the background of the angel with the crowns (Fig. 221) show that the whole must have glowed with gilding and brilliant hues. The accompanying diagram shows the arrangement of the series of angels and enables the position of each to be identified.

The idea of filling the spandrels with great angels came, no doubt, from Westminster, but the style is so different that they must be regarded as the product of a local school. The good stone available led to a rather more florid treatment in figure and foliage alike, which we shall notice again later in the north-eastern counties, while the firmer handling and sharp angular folds of Westminster may have been influenced to some extent by the bold and forceful technique of the Purbeck marblers.

We must now return to our chief gallery of thirteenth-century sculpture on the west front of Wells Cathedral. We have already described the theological scheme embodied in it in our introductory chapter (see p. 4), but now have to examine it from a more technical point of view. Some critics brought up on the Ruskinian tradition are apt to complain that the doorways are much too small as compared with their French counterparts and that

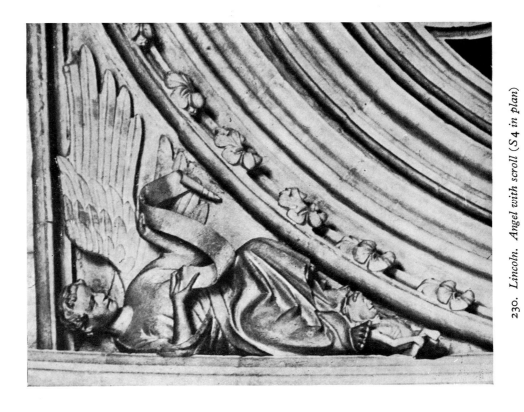

230. *Lincoln. Angel with scroll (S 4 in plan)*

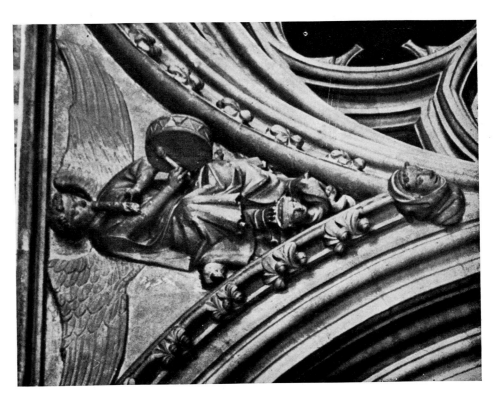

229. *Lincoln. Angel with pipe and tabor*

124

LINCOLN ANGEL CHOIR

SOUTH

NORTH

S.E.　　　　　　TRANSEPT　　　　　　N.E.

	South		North	
1	Madonna		Wreath	1
2	Soul	A	Expulsion	2
3	Book		Spear	3
4	Scroll		Christ	4
5	Hawk	B	St Michael (scales)	5
6	Scroll		Censer	6
7	Book		Scroll and sword	7
8	Pipe and Tabor	C	2 Crowns	8
9	2 pipes		Scroll	9
10	Scroll		Lute	10
11	Scroll	D	Viol	11
12	Pipe (or trumpet)		Palm	12
13	Finger pointing		Harp	13
14	David (harp)	E	Sun and Moon	14
15	Scroll		Scroll	15

EAST WINDOW

125

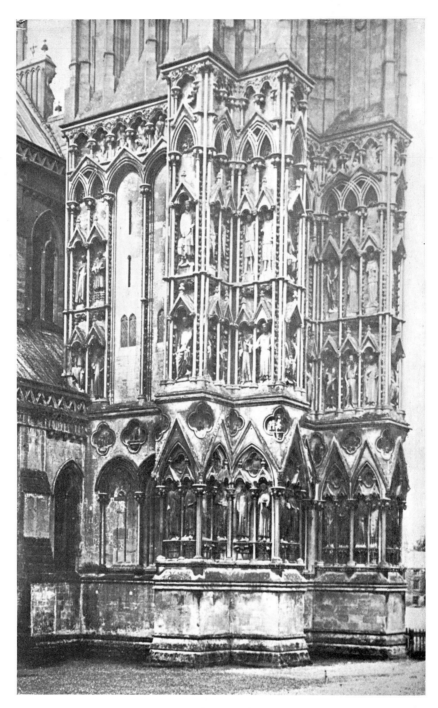

231. *Wells. North tower*

126

the whole design lacks the logical correspondence with the structure of the church behind of some continental examples. This, however, is not fair criticism, and ignores the idea which our English builders were trying to work out. Huge doorways are not suited to our northern climate, and what they were aiming at was a vast sculptured screen, like a reredos or altar-piece on an enormous scale. When fresh and new with the sculptures gleaming with gold and colours it must have produced an overwhelming effect, for we must realise that even out-door sculpture was painted. When Sir William St John Hope and Prof. Lethaby[1] examined the front in 1904 they found traces of a colour wash over the whole

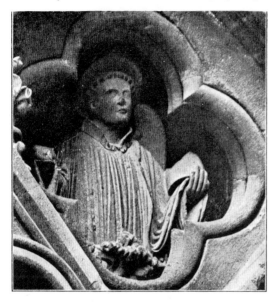

232. *Wells. Quatrefoil*

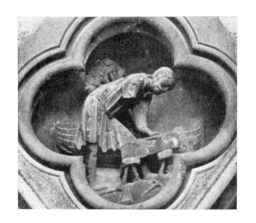

233. *Wells. Quatrefoil. Noah building the Ark*

which served as a base for the brighter colours, and incidentally helped to preserve the surface in our damp climate. The background of several of the niches still retained traces of having been painted red, and there were considerable remains of brilliant colouring on the sculptures of the west door and elsewhere. The placing of the western towers outside the aisles gives an impression of breadth and stability which is more satisfying in some ways than the narrower lofty façades of some foreign contemporary churches, and even the later completion of the towers fits in not unsatisfactorily. The bold buttresses break up the lines of the front and give the contrast and shadow which our French neighbours got from their cavernous portals.

The quatrefoils above the niches containing the lowest tier of statues are filled with half-figures of angels emerging from clouds and treated almost in the round (Fig. 232). They are of a strong masculine type, hold crowns or scrolls and are mostly clad in albs, the folds of which produced a rippled effect without any deep shadows—a method of treating drapery which may be taken as typical of the local Wells school.

Above the canopies of the lowest tier are large quatrefoils containing the groups of scenes from the Old Testament on the south side and from the New on the north. These are not

[1] See their paper in *Archaeologia*, LIX, 1904, for a complete description from close observation from a scaffolding of all the statues, etc.

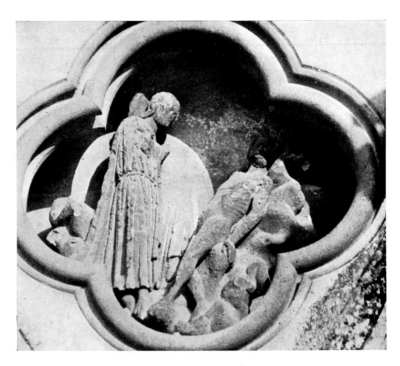

234. *Wells. Quatrefoil. The Creation of Adam. c. 1240*

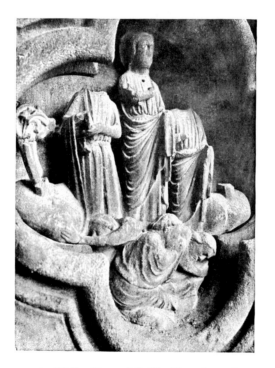

235. *Wells. Quatrefoil. The Transfiguration*

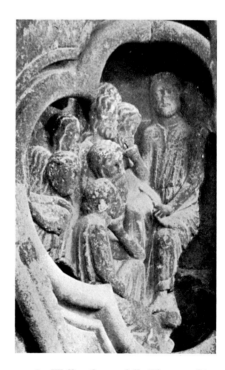

236. *Wells. Quatrefoil. The preaching of John the Baptist*

128

237. *Wells. The General Resurrection*

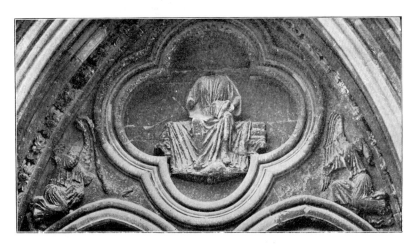

238. *Wells. Tympanum of central doorway. c.* 1220

real reliefs, but groups of statuettes almost in the round except for the flat backs. They cannot, therefore, be compared closely with the spandrel reliefs of Worcester, but where sufficiently well preserved show more statuesque pose and dignity of composition. The Creation of Adam (Fig. 234) with its fine figure of the Creator and its suggestion in the heap of clay of the human form emerging from it is a masterpiece, and Noah building the Ark (Fig. 233), with his tools lying around him, is a delightful picture of a thirteenth-century carpenter at work. Among the New Testament groups the Transfiguration (Fig. 235) and the intent group of disciples listening to the preaching of the Baptist (Fig. 236) may be singled out for special praise. All the subjects are treated directly and simply with only the necessary accessories and no background beyond an occasional spray of foliage to fill a blank space.

At the top of the front is a cornice, supported by trefoil-headed niches enriched with beautiful foliage scrolls, and containing a representation of the General Resurrection, carried all round the façade. The little naked figures rising stiffly from their tombs display a lack of skill in treatment of the nude when seen from near at hand, which is not always equal to the rendering of the heads, but the general effect of the varied attitudes seen from far below is quite impressive (Fig. 237).

In the tympanum of the central door the Gothic quatrefoil has replaced the Romanesque vesica, and contains a Madonna, now headless, and on each side are censing angels (Fig. 238). Above the doorway is a broad niche, which looks like an afterthought as though it were felt that sufficient importance had not been given to the central feature. In this is a Coronation of the Virgin (Fig. 239), now headless, but showing the bolder treatment of drapery of the latest Wells school.

The statues are arranged in three tiers of niches, and 127 still remain, excluding the later figures of Apostles and angels in the gable. They are carved in the Doulting stone of which the Cathedral is built and must have been prepared either on the spot or at the Doulting

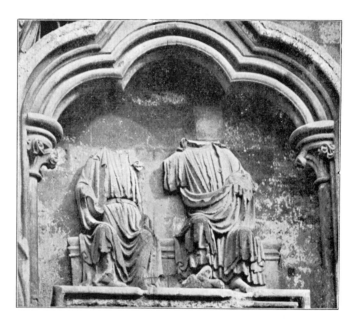

239. *Wells. Coronation of the Virgin. c.* 1240

quarries near Shepton Mallet. They are mostly about life-size, though some exceptionally tall ones are as much as eight feet high. These last may have been intended to correct the perspective when seen from below, or merely were made to fit the taller upper niches. In most such cases, however, a block, either plain or ornamented with foliage sprays, was inserted under their feet to bring them to the right position.

As we have noticed at Worcester and Lincoln there is a distinct advance in quality as the sculptors gained experience while the work was in process. The distinctive rippled Wells drapery is seen in process of evolution during the fifteen or twenty years from soon after 1220 to 1240 while the great work was in progress. The types are English and local, and though hints may have come from contemporary developments at Chartres or Amiens, the handling of details is quite distinct, and casual resemblances are to be accounted for by the fact that at the time thin draperies arranged in simple ways were in fashion, due partly to a reaction against the over-elaboration of the twelfth century. Although the work of more than a dozen different hands can be picked out, there is a general similarity of treatment, which proclaims them all as the production of one workshop. Folds fall very straight with few deep depressions and often assume a V-form at the neck. Bishops are

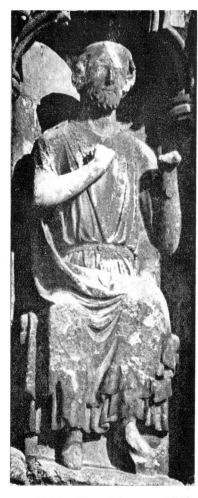 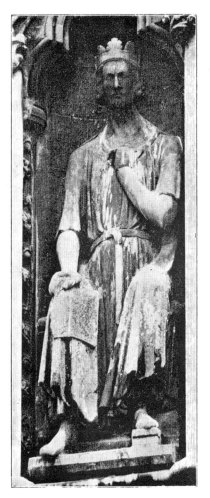

240. *Wells. Face of buttress. Noble* 241. *Wells. Face of buttress. King*

in mass vestments with the chasuble falling deeply in front, and ladies sometimes hold up a fold of their skirts, sometimes play with a necklace. Large, seated figures of popes and bishops, kings and nobles (Figs. 240, 241) occupy the outer niches of the buttresses. Several of the kings have their arms akimbo in the attitude usually given to tyrants like Herod, but as Saxon saint-kings have been identified beside them we may merely describe this as a 'Plantagenet' pose suitable for any royal personage at the time. The king we show (Fig. 241) is in a quieter attitude and is one of the finest of the series. The seated noble (Fig. 240) is also an imposing figure; as in most seated statues where the niche does not provide cover for too great projection of the knees the upper part of the body is somewhat exaggerated in order to obtain the necessary perspective effect from below.[1] Several groups of four or more statues appear to have been worked together like the four hermits (Fig. 242) on the south side.

The earliest type of statue has large heads and flat faces, and may be found chiefly among the bishops or abbots on the south side (Fig. 244), and in some of the standing kings

[1] The head and hands of the seated bishop, which figures prominently in illustrated books on Wells, have been restored after a fall, and must not be regarded as genuine medieval work.

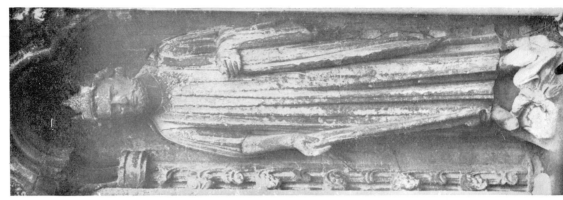

*245. Wells. Return of buttress.
King*

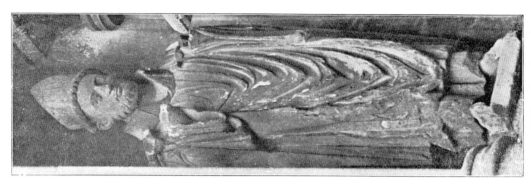

*244. Wells. South panel.
Bishop*

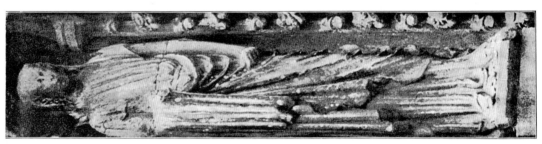

*243. Wells. North tower.
Lady*

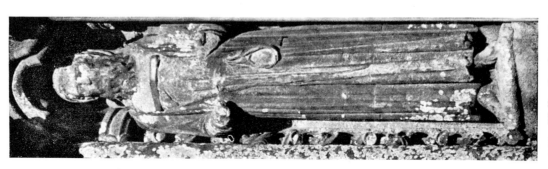

*242. Wells. South panel.
Hermit*

132

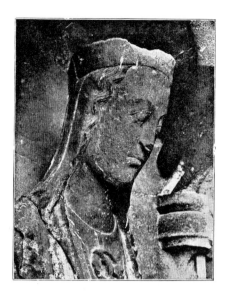

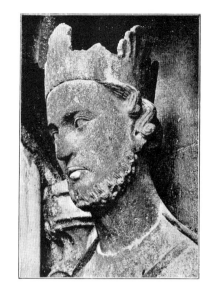

246. *Wells. Head of queen*

247. *Wells. Head of king (Fig. 245)*

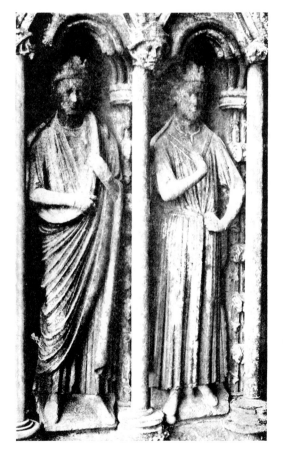

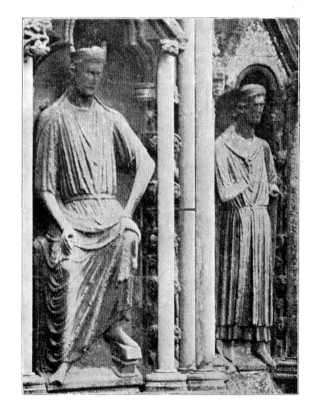

248. *Wells. Return of north buttress. Nobles*

249. *Wells. North tower. Nobles*

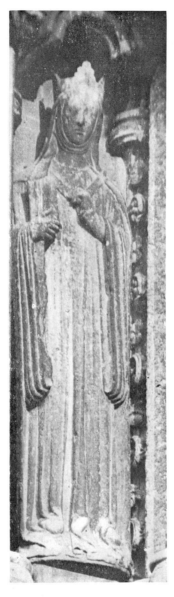
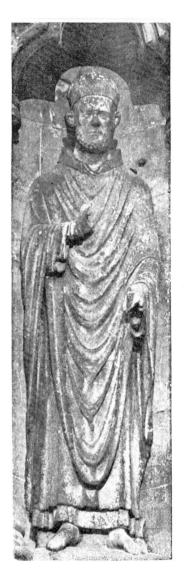

250. *Wells. North tower panel. Lady* 251. *Wells. Centre panel. Bishop*

(Fig. 245). Some very tall ladies with small heads and rather stiff monotonous draperies falling with little reference to the forms beneath, also appear among the more primitive examples (Fig. 243). The head types may be seen in Figs. 246 and 247. A more advanced series may be found in the young nobles or princes grouped round the north tower (Figs. 248, 249), including the Saxon martyr kings. Some of the ladies, especially those of the central panel, show more refinement (Fig. 250) and may be placed beside some much more delicately modelled bishops with smaller heads, such as the one beside one of the tall ladies (Fig. 252), the fine figure on the central panel (Fig. 251), or the St Thomas of Canterbury (Fig. 253). Certain kings on the north tower (Fig. 254) and queens not far

134

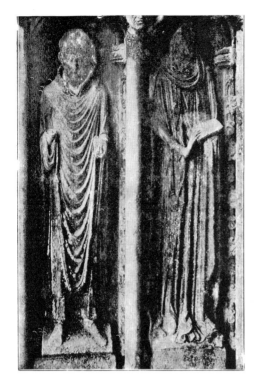

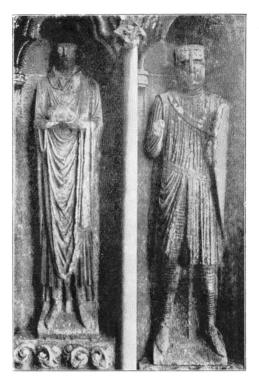

252. *Wells. Bishop and lady*

253. *Wells. St Thomas of Canterbury*

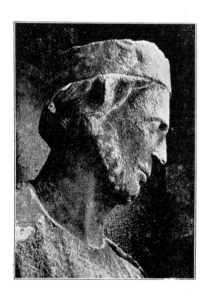

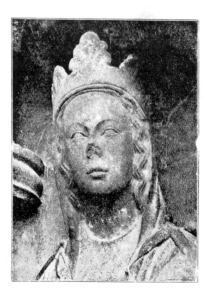

254. *Wells. North tower. King*

255. *Wells. Queen*

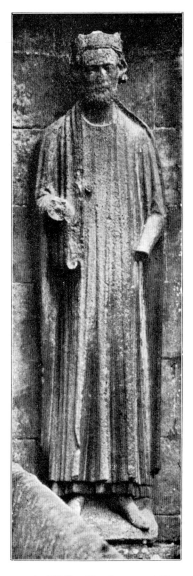

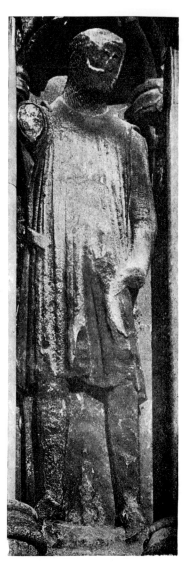

256. *Wells. North tower. King* 257. *Wells. Mailed knight*

from them show more advanced character. The brows are more arched, the faces oval and eyelids carried straight across the bottom of the eyeball (Fig. 255).

On the whole the finest statues are those in the lowest tier preserved on the north tower. There are four grave, bearded personages who hold, or probably held, books (Fig. 258) who would do for the Evangelists, or doctors, or, as one of a neighbouring group, which is more dilapidated, appears to wear a conical cap, we might label the whole lot as prophets. There are also four ladies, one of whom holds a pot of ointment and must therefore be Mary Magdalene (Fig. 259), the others probably being the holy women witnesses of the Resurrection. One of these has her dress arranged like the folds of the priestly chasuble; this device is used at Amiens and Rheims in the case of the Virgin Mary, to give a kind of hieratic effect, and it is possible therefore that this Wells statue represents her. Finally

there is a group of five deacons (Fig. 260), either the regular deacon saints or the companions of St Stephen. These are interesting as displaying the characteristics of the Wells school in their fullest development. They are young men, tall and powerfully made, and the rippling of the Wells drapery has in them its clearest individuality. One has a slight moustache without a beard, which is very unusual in medieval art (Fig. 261).

The question naturally arises as to where this very individual school of Wells got its inspiration. We can see how, once it was started, development took place in the course of the work, but there is a great gap between such figures as the Malmesbury Apostles and the fully fledged statues of Wells.

258. *Wells. North tower. Evangelists (?)*

There may be some reminiscences of metal-work in the fine lines of the draperies, and masons had had some practice on the capitals of the nave, but the immediate predecessors of the statues may be found in the monumental effigies, which by this time were beginning to be placed over the tombs of important people. At Westminster we suggested that the bold lines and angular folds had come from the Purbeck marblers, who were beginning to take the lead in effigy-making. Now at Wells in the choir there are a set of bishop effigies made not of marble, but of the local Doulting stone, and ornamented with sprays of foliage which date them soon after 1200, when a set to commemorate the first five bishops of the see were no doubt made for the newly erected choir of the cathedral (Fig. 263). In these the draperies are rendered by parallel rounded folds, not much different from those of the Romanesque sculptures at Lincoln and York, but the large heads and broad faces and

137

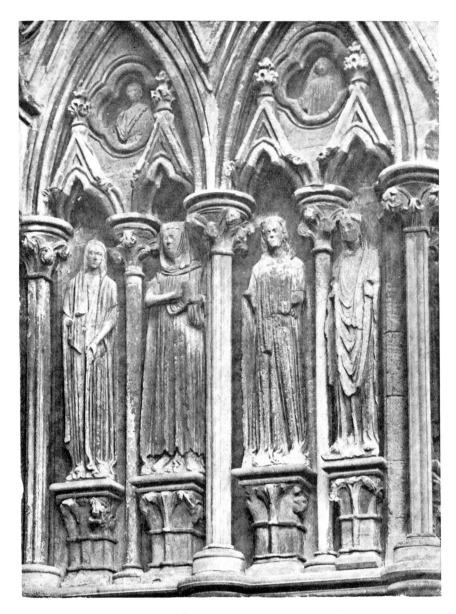

259. *Wells. North tower. Mary Magdalene and holy women*

general outline of the figures are so like those of the earliest bishops of the front that these effigies would hardly look out of place if set up on the front. Two other bishop effigies were added to the series a few years later and in these there is some advance towards the crisper rippled drapery characteristic of the statues. A comparison, too, between the warrior in mail and surcoat from Wells (Fig. 257) with the famous effigy of William Longsword, Earl of Salisbury (Fig. 264), shows close affinity of style, while a civilian effigy in St James's Church, Bristol (Fig. 265), has exactly the same costume as the nobles of the Wells north tower.[1] The tendency to tall proportions at Wells may therefore come from the effigies

[1] This church was twice bombed during the War, and this figure may no longer survive.

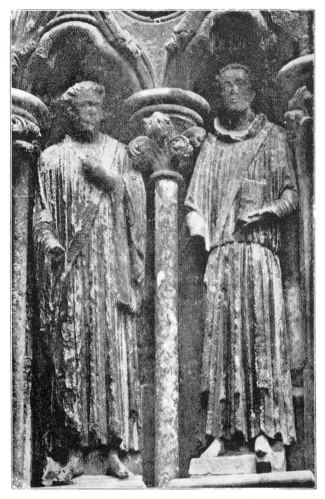

260. *Wells. North tower. Deacon saints*

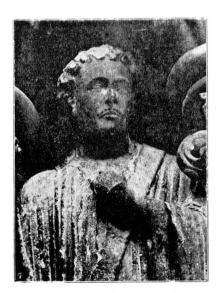

261. *Wells. Head of deacon in Fig. 260*

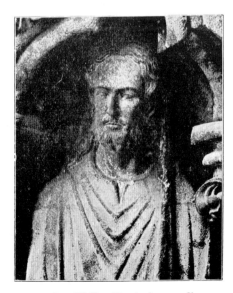

262. *Wells. Head of evangelist*

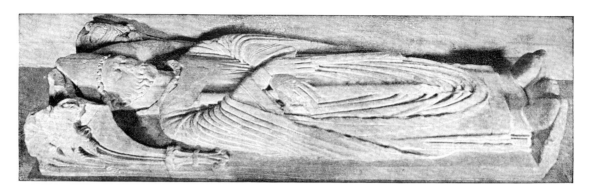

263. Wells. Effigy of bishop. c. 1200

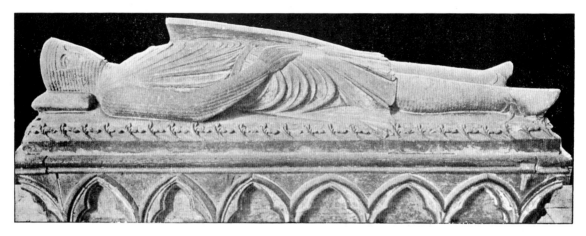

264. Salisbury. Effigy of William Longsword, Earl of Salisbury. c. 1240

made to cover coffin lids or tombs, and it certainly looks as though the Wells statue-makers had learnt the rudiments of their art in the workshops of the effigy-makers either at Doulting or possibly at Bristol.

The story of west-country sculpture would have been carried on for us by the west front of Salisbury Cathedral, but the statues there have disappeared with the exception of two or three which are too mutilated for reproduction.

At Winchester a headless statue now in the feretory was dug up in the Dean's garden, and may serve to show a later development of the Wells style (Fig. 266). It evidently had a metal girdle, and possibly held a broken metal staff, representing the Synagogue. The freedom of pose and sweep of the drapery show an advance on the Wells ideal, and this may have been designed for some position inside the cathedral.

At Peterborough, at a great height over the three lofty arches of the front, a number of statues survive, which must be contemporary or a little earlier than the first school at Wells. They are of an entirely different type, and though drawn on broader lines for distant effect, they are evidently inspired by quite different models (Fig. 268). The broad flat folds, squat proportions and heavy nimbus behind the head can only have come from the wooden images provided for internal decoration.

267. *Lanercost (Cumb). Mary Magdalene in west gable. c. 1270*

266. *Winchester. 'The Synagogue'*

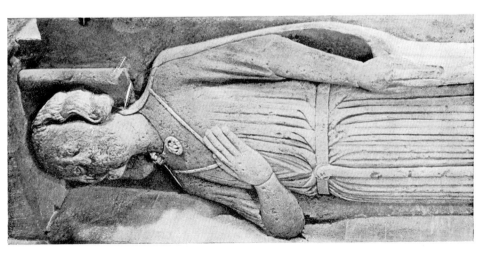

265. *Bristol. St James's Church. Effigy of civilian*

141

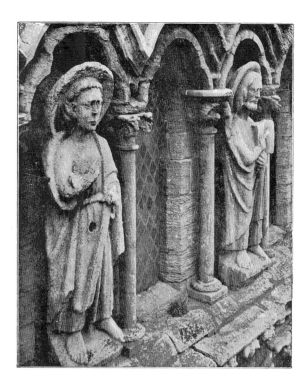

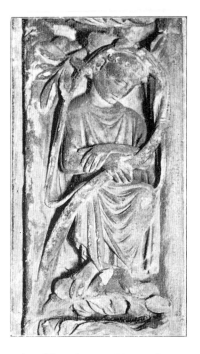

258. *Peterborough. West front. Statues.*
c. 1200

269. *Westminster. Chapter-house*
door. c. 1250

We have already seen the high-water mark of our English sculpture in the angels of the Westminster transepts. This church combines the French plan with English execution in the details, and from the meagre evidence available this must have been the case in the great portals of the north transept, which was the main entrance to Henry III's new abbey, begun soon after 1245. Here there was a great triple portal on the lines of the porches of Amiens or Rheims, with sculptured tympanum and life-size statues at the sides. There is a record that these included the Apostles, and it seems likely therefore that the central doorway followed the regular French scheme with a carving of the Last Judgment, while the side porches may have been devoted to the Virgin and St Peter, the patron saint of the church.[1] In the tympanum, however, the French scheme of reliefs arranged in horizontal tiers was not adopted, and Scott was no doubt correct in reconstructing the modern doorway with the central figure in a quatrefoil, but the lower part of the tympanum probably had a number of smaller quatrefoils all containing figures. The mouldings of the arch also probably contained little statuettes or animals embowered in foliage instead of in stiff niches placed one above another in the French manner. Later French tympana, *c.* 1300, at Sens and St Urbain at Troyes have the sculpture arranged in tracery panels, but we can best form a notion of what the Westminster porch was like by turning to the south doorway of the Angel Choir at Lincoln, which seems to have been inspired by it.

Meantime, another doorway at Westminster leading from the cloister to the chapter-house has retained some of its original sculpture incorporated in the modern reconstruction.

[1] All the available evidence as to what this porch was like has been carefully sifted by Prof. Lethaby in his *Westminster Abbey Re-examined*, ch. IV.

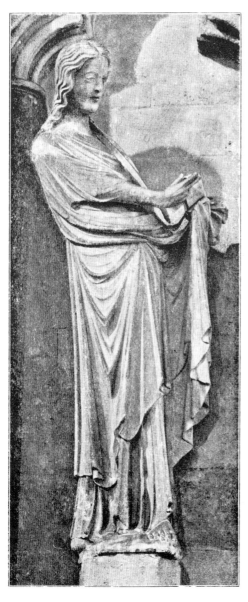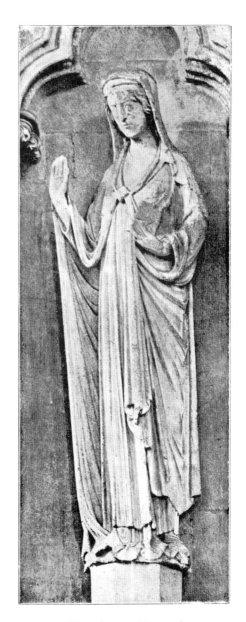

270. *Westminster. Chapter-house.*
Gabriel

271. *Westminster. Chapter-house.*
Virgin Annunciate

The tympanum towards the cloister had its ground covered with beautiful foliage scrolls on which were three brackets supporting a statue of the Madonna and two angels. One of the latter, minus head, remains in a much dilapidated condition. The inner doorway to the chapter-house is mostly modern, but just above it are placed two fine statues forming an Annunciation, the dramatic discovery of which is described by Scott in *Gleanings from Westminster Abbey*, p. 41 (Figs. 270, 271). The wings of the angel are lost, but were probably of wood or metal; the groove for fixing them remains. These are the statues possibly paid for in 1253 (see p. 15). The quiet immobility of the Wells attitudes and the soft clinging

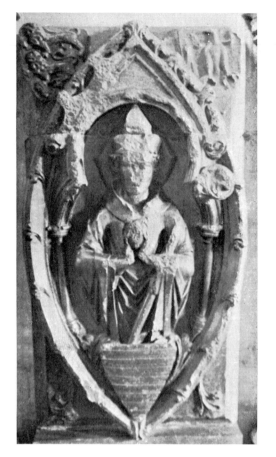

272. *Winchester. Purbeck memorial of Bishop Aymer*

273. *Lincoln. West front. Statue*

drapery have here given way to a bolder treatment and the sharp angular cutting which we have already seen in the other Westminster sculptures, and which we think was derived from contact with the Purbeck marblers, a specimen of whose work may be found in the heart memorial of Bishop Aymer at Winchester (Fig. 272). In the chapter-house doorways twisted tendrils of foliage enclosing small figures of delicate workmanship fill mouldings round the arches or run up between the shafts on the jambs (Fig. 269). In one case they seem to represent a Tree of Jesse, but the arrangement is peculiarly English and more satisfactory than the superposed niches of the ordinary French scheme. It is tempting to trace the idea back through the foliage medallions of Malmesbury or Glastonbury to the primitive Saxon crosses.

Four statues still remain in the niches of the west front at Lincoln (Fig. 273). They are of the broad-bodied large-headed type which connects them with those in similar positions at Peterborough, but the draperies are more boldly cut. They must be dated to the second quarter of the thirteenth century.

But the finest work at Lincoln is to be found in the famous Angel Choir, the most profusely decorated work in any English cathedral. Here the great south doorway, or Judgment Porch (Figs. 274 to 278), has been mentioned as probably inspired by the destroyed porch at Westminster. It is the only one remaining in England which can be

144

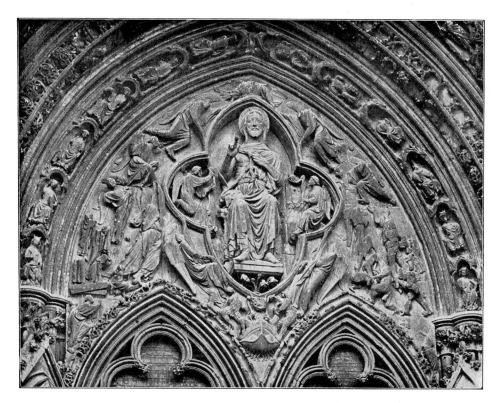

274. *Lincoln. Tympanum of Judgment Porch. c.* 1280

classed at all with the French examples in scale, and even here it is a single door, not a triple portal. As already stated, this part of the cathedral was begun in 1256 and finished about 1280, and we shall be fairly safe in dating the sculptures of the portal 1270–80. The style is so different from that of the triforium angels with their smooth baggy folds that it seems likely that the sculptors of the Westminster porch came on to Lincoln when their work in the royal abbey was finished. Edward I was frequently at Lincoln in connection with his wars with Scotland and personally assisted in the translation of the relics of St Hugh to the new shrine in 1280, so that an importation of the royal masons to a work specially favoured by the king seems not unlikely. The tympanum (Fig. 274) represents the Last Judgment, with the Judge in a quatrefoil in the English manner, the general resurrection and angels conducting the souls of the blessed to Heaven on one side, and devils carrying off those of the lost, to be cast into the mouth of Hell at the bottom, on the other. New heads have unfortunately been given to the central figures, but in spite of this and the mutilation that the figures have suffered, the draperies can be seen to be of the tense Westminster type, and the fluttering angels must have formed a very graceful and effective throng when fresh and gleaming with colour and gold.

Round the arch are three richly sculptured orders; the inner one has a series of queenly figures in niches more on the French plan, the next is composed of magnificently undercut foliage scrolls, and the third has beautiful little statuettes embowered in more undercut scrolls of the typically English thirteenth-century foliage. On one side these represent the Wise and Foolish Virgins of the parable, and on the other male figures difficult to interpret.

145

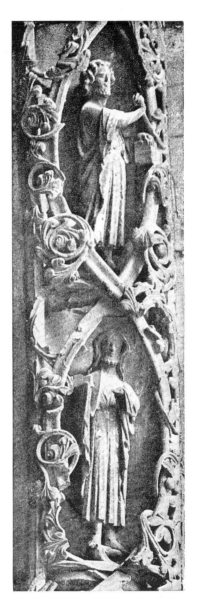

275. *Lincoln. Judgment Porch.*
The Foolish Virgins

276. *Lincoln. Judgment Porch.*
Male figures

These little figures have the grace and charm of Tanagra statuettes, and in their leafy housings form as delightful a series as anything the middle ages ever produced (Figs. 275, 276). The resemblance of these little figures and their setting is very like that to be found in the badly decayed chapter-house doorway into the cloister at Westminster, another confirmation of the theory that the Westminster sculptors went on to Lincoln.

On either side of the porch are four magnificent statues, unfortunately headless and mutilated, but even in their present condition they demonstrate that their authors could produce something fit to stand beside the famous statues of Amiens and even of Rheims. They are placed on brackets, and are not column figures, like the French examples or

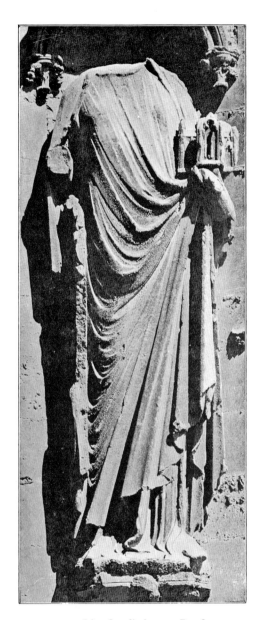 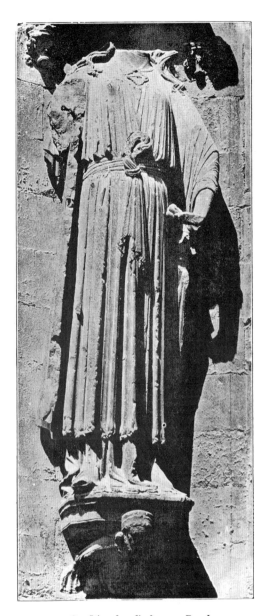

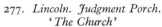
277. *Lincoln. Judgment Porch.*
'*The Church*'

278. *Lincoln. Judgment Porch.*
'*The Synagogue*'

those from St Mary's, York. Two of them represent the Christian Church and the Jewish Synagogue, typifying the Old and New Covenants. The Church (Fig. 277) stands upright with nobly flowing robes, holding a model of a church in her hand, and the Synagogue must originally have had bandaged eyes and held a broken staff and the Tables of the Law falling from her hand (Fig. 278). The contrast between the thick-fringed material of the outer cloak and the thinner garment falling about the feet is a new and splendid feature. The deeply cut folds and knotted girdle are found in a very similar, but more worn, figure at Crowland, which must have been almost a direct copy.[1]

[1] A statue of late thirteenth or early fourteenth century date is preserved in St Mary's, Stamford.

147

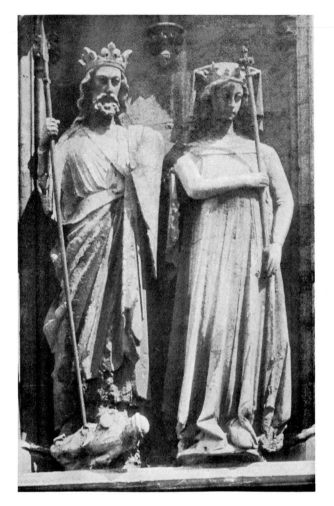

279. *Lincoln. Buttress of Angel Choir. Edward I and*
Queen Eleanor (restored)
280. *Lincoln. Angel Choir, north*
side. Queen Margaret (?)

In the buttress niches to the east of the porch are three more statues from the same workshop, two of which have been restored as Edward I and Queen Eleanor (Fig. 279) and the third on the next buttress is identified without any substantial evidence as Queen Margaret who married Edward in 1299 after the death of his beloved Eleanor (Figs. 280, 281). Cockerell in the Appendix to his book on the iconography of Wells published in 1851, is loud in his praise of these statues, of which he says: 'there is a prodigious grandeur, freedom of energy of style in these figures, which belongs to this period beyond any other of the art in this country. In the adjoining pier is a female statue of equal merit of execution, but affecting great delicacy and refinement in the character.... The neglect of these fine works, most of which are mutilated, the head of the king having been knocked off within a few years, is disgraceful.' The Edward and Eleanor have now been restored with new heads etc., and so can hardly be claimed as medieval examples, but the drapery of the king with its bold treatment and deeply cut folds places it in the same class as the Church and Synagogue of the adjoining porch (Fig. 279). The lower part of the 'Queen

148

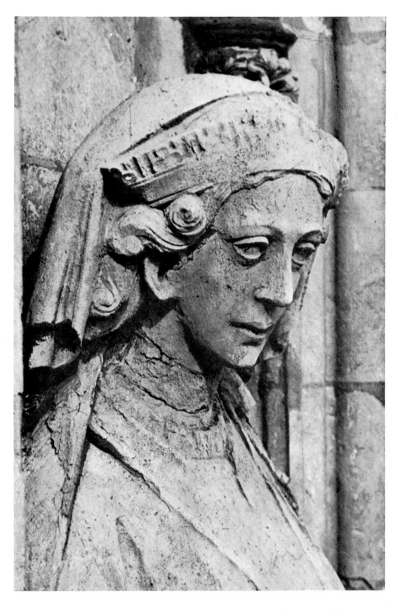

281. *Lincoln. Angel Choir, buttress. Queen Margaret (?)*

Margaret' has been cut into by the parapet of the sixteenth-century chantry, but her head is preserved, and is of great value as one of the few surviving examples of English sculpture at the height of its achievement, and helps us to realise the grandeur of effect when the statues of the porch were complete.[1] The treatment of the eyes with the sharply cut lids

[1] As this figure is at some height from the ground it was assumed by Prof. Lethaby and others, without close inspection, that the head had been renewed like the others. Mr J. L. Hodgson, however, in 1924–5 published a pamphlet called *The Queen Margaret Statue*, in which he proved from close inspection that it had not been tampered with and pointed out that it was intact when Cockerell wrote of it in 1851 before the days of the Gothic Revival restorers, and a masterpiece like this could not have been produced by the clumsy earlier restorers who made the figures attached to the wall arcade

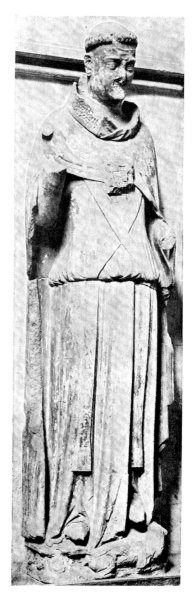

282. *Lincoln. Judgment Porch.*
Headless statue

283. *Lincoln. Statue of ecclesiastic*
now in north transept

in the choir aisle or fitted the statues on the west front with new heads. C. Wild published a small drawing of it in 1819, showing it much in its present condition. As this statue takes such a prominent place in the history of our medieval sculpture the present writer, together with Mr R. P. Howgrave-Graham, F.S.A., made a special visit to Lincoln to check Mr Hodgson's conclusions, and was enabled by the help of Mr R. S. Godfrey, C.B.E., F.S.A., the eminent and very experienced surveyor of the Cathedral, to examine the figure close at hand. We were all three satisfied that it is a genuine medieval work of the highest quality. The crack in the neck does not go right round and can be matched by similar features in shafts of the same stone near by, and there are no signs of any joints or retouching. The head-dress is of a type repeated with little varieties in a number of heads scattered about the Cathedral. It is of the Lincoln stone from the silver bed, the fine lasting quality of which can be seen in many heads all over the Cathedral.

284. *Salisbury. Chapter-house. Virtues and Vices*

is remarkable, and there are subtle irregularities in them and the mouth which give life to the expression, which seems to vary according to the angle at which it is seen. Inside the cathedral a statue of an ecclesiastic in cope and alb (Fig. 283) must belong to the last quarter of the century. The restrained dignity of the treatment of the vestments and general pose belong to the great period of Gothic sculpture, but the realistic portraiture of the wrinkled face has more affinity to contemporary work in Germany than to that of the more idealistic French schools. The head carvings, of which our English masons were so prolific, must have given them a special skill in rendering faces and studying expression.

There is a fine mid-thirteenth-century statue in a niche in the west gable of Lanercost Priory, Cumberland, carved in the local red sandstone, but allowing for a rather coarser treatment necessary for its lofty situation somewhat reminiscent of the Lincoln style (Fig. 267). Prof. Prior has suggested that as Edward I was frequently in this neighbourhood during his Scottish expeditions and was at one time actually lodged at Lanercost, he might have brought a sculptor with him from Lincoln to make what might have been a royal gift to the Priory.

In the chapter-house doorway at Salisbury there are a series of statuettes in niches round the door-head, set well back in a deep moulding. They represent the Virtues punishing the Vices, according to a poem by Prudentius called the *Psychomachia*, which was very popular in the middle ages. In our illustration Truth is pulling out the tongue of Falsehood and Chastity is hanging Lust (Fig. 284). In spite of a certain amount of restoration these little figures retain much of their original charm.

(2) THE PURBECK EFFIGIES

In dealing with head-stops (p. 101) we have referred to the work of the craftsmen in Purbeck marble as setting a model for their contemporaries, and we have again and again suggested their influence on the formation of the Westminster school of carving. Their most important production in the way of sculpture consisted in the recumbent effigies for tombs, which led the fashion throughout the thirteenth century for the greater part of England.[1]

Though early Christian churches grew up over the tombs or round the shrines of local saints or martyrs the custom of burial inside churches did not come into fashion until well on in the twelfth century. Abbots were generally buried in the chapter-house or cloister, but gradually the custom grew of placing the tomb of a founder near that of the saint or the altar, and very soon important persons left instructions in their wills for burial in a special church, in which, as time went on, chantry chapels were founded in which priests should continue to say mass for the souls of those buried within. In the great cathedrals which sprang up in the thirteenth century it became the fashion for a bishop to order a series of tombs for his predecessors, and thus we have already (p. 137) described a set made for Wells. There is another collection all of the same date at Hereford, and in France St Louis had a magnificent series of his ancestors made for the royal abbey of St Denis.

Among the earliest tomb covers is a slab of dark Belgian marble from Tournai, now in Southover Church, Lewes. It has an inscription with epitaph of Gundrada, Countess de Warenne, foundress of the Priory, who died in 1085. It has no figure work, but a decoration of acanthus-type foliage. This was apparently an importation, and it seems likely that it was brought to honour a foundress some half-century or more after her actual death, and should be classed with the Tournai fonts which were described in chapter III. A slab at Ely with St Michael holding a soul (Fig. 285) in a dark-coloured stone may probably have a similar origin. It has a canopy over the head of the angel and is carved in a flat formalised technique, indicating a practised and established craft. The date is probably the middle of the twelfth century, or even a little later. The much-worn figure of an abbot in the cloister at Westminster also appears to be of the black Tournai marble. It may be the earliest example of this type of memorial in England, and is ascribed to Abbot Gilbert who died in 1121.[2] At Salisbury, too, the effigy of Bishop Roger, d. 1140 (Fig. 286), is carved in the same formal flat way with foliage round the slab and a dragon at his feet. One hand is raised in blessing and the other holds a crozier, the butt end of which rests on the dragon's head. This must have been brought from Old Sarum to the new cathedral in the thirteenth century, when a new head in freestone seems to have been added. Purbeck marble seems

[1] They were even sent abroad. The author has noted one in the north transept of Lisieux Cathedral in Normandy. Purbeck shafts also existed at Mont St Michel until replaced by restorers who did not realise what they were.

[2] Illustrated in the volume published by the Royal Commission on Ancient Monuments, Westminster, pl. 202.

285. *Ely. Tomb slab in choir aisle. St Michael with soul. c.* 1150

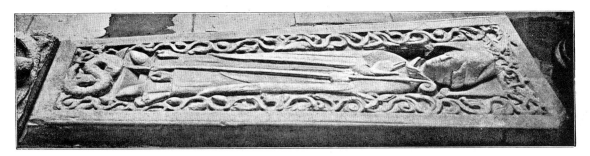

286. *Salisbury. Black marble slab of Bishop Roger. c.* 1140

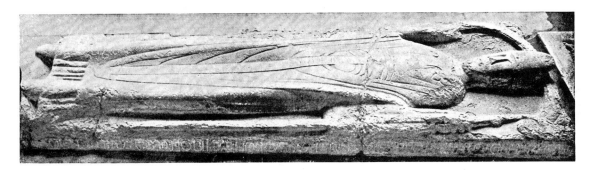

287. *Salisbury. Purbeck effigy. Bishop Jocelin. c.* 1184

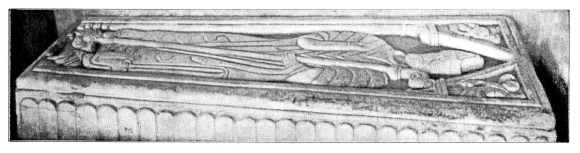

288. *Exeter. Purbeck effigy. Bishop Iscanus. c.* 1180

153

to have been introduced to replace these foreign importations,[1] and at Salisbury there is one of their early efforts in this line, probably the effigy of Bishop Jocelin, d. 1184 (Fig. 287). The style is ruder and more experimental, the lines of the vestments being simply incised, but the relief is higher, and it shows more promise than the sophisticated tradition of the Flemish workers. The effigy of Bishop Iscanus at Exeter, who died about the same time, is very flatly rendered, drawn rather than modelled (Fig. 288), and the face treatment of these early figures can be seen in the head of an abbot at Sherborne identified by an inscription as Abbot Clement, c. 1160–5 (Fig. 289).

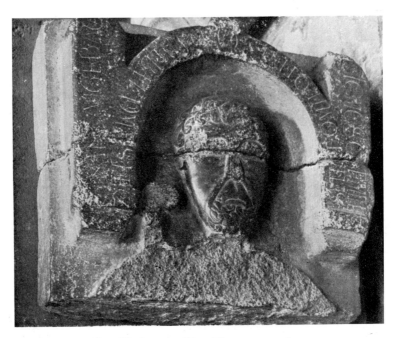

289. *Sherborne. Abbot Clement. c.* 1165

The next stage may be seen in the tomb of Bishop Marshall (Figs. 290, 291) at Exeter (d. 1206), brother of the Earl of Pembroke. This is in higher relief with the head projecting more above the slab, but the folds are still hardly modelled though represented more by ridges than incisions. Two little flat angel reliefs are placed on the canopy on each side of the head, and the tomb-chest is now richly carved with seated figures and heads in quatre-foils separated by sprays of boldly cut foliage.[2]

Peterborough also possesses several of these marble slab-effigies over the tombs of abbots, c. 1200 (Figs. 292, 293). In these there is some advance in the attempt to render the folds more naturally, the heads—some bearded, some clean-shaven—are bluffly and fully modelled, the architectural canopies boldly carved, and the whole has something almost Egyptian in the strength and assurance of its conventions.

In all these effigies there is no attempt to give the effect of recumbency, and they would

[1] It was known to the Romans, who used it in pavements. Fragments have been found as far afield as Verulamium (St Albans).

[2] It has recently been claimed that the tomb-chest is of a more developed character than the effigy, and that they have been put together wrongly in the course of an old restoration.

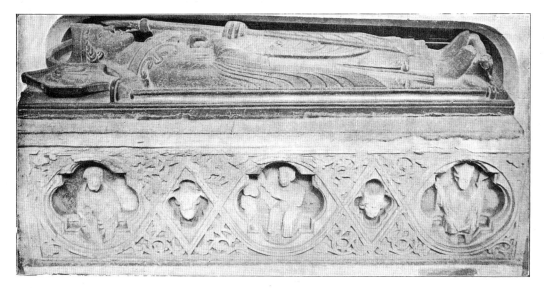

290. *Exeter. Purbeck effigy. Bishop Marshall. c.* 1206

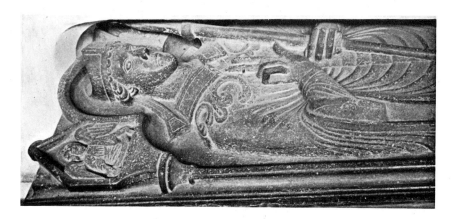

291. *Exeter. Bishop Marshall*

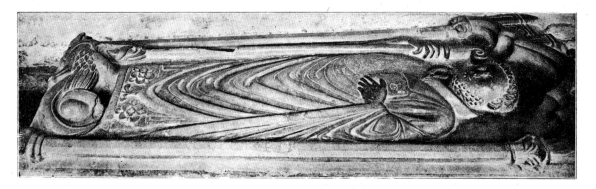

292. *Peterborough. Purbeck effigy. Abbot. c.* 1200

155

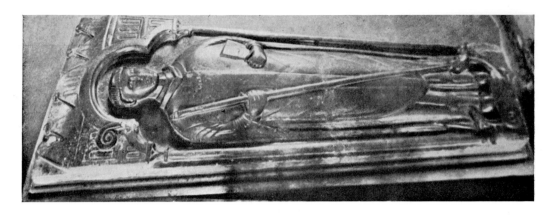

293. *Peterborough. Purbeck effigy.* **Abbot.** *c.* 1210

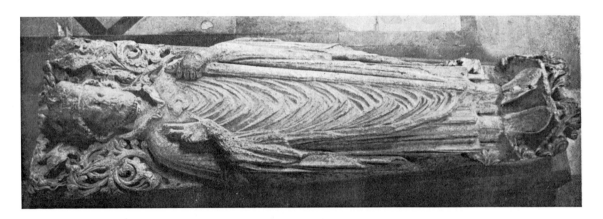

294. *Worcester. Purbeck effigy.* **Bishop.** *c.* 1240

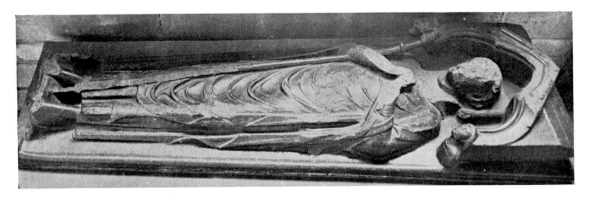

295. *Sherborne. Purbeck effigy.* **Abbot.** *c.* 1270

156

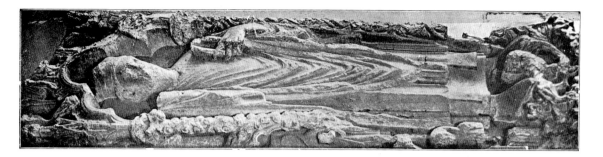

296. *Ely. Purbeck effigy. Bishop Northwold. c. 1255*

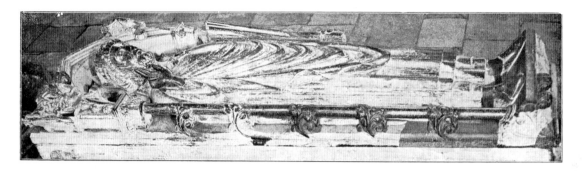

297. *Ely. Bishop Kilkenny. d. 1256*

look more natural set up on end. There is, of course, no attempt at portraiture; in fact all through the middle ages types rather than individual characterisation are the aim.

Effigies of the second quarter of the thirteenth century may be found at Worcester (Fig. 294), Carlisle, Sherborne and Ely. These show a tendency to more elaborate, more natural draperies, and less of the Egyptian severity. There is also a decoration of the slab with more undercut foliage, and in the later examples, as at Sherborne (Fig. 295), there are some concessions to the recumbent position, such as the placing of a cushion under the head or allowing some of the folds to fall down on to the slab. The most gorgeous of all these Purbeck bishops is Bishop Northwold of Ely, d. 1254 (Fig. 296). Here the effigy is set in a kind of cradle of rich carving. The shafts of the canopy are foliated all the way down, and little figures in niches occupy the sides. Bishop Kilkenny, d. 1256, also at Ely, is a taller and slighter figure (Fig. 297) and has bold crockets of stiff-leaf foliage at the sides, but the finest of these mid-century ecclesiastics is Archbishop de Gray, d. 1255, at York (Fig. 298), who lies under a magnificent canopy in the south transept of the cathedral. This is difficult to photograph without distortion under the canopy, but our illustration shows that the standing posture is still maintained and that the figure, in spite of its masterly execution in other ways, is still a statue in a niche laid on its back.

The later phases of the Purbeck bishop may be illustrated by the tombs of Bishop de la Wyle, d. 1271, at Salisbury (Fig. 299), and Bishop Inglethorpe, d. 1290, at Rochester (Fig. 300). The former exhibits the smoother thinner draperies and overlapping folds then coming into fashion, and in the latter there is great simplification of handling, but the broad smooth surfaces of the drapery were intentionally prepared in this way to allow for

157

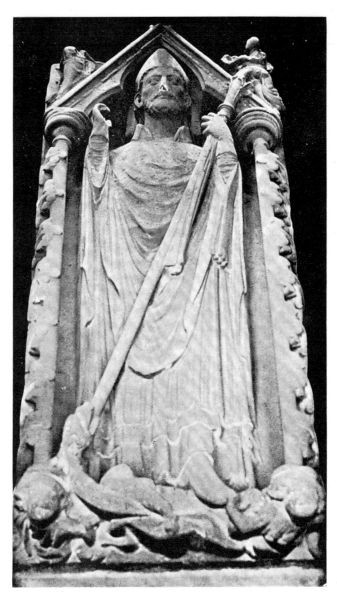

298. *York. Archbishop de Gray (Purbeck). d.* 1255

surface decoration in gold and colour. It was probably this tendency to gild and colour the surface which caused the end of the Purbeck marble trade. Beginning with gilded ornaments the addition of other colours tended to encroach more and more upon the surface until it was found that more easily worked freestone with detailed ornament worked up in gesso, or plaster, and coloured all over provided just as effective and sumptuous a monument as the more expensive marble figure. An interesting effigy of a deacon in Forest marble, a similar material with larger shells in it, is preserved at Avon Dasset (War). It is an early example in rather flat technique under a canopy of Romanesque type (see Fig. 311).

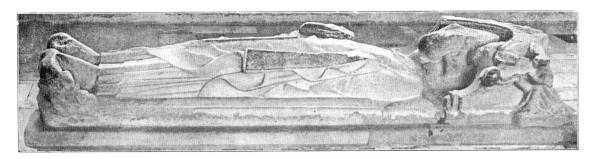

299. *Salisbury. Purbeck effigy. Bishop de la Wyle. d.* 1271

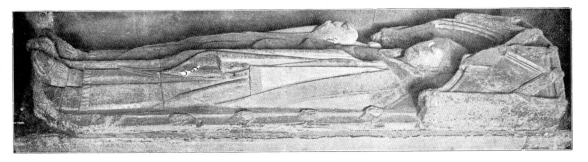

300. *Rochester. Purbeck effigy. Bishop Inglethorpe. d.* 1290

Besides ecclesiastics, the Purbeck marblers produced knights and ladies. How far they were worked on the spot and how far in London or other big towns is not known, but probably both methods were employed. It is, however, purely a matter of conjecture if we try to assign to one or another district. Masses of chips and fragments have been found in digging foundations in the village of Corfe, which proves that at any rate much carving was done on the spot. The writer has notes of about eighty Purbeck effigies scattered over the country, without counting copies in Frosterley marble or other local varieties.

The earliest knights could best be studied in the Temple Church, London. Their destruction in the London 'blitz' was one of our major losses to art history caused by the 1939–45 war. These were cleverly restored by Richardson in 1842, but he has left us a description of the state in which he found them. The earliest one was in low relief with no cushion under the head and straight legs. The figure was covered with mail, with mail coif over the head and a surcoat of linen, or some such material, which was introduced during the Crusading period to keep off the heat of the sun. Another explanation is that it was required for heraldic devices. This effigy was much decayed and was heavily restored.

The next in date, conjecturally assigned to William Marshall, Earl of Pembroke, d. 1219 (Fig. 301), was more genuine, though it was broken into four pieces and needed much patching. It showed considerable progress, but the pictorial representation of a standing figure was still retained. The legs were straight and there was some bold foliage on the slab, while a flat cushion was placed under the head, as the first slight concession to the recumbent pose.

The two knights we illustrate in Figs. 302 and 303 appear to date from about 1245. The first (Fig. 302) was well preserved and needed little repair. The legs are crossed high up,

159

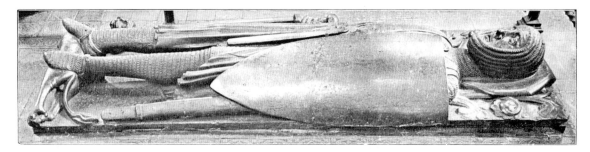

301. *London. Temple Church. Purbeck effigy. William Marshall, Earl of Pembroke. d. 1219*

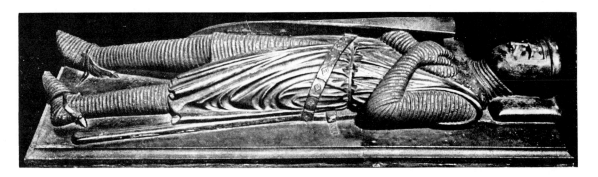

302. *London. Temple Church. Purbeck effigy. Knight. c. 1245*

a convention which became the standard pose for English knightly effigies for the next hundred years. The popular belief that these cross-legged knights were Crusaders is obviously untenable; it was no doubt introduced merely to give a certain liveliness of effect, and is a purely English feature, which never occurs in French monumental effigies, though it had been frequent in the statues of the twelfth-century Toulouse school. The Temple knight was wearing a steel cap with protection for the face and chin which was left smooth and was therefore not meant for mail. The hands were crossed on the breast and a cushion placed under the head. The second knight (Fig. 303) needed heavier repairs, but the easy attitude and spreading of the tail of the surcoat over the slab show that the sculptor was at last attempting to realise the recumbent position, and the coal-scuttle helmet gives an individuality to this figure.

Outside London we may illustrate the straight-legged type by a fine effigy at Sandwich (Fig. 304) with shield laid on breast, and a bold canopy over his head. About the middle of the century a more restless type comes into favour: not only is the warrior represented with crossed legs, but he is drawing his sword from the sheath, as though he were not dead, but just about to start up from slumber to engage a foe. A knight in a closed visor at Walkern (Fig. 305) is an early example of this attitude, *c.* 1245, and later ones may be found in the second Longespée at Salisbury, at Wareham, Winchester, Rushton and elsewhere.[1] The quieter type was being produced at the same time, side by side with these vigorous warriors, as at Stowe-nine-churches (Fig. 306), where hands are laid one on the

[1] A very large early example, though much damaged, with closed visor may be found at Kirkstead Chapel, Lincs.

160

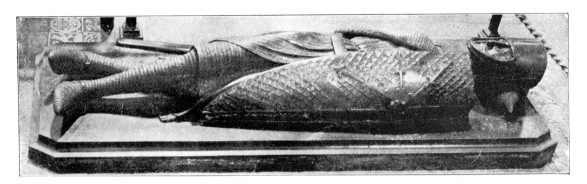

303. *London. Temple Church. Purbeck effigy. Knight. c. 1245*

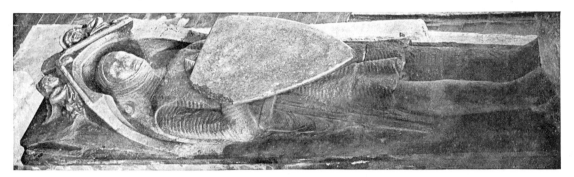

304. *Sandwich (Kent). Chapel of St Bartholomew's Hospital. Purbeck effigy. Knight. c. 1240*

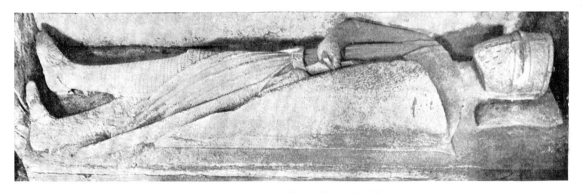

305. *Walkern (Herts). Purbeck effigy. Knight. c. 1245*

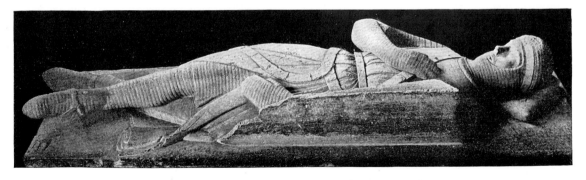

306. *Stowe-nine-churches (Northants). Purbeck effigy. Knight. c. 1260*

161

breast and the other at the side, and the surcoat is spread out on the slab as in the Temple knight with the coal-scuttle helmet.

The latest of the Purbeck knights is probably that at Dodford (Fig. 307). Here the attitude is rather quieter, though the sword-drawing motive is still employed. It is tempting to connect the quiet type of these knights with the marblers working for the king at Westminster, where the restful, more sculpturesque design was favoured, and the livelier sword-drawing figures with some other workshop, possibly that of Salisbury or of the quarries at Corfe itself, though this, of course, must be purely a conjecture.

A few ladies have come down to us from the Purbeck shops, though not of the earliest period. One at Worcester (Fig. 308), c. 1240, has a long robe spread over her feet without any attempt to indicate the prone position, though she is given a pillow under her head. She wears a wimple under her chin, and the slab beneath is ornamented with undercut foliage. Romsey has a lady, c. 1270 (Fig. 309), under a bold canopy, with foliated sides to the slab. She is holding up the folds of her dress with one hand and fingering the cord of her cloak with the other, very much in the attitude of the later Wells statues or the Virgin from Westminster chapter-house.

Civilians wear a long plain gown, as at Winchelsea, and we have one royal effigy in Purbeck marble. Our earliest Norman kings were buried in Normandy, and the effigies of Henry II and his queen and of Richard I at Fontevrault[1] are quite different in style from anything we have in England. The Purbeck effigy, therefore, of King John at Worcester is the earliest of the long series of royal tombs in England.[2] It looks some years later than his death in 1216, being boldly carved in high relief with well-executed drapery (Fig. 310). Two small figures of bishops are carved on each side of his head, representing St Oswald and St Wulfstan, between whose shrines the wicked king was buried in the hope that under their escort his soul might obtain a better reception than was justified by his life (Fig. 312)![3]

An interesting variety of monument by the marblers can be seen in the wall tomb of Bishop Aymer at Winchester. A half-length figure of the bishop is set in a cusped niche enclosed in a kind of vesica enriched with stiff-leaf foliage (Fig. 272).[4]

[1] See the author's *Medieval Sculpture in France*, Figs. 354, 355, and Stothard's drawings.

[2] William Rufus was buried at Winchester, but the tower fell on the grave. The coped slab shown as his tomb is a very doubtful identification.

[3] King John's effigy seems to have preserved much of its original colour when drawn by Stothard, but it was unfortunately gilded all over by order of Queen Victoria. It has now been cleaned and polished, but has necessarily lost the old colouring.

[4] Effigies of Purbeck or similar marbles, not mentioned in the text, may be found in the following places:

Bishops or Ecclesiastics: *Didcot (much decayed), *Exeter (Bp. Simon de Apulia), *Salisbury, (Bp. Bridport), *Rochester (Bp. Lawrence), *Worcester (Bp. Giffard), *Winchester, *Sherborne (a third effigy), *Abbotsbury, *Lichfield, *London, Temple Church (a fine example), Peterborough (three more abbots).

Knights: Ashendon, Twyford, Eastwick, *Horton, Down Ampney, Kemble (very worn), *Hitchin (half size), *Kirkstead, Mautby, *Blyth, Castle Ashby, Gt. Haseley, Lewes (fragment), Sullington, *Winchelsea, Horworth, *Hatfield (half size).

Ladies: *Warblington, *Sopley, *Easington.

Civilians: *Britford (half size), Plymouth (?), Dartmouth, Thraxton, *Winchelsea, *Sopley, Droxford.

The above lists are compiled from various sources and their accuracy cannot be guaranteed in all cases. Those with an asterisk have been seen or photographed by the author. Many are badly mutilated.

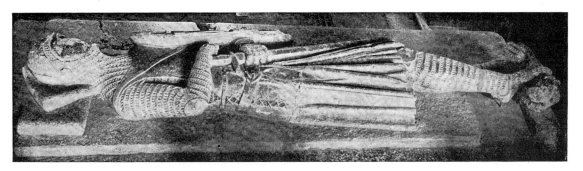

307. Dodford (Northants). Purbeck effigy. Knight. c. 1305

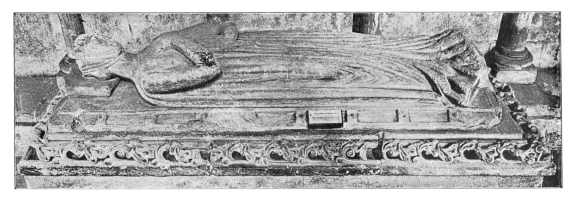

308. Worcester. Purbeck effigy. Lady. c. 1240

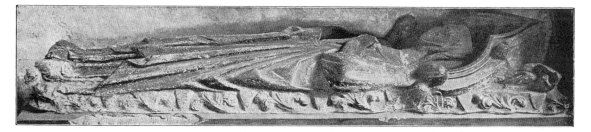

309. Romsey (Hants). Purbeck effigy. Lady. c. 1270

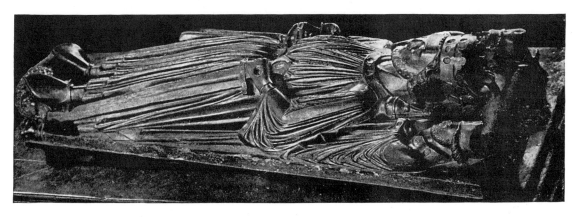

310. Worcester. Purbeck effigy. King John. c. 1230

163

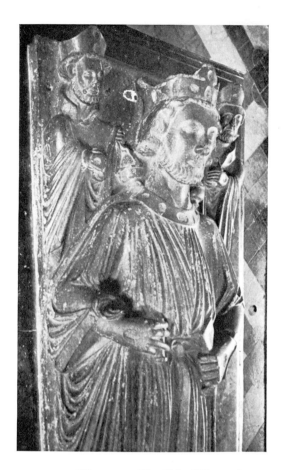

311. *Avon-Dasset (War). Marble deacon* 312. *Worcester. King John (Fig. 310)*

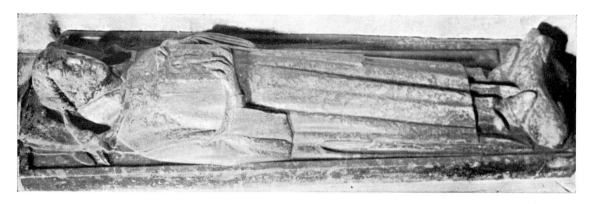

313. *Ryton (Durham). Frosterley marble effigy. Deacon*

164

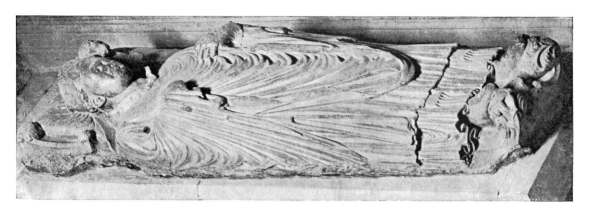

314. *Lichfield. Bishop Patteshull. c. 1245*

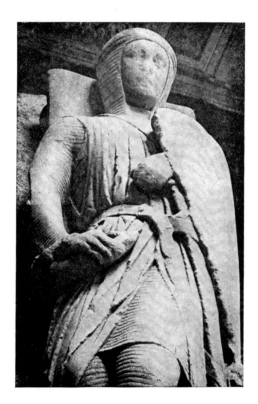

315. *Pershore (Worcs). Freestone effigy. Knight. c. 1280*

As already pointed out, the products of the Purbeck marblers set the standard for tomb-making for most of the thirteenth century. Substitutes were found for the genuine article in places where it was not available, such as the Frosterley marble in Durham, which is bluer in colour and has much larger shells. An effigy of a deacon holding a book at Ryton (Fig. 313) is in a similar material, and has the bold lines and smooth broad folds of the later Purbeck school. At Lichfield a bishop in a kind of dark slaty limestone is probably to be assigned to Bishop Patteshull (1239–41) and is based on the Purbeck style of the middle of the century (Fig. 314), while at Worcester, beside the Purbeck bishop we

165

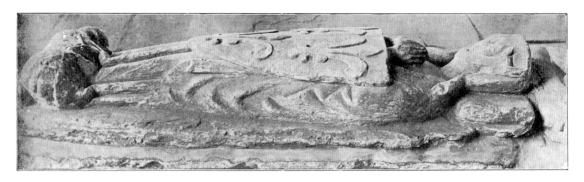

316. *Abergavenny (Mon). Freestone effigy. Lady. c. 1270*

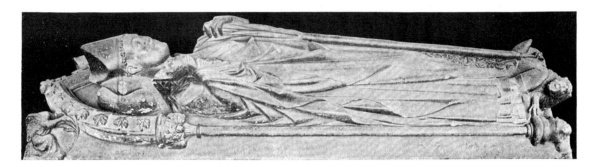

317. *Exeter. Bishop Bronescombe. d. 1280*

have illustrated (Fig. 294), there is an obvious copy in a softer freestone which has worn away more severely, but must have been a little coarser in treatment. Bishop Aquablanca, *c.* 1270, at Hereford, is based on the type of Archbishop de Gray at York, and a large number of freestone knights, such as that at Pershore (Fig. 315), owe much to the later Purbeck models. A striking effigy of a lady at Abergavenny with a shield blazoned with fleurs-de-lis resting on her breast (Fig. 316) is also just what we should expect to have found in a marble prototype. A knight at Bridport has traces of having been painted black, as though in imitation of the marble.

Local schools existed in various parts of the country, such as that of Bristol and the Doulting quarries which has already been described, but most of them do not become very important till quite the end of the century, when they will fall better into place in a later chapter.

The distinguished figure of Bishop Bronescombe, d. 1280, at Exeter, is based on the later Purbeck models, but begins to show a distinct advance in the treatment of the drapery with thin overlapping folds (Fig. 317). The head is raised high on a double cushion, and the little leaves carved on the canopy begin to assume the naturalistic form of the last years of the century, and proclaim this effigy as transitional to the next period with which we have to deal.

CHAPTER V

THE FOURTEENTH CENTURY
(OR DECORATED PERIOD)

(1) STATUES, ARCHITECTURAL AND FURNITURE SCULPTURE

It has already been pointed out in our introductory chapter that by the second half of the thirteenth century there are signs that the sculptors of figure and foliage were beginning to specialise. The Purbeck marblers were sending out tombs and effigies ready carved, besides shafts and capitals, and we have seen how in 1258 John of St Albans is spoken of as 'sculptor of the king's images'. These imagers of the end of the thirteenth century no doubt began as masons, and their work shows a sympathy for their architectural surroundings and a dignified monumental style which attains the high-water mark of medieval art. By the beginning of the fourteenth century, however, we begin to see signs of the divorce of the figure-sculpture from the building craft. The imager has become a specialist and begins to let individual dexterities and clever fancies lure him away from the monumental ideal. The result is that in spite of greater knowledge and surer technique there is a loss of dignity and his work merits such descriptions as 'pretty' and 'graceful' rather than 'grand' or 'noble'. The change comes slowly, and is perhaps less noticeable in the tomb-sculpture than in the architectural work.

Just at the turning point we have the famous Eleanor Crosses, the accounts for which fortunately survive, and, as already stated (see p. 15), were published in *Archaeologia* in 1842. The surviving crosses are those at Waltham and Hardingstone, just outside Northampton. There is also a smaller cross, not mentioned in the accounts, at Geddington in Northamptonshire, which has suffered less from restoration than the others. Alexander of Abingdon's statues at Waltham, of which we show the best preserved, are not portraits in the modern sense, but seem based on the model set by images of the Virgin or other female saints (Fig. 318). The queen stands with the body slightly bent and the weight resting on one leg; one hand plays with the cord of her cloak as in the Wells statues, and the cloak falls in a cascade of little twisted folds at the side. It is, perhaps, worth while to draw attention to the likeness of these statues to a beautiful effigy of a lady at Aldworth (Fig. 320), not very far from Abingdon, which exhibits very much the same treatment, and it is tempting to suggest that this is another work of Alexander's, or at any rate came from the same atelier in which he was trained.

William of Ireland's statues at Northampton show a change in style, though still based on the Virgin motive. The drapery is brought across the figure in flatter and more sweeping folds (Fig. 319). William is described indifferently as mason (*caementarius*) and imager (*imaginator*), which seems to prove that architectural grounding of his craft which we have claimed for the thirteenth-century sculptors. There is a general resemblance of some of these statues to the tomb of Aveline, Countess of Lancaster, d. 1273, in Westminster Abbey (Fig. 321), and we may therefore take these together as typical productions of the London workshops in the last decade of the thirteenth century. The first signs of this thin and

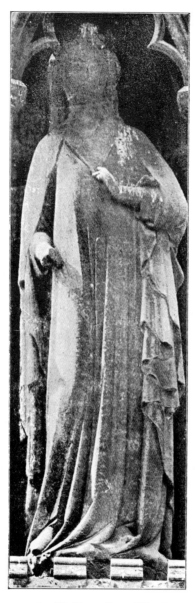

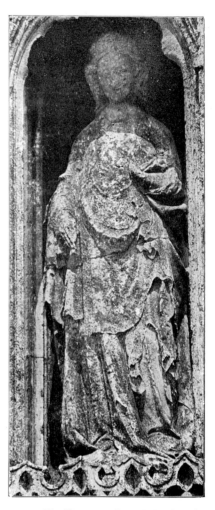

318. *Waltham Cross (Herts).*
Queen Eleanor

319. *Hardingstone Cross (Northants).*
Queen Eleanor. c. 1292

fluttering drapery may have appeared at Salisbury on the west front, where the decayed fragments which remain seem to indicate a departure from the Wells style which we should have expected to see developing in a façade evidently based on the Wells model. Possibly suggestions from France of a more elegant treatment may have begun to exercise some influence by this time. These graceful overlapping folds, especially at the side, are different from the bold deeply cut straight columnar draperies of the Lincoln statues described in a previous chapter.

The Geddington Eleanors are less distinguished, though better preserved (Fig. 322). They too have the cascade of the folds of the cloak at the sides, but the coarser rendering

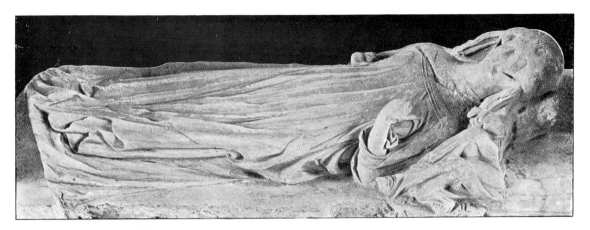

320. *Aldworth (Berks). Effigy of lady. c.* 1300

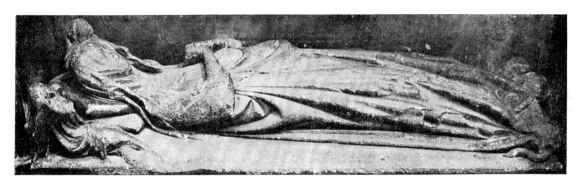

321. *Westminster. Aveline, Countess of Lancaster. d.* 1269. *Tomb probably c.* 1290

seems to be more local work, based on the statues of the Lincoln or Peterborough school.

The one remaining ancient statue on one of the buttresses at Lichfield (Fig. 323) bears a strong resemblance to the Eleanor statues. The same arrangement of the draperies with folds of the cloak at the side can be seen repeated, but the long hair falling on each side of the face in zigzag curls is a regular feature of early fourteenth-century style, especially in the Midlands and North.

On the other hand, the rather florid style of the Lincoln angels with the smooth baggy folds is continued in a more or less exaggerated form at Durham in two angels placed high up near the vault at the junction of the choir with the eastern transept known as the Nine Altars (Fig. 324). These must be dated *c.* 1280.

The exaggerations in attitude and hair treatment, which we see beginning in the Durham angels, are carried a little further in the Madonna of the York chapter-house (Fig. 325), *c.* 1320. The pronounced sway of the figure, the corkscrew curls and voluminous folds over the feet are characteristic of the florid style encouraged by the deep-bedded magnesian limestone from Tadcaster, as we shall see when we come to deal with the effigies of this period. There seems to be more affinity to German sculpture at York than at Westminster, where French suggestions seem favoured, though both schools retain their own individuality. The rather narrow sloping shoulders of this type are repeated in some headless

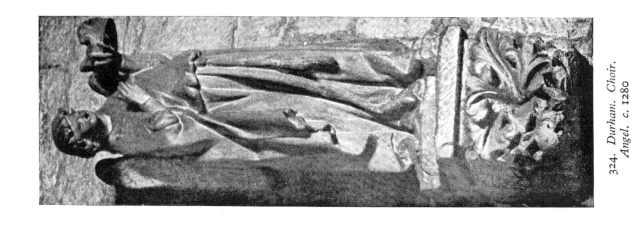

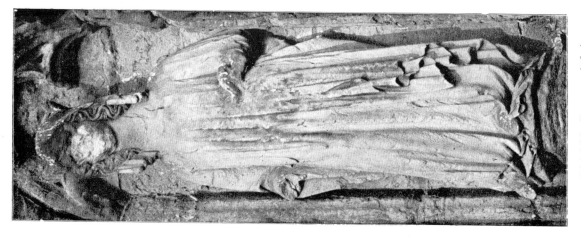

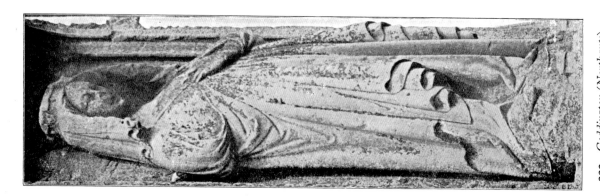

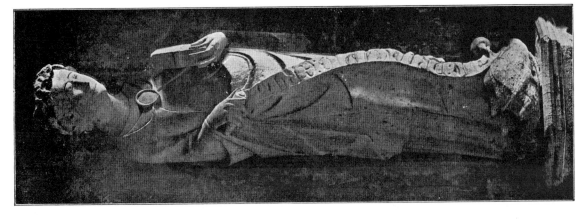

327. *Howden (Yorks). Figure*

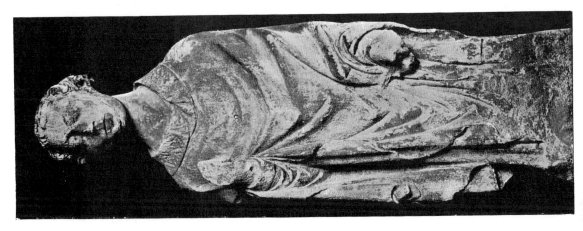

326. *Howden (Yorks). Figure*

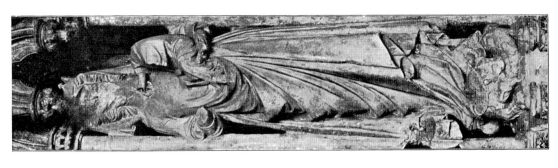

325. *York. Chapter-house.*
Madonna. c. 1320

171

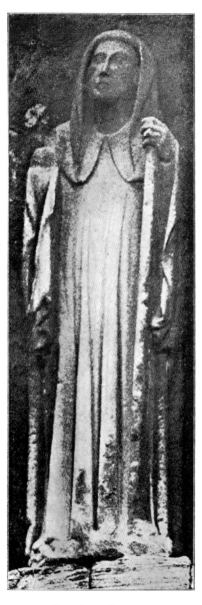

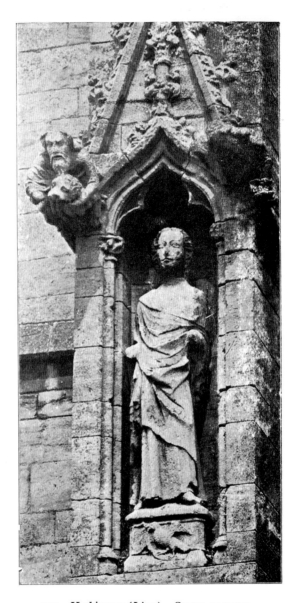

328. *Peterborough. Gateway.*
Prior. c. 1290

329. *Heckington (Lincs). Statue on tower.*
c. 1320

statues now in the Minster Library at York and in the collection of much-worn figures at Howden (Figs. 326, 327), though these last are more restrained and form a half-way house towards the statues of the eastern midlands. A priest and a St John holding a long scroll are among the best preserved, and a Synagogue, a St Peter and a St Paul have the swaying attitude referred to above.

The range of hills stretching across Northamptonshire, Rutland and Lincolnshire provides excellent building stone, of which the coarse oolite of Barnack and the finer variety quarried at Ancaster were most famous. This region has a fine series of churches,

172

330. *Boston (Lincs). Nave
buttress. Madonna*

331. *Swynnerton (Staffs). Christ*

which frequently make use of figure work. Some statues on the Abbot's gate-house at
Peterborough, of which we show the Prior (Fig. 328), may serve to start the series as they
date from the last years of the thirteenth century. The high shoulders, raised arms and
straight folds distinguish them from the swaying figures and billowy draperies of York.
The figure of St John in a richly decorated niche on the tower at Heckington church
(Fig. 329) is a good example of a few years later, *c.* 1320. This is still mason's work,
probably done by the same man who carved the foliage of the ogee-headed canopy and
the fine gargoyles on either side. A number of external statues survive in this district,
such as the Madonna on a bracket on the north side of the nave at Boston (Fig. 330), or

173

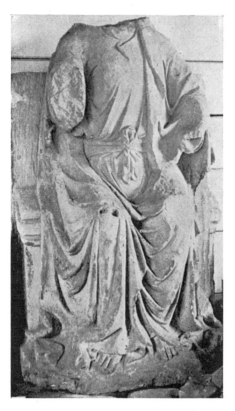

332. *Rievaulx Abbey. Christ* 333. *Fountains Abbey. Fragment*

the big seated figure of Christ at Swynnerton, Staffs (Fig. 331), which must have come from an exterior niche, probably in the gable of some important building. This last is some eight or nine feet high, and it is suggested that it may have come from Lichfield, though there seems to be no record of how it got to its present location. The long body is evidently meant to correct the perspective as seen from below, and the hair treatment is what we have noted elsewhere at this period.

A number of statues of varying quality may be found in positions high up on these churches. They are mostly weather-worn, but naturally lack the finish of the porch statues of Lincoln. They are well suited to their position and often pleasing in effect, but as a rule fall a little short of the dignity of those of the preceding generation.

A small seated figure of Christ, unfortunately headless, has been dug up in the ruins of Rievaulx Abbey (Fig. 332). It is of fine workmanship and apparently dates from the end of the thirteenth century. It has the knotted girdle of the Lincoln and Crowland statues. A somewhat similar fragment from Fountains may be set beside it (Fig. 333).

Mention should also be made of two statues, a king and a bishop standing in the forecourt of Bovey House near Beer in Devonshire. The late P. M. Johnston, F.S.A., who called the attention of the writer to them, dated them *c.* 1270, and suggested that they may have come from the façade of Ford Abbey, not many miles off. They are in an oolite stone about five feet high, and deserve a worthier use than as garden ornaments (Figs. 334, 335).

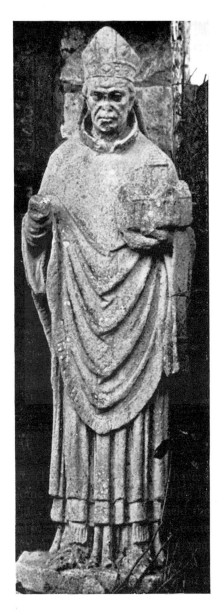

334. *Bovey House (Devon). King* 335. *Bovey House (Devon). Bishop*

But it is in the internal fittings, screens and tombs that we find the most characteristic works of the fourteenth century. The great church-building era was drawing to a close, and the imagers were called upon to supply figure-work for the internal fittings. In these we find a delicacy and fancy and technical skill on a higher level than ever, though the smaller scale leads to a less monumental treatment. A transitional figure of St Christopher at Terrington St Clement (Fig. 349) seems too delicately wrought for an external position; the smooth draperies and general treatment point to a date in the second half of the fourteenth century.

In this line the masterpiece of the York imagers was the tomb erected at Beverley for

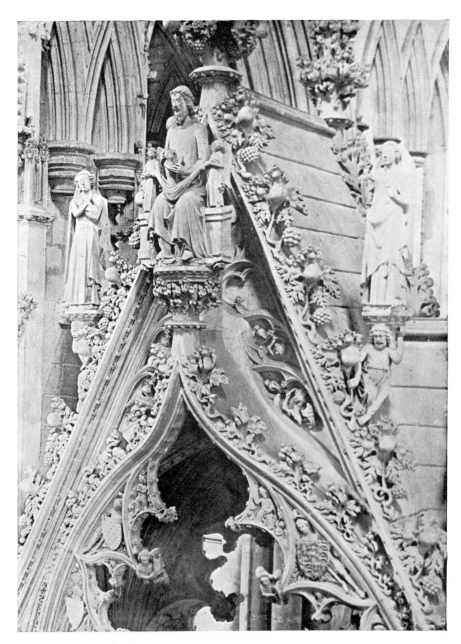

336. *Beverley (Yorks). Canopy of Percy tomb. c. 1330–50*

Lady Eleanor Percy, who died in 1328 (Fig. 336). Some doubt has been felt as to the identification, as one of the shields carved on it bears the arms of England quartered with those of France (Fig. 337) which was not adopted by Edward III before 1339, but such an elaborate monument may easily have taken several years to complete. There is no effigy: possibly this was a brass, but the slab at the bottom may have been tampered with. The wonderful canopy wrought in the magnesian limestone from Tadcaster is almost perfect. At the top is a statue of Christ seated receiving in a napkin the soul of the deceased, and

176

337. *Beverley. Detail of Percy tomb*

338. *Beverley. Percy tomb. Lion and dragon*

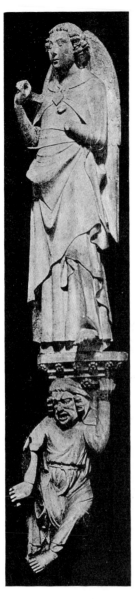

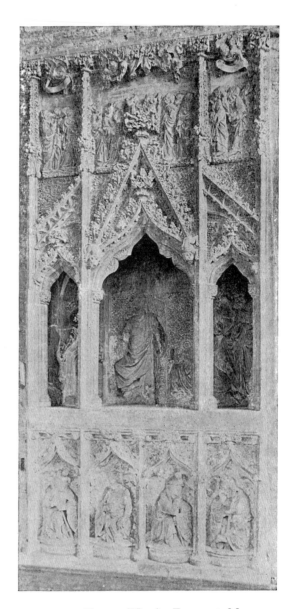

339. *Beverley. Percy tomb. Angel*

340. *Hawton (Notts). Easter sepulchre*

large statues of angels on either side are supported by brackets composed of grotesque figures (Fig. 339). The cusps of the ogee arch are occupied by knights and a lady holding shields carved with heraldic devices, and other spaces are occupied by little figures, angels and heads. A corbel below has a most spirited combat between a lion and dragon, which combines the vigour of such an old Romanesque carving as that in the York museum (Fig. 158) with the refined skill of a later age (Fig. 338). In the large statues we recognise the sloping shoulders, billowy drapery and side curls of the York school, and though the monumental conception of the previous generation is not quite reached we can forgive the

178

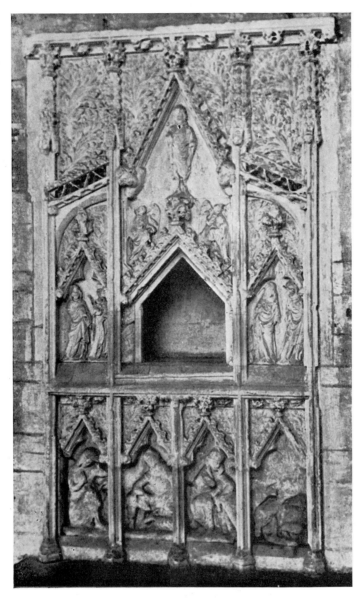

341. *Heckington (Lincs). Easter sepulchre*

slight loss of dignity when we contemplate the exquisite finish and masterly handling of every detail.[1]

Corresponding work of the Ancaster school may be found in the Easter sepulchres in which the Host was reserved from Good Friday till Easter Day. Usually these were temporary erections, but in Lincolnshire and the neighbouring district they were permanent stone erections, and in such churches as Heckington and Hawton their elaborate carving corresponding to that of the sedilia on the opposite side gave a very sumptuous appearance

[1] The back of the screen at Southwell has more delicate work of this type. The fragments of St William's shrine in the York museum are other examples of the northern imagers' work of this period.

342. *Lincoln. Easter sepulchre*

343. *Northwold (Norfolk). Easter sepulchre*

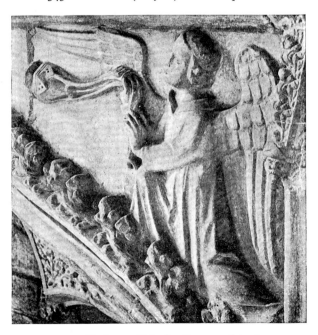

344. *Gosberton (Lincs). Canopy of tomb*

345. *Mattersey (Notts). St Martin*

346. *Norwich. Cloister door. Christ and figures. c.* 1300

181

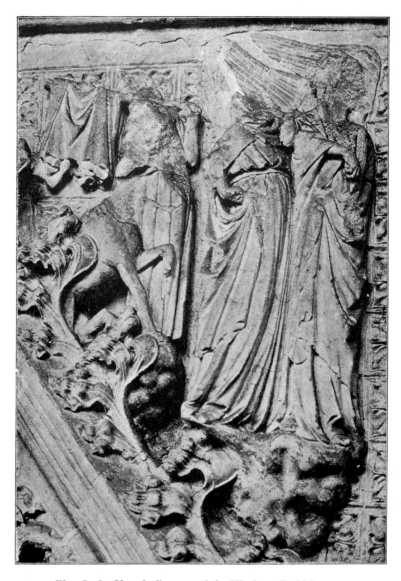

347. *Ely. Lady Chapel. Journey of the Virgin to Bethlehem. c.* 1340

to the chancel (Figs. 340, 341). In the centre there is a relief of the Resurrection of Our Lord, and the sleeping soldiers are carved at the bottom of the monument, and there is a striking group of the Ascension at the top. The whole effect tends to be over-elaborate and crowded with a consequent loss of dignity. The Easter sepulchre in Lincoln Cathedral is a little earlier, *c.* 1300, and the sleeping soldiers must have been very fine before mutilation (Fig. 342).[1] A tomb at Gosberton has some very pleasing angels swinging

[1] Other sculptured Easter sepulchres remain at Navenby, Northwold (Fig. 343) and Fledborough, and a less dignified one at Patrington in Yorkshire. Sometimes the founder's tomb occupying a niche on the north side of the chancel appears to have been used for this purpose. A curious fragment of one with stiff figures of the three Mary's remains at East Kirkby. The elaborate example at Irnham probably served also as a founder's tomb; its rich decoration is entirely of foliage apart from some small heads.

182

348. *St Albans. End of shrine base. Martyrdom of the saint*

censers over its canopy (Fig. 344), which also come from the same workshops, as also did slabs at Mattersey representing the Invention of the Cross and a St Martin dividing his cloak (Fig. 345), which must have formed part of an altar piece.

The cloister door at Norwich has niches carved round its head containing figures of early fourteenth-century date, which have many of the characteristics of those we have been examining (Fig. 346). Our illustration shows Christ at the top, a charming angel, a pope (who is supposed to be Aaron corresponding to Moses on the other side) and John the Baptist in his robe of camel's hair.[1] The most ambitious monument of the first half of the fourteenth century in the eastern counties is the Lady Chapel at Ely, begun in 1321 and finished in 1349. It is surrounded by an arcade of marvellous intricacy, with statuettes standing or sitting under the projecting ogee canopies, and the spandrels filled with reliefs illustrating the life and miracles of the Virgin.[2] These must have originally numbered over a hundred, but many have been cut away and all so badly mutilated that hardly a head remains. The work is in a chalk-stone (clunch) which is easy to work and tempts the carver to over elaboration of detail. There are exaggerations of gesture, and certain features like hands are sometimes too large in the desire to make the story dramatic, but the whole effect when new and gleaming with colour and gold must have been overwhelming (Fig. 347).

Coming south we have in the base of the shrine at St Albans a last *tour de force* on the part of the Purbeck marblers, who after this seem to have abandoned the attempt to compete

[1] These have now been coloured under Prof. Tristram's direction.
[2] These have been elucidated as far as their condition allows by Dr M. R. James, *The Sculptures in the Lady Chapel at Ely*, 1895.

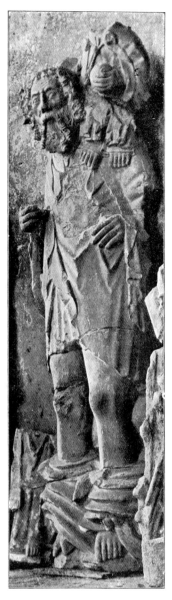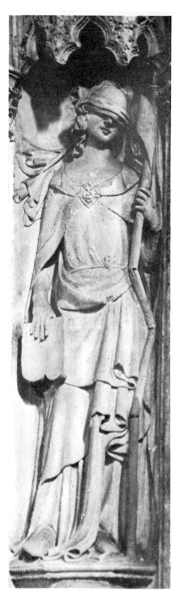

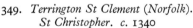
349. *Terrington St Clement (Norfolk).* 350. *Rochester. Chapter doorway.*
St Christopher. c. 1340 '*The Synagogue.' c.* 1330

with workers in less obstinate materials in figure-work. It was discovered in 1872 in more than 2000 fragments, and was carefully pieced together like a jig-saw puzzle. The spandrels are occupied by seated kings and censing angels, and at the east end in the gable is the martyrdom of the saint (Fig. 348). This last is awkwardly crowded into the space, but the bigger figures are graceful, and the naturalistic foliage of the first decade of the century is deeply undercut and must have required extraordinary skill to execute.

Perhaps the most accomplished work of the southern imagers is to be found in the chapter doorway at Rochester. There are statues of the Church and Synagogue on either side, the latter with bandaged eyes, broken staff and the Tables of the Law falling from

184

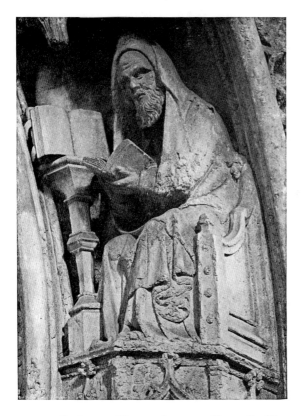

351. *Rochester. Chapter doorway. Evangelist (?)* 352. *Winchester. Headless figure*

her hand (Fig. 350). The Church has a new head which replaces an absurd male head affixed in a previous restoration. The smooth thin draperies with overlapping folds are typical of the new manner which had come in with the second quarter of the century. Finer still, and less touched up, are four seated figures of Doctors of the Church (or Evangelists?) occupying broad niches in the mouldings of the door-head. Their furrowed faces, deep-set eyes, and whole pose as they sit in front of their reading desks, are those of an individual pictorial expression, such as an image-maker, as opposed to a building mason, would cultivate (Fig. 351). Work of the same school, if not of the same hand, may be seen in the exquisite little groups of monks at their meals (Fig. 353) and at their desks in the trefoils of the canopy over Archbishop Meopham's tomb (d. 1333). They have the same bold head-features and broad smooth draperies with twisted folds at the edges, which we found at Rochester.

There are some broken figures and one or two fine heads (Fig. 354) from a destroyed screen or altar piece at Cobham, Kent, which are good examples of what was being produced by the imagers of this period. At Winchester, there are some headless statues, three or four feet high, from a screen or reredos which are excellent examples of the new style of drapery (Fig. 352), with silky overlappings and composed of a thin almost transparent material showing something of the figure and limbs beneath. The swaying pose is a little theatrical and shows a tendency to the picturesque which is characteristic of the first half of the fourteenth century. Winchester also possesses the upper part of a statue of the

185

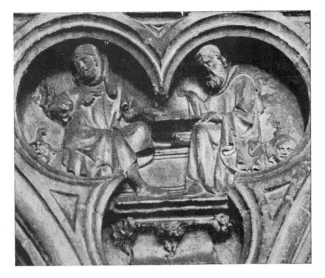

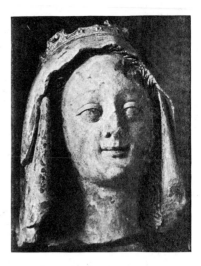

353. *Canterbury. Canopy of Archbishop*
Meopham's tomb. d. 1333

354. *Cobham (Kent). Head.*
c. 1320

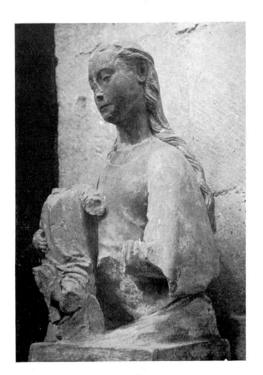

355. *Winchester. Madonna. c.* 1340

356. *Hawton (Notts). Head*

186

357. *Westminster. Canopy of Edmund Crouchback's tomb. d.* 1296

358. *Westminster. Canopy of Aymer de Valence's tomb. d.* 1323

Madonna which was probably an altar image (Fig. 355). It has very smooth draperies and a charming expression, helped out by considerable remains of colour.

A head from the chancel at Hawton is typical of fourteenth-century style; if not actually imager's work it comes from the hands of men who were turning their attention from architectural masoncraft to the interior furnishings of the churches (Fig. 356).

For the Westminster style we must turn to the magnificent tombs in the sanctuary of the Abbey. The statues which formerly crowned the canopies have gone, but the trefoils at the head of the arch have carvings of the deceased princes on horseback, which resemble the figures on the fine seals of the period (Figs. 357, 358). The three tombs in question are those of Edmund Crouchback, Earl of Lancaster, d. 1296; of Aveline his wife, d. *c.* 1273; and, between them, of Aymer de Valence, Earl of Pembroke, d. 1323. In the little trefoils it is interesting to compare the quiet stately figure of 1296 with the galloping, flashy but less satisfying horseman of thirty years later. The weepers, too, as the little figures of relatives or mourners ranged along the tomb-chest are called, also show a decline in art from the stately little figures in the drapery of the Eleanor Crosses on Crouchback's tomb (Figs. 359, 361) to the tighter dresses and smoother and more monotonous folds of those on Aymer's monument (Fig. 360). It is interesting to compare these with the weepers of Prince John of Eltham's tomb, also in the Abbey, d. 1334, which mark a further step in

187

359. *Westminster. Weepers from E. Crouchback's tomb*

360. *Westminster. Weepers from A. de Valence's tomb*

188

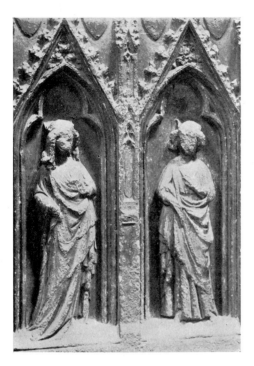

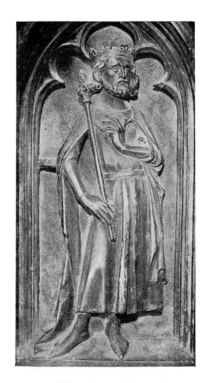

361. *Westminster. Weepers from*
E. Crouchback's tomb

362. *Westminster. Weeper from*
Prince John of Eltham's tomb

363. *Heckington (Lincs). Gargoyles of chancel. c.* 1330

189

364. *Over (Cambs). Gargoyle of porch* 365. *Over. Gargoyle of nave*

366. *Ely. Gargoyles of choir*

the direction of theatrical exaggeration and picturesque poses (Fig. 362). These are in alabaster, cut out and set against a background of dark stone or marble, and the introduction of this new material leads us on to the new movement which plays such an important part in the story of the last Gothic period, to which we shall return in a subsequent chapter.

Churches in the district supplied by the Ancaster and neighbouring quarries were decorated with a profusion of carving of figures as well as foliage. Heckington church, a building of quite modest size, had besides its Easter sepulchre and sedilia, and besides

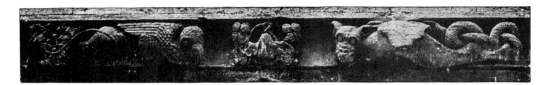

367. *Adderbury (Oxon). Cornice of nave. c. 1340*

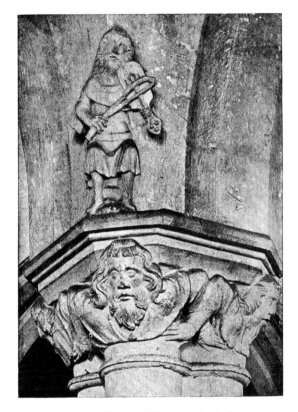

368. *Hanwell (Oxon). Capital*

369. *Westbere (Kent). Corbel*

31 niches for statues, no less than 80 separate carvings of heads and figures on corbels inside and out, and as many as 198 gargoyles (Fig. 363), many of them of large size. In these the mason was able to give free play to his fancy, and towers and parapets all over the country bear witness to the way he took advantage of his opportunity, though the exposed position has often led to decay and, what is worse, to restoration. Good examples of mid-century date may be found on the nave and fine south porch at Over, near Cambridge (Figs. 364, 365). The choir at Ely possesses some rather earlier examples (Fig. 366). These continued to be popular to the end of the Gothic era, and examples are so numerous that a book could be devoted to them alone, but these few must suffice in a general work like the present.

A group of churches in Oxfordshire and neighbouring districts developed a special style of their own, with long cornices under the eaves carved with heads, animals, hunting scenes and monsters. Those at Adderbury (Fig. 367), Stannion, Hanwell, Alkerton and Olney may

191

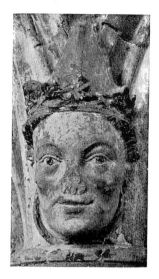

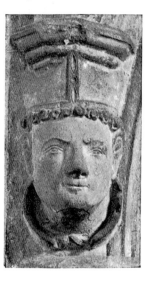

370. *Wells. Chapter-house.*
Corbel. c. 1310

371. *Exeter. Corbel.*
c. 1290

372. *Winchelsea (Sussex).*
Corbel. c. 1300

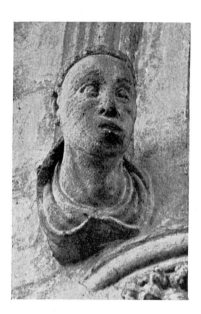

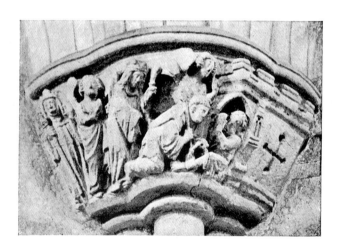

373. *Ely. Octagon. Alan of*
Walsingham

374. *Ely. Octagon. Legend of St Etheldreda*

be mentioned.[1] In these, too, capitals are formed of crouching human or grotesque figures, which take the place of foliage, as at Hanwell (Fig. 368).

The use of heads as stops and corbels continues, and we have an astonishing variety of expression and liveliness. Examples may be taken from Wells chapter-house, where colour

[1] Rather less striking examples can be found at East Hagbourne, Ambrosden, North Moreton and Teddington.

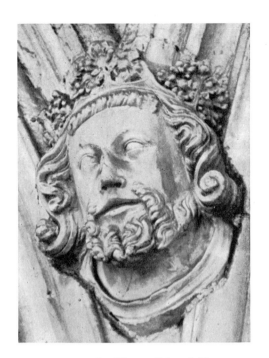

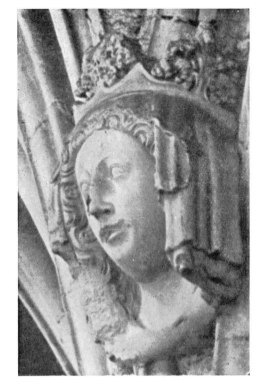

375. *St Albans. Edward II*

376. *St Albans. Queen Isabella*

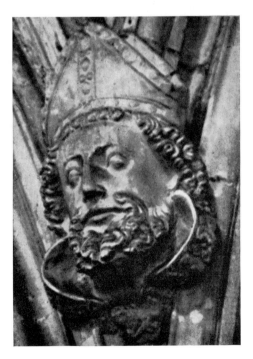

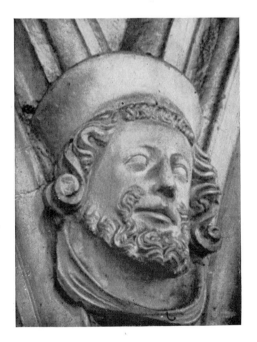

377. *St Albans. Abbot Hugh*

378. *St Albans. Master (mason) Geoffrey*

193

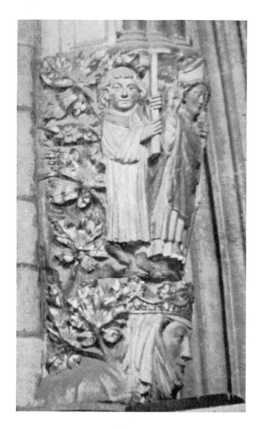

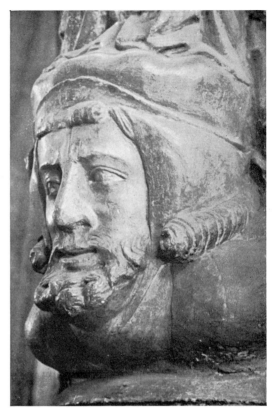

379. *Exeter. Corbel* 380. *Exeter. Corbel. Master mason*

adds life to the smile on the face of the pope (Fig. 370), Exeter (Fig. 371), Winchelsea, where the elaborate corkscrew side-curls of the period are well represented (Fig. 372), and Ely, where king, queen, bishop, prior, mason and sacrist—the latter usually identified as Alan of Walsingham, the sacrist who is given the credit for designing the famous octagon[1]— are placed as a kind of signature to their work on the building (Fig. 373). The fashion set in the octagon at Ely of commemorating those connected with the building by a series of head-stops is followed elsewhere. Thus in the bays of the nave of St Albans, built *c.* 1330, are four heads which seem to represent Edward II, Queen Isabella, Abbot Hugh de Eversden and Master (mason) Geoffrey (Figs. 375–378). At Exeter, too, the four corbels at the crossing rest on heads of larger size than any of the rest. As these represent a king, queen, pope and a fine example in what looks like a mason's cap, we have here another example of this pictorial signature and dating (Figs. 379, 380). Round the octagon at Ely are a series of corbels carved with incidents from the life of St Etheldreda (Fig. 374). Though skilfully carved and full of charm, when regarded individually in detail they are not sufficiently bold to be really effective in their position on the building. Corbels composed of grotesque figures mask the junction of arches, or conduct the vaulting shafts down to the capitals, as at Exeter. In the latter cathedral it is interesting to compare those of the choir of *c.* 1290 (Fig. 381), and their bold and effective relief and naturalistic foliage, with those of the nave

[1] The actual design must be credited to William Hurley, carpenter, assisted by John Attegreene, mason.

194

381. *Exeter. Corbel of choir. c.* 1290 382. *Exeter. Corbel of nave. c.* 1330

of some 40 years later (Fig. 382) in which the proportions are more correct, but the cutting shallower and the whole effect colder and more confused.

In smaller churches corbels formed of crouching figures are often very effective, as in the example we show from Westbere, near Canterbury (Fig. 369).

Vaulting bosses assume more importance as the vaults grow more complicated. This again is a specially English development, as our comparatively low vaults with numerous extra ribs, and especially the lierne vaults of the middle of the century, gave far more opportunity for the display of sculpture to cover the junctions and crossing places of the ribs than the lofty French vaults which were so high that any elaboration of this kind would have been ineffective from the floor. There are some fine bosses of the end of the thirteenth century in the high vault of the choir at Exeter, which have the grace usually associated with sculpture of this date (Fig. 383). It is estimated that there are some 570 bosses in the vaults of Exeter Cathedral,[1] ranging from six inches in diameter up to nearly three feet for the great bosses of the ridge rib. The finest are those of the east end, *c.* 1300, while those of the nave of some forty or fifty years later show the same decline in artistic quality which we saw in the corbels in the same parts of the cathedral, though they are

[1] *Bosses and Corbels of Exeter Cathedral*, by E. K. Prideaux and G. R. Holt Shafto, 1910.

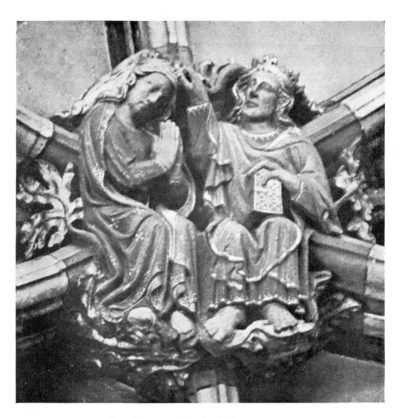

383. *Exeter. Boss in choir. c.* 1390

still well designed and effective as seen from below. There is a large and important one of the martyrdom of St Thomas of Canterbury at the west end of the nave (Fig. 385), and a very pleasing one of a kneeling canon holding a scroll (Fig. 384). Some good bosses of thirteenth-century date from the ruined choir at Abbey Dore are preserved in the remaining eastern chapels, and carry on the tradition we described at Lincoln and Chester (Fig. 389).

As we reach the middle of the century the bosses of the high vaults tend to become coarser and rougher in execution, as it was realised that fine work could not be appreciated from the ground. Those at Tewkesbury, for instance, where they illustrate the Nativity (Fig. 386) and Passion scenes with angels playing musical instruments in the less important positions, are effective but lacking in refinement when looked at with a magnifying glass, though this may partly be due to the thick coat of modern painting and gilding.[1]

It is, then, in the cloisters that we can look for the finest bosses of this period, as they are not too highly placed to be seen, and were therefore much more delicately wrought. There are some beautiful wooden examples, *c.* 1290, in the cloister at Lincoln, of which we show a bishop, possibly St Hugh (Fig. 387), carved in the best style of the day. The

[1] These have been minutely described and illustrated in 'Roof bosses in the nave of Tewkesbury Abbey', by C. J. P. Cave, in *Archaeologia*, LXXIX, 1929. Mr Cave has devised a remarkable combination of telephoto lens and a spot light, which has enabled him to produce a wonderful collection of photographs of bosses, etc., situated in positions where they can hardly be appreciated by the naked eye. He has published the later bosses at Norwich in *Archaeologia*, LXXXIII, 1933, and his magnificent volume *Roof Bosses in Medieval Churches* is a revelation of hidden beauties and fascinating sculpture hitherto almost unknown and out of reach to the casual observer from the ground.

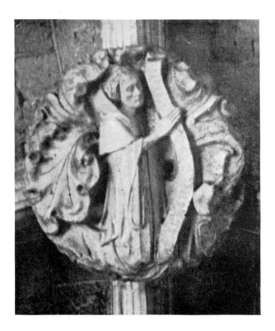

384. *Exeter. Boss in nave. c. 1350*

385. *Exeter. Boss in nave. Martyrdom of St Thomas of Canterbury. c. 1350*

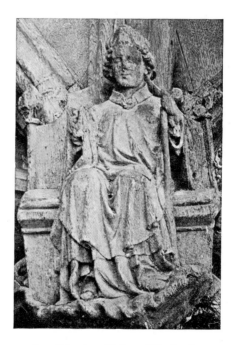

386. *Tewkesbury (Glos). Boss in nave. The Nativity. c. 1350*

387. *Lincoln. Cloister. Wooden boss. c. 1290*

388. *Norwich. East cloister. Crucifixion*

389. *Abbey Dore (Herefords). Boss*

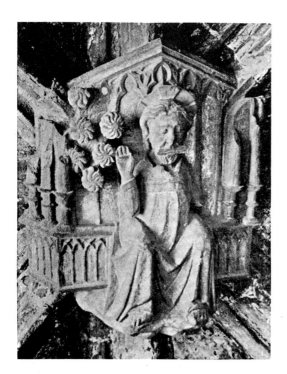

390. *Norwich. Cloister, south walk.*
The Son of Man. c. 1340

391. *Norwich. Cloister, south walk.*
The second angel. c. 1340

cloisters at Norwich afford a particularly useful series as the work was spread over 130 years, and three successive periods can be studied side by side. The east walk was built *c.* 1300, and such bosses as that of the Crucifixion (Fig. 388) have the charm of all the lesser works of the time, the graceful swaying attitudes and naturalistic foliage, and are quite in the tradition of the doorway already illustrated (see Fig. 346). The south walk followed about forty years later and illustrates the Apocalypse in a series of fine and dramatic scenes. The two examples given here are taken from Rev. i. 11–16 in which the Son of Man appears on his throne with the seven golden candlesticks, the seven stars in his right hand, and a two-edged sword proceeding out of his mouth (Fig. 390); and from Rev. viii. 8–9, 'the second angel sounded, and as it were a great mountain burning with fire was cast into the sea...and the third part of the ships were destroyed' (Fig. 391). These are excellent examples of the simple and direct way in which a medieval carver tackled a subject which would have daunted any classical or modern artist, but by so doing he produces a graphic work of art, with the tremendous angel trumpeting above and all confusion below. Even here, however, some of the less successful bosses in their anecdotal and crowded compositions begin to pave the way to the more standardised uniformity of the fifteenth-century bosses of the west and north walks, the treatment of which must be postponed to a later chapter.[1]

(2) MONUMENTAL EFFIGIES

We have already had occasion to speak of the growing importance of funeral sculpture in dealing with the canopies and weepers of the tomb chests in such magnificent erections as the royal tombs at Westminster. It is now time to turn to the effigies[2] themselves.

It has been pointed out that the increasing use of painting sounded the death-knell of the Purbeck effigy, as it was found that softer and more easily worked stone, or even wood, produced very much the same effect when coated with paint, and details worked up in gesso, a kind of gummy plaster. For the next seventy or eighty years, therefore, from 1280 or 1290 to about 1360 the standard type of effigy is in freestone, until the lead is taken by the alabaster trade, which must be dealt with in our final chapter.

As in the building sculpture the quality of the stone available in the various districts will be found to be the determining factor of style, and though outside influences affect different centres in other ways, the material set before the tomb-maker must prove the basis of classification. Such classification must necessarily be vague with considerable overlapping of boundaries, and, as an effigy was a portable commodity, important tombs in the provinces may sometimes have been ordered from London or other leading centres, just as the Purbeck tombs had come from the quarries at Corfe. Still, allowing for these reservations, certain main schools, *c.* 1300 to *c.* 1360, may be distinguished, of which the south-western, northern, midland and London types are most important.

(a) The South-western Schools

As already seen, the Wells and Bristol effigies of the thirteenth century had formed a class by themselves which resisted to some extent the all-pervading influence of the Purbeck marblers. The fine oolite available allowed of delicate detail, but was not always very deep

[1] The Norwich bosses have in recent years (1935–6) been cleaned and recoloured under the advice of Professor Tristram.

[2] In this book the term 'effigy' is reserved for the recumbent figure on a tomb, the upright standing figure being referred to as a 'statue'.

199

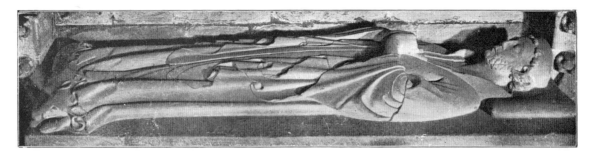

392. *Hereford. Chancellor Swinfield. c.* 1290

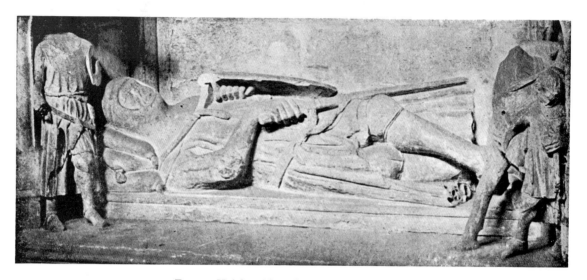

393. *Exeter. Knight with squire, page and horse. c.* 1320

in bed, and there is therefore a tendency to keep the effigies fairly flat. The effigy of Chancellor Swinfield, *c.* 1290, at Hereford may be taken as a typical example (Fig. 392). The depressed chin, small features, hands and other projecting features kept low, and the draperies neatly laid in silky overlapping folds are characteristic, and appear in such figures as those attributed to Bishop Droxford, *c.* 1329, and Dean Myddleton, *c.* 1337, at Wells; Dean Aquablanca, *c.* 1320, at Hereford, etc.

Exeter, where a soft sandstone, or a big chalk-stone from Beer, was in use, produced figures of a much bolder and less refined type, like the knight with squire standing at his head and page and horse at his feet, in the cathedral (Fig. 393). He lies slightly on one side, shield on arm, with legs crossed and drawing his sword from the scabbard—a lively representation far removed from the original idea of a laid-out corpse. Less truculent attitudes are assumed by the knight and lady at Beer Ferrers (Fig. 394), and by the knights of the Berkeley family at Bristol, who clasp their hands in prayer (Fig. 395), in all of which London influence may be suspected.

In all these knights the mail and surcoat of the crusading period are retained, with a round steel cap usually worn over the mail coif. As we approach the middle of the century, the steel cap tends to become pointed and approaches in shape the bascinet of

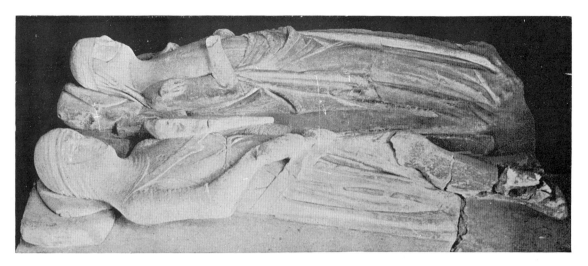

394. *Beer Ferrers (Devon). Knight and lady. c.* 1300

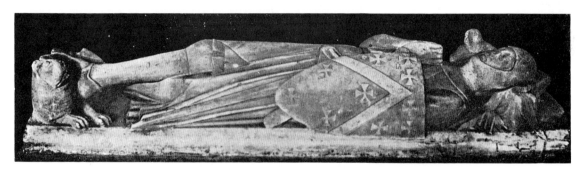

395. *Bristol. Knight of Berkeley family. c.* 1300

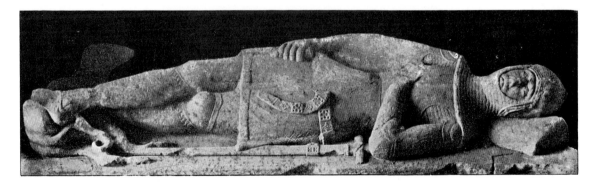

396. *Abergavenny (Mon). Lawrence de Hastings (freestone). c.* 1340

201

the French wars of the second half of the century. From about 1320 to 1340 the surcoat was often cut short in front, but left longer behind, in which form it has, though incorrectly, been called the 'cyclas'. This is eventually replaced by the tight-fitting 'jupon' reaching only to the hips, which is the characteristic feature of the Edwardian period. Towards 1340 or 1350 there is also a tendency to vary attitudes: thus at Abergavenny one knight has his legs straight instead of crossed and another called Lawrence de Hastings (Fig. 396) lies on one side in a graceful attitude with one hand on his breast as if asleep.

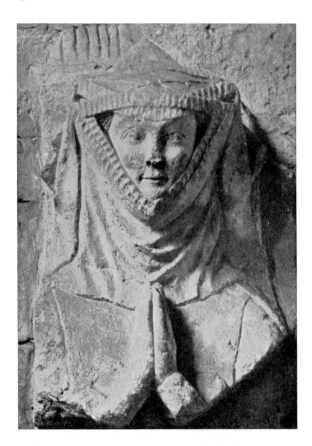

397. Bradford-on-Avon (Wilts). Lady with wimple. c. 1300

Ladies, *c.* 1300, usually wear the wimple frequently with a straight band across the forehead with a veil over it, as at Bradford-on-Avon (Fig. 397). Later, a round frilled cap begins to appear, though this hardly comes into fashion until the second half of the century.

(b) The Northern Schools

The big-blocked magnesian limestone from Tadcaster seems to have been the governing factor in the style of the York effigy makers, and the florid types evolved were copied as far as possible in the fine sandstones and other materials available in the North. We may take the knight and lady at Bedale (Fig. 398) as typical of their productions. In these the surcoat of the knight is voluminous and the lady's skirts fall about her feet in billowy convolutions. The knight is bare-headed with side curls, and the mail coif thrown back;

202

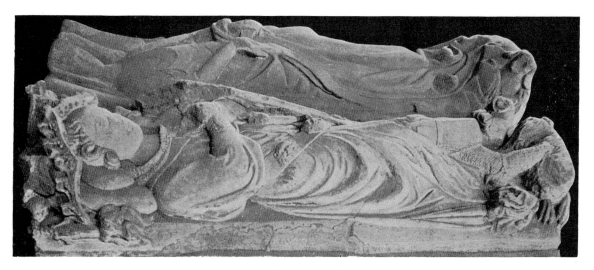

398. *Bedale (Yorks). Knight and lady. c.* 1300

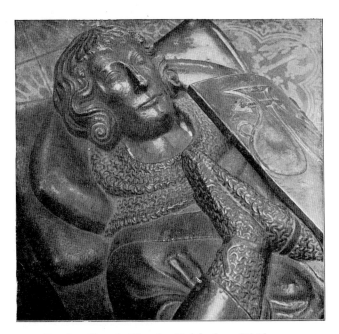

399. *London. Temple Church. Knight from Kirkham. c.* 1300

a depressed ogee canopy comes close over the head. The mail also is rendered in interlacing rings instead of in the parallel ridges usual in the South, and hands are folded in prayer. Sword-belts and other accessories are profusely ornamented, and the whole effect florid and bold as compared with the quiet, sober and refined work of the Bristol imagers. The effigies are laid flat on their backs with no sign of the half-sideway reclining posture seen in London and the South. The head and mail treatment can be well seen in an effigy in the Temple Church, London, said by Richardson, who restored[1] the Temple figures, to

[1] He reported the effigy in fairly good condition, but had to renew the nose, the right lock of hair, part of the shield, and some of the more exposed parts of the mail which were worn.

203

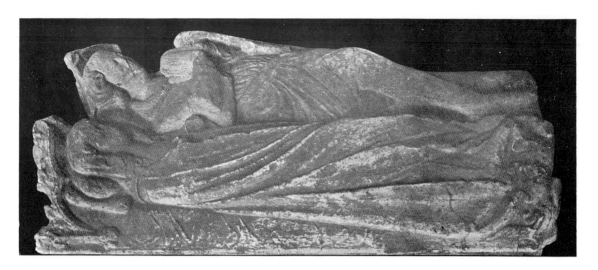

400. *Howden (Yorks). Knight and lady. c. 1320*

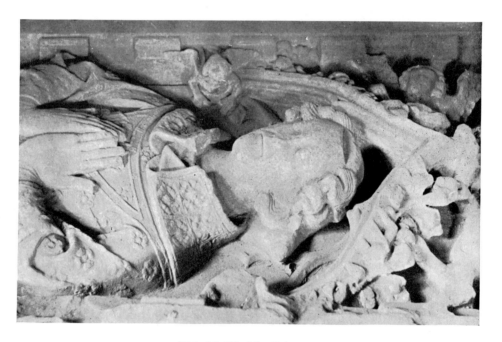

401. *Welwick (Yorks). Priest. c. 1310*

have been brought in about 1682 from Kirkham Abbey in Yorkshire (Fig. 399). Other very similar examples occur at Fountains and at Howden (Fig. 400). In the latter the lady beside her husband shows her legs crossed beneath her flowing gown—a very unusual attitude in a female figure.

A good example of a priest of the Yorkshire school is to be found at Welwick. He is bare-headed with curly hair and richly embroidered vestments, and over his head is an ogee canopy decorated with foliage and flying angels (Fig. 401).

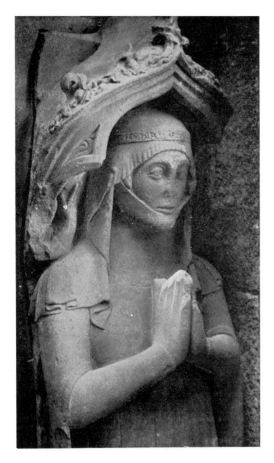

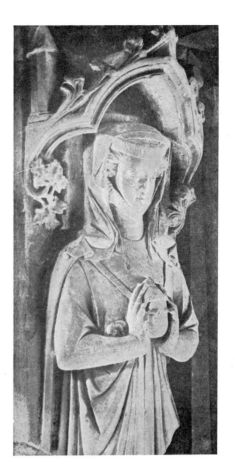

402. *Alnwick (Northumb). Lady.*
c. 1330

403. *Gonalston (Notts). Lady with*
reliquary. c. 1310

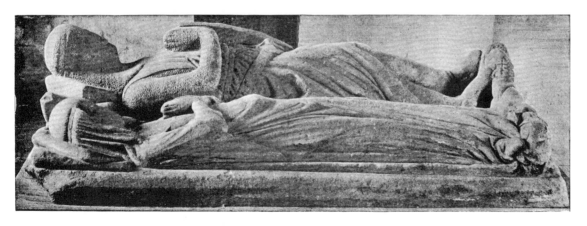

404. *Threckingham (Lincs). Effigy. c.* 1310

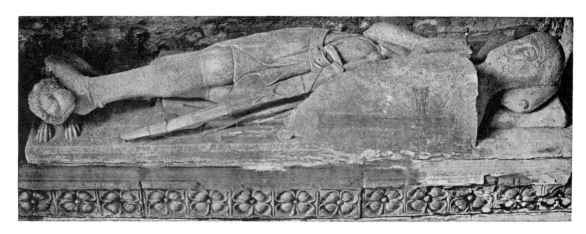

405. *Gosberton (Lincs). Effigy. c.* 1310

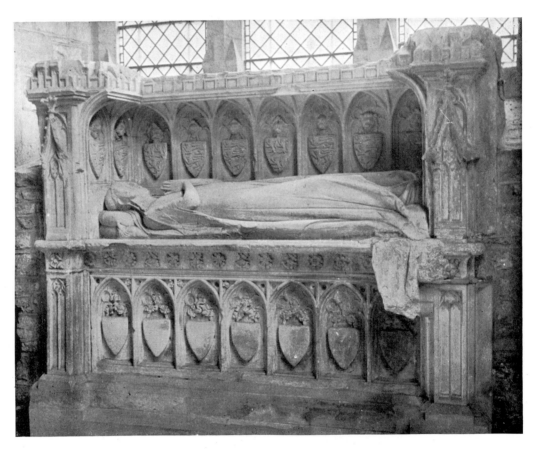

406. *Ledbury (Herefords). Lady*

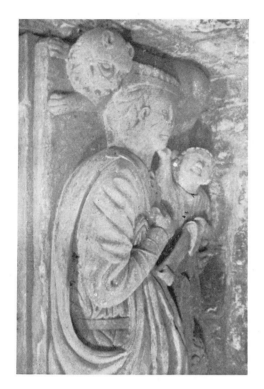

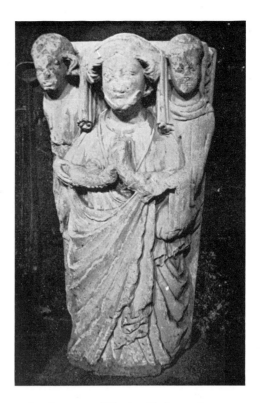

407. *Scarcliffe (Derby). Mother and child*

408. *Stevenage (Herts). Mother and two sons*

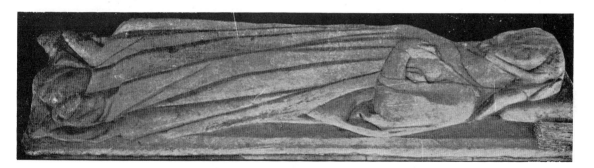

409. *Worcester. Sandstone effigy. Lady. c.* 1300

Further north a rather simpler type of lady was evolved with smoother draperies, but still under the depressed ogee canopy. There is an excellent example at Alnwick (Fig. 402) and a very similar figure at Staindrop. These ladies clasp hands in prayer and wear a wimple under the chin and a veil over the head, giving a triangular aperture for the face.

In the Ancaster district a more sober presentation usually prevails, influenced perhaps to some extent by London types. The hands are usually folded in prayer and the mail with interlacing rings is mostly favoured, but the mail coif usually covers the head, with or without a steel cap, and the billowy folds of drapery are less pronounced. Good examples occur at Threckingham and Gosberton (Figs. 404, 405). In the latter the smoother folds of the surcoat and graceful attitude seem to have come from the south, though the floral

diaper work along the plinth is reminiscent of Lincoln. At Gonalston, Notts, a very beautiful lady retains the canopy, though of loftier proportions than those of Yorkshire, and ornamented with stiff-leaf foliage on one side and naturalistic on the other (Fig. 403).

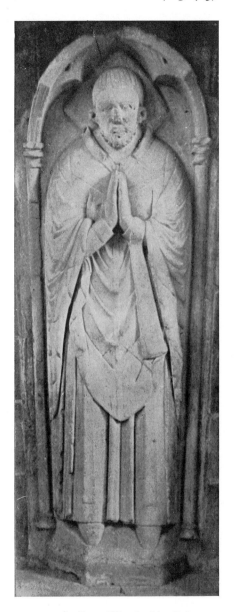

She is holding a small pot or reliquary in her clasped hands, and her draperies are more those of Madonna statues, apart from her head-dress of more fashionable type. They may derive from Purbeck models, such as the lady at Romsey (see Fig. 309). It is worth noting that at Ancaster itself some unfinished effigies with the main outlines merely roughed out are preserved in the church porch, showing that it was the practice, at any rate in some instances, to prepare these tomb figures on the actual site of the quarry, as had been done at Corfe before, and was afterwards done at Chellaston where the alabaster was found.

We find more variety of pose and design at this period than at any other, witness the lady at Ledbury with her train falling over the edge of the tomb-chest (Fig. 406), the lady at Scarcliffe holding her baby with her head resting on a lion (Fig. 407), or the lady at Stevenage with her two sons one on each side of her (Fig. 408).

(c) The Midland and London Schools

As we approach the capital city we find its influence spreading and affecting local productions, and as stone-carvers seem to have travelled fairly extensively and their wares were also portable it becomes more difficult to separate the work of the different districts. Round Lichfield, Coventry and Chester a rather coarse sandstone was the usual material, and as this did not allow of the incisive cutting of the Bristol oolite we find effigies bluntly rendered, and depending for their effect on the gesso finishing, which has in most cases perished. Our examples, therefore, like the Worcester lady in Fig. 409, look rough and uninteresting in their present condition, as we have to supply mentally the details which made them attractive.

410. *Ledbury (Herefords). Priest*

A priest at Ledbury (Fig. 410) may serve as a second example. He is set in a niche with shafts, and apart from the cushion under his head he really looks best set up on end against the wall, as he is at present, there being few concessions to the recumbent attitude.

In Northamptonshire types approach those of the Ancaster district or follow the Eleanor Cross tradition for the ladies, but most of the South country looked to London as the centre of fashion. Two of the later knights in the Temple were in Reigate stone, but follow closely

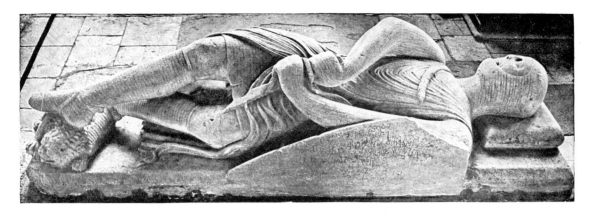

411. *Dorchester (Oxon). Freestone effigy. Knight. c.* 1310

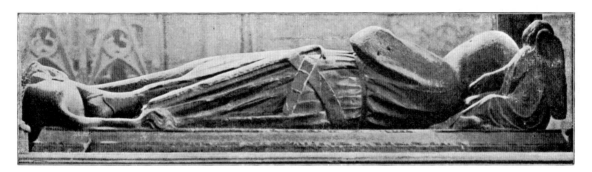

412. *Westminster. Edmund Crouchback, Earl of Lancaster. d.* 1396

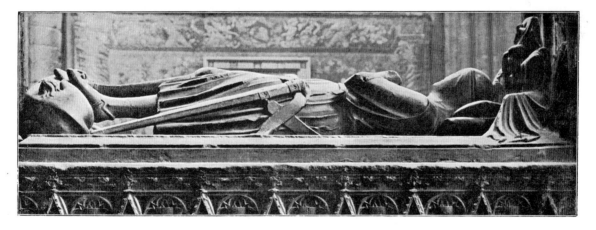

413. *Westminster. Aymer de Valence, Earl of Pembroke. d.* 1323

209

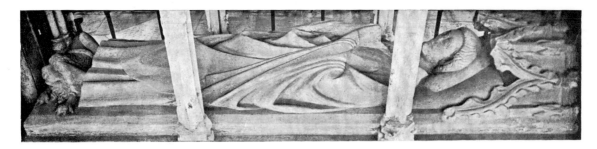

414. *Oxford. Prior Sutton. c.* 1320

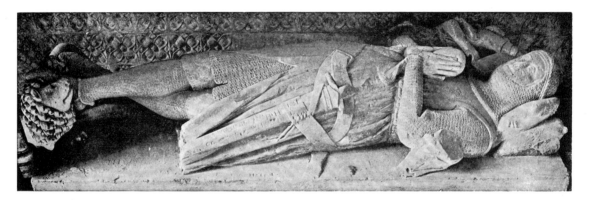

415. *Winchelsea (Sussex). First Alard Knight. c.* 1300

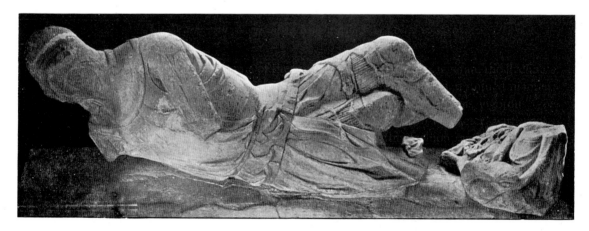

416. *Aldworth (Berks). Knight. c.* 1320

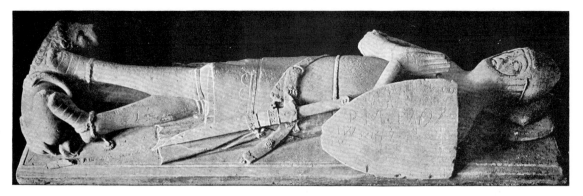

417. *Ifield (Sussex). Knight with crossed legs. c.* 1335

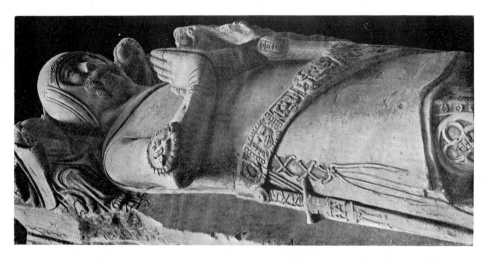

418. *Warkworth (Northants). Knight with sword belt. c.* 1350

on the Purbeck models, though some of these stone figures tend to exaggerate the liveliness of the later Purbeck knights, and are drawing their swords in a most determined manner. A knight at Dorchester, Oxon, may be taken as one representative of this vigorous type (Fig. 411), but there was also another type of a much more restful character, with hands clasped in prayer. The royal effigies at Westminster adopt this fashion, and those of the Earl of Lancaster (Crouchback), d. 1296 (Fig. 412), and Aymer de Valence, Earl of Pembroke, d. 1323 (Fig. 413), lie in a quiet restful attitude, turned slightly to one side, with little angels seated at their heads which are supported by double cushions. The mail is not carved in the stone and must have been added in the gesso finish.[1] The Countess of Lancaster's effigy has already been referred to for comparison with the Eleanor statues. Some boldly carved ecclesiastics, like Bishop Marcia at Wells, Bishop Leophard at Chichester and Prior Alexander de Sutton at Oxford (Fig. 414), do not fall in with the general sequence of the locally produced figures, and as the former two have the Westminster angels at the head

[1] The holes in the flattened arm of the Crouchback figure were for fixing a wooden shield. The same thing occurs in an effigy at Halstead, Essex, where a shield hanging up in the church has been found to fit exactly by pegs to the holes—I am indebted to the Vicar of Halstead for this information.

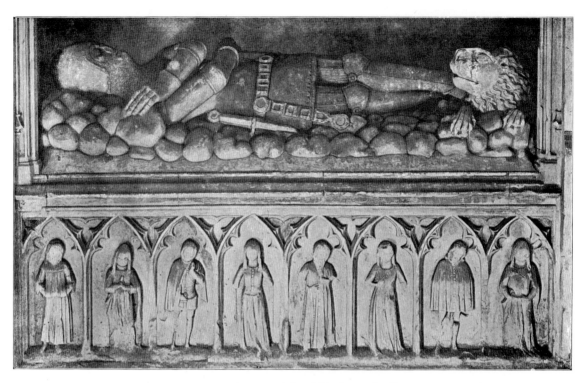

419. *Reepham (Norfolk). Knight of Kerdeston family. c.* 1350

they were probably direct importations from the capital. The same is probably the case with the fine Alard knight at Winchelsea (Fig. 415), lying under a gorgeous canopy in very much the Westminster pose, while a second knight in the same church seems a local copy of the model imported from London.

In all these military effigies we still have the mail and surcoat equipment, but as we approach 1350 a change begins to be felt, and there is also some attempt to give more variety of attitude, just as we found it in the west in the Abergavenny knights (see Fig. 396). At Aldworth, for instance, a knight of *c.* 1320, carved with great attention to detail, is resting on one arm as though wounded, almost in the attitude of the 'Dying Gaul' of Pergamene art (Fig. 416). At Ifield (Fig. 417), Waterperry and in South Kensington Museum, there are knights with clasped hands and crossed legs which begin to show the change in accoutrements towards those of the next period. These knights of *c.* 1330–40 wear the so-called cyclas, and the steel cap is becoming pointed—almost a bascinet. The upper part of the surcoat is very smooth, as though composed of a thicker material, like leather. This must certainly be the case in a knight at Warkworth (Fig. 418) carved in a fine-grained white stone which allows of elaborate detail, as in the rosettes and lion-heads of the sword-belt; the lacing up at the side of the leather coat which appears to be worn over the short fronted surcoat is clearly shown, and this coat is well on the way to the close-fitting jupon of the next period. The arms also appear to be protected by plate instead of mail, and roundels with lion-heads protected the elbow. This fine figure also has the Westminster angels supporting his head.

Several romantic effigies of the second quarter of the fourteenth century depart in some particulars from the stock models. Thus at Ingham and Reepham (Fig. 419) in Norfolk

212

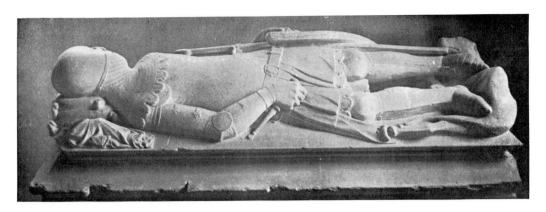

420. *Clehonger (Herefords). Knight. c.* 1350

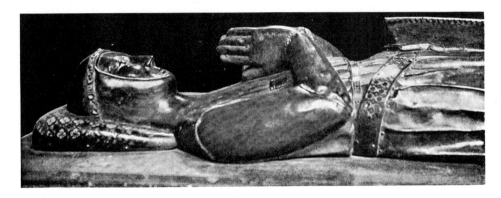

421. *Westminster. William de Valence, Earl of Pembroke. d.* 1296

knights are lying on a bed of stones, with large and formidable lions at their feet. In both of these the bascinet with 'camail', or curtain of mail, suspended from it to protect the neck, indicate a date not far short of 1350. The 'Shurland' knight at Minster in Sheppey is another good example of the romantic attitude, while another knight at Clehonger in Herefordshire is also a good example of the type (Fig. 420).

Besides the freestone effigies we have figures in bronze, wood, and at the end of the period in alabaster. Although the first alabasters strictly belong to this chapter, it will be convenient to treat them all together in a later section.

One of the earliest of our metal effigies is that of William de Valence, d. 1296, half-brother of Henry III, in Westminster Abbey (Fig. 421). This was produced by affixing bronze plates to a wooden core, and adding the heraldry and ornaments in Limoges enamel. The effigy of Blanche de Champagne in the Louvre[1] is produced in exactly the same way, and we must therefore regard our tomb as a direct importation from Limoges.

The two magnificent bronze, or laton, effigies of Queen Eleanor (Fig. 422) and Henry III (Figs. 423, 424) in the Abbey were made in London, as the accounts describe the ordering of the material for casting them after the king had approved the pattern submitted to him by Master William Torel, goldsmith (*aurifaber*) of London in 1291 and 1292.

[1] See the author's *Medieval Sculpture in France*, Fig. 361.

213

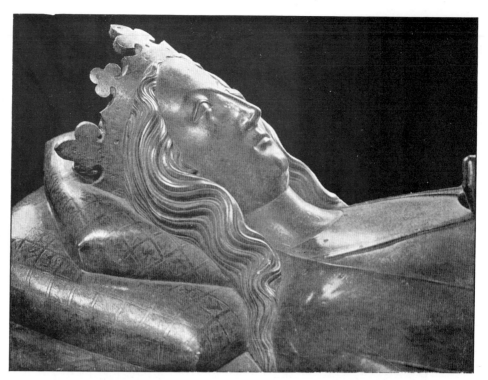

422. *Westminster. Bronze head of Queen Eleanor by William Torel. c. 1292*

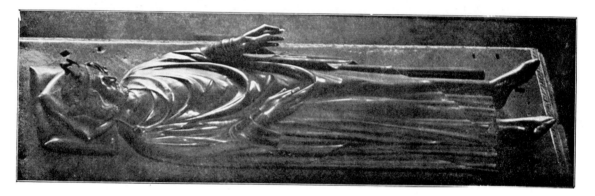

423. *Westminster. Bronze effigy of Henry III by William Torel. c. 1292*

They appear to have been cast on the cire-perdue system, in which a layer of wax is modelled upon a core, and then melted out and replaced by metal. They are unduly solid, as though Torel were used to smaller objects and these full-sized figures were new to him. The cushions and accessories are finely engraved with patterns similar to those worked in gesso on the stone and wood figures. The queen's head is raised on a double cushion, and her hair falls loose about her shoulders. Her features and arched eyebrows are those of the Madonna statues, and are an idealised version of a beautiful queen rather than an accurate portrait. The same must be said of Henry III's face as the king had been dead for twenty years when the tomb was erected. The general conception of both figures is

214

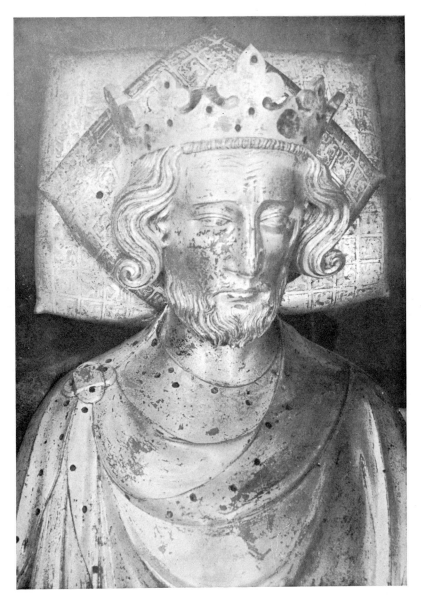

424. *Westminster. Head of Henry III by William Torel. c.* 1292

founded upon the style of the London effigy makers in stone or marble, and as the metal preserves its original surface we are fortunate in being able to base our ideas of the masterpieces of the finest period of our native art on such important and well-preserved examples.

The displacement of these effigies for safety during the war enabled detailed photographs to be obtained which may serve to give a better notion of their quality. In speaking of the Queen Eleanor Prof. Lethaby questions whether all Europe can find anything finer. Torel seems to have made two other similar figures for Blackfriars and Lincoln, and received £113. 6s. 8d. for the three.

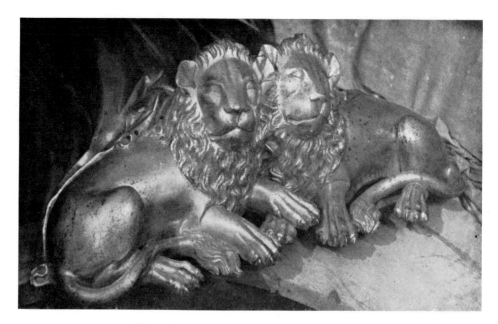

425. *Westminster. Bronze lions at feet of Queen Eleanor*

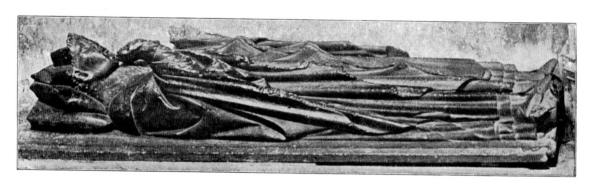

426. *Canterbury. Wooden effigy of Archbishop Peckham. c. 1290*

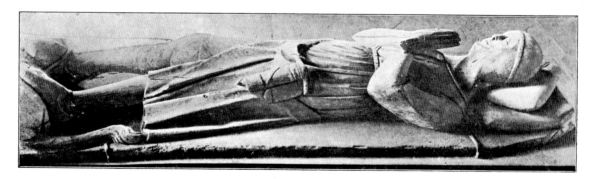

427. *Abergavenny (Mon). Wooden knight. c. 1300*

216

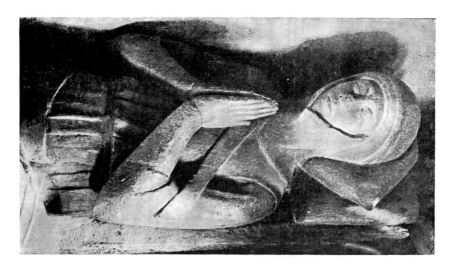

428. *Danbury (Essex). Wooden knight. c. 1300*

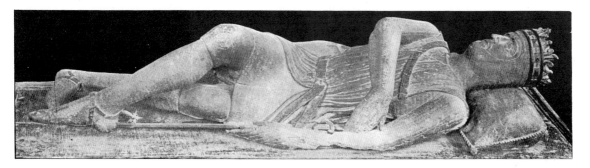

429. *Gloucester. Wooden effigy. Robert of Normandy. c. 1290*

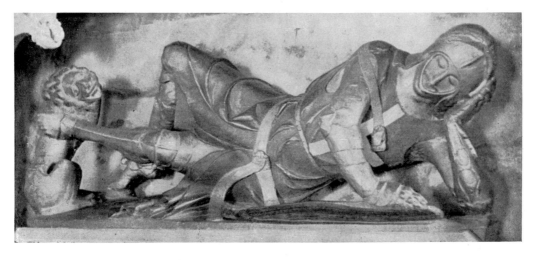

430. *Chew Magna (Somerset). Wooden knight. c. 1350*

217

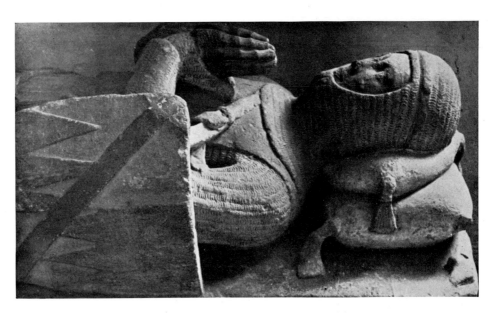

431. *Leighton-under-Wrekin (Salop). Stone knight. c.* 1270

The pair of lions at her feet, now almost hidden by the base of Henry V's chantry, are very engaging (Fig. 425).

Wooden knights, ladies and ecclesiastics were also being fabricated in the London workshops and elsewhere in considerable numbers. They are commonest in the eastern counties, where wood was plentiful and stone scarce, but they are found everywhere. Archbishop Peckham, d. 1292, is commemorated by a wooden effigy at Canterbury (Fig. 426), which follows closely the type worked out in stone or marble. The mitre is missing and was probably added in metal. Jewels or glass and enamels may have been inset, but the loss of the gesso ornaments makes it difficult to appreciate the effect of these wooden figures, especially when we have also to allow for the decay of the surface which most of them have suffered. We may take as examples of the quiet knight effigies, based on the Westminster royal models, a fairly well-preserved figure at Abergavenny, *c.* 1300 (Fig. 427), and a knight of about the same date at Danbury in Essex (Fig. 428). Both wear mail and surcoat, the details of the mail no doubt having been added in gesso, the hands are clasped in prayer, and the head rests on a double cushion. The lively type of knight may be represented by the figure called Robert of Normandy at Gloucester (Fig. 429), which was obviously made about the end of the thirteenth century, though it has been touched up and repainted in more modern times. The sword-drawing hand and high raised knee show that the wood carver was inclined to make the most of the opportunities given him by his easily worked material.

The restored and repainted knight at Chew Magna (Somerset), resting his head on his hand and in a very lively attitude (Fig. 430), may serve to give some notion of what these wooden effigies were designed to look like in all the brilliance of their original colour decoration. The contrast between this vigorous attitude and the quiet London style with hands folded in prayer is well seen in comparing this with the fine freestone knight at Leighton-under-Wrekin (Fig. 431).

218

CHAPTER VI

THE LATE GOTHIC OR PERPENDICULAR PERIOD

(1) GENERAL REMARKS

The terrible visitation of the Black Death in 1348–9 profoundly modified social conditions in the country, and when active building began again it was under altered conditions and in a different spirit. The shortage of labour led to greater organization of the building trade and necessitated greater mobility on the part of the masons. The result in architecture was the crystallization of the romantic Decorated style into the stately and efficient Perpendicular. Local styles tended to be submerged, though some broad distinctions can be made between east and west. Conditions were beginning to approximate more nearly to those of more modern times, and contract-work was becoming a substitute for artistic creation.[1]

The sculpture, under such conditions, was produced from stock patterns and began to lose its intimate connection with the building. The masons constructed niches for it, and provided gargoyles or angel cornices, but left the statues to be bought separately at a shop, and added or not as funds permitted. Tradition prevented gross incongruity, and the general effect was not unpleasing, but individually such figures became monotonous and less interesting than their predecessors. Quality varied less with locality than according to the depth of the purse of the patron: reasonably good work could be provided for those who could pay for it, but commonplace stuff was all that the less affluent could provide. Fifteenth-century architectural sculpture in England was often respectable, but rarely fresh or inventive. The best is to be found no longer in building sculpture, but in the productions of the furnishing trades, in tombs and screens and chantries. The most imaginative work was probably in the misericords of the stalls, where the wood-carvers were less bound by precedent and were able to give fuller play to their inventive skill.

Thus we find individual work of considerable distinction produced by the imagers from time to time, such as the statues of kings in Westminster Hall, the statues from the gate at All Souls, Oxford, the statuary of Henry VII's Chapel, the best of the alabaster tombs or the fragments preserved at Winchester and elsewhere, all of which will be described in due course. These were all produced under royal or wealthy patronage, and stand out against the dull uniformity of most purely architectural sculpture.

The earlier years of the sixteenth century produced some more important work by the imagers, as may be seen in the great array of sculpture of this period at Westminster. In some cases foreign influence may be discerned, or foreign sculptors may have been imported, but it was more Flemish than Italian in character, and there is little evidence of the Classical renaissance before 1540 or even later. Even Torrigiani's tombs at Westminster retain the general Gothic design combined with his newer fashions in detail.

[1] Modern writers have pointed out that the earliest examples of the Perpendicular style at Gloucester and other places in the west country and being erected before the Black Death, but the reasons for the rapid spread of the new style after the middle of the century must be as stated in the text.

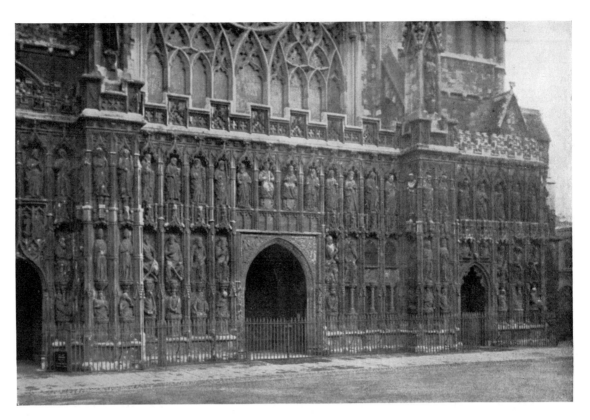

432. *Exeter. West front.* c. 1340 *and* 1380

(2) ARCHITECTURAL STATUES

The first effects of the changed conditions may be studied on the west front of Exeter Cathedral, which provides our greatest collection of fourteenth-century sculpture (Fig. 432). It was begun by Bishop Grandisson (1327–69), and the lower stage must have been completed before the Plague years as the knight in Fig. 428 is wearing the short fronted surcoat, which was not worn after about 1345. The lower range of statues should therefore, strictly speaking, have been dealt with in the preceding chapter. The upper row is, however, of a rather different character, and, as a shield with the arms of Richard II is carved on it, it seems that the façade can only have been completed by Grandisson's successor, Bishop Brantyngham, somewhere about 1375 or 1380. There are 88 figures, including the angel brackets beneath the statues of the lower row. Of these three are modern substitutes and three or four have modern heads, but the rest are fairly genuine though sadly decayed, and in the absence of the protection originally given by the colouring the decay seems to be increasing more rapidly.

Though the work appears to have been spread over some thirty or forty years the original scheme planned by Grandisson must have been carried out, but the later sculpture of the upper tiers falls short of the earlier in some of its essential qualities. Decay of attributes makes the identification of individual figures difficult, but it is obvious that the old attempt to name the statues after kings of England was very wide of the mark. The central group of the upper tier was a Coronation of the Virgin, at present disguised by the substitution

220

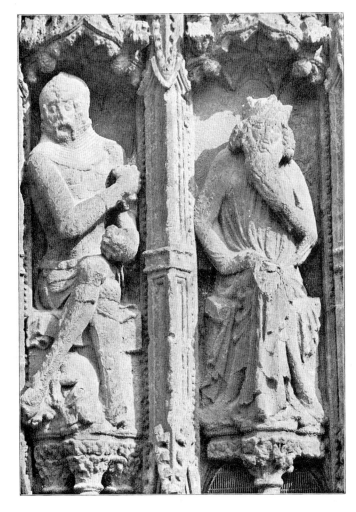 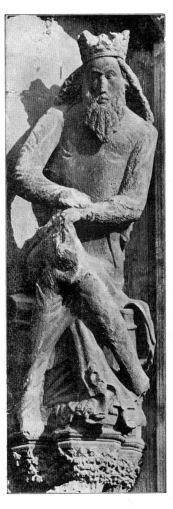

433. *Exeter. West front. Lower tier.*
c. 1340

434. *Exeter. King from lower*
tier. c. 1340

of a ridiculous figure of a king to replace the statue of Our Lady destroyed at the Reforma-tion. On either side are ranged the Apostles and Prophets. On the buttresses are the four Evangelists, and below them four ecclesiastics (three with poor new heads) who may be the Doctors of the Church. Below are a range of kings and warriors who must represent the royal line of Judah, figuring here as ancestors of the Virgin. The earlier figures in the lower tier are the most romantic and picturesque sculptures which have come down to us (Figs. 433, 444). They are seated in varied attitudes with legs crossed, some thoughtful, some conversing, and some ready to spring into action. The kings have long faces, are very hirsute and some of them are stroking their long beards. Draperies are usually drawn tight across the upper part of the body, and fall in overlapping folds over the knees. The liveliness of pose should be compared with that of the sword-drawing knight effigies described in the last chapter (see Fig. 411).

The Apostles (Fig. 435) and Prophets in the upper tier, which date from after the Black Death, are still picturesque, though they are not quite so romantic. They are short broad

221

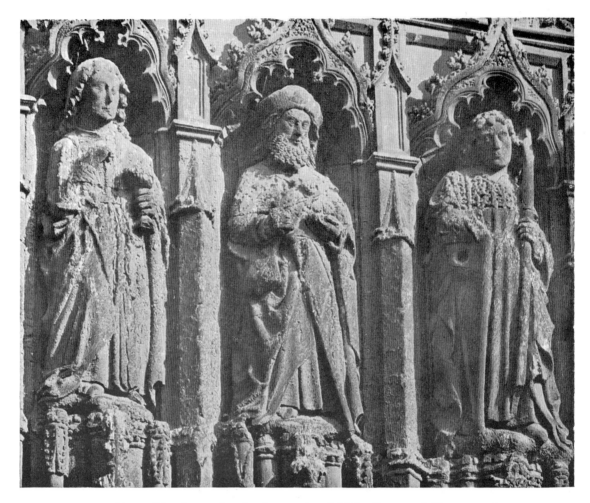

435. *Exeter. West front. Apostles of upper tier, SS John, James and Simon. c.* 1380

figures, clad in broad smooth draperies on which rich patterning could have been added in gold or colours, and, with one exception which is turned sideways, they stand squarely in their niches. The whole effect when new and resplendent with painting and gilding must have been extremely picturesque, even if lacking in the dignity of their thirteenth-century predecessors at Wells or Lincoln.[1]

The same sculptors who began the Exeter west front must have been employed on the reredos at Christchurch (Fig. 436), where the same cross-legged attitudes, long heads and beards and high cheek bones are identical in handling. Here the principal figures were of wood plated with silver, and have consequently disappeared, but the Beer stone figures remain, and as they are under cover they are sufficiently well preserved to enable us to form a better opinion of what the Exeter statues were like. The whole scheme was a great Tree of Jesse. Jesse lies at the base with the stem growing out of his side and winding among the niches containing his descendants. On each side of him are David and Solomon,

[1] For a complete description and illustrations see E. K. Prideaux, *The Figure Sculpture of the West Front of Exeter Cathedral Church.*

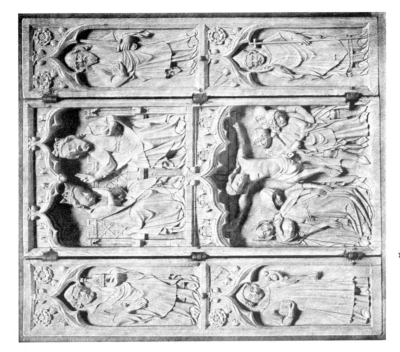

437. *British Museum. Ivory triptych. c. 1340*

436. *Christchurch (Hants). Reredos. Jesse and Magi. c. 1350*

223

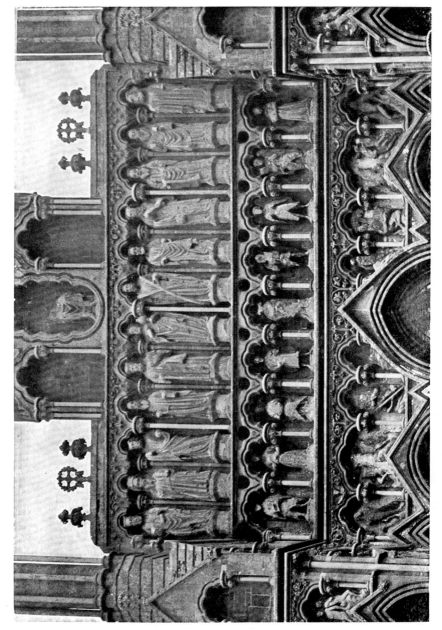

438. *Wells. Upper part of west front. Apostles and angels*

224

 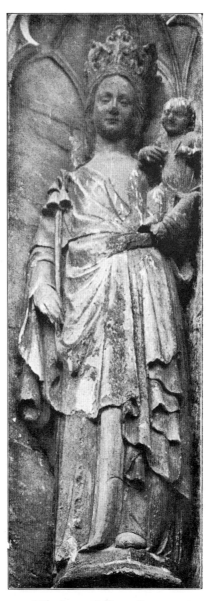

439. *Winchester College. Inner gateway.*
Madonna. c. 1390

440. *Winchester College. Outer gateway.*
Madonna. c. 1390

and, above, the Adoration of the Magi. A moment's comparison of the Exeter kings with the David, extending even to the pearl ornament on the uprights dividing the niches, will satisfy the inquirer as to a common authorship.

We have not attempted as a rule to deal here with small portable objects like ivories, whose origin is difficult to prove,[1] but a triptych in the British Museum may be illustrated here as a work of the Exeter school, as it has the same long heads and an escutcheon and badge have been identified as those of Bishop Grandisson (Fig. 437).

[1] For the best account of ivory sculpture in England see Miss M. H. Longhurst's *English Ivories*, with beautifully reproduced illustrations.

225

441. *Thornton Abbey (Lincs). Gateway. c. 1380*

The picturesque western style may also be recognised in the nine orders of angels of the central gable of the Wells west front, which were evidently added at a later date than the thirteenth-century work below them (Fig. 438). The Apostles above them are stiff and ungainly figures, designed for effect at a great distance, and we may suppose these all placed in the earlier niches when the western towers were raised, in 1386 and 1425, the Apostles belonging to the later period. The angels appear to have been coloured a rosy red.

The statues of the Madonna which adorn the gateways of William of Wykeham's College at Winchester, *c.* 1390 (Figs. 439, 440), are among the finest productions of this period, that on the outer gateway being fortunately well preserved. As is natural in hieratic statues of the kind the traditional type of the Madonna has been retained, and apart from the large crown and rather broad features and the flower sceptre, they might have been taken for work of fifty or sixty years earlier.

External sculpture at this date tends to become commonplace and designed for pictorial effect rather than close examination. The statues, for instance, on the gateway at Thornton Abbey (Fig. 441) are clumsy if looked at in detail, but they fit their position in the architectural scheme and the broad sweeping folds of their draperies would have lent themselves to colour decoration.

Niches were still prepared on the Perpendicular towers, which were not always filled subsequently with figures. At Beverley one ancient figure remains (Fig. 442), but the general impression we get of these statues is that they may be respectable but tend to become more and more uninspired shopwork and to reproduce stereotyped models without much fresh invention or imagination. A good idea of this type of work may be obtained from the

226

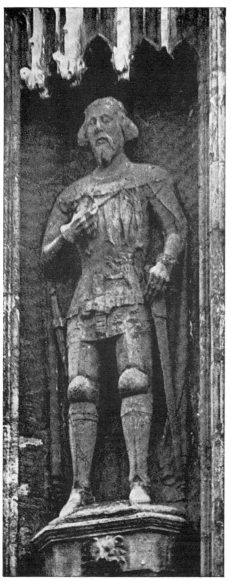

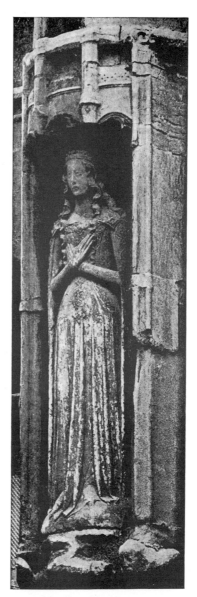

442. *Beverley (Yorks). Tower. Niche with figure. c.* 1400

443. *Lincoln. Stonebow Gateway. Virgin Annunciate. c.* 1500

444. *Lincoln. West front. Kings over central door. c.* 1380

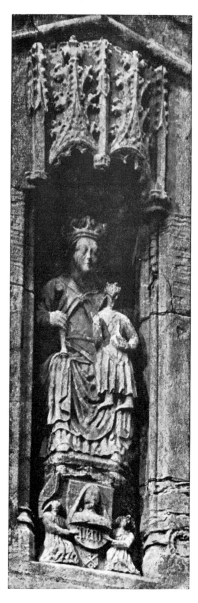 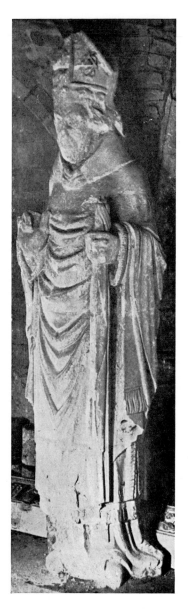

445. *Newark. South porch.*
Madonna. c. 1450

446. *Winchester. Crypt.*
St Swithin. c. 1410

row of playing-card kings inserted over the central west door at Lincoln in the latter part of the fourteenth century (Fig. 444), or in such statues as the Virgin Annunciate on the Stonebow Gateway at Lincoln (Fig. 443) or the Madonna of the south porch at Newark, *c.* 1450 (Fig. 445). A colossal statue now in the crypt at Winchester (Fig. 446), said to have come from the west front of the cathedral, probably represents St Swithin, and may be taken as the stock model of a bishop of the beginning of the fifteenth century.

228

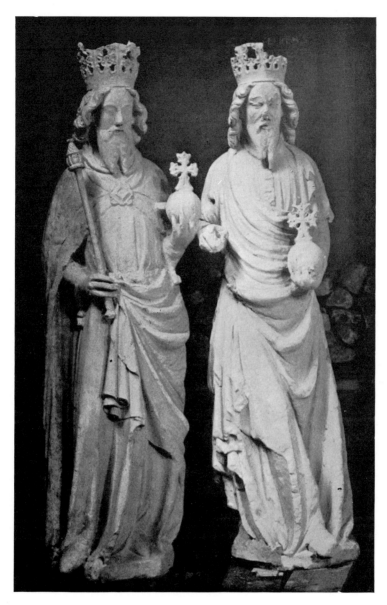

447. *Westminster Hall. South wall. Kings*

(3) IMAGERS' SCULPTURE

The interest now shifts to the statues prepared for internal decoration of screen and altar. Here we have a better series to illustrate the advance of style, as the practice of setting up statues of kings of England instead of saints has saved a number of them from destruction by Puritan iconoclasts. We may begin the series with six statues of kings about 6 feet high in the niches, three on each side of the great south window of Westminster Hall (Fig. 447). They must have been set up when the great hall was reconstructed by Henry Yevele and

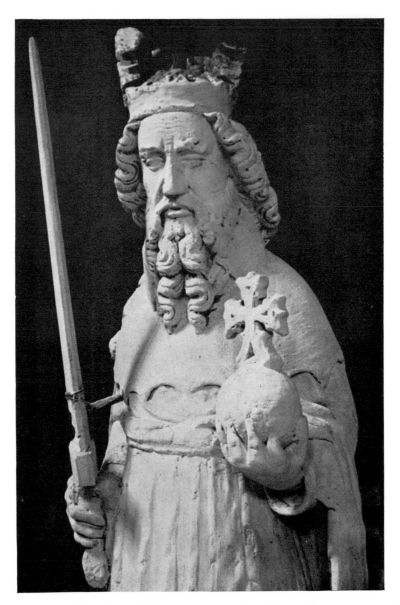

448. *Westminster Hall. South wall. King with sword. c.* 1395

Hugh Herland, the carpenter responsible for the famous roof, in 1393–8. The sculptured string course, in which the helm and white hart badges of Richard II are prominent, is carried all round the building and works in with the bases of the niches in which the statues are placed. There is no attempt to particularise any of these as representing any individual king. All have long hair and beard, tall floreated crowns and carry the orb in the left hand. Two hold drawn swords, two sceptres and the other two seem to have lost what they held. The drapery is still in earlier fourteenth-century tradition of a thin material in some cases wrapped round the figure and held up by one hand and falling in a bunch of overlapping folds. Four of them wear a regal cloak or mantle over the shoulder clasped by a large brooch, in one case with a long pendant chain. The one in our illustration (Fig. 448)

230

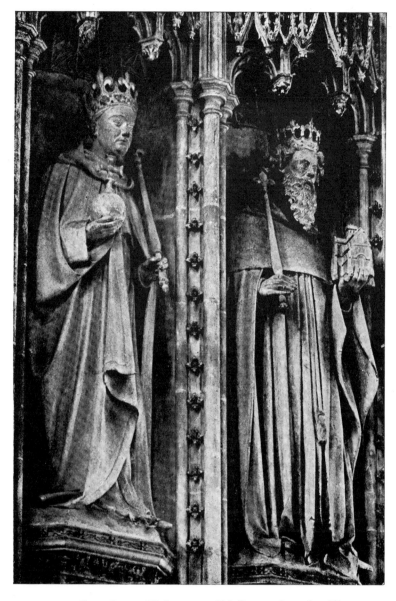

449. *Canterbury. Choir screen. Ethelbert and another King*

with the elaborately twisted beard wears a kind of dagged tippet over his cloak and what looks like a dalmatic over his inner robe. Mr J. Harvey[1] is inclined to suggest the name of William Walton as the sculptor. He seems to have been an assistant of Yevele and received payment for sculptures in the Hall. William Chuddere also was paid for images for the same building.[2]

[1] J. Harvey, *Gothic England*, p. 60.
[2] Our illustrations were taken while these figures were taken down for safety during the war, just before restoration to their niches in 1950. They had been cleaned and treated with a preparation of thin white gesso which does not disguise the surface of the stone. Mr Newell, the Ministry of Works foreman on the job of restoration, says that they are of Chilmark stone.

231

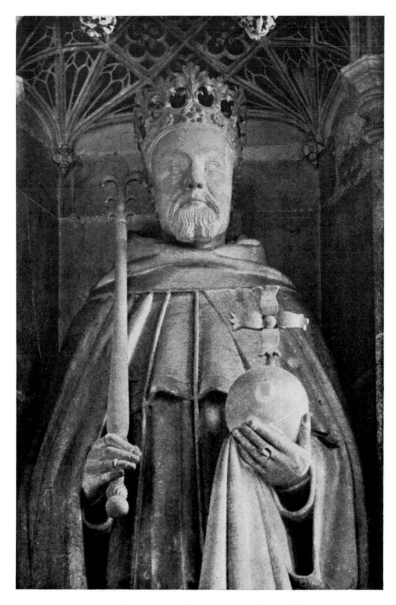

450. *Canterbury. Choir screen. Henry IV*

There are also preserved in the Hall three large statues of kings about 8 feet high. They are rather coarser with heavy heads and masses of hair suggesting that they were intended for a position high up, possibly on the outside of the building.

The series may be continued by the six fine statues of kings on the Choir screen at Canterbury (Fig. 449). On one side of the doorway is a figure with a long beard holding a model of a church, who must be Ethelbert, while his opposite number has no distinguishing attribute, but might be Edward the Confessor. Of the remaining four one has the short beard and general features of Henry IV as he appears on his tomb in the Cathedral (Fig. 450), while the other three are clean-shaven with nothing to identify them. It is

232

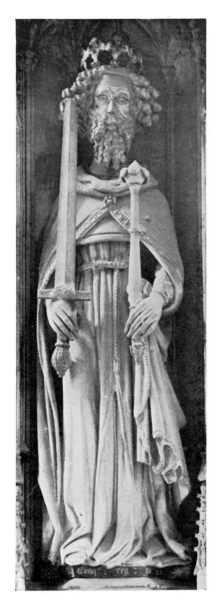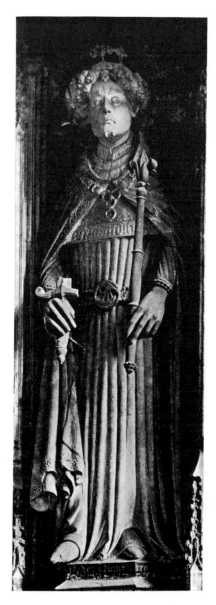

451. *York. Choir screen.*
William the Conqueror

452. *York. Choir screen.*
Henry V

generally assumed that the screen was built by Prior Chillenden, 1390–1411, who rebuilt the nave,[1] but it has been suggested that the last of the kings has crosses instead of fleurons in his crown, and so may be meant for the saintly Henry VI. This, however, would make the date *c.* 1500 when the central tower was built, and though the sweep of the draperies and deep undercutting of the folds marks a considerable change from those of the Westminster Hall kings, it is perhaps safer to assume that the statues and final touches to the screen were

[1] Prof. Willis in his *History of the Monastery of Christchurch, Canterbury*, quotes a roll giving a list of Prior Chillenden's works, which includes 'Navis ecclesie Cantuariensis cum apparatu gradus et *pulpite*'.

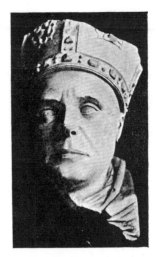

454. *Winchester. Head*

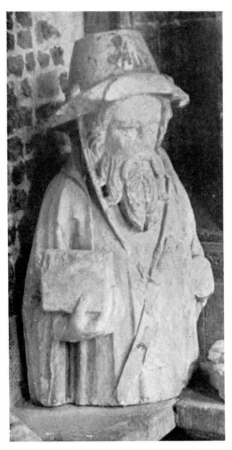

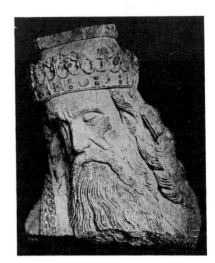

453. *Milton Abbas (Dorset). St James*

455. *Winchester. Head*

not completed till some years after Chillenden's death. A later screen of similar type exists at York, where there are also a number of English kings. The style is remarkable, with bunched-out hair, and an extraordinary enforcement of line by deep undercutting (Figs. 451, 452). It has been suggested that this has been derived from the art of glass painting, which was in great repute at York, and it is not unreasonable to conjecture that we have here one of the productions of the Drawswerd shop mentioned in our introductory chapter (p. 19). Their names are on the pedestals, but the portraiture is purely fanciful. The statue of Henry VI was removed owing to his claim to canonisation, and has been replaced by a modern figure. Many a great reredos was erected on the plan of that at Christchurch, the most notable being at Winchester, St Albans, Milton Abbas, New College and All Souls Oxford, and Southwark. From all of these the images which crowded the niches have been removed, but certain fragments dug up here and there may have come from them such as the St James at Milton Abbas (Fig. 453). There are some splendid heads now in the

234

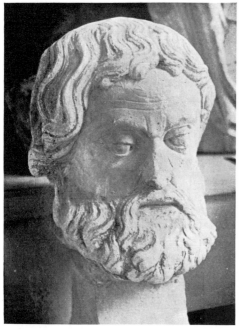

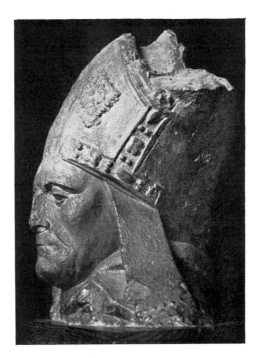

456. *Winchester. Head* 457. *Westminster. Abbot Islip*

Winchester Cathedral Lapidary Museum (Figs. 454, 455, 456), which may have come from some such position, and show a refinement coupled with dramatic power and mastery of technique that we hardly found in the purely architectural figures.

There can be no question of the fine quality of some of the heads like that of the Almighty (Fig. 455) or the extremely able treatment of the features in Figs. 454 and 456, which must have been studied from life. If they are from the great reredos which is usually dated *c.* 1480 they show that the imagers could still produce work of astonishingly high quality, as we shall see again twenty or thirty years later in Henry VII's Chapel at Westminster.

The images for the great reredos at All Souls were made by John Massingham, one of the few important sculptors whose name is known to us as connected with any special work. These are no longer in existence, but Mr J. Harvey is probably correct in assigning to him the refined statues of Henry VI and Archbishop Chichele which stood in the niches of the gateway of the college (Figs. 458, 459),[1] and which were praised by Flaxman.

A very fine head of an abbot is preserved in the Muniment Room at Westminster. It was found by restorers embedded in the stonework at the top of the gable of the north transept, evidently placed there at a previous restoration. Mr L. E. Tanner identifies it with Abbot Islip, and it is valuable as showing the high quality of some of the work *c.* 1500 (Fig. 457).

In the panelling at the end of the Divinity School at Oxford, and in the mouldings against the wonderful fan-vault there, niches are contrived which still retain a number of delicately wrought statuettes (Figs. 460, 461) dating from soon after 1450. Others are set

[1] These were replaced by modern figures in 1939, but the old ones are preserved in the college cloister.

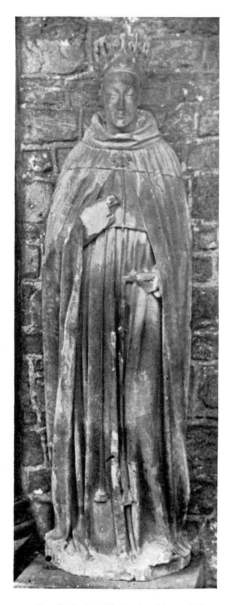
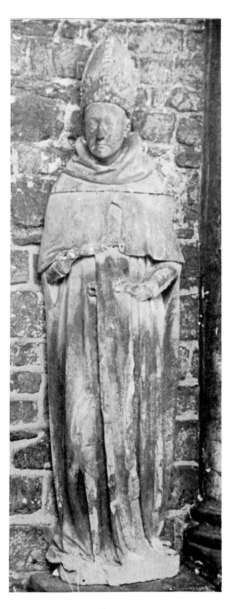

458. *Oxford. All Souls. Henry VI* 459. *Oxford. All Souls. Archbishop Chichele*

in the pendant bosses, and show that the imagers could still produce work of considerable distinction.

But the chief collections of late Gothic imagery are at Westminster, and provide us with first-rate examples at an interval of sixty or seventy years. Henry V's chantry, according to Sir William Hope,[1] was not completed till 1440 or 1450, though the king himself had projected some such erection in his will, and the actual tomb was set up soon after his death in 1422. The chantry was probably erected under the direction of John Thirsk, mason. It is built in the form of an H (Fig. 463) supported by two open-work towers

[1] *Archaeologia*, LXV, 1914.

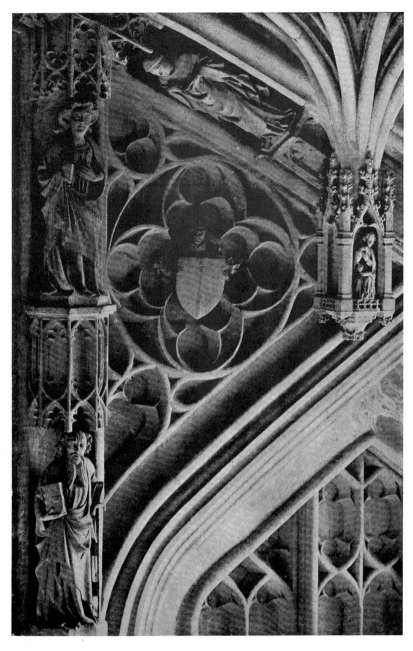

460. *Oxford. Divinity School. Fan-vault and statuettes. c. 1452*

joined by a cross-piece. The tomb was on the floor level, and above it was a little chapel with an altar piece with an Annunciation, St Edward, St Edmund, St George and St Denis, together with a vacant niche (Figs. 465–470).[1] This is the only important reredos remaining in England in which the main figures, with the exception of the central niche, are intact.

[1] For fuller illustration of all these Westminster statues see the volume on the Abbey published by the Royal Commission on Historical Monuments.

461. *Oxford. Divinity School. Statuette*

462. *Westminster. Henry VII's Chapel. Dog*

The St George is a fine statue in heavy plate armour wearing a sallet with raised vizor, and the other three standing statues are accomplished and stately figures, the head of St Denis, which he is holding in his hand, being especially realistic. The Virgin of the Annunciation also breaks away from older traditions in her realistic treatment; so much so that it has been suggested that these figures are a later insertion, especially as the bases on which they stand bear a close resemblance to those of Henry VII's Chapel. The armour, however, of the St George (Fig. 469) is definitely of mid fifteenth-century type. On the staircase towers a number of statues are placed, including the Confessor and the Pilgrim (to whom he gave his ring, and who afterwards turned out to be St John), two kings, two bishops, a cardinal, a deacon and two or three other statues (Figs. 464, 471, 472). They are mostly fine and dignified figures, well proportioned and with draperies boldly wrought. In one or two of them the long fluttering hair and beard are marks of the dramatic ideals of the period, but they are not carried to such excess as in the York kings. The Confessor originally wore a metal crown, the holes for fixing which can be clearly seen. At the sides of the chantry the arches over the ambulatory are elaborately carved with the king's badges and with niches containing two representations of the coronation, probably not the two coronations as King of England and of France, as usually stated, but two incidents in the coronation service, the acclamation and the homage, as on one side the attendant nobles are bare-headed, and on the other they are wearing hats (Figs. 473, 474, 475).

238

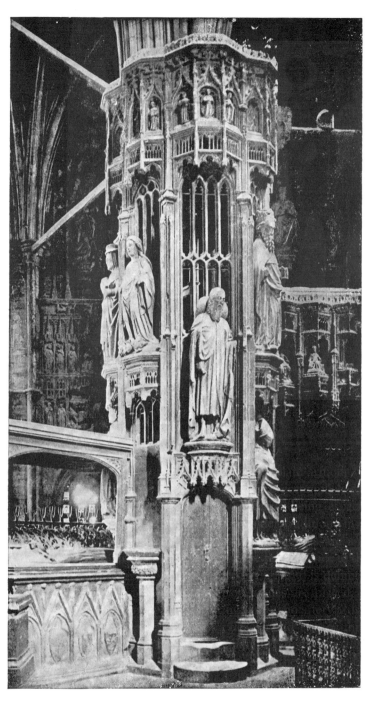

463. *Westminster. Henry V's chantry*

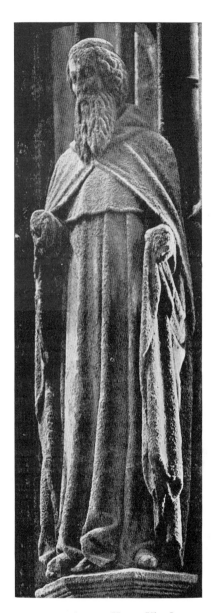

464. *Westminster. Henry V's chantry.*
Edward the Confessor

239

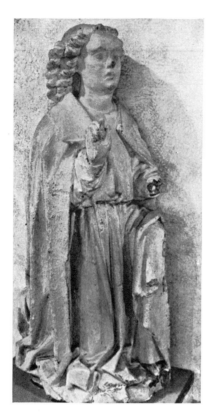 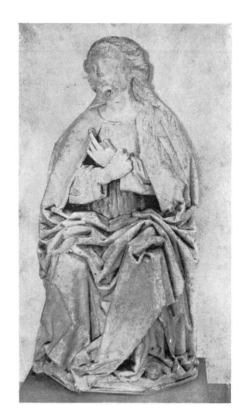

465. *Westminster. Henry V's*
chantry, reredos. Gabriel

466. *Westminster. Henry V's chantry,*
reredos. Virgin Annunciate

Two reliefs over the arch leading to Henry VII's Chapel are of special interest. They represent King Henry V in full armour charging on a richly caparisoned horse across rough ground. These should be compared with the reliefs in the trefoils over the tombs in the Sanctuary (see Figs. 357, 358), which were described as influenced by the seals. But the most striking feature about the Henry V figures is in the landscape backgrounds, which appear here for about the first time in English monumental art. In one he is crossing a river, with buildings on the heights behind, and in the other there are two castles, one of which suggests Richard I's Chateau Gaillard, from the battlements of which men-at-arms appear to be hanging (Fig. 476).

Henry VII's Chapel[1] was begun in 1502 and was almost complete in 1512, but although entirely built in the sixteenth century it contained no evidence of the Renaissance apart from Torrigiano's tomb in the centre. Robert Vertue, Robert Jenins and John Lebons were the King's master masons, but they were probably more concerned with the marvellous architectural structure than with the images that adorned it, and Lawrence Ymber, who made estimates for the images of the tomb, is a more likely candidate for the honour of having carved some of them.

The whole of the exterior stone-work has been renewed, and the statues there have all disappeared, but inside there are still ninety-five statues mostly in good preservation. All

[1] *Archaeologia*, XLVII, 1883.

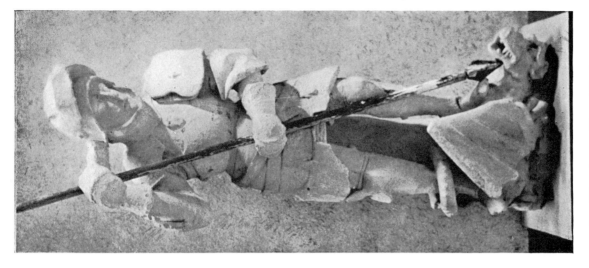

469. *Westminster. Henry V's chantry, reredos. St George*

468. *Westminster. Henry V's chantry, reredos. St Edmund*

467. *Westminster. Henry V's chantry, reredos. St Edward*

241

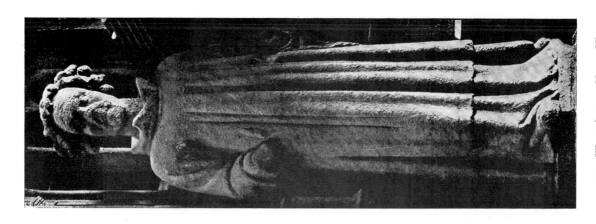

472. *Westminster. Henry V's chantry. Deacon*

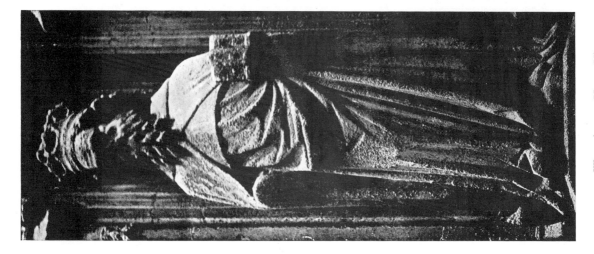

471. *Westminster. Henry V's chantry. King*

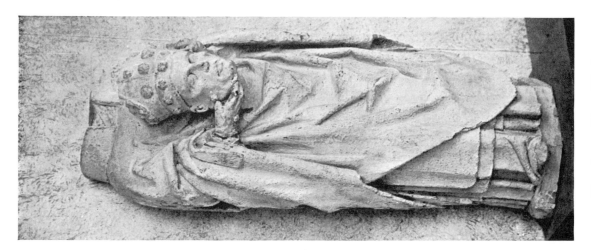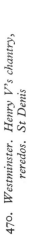

470. *Westminster. Henry V's chantry, reredos. St Denis*

242

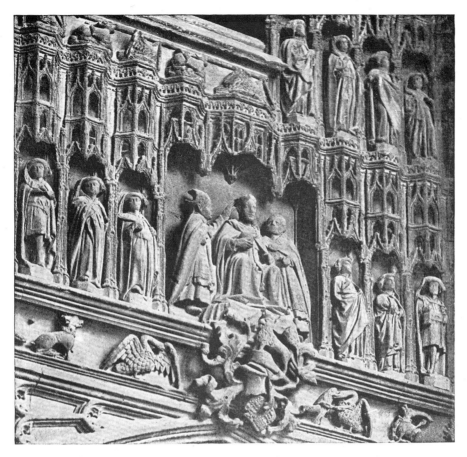

473. *Westminster. Henry V's chantry. Coronation*

round the building at triforium level are a range of niches containing figures less than half life size. Christ, the Virgin and Apostles are grouped at the east end, and all the most popular saints of the day are ranged to north and south. They are full of character and variety with a tendency to dramatic exaggeration in the large hats and billowy draperies. The St Anne teaching the infant Mary to read is one of the most pleasing of them (Fig. 477). In some the heads are rather large, and several are actually wearing spectacles (Fig. 480, 487).

This series forms the most complete set of popular saints which has come down to us, and fortunately they are mostly in excellent preservation, with their distinctive attributes intact, so that with very few exceptions they can be identified without difficulty, as has been pointed out in our introductory chapter (see pp. 5 and 6). Five or six of them appear to have been carved in Reigate stone, which has suffered some deterioration of the surface in the London atmosphere, and these seem to be by a different hand to the rest, with smaller heads and more delicate treatment of detail. The rest appear to be of Caen stone, and are almost perfect, but no traces of colour have been found on them, though Henry VII's will specified that the work should be painted, and even the scrolls provided for their names are absolutely blank. The treatment of the faces is powerful and shows a mastery of technique rarely attained since the heads at Winchester illustrated in Figs. 454, 455 and 456.

243

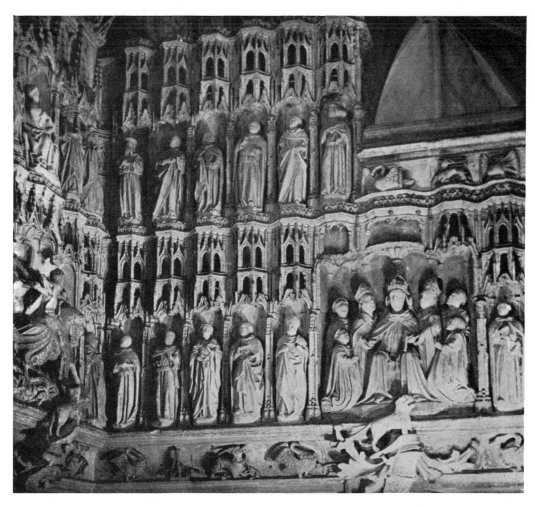

474. *Westminster. Henry V's chantry. Coronation, the homage*

Perhaps the most remarkable are the ten statues in the opposing western bays which have been identified as pagan philosophers, but who are more probably prophets. They wear the fantastic hats which are usually given to eastern potentates, patriarchs and prophets, as in the little figures on the stalls at Windsor[1] (Fig. 485).

Larger statues are placed in elaborate niches supported by angel cornices in the chapels which radiate round the apse. St Sebastian between the two archers who were to execute him form a dramatic group (Fig. 492) and the representation of the nude is not a bad attempt on the part of sculptors who were seldom called upon for anything of the kind. The elaborately curled locks of the Confessor and St Edmund, who stand on each side of St Peter (Fig. 493), and the crumpled folds of their heavy draperies are an attempt at realism, and throughout there is a freedom of pictorial representation a little outside the old medieval conventions, but at a time when Italian art of the Renaissance was at its height there is no sign of classicism.

[1] Compare also the contemporary series of prophets in the magnificent screens at Albi in the south of France and the prophets in the glass at Fairford.

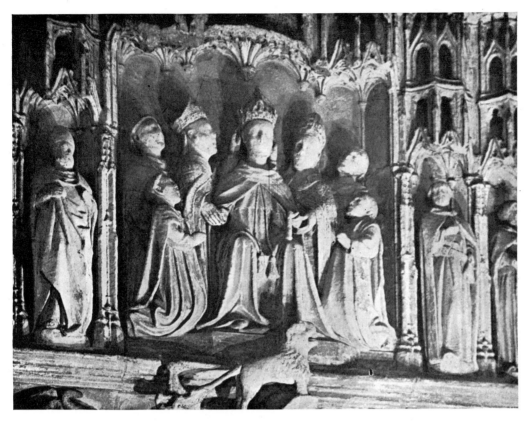

475. *Westminster. Henry V's chantry. Coronation, the homage*

Some of the statues of the chapels repeat the smaller figures above, and it appears that one set must have been copied from the other. The St Sebastian between the archers, the St Paul (Fig. 495) and the St Armil (Fig. 494), for instance, correspond most closely with their counterparts above. The whole series shows a considerable advance on most of the work of the preceding century, and gives the final stage of the old Gothic tradition a distinguished place in the history of English art.

The canopies over these statues are crowned by a set of dogs and heraldic beasts which also show observation of nature and imagination (Fig. 462). They give some indication of the value of what we have lost by the destruction of the exterior sculpture of the chapel and of the royal beasts which once crowned the buttresses of St George's Chapel at Windsor.

As this is perhaps the most complete set of sculptured saints in Europe, a sketch plan has been added showing the position and arrangement of the statues.

If Tudor sovereigns set the example of building the most magnificent mausoleum ever erected in the country, their most powerful subjects followed their lead in the founding of gorgeous chapels to contain their own monuments. One of the finest of these is the Beauchamp Chapel at Warwick, built to contain the tomb of Richard Beauchamp, the famous Earl of Warwick. We shall deal with the actual tomb later, but part of the splendid stone decoration survives in the statuettes arranged in niches all round the east window. They

245

476. *Westminster. Henry V's chantry. King Henry V and landscape background*

represent saints (Fig. 498) and angels, and are certainly imagers' work. Much colour remains to give an idea of the sumptuous appearance of such a memorial chapel.[1]

Finally, in the Golden Chapel at Tong, Salop, is the curious bust of Sir Arthur Vernon, priest, who died in 1517 (Fig. 499). He is represented as though preaching with a book before him, and his tomb with a brass showing him in academical robes is just below.

[1] *Archaeologia*, LXXVII, 1927, contains a full description with illustrations of the sculptures at Warwick.

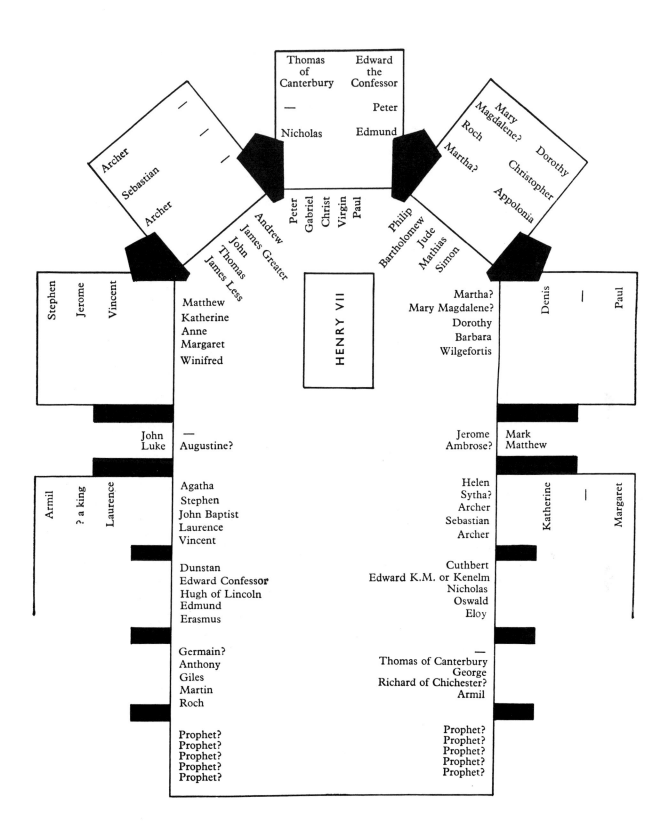

Thomas of Canterbury Edward the Confessor

— Peter

Nicholas Edmund

Archer

Sebastian

Archer

Mary Magdalene?

Roch

Martha?

Dorothy

Christopher

Appolonia

Andrew
James Greater
John
Thomas
James Less

Peter
Gabriel
Christ
Virgin
Paul

Philip
Bartholomew
Jude
Mathias
Simon

Stephen
Jerome
Vincent

Matthew
Katherine
Anne
Margaret
Winifred

HENRY VII

Martha?
Mary Magdalene?
Dorothy
Barbara
Wilgefortis

Denis

Paul

John
Luke

—
Augustine?

Jerome
Ambrose?

Mark
Matthew

Armil
? a king
Laurence

Agatha
Stephen
John Baptist
Laurence
Vincent

Helen
Sytha?
Archer
Sebastian
Archer

Katherine

Margaret

Dunstan
Edward Confessor
Hugh of Lincoln
Edmund
Erasmus

Cuthbert
Edward K.M. or Kenelm
Nicholas
Oswald
Eloy

Germain?
Anthony
Giles
Martin
Roch

—
Thomas of Canterbury
George
Richard of Chichester?
Armil

Prophet?
Prophet?
Prophet?
Prophet?
Prophet?

Prophet?
Prophet?
Prophet?
Prophet?
Prophet?

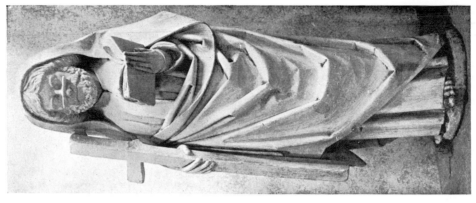

480. *Westminster. Henry VII's Chapel. St Matthew the Apostle*

479. *Westminster. Henry VII's Chapel. St Helen*

UPPER SERIES

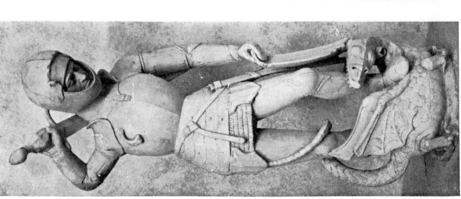

473. *Westminster. Henry VII's Chapel. St George*

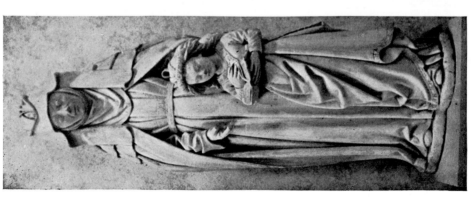

477. *Westminster. Henry VII's Chapel. St Anne teaching infant Mary to read*

248

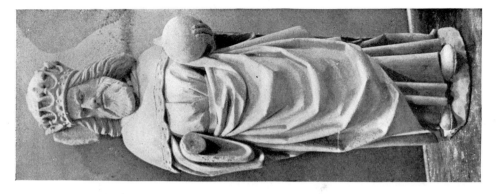

484. *Westminster. Henry VII's Chapel. St Edmund*

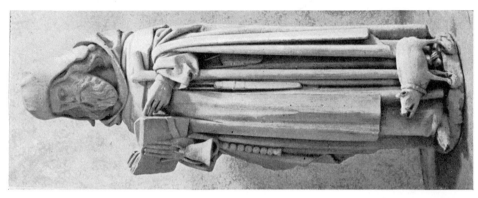

483. *Westminster. Henry VII's Chapel. St Anthony*

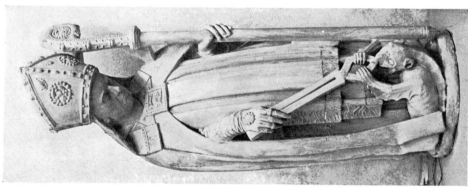

482. *Westminster. Henry VII's Chapel. St Dunstan*

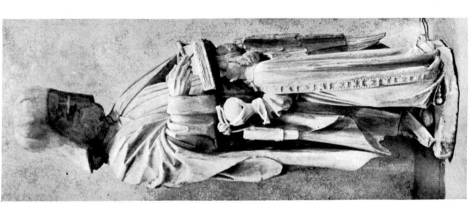

481. *Westminster. Henry VII's Chapel. St Matthew the Evangelist*

UPPER SERIES

249

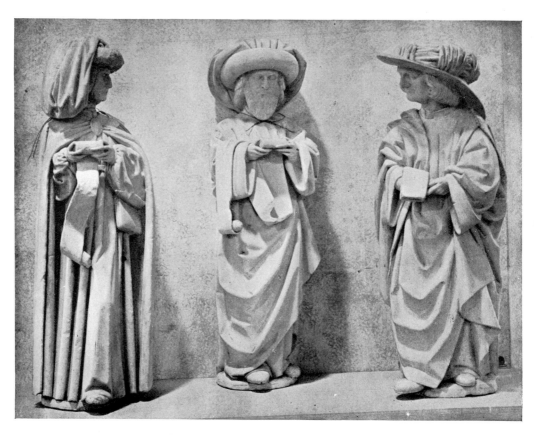

485. *Westminster. Henry VII's Chapel. Upper series. Prophets*

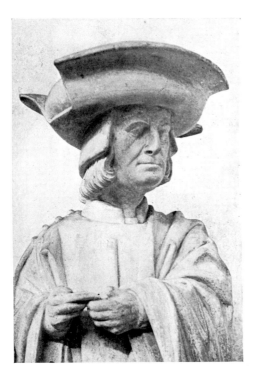

486. *Westminster. Henry VII's Chapel.*
Upper series. Prophet

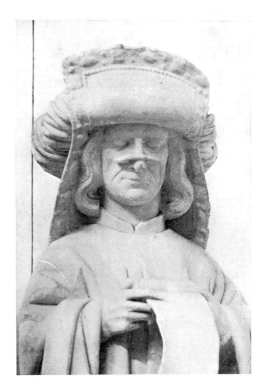

487. *Westminster. Henry VII's Chapel.*
Upper series. Prophet

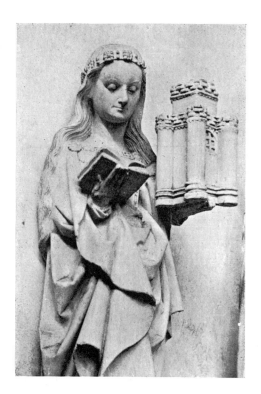

488. *Westminster. Henry VII's Chapel.*
Upper series. St Thomas of Canterbury

489. *Westminster. Henry VII's Chapel.*
Upper series. St Barbara

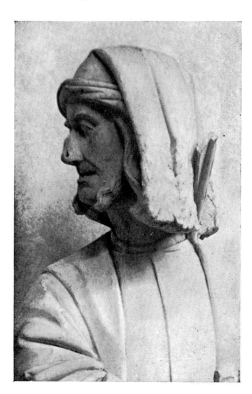

490. *Westminster. Henry VII's Chapel.*
Upper series. St John the Evangelist

491. *Westminster. Henry VII's Chapel.*
Executioner of St Sebastian.
Upper Series

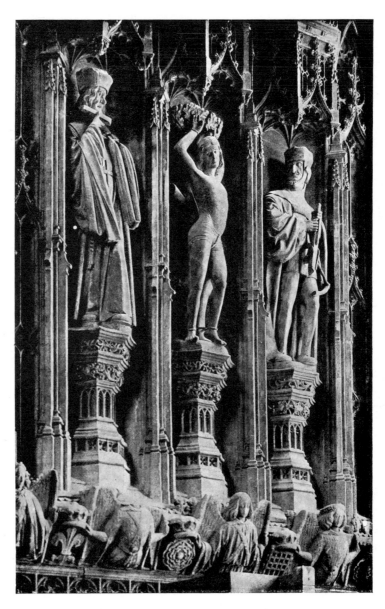

492. *Westminster. Henry VII's Chapel.*
St Sebastian between the archers

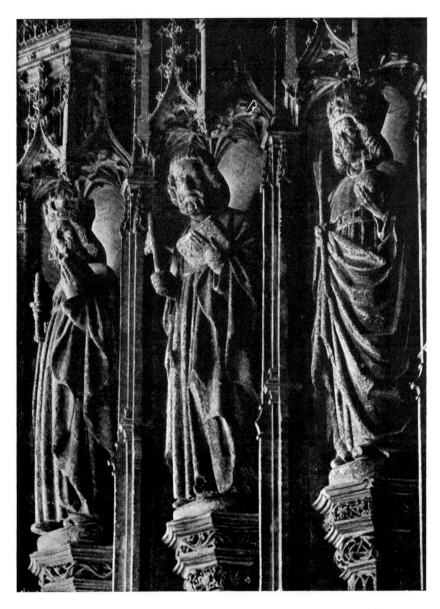

493. *Westminster. Henry VII's Chapel. St Peter between Edward the Confessor and St Edmund*

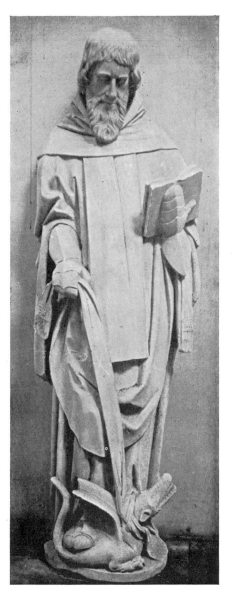 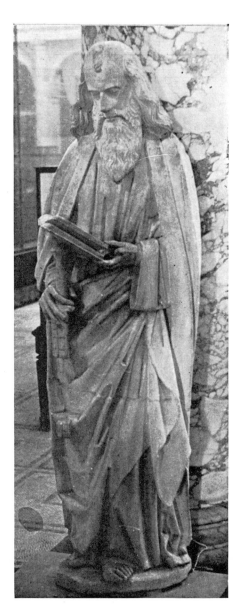

494. *Westminster. Henry VII's Chapel,*
apse chapel. St Armil

495. *Westminster. Henry VII's Chapel,*
apse chapel. St Paul

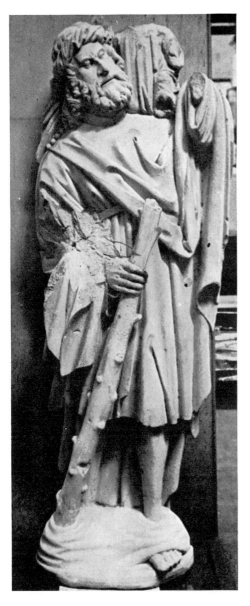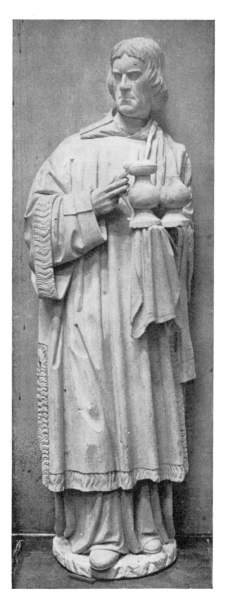

496. *Westminster. Henry VII's Chapel,*
apse chapel. St Christopher

497. *Westminster. Henry VII's Chapel,*
apse chapel. St Vincent

255

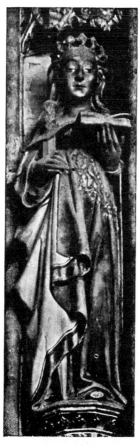

498. *Warwick. Beauchamp
Chapel. Saint Catherine*

499. *Tong (Salop). Golden Chapel. Sir Arthur
Vernon. c.* 1517

500. *Addlethorpe (Lincs). Gargoyle on porch*

256

501. *Newark. Gargoyle. c.* 1450

502. *Croscombe (Somerset). Gargoyles*

(4) LESSER ARCHITECTURAL SCULPTURE

The architectural sculpture of the fifteenth century need not detain us long. It follows the traditions of the fourteenth, but with a tendency to deteriorate into stereotyped forms and repetitions. Gargoyles still show a certain amount of imagination in the devils and monsters pressed into this service. They can be found all over the country on Perpendicular towers and the parapets which were so often reconstructed when bigger clerestory windows were added to older churches. Examples from Addlethorpe porch (Fig. 500), Newark, *c.* 1450 (Fig. 501), and Croscombe, near Wells (Fig. 502), must suffice here.

Bosses in the high vault at Norwich carry on the Tewkesbury tradition. The nave vault was built by Bishop Lyhart after a fire in 1463. The 328 bosses illustrate the Bible story

257

503. *Norwich. Bosses of nave and vault. Herod. c.* 1450

504. *Norwich. Cloister boss.*
Herod's Feast. c. 1420

505. *Norwich. Cloister boss.*
The Nativity. c. 1420

in both Old and New Testaments. A section is shown here with Herod and the Massacre of the Innocents (Fig. 503). Though effective at a distance the figures are crude puppets if examined closely, and the scenes seem copied from manuscript originals. The bosses nearer the eye in the north and west walks of the Norwich cloister are very inferior to the earlier carvings in the walks built in the previous century. Such versions as Herod's Feast, with Salome performing the licentious dance in the tumbling manner which had been assigned to her since the thirteenth century (Fig. 504), or the Nativity (Fig. 505) with its

258

506. *Worcester. Cloister bosses. Madonna with beasts and angels. c.* 1390

507. *Gloucester. Choir vault bosses. Angels with musical instruments. c.* 1370

508. *Westminster. Henry VII's Chapel. Angel cornice. c.* 1510

509. *Windsor. Angel cornice. c.* 1500

monotonous lines, are ineffective, shallow and confused in composition beside the earlier examples. In the Worcester cloister, *c.* 1390, there is a Jesse tree, and a curious Madonna holding the Child straight in front of her, and surrounded by the Four Beasts and angels (Fig. 506).[1] The vault of the choir at Gloucester, *c.* 1370, has a regular choir of angels playing musical instruments on its bosses (Fig. 507). Angels, in fact, become the stock motive of decoration, and appear everywhere as supporters of brackets, as bosses, filling spandrels as at Sall (Fig. 513), or forming cornices as at Southwark, Westminster (see Fig. 508) and Windsor (Fig. 509). They are no longer the great heavenly beings of the thirteenth century, weighing souls or expelling our first parents from Paradise, but have become little more than fairies whose functions are to hold up scrolls or shields of arms, and to minister to the glorification of human masters.[2] Angels at King's College, Cambridge, holding up the royal arms (Fig. 510) have only the same function as the monsters

[1] Can it be that this is a restoration?
[2] Good examples on a bold scale may be found on the grand arcade of the nave at Cirencester.

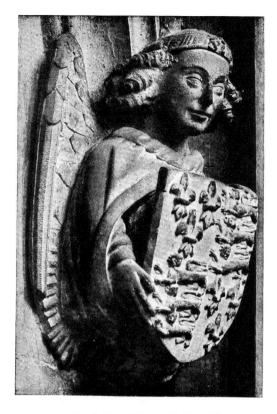

510. *Cambridge. King's College Chapel.*
Angel with royal arms

511. *Cambridge. King's College Chapel.*
Heraldic beast

(Fig. 512) and heraldic beasts (Fig. 511) which become an important item in the sculptural decoration of this period. Frequently, as in the Sall spandrel (Fig. 513), they are shown as feathered all over instead of wearing the usual alb; this was probably a reminiscence of the feathered tights in which actors of such parts appeared in the mystery plays, which were coming more and more into fashion. A good example of the decorative use of heraldic devices combined with little figures of saints in niches may be found in Prince Arthur's chantry at Worcester dating from 1504 (Fig. 515).

By the fifteenth century sculpture was becoming less intimately part of the building scheme. Niches were left to be filled by the imagers, and though they sometimes produced work of high quality the average production of the furnishing trade lacks the dignity and sculpturesque feeling of the earlier work. Much of it was on a small scale and devoted to the decoration of screens and canopies of tombs. Prince Arthur's chantry at Worcester, besides the exterior decoration described above, contains a reredos with figures, unfortunately too mutilated for illustration here, but which seems a reproduction on a smaller scale of that in Henry V's chantry at Westminster. The elaborate canopy of a tomb chapel at Paignton has a number of small reliefs, including one of the Mass of St Gregory (Fig. 516), and a high tomb at Hingham in Norfolk has a considerable amount of sculptured detail. Mention should also be made of the canopy over the tomb of the Duke of Exeter from St Catherine's Chapel, now removed to the chapel of St Peter ad Vincula in the Tower. This has boldly carved angels in the spandrels and the story of Renard the Fox with

261

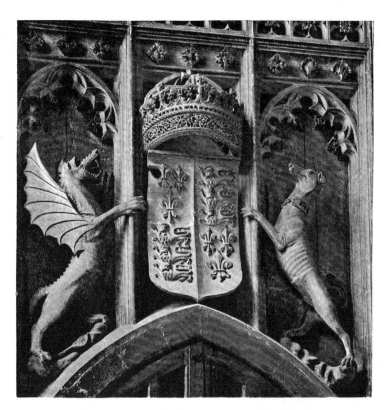

512. *Cambridge. King's College Chapel. Heraldic beasts*

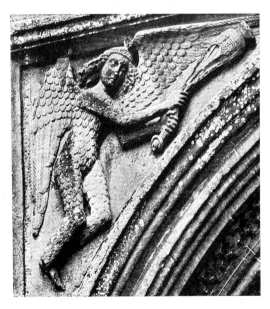

513. *Sall (Norfolk). Angel of porch.*
c. 1475

514. *Cawston (Norfolk). Wooden*
roof angel. c. 1475

262

515. *Worcester. Prince Arthur's chantry. Heraldic ornament. c. 1504*

516. *Paignton (Devon). Mass of St Gregory*

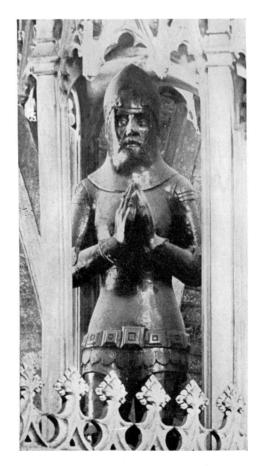

517. *Tewkesbury. Despenser chantry.*
Lord Despenser in armour. c. 1380

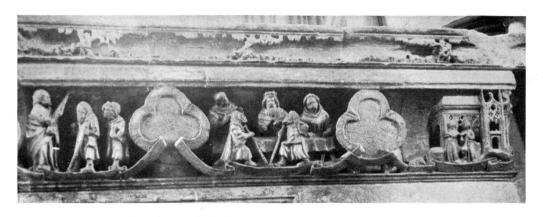

518. *Westminster. Back of reredos. Legends of Edward the Confessor*

519. *March (Cambs). Roof angels. c. 1450*

264

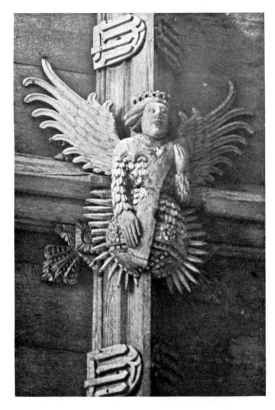

520. *Ewelme (Oxon). Roof of Suffolk Chapel. Angel* 521. *Rufford (Lancs). Roof angel*

a number of small carvings of animals in the mouldings of the uprights on each side. Chantries at Winchester and St Albans must have had an immense number of small figures now lost, though Abbot Ramryge's rams with the letters RYG on their collars at the latter place are good examples of heraldic punning devices. The little scenes from the life of the Confessor at the back of the reredos at Westminster have a pictorial quality in spite of decay (Fig. 518). The chantry-chapel of Lord Despenser at Tewkesbury has the unusual feature of him in late fourteenth-century armour kneeling in a little tabernacle on the top of the chapel (Fig. 517).

Great angels with outspread wings were a feature of the famous hammer-beam roofs of the eastern counties, and when glowing with fresh colours must have produced a very splendid effect, though they look rough and clumsy when detached from their positions. Statues of Apostles and others were also used by the wood-carvers to support the brackets as at March (Fig. 519), and the fluttering wings of the angel host spread all over the roof of the church caught the imagination of the people, and this scheme was repeated in many grand timber roofs, as at Wymondham, Cawston (Fig. 514) and many other places.

An outlying example of this eastern counties wooden carving of angels may be found at Ewelme in Oxfordshire in the ceiling of the chapel enclosing the tomb of the foundress, the celebrated Duchess of Suffolk, which is illustrated elsewhere (Fig. 520).

The angels of the famous roof of Westminster Hall were carved by Robert Grassington,[1] and examples also are found in domestic halls as at Rufford (Fig. 521).

[1] J. Harvey, *Gothic England*, p. 59.

It is time now to turn to the furniture sculpture which plays a more important part as time goes on. Among the fittings necessary for the larger parish churches, which in the fifteenth century were ousting the monastic churches in popular favour, fonts were again in demand. For some reason after the Norman fonts had ceased to be made figure-sculpture was very seldom used, and during the thirteenth and early fourteenth centuries arcading, mouldings, or occasionally foliage were almost exclusively used for font decoration. In the second half of

522. *Burford (Oxon). Font. c.* 1340

the fourteenth century, however, figures were again called into use for the purpose, and at Burford there is a tub-font with a Crucifixion and saints under crocketed canopies carved upon it (Fig. 522).

The most important developments in this line are to be found in the eastern counties, where the wealth derived from the wool and textile trade, of which these counties were the centre, encouraged the building of splendid parish churches during the fifteenth century. Two or three types are repeated again and again, and it is evident that there were regular shops sending out stock patterns in all directions. One of these was no doubt situated in Norwich, whence carriage of such bulky objects by water up the various estuaries was not difficult, and another may have been at Ipswich. A full classification of these fonts depends mainly on shape and general design and belongs to the study of ecclesiology generally rather

266

than to one of sculpture,[1] as the figure work is mere shop production and has little claim to distinction as sculpture. It will, therefore, only be necessary here to illustrate a few typical examples to show their general position in the story of our native art.

The font at Orford (Fig. 523) may be taken as a specimen of a common type. The base is supported by clumsy lions alternating with Wodehouses (or savage men). The bowl is

523. *Orford (Suffolk). Font. c.* 1400

supported by demi-figures of angels with outspread wings, and is divided by buttresses into oblong panels containing the Evangelistic symbols and sacred figures such as the Trinity.

Another type occurs in Norwich All Saints' (Fig. 524), and has almost a duplicate in St James's Church in the same city. Here the shaft is divided into niches containing stiff figures by mouldings which are continued upwards to form branches of foliage to cover the swelling part beneath the bowl. The square compartments of the latter are occupied by pairs of saints.

[1] The reader may be referred to F. Bond's *Fonts and Font Covers* for a full treatment of the subject. This contains over 400 photographs and drawings of all periods.

 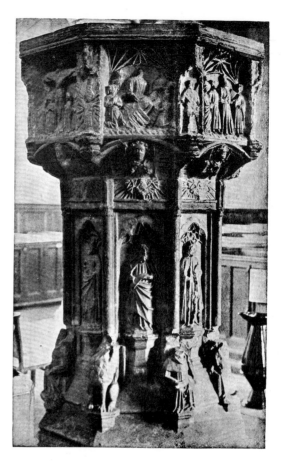

524. *Norwich. All Saints. Apostle font.*
c. 1420

525. *East Dereham (Norfolk).*
Seven Sacraments font. c. 1470

Another series fills the panels with little reliefs of the Seven Sacraments with the eighth panel occupied by a Baptism of Christ, a Crucifixion, an Assumption or some such scene. A good example may be found at East Dereham (Fig. 525), on which niches are contrived on the stem as well as the lions and other figures on the base. In this, too, elaborate lierne vaulting is given to the heads of the niches and the bowl panels, and these later fonts are often raised on stepped platforms with panelled sides, which gives a dignified effect. The actual figure work becomes more perfunctory and mechanical as time goes on, and the interest is centred more on the subjects of the reliefs than on the execution. No doubt when new and gay with colour they were more effective than they are now in the mutilated condition so many of them are in, making the details difficult to identify.

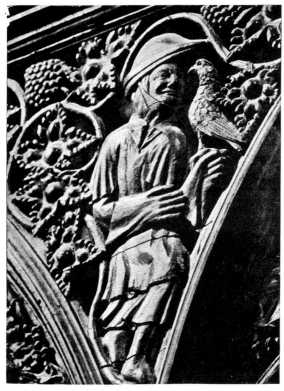

526. *Winchester. Stalls. c. 1300* 527. *Faversham (Kent). Stalls. Antelope*

(6) WOOD-SCULPTURE

In the fifteenth century the carpenter's art reached a new level of attainment in the splendid hammer-beam roofs of East Anglia, in the screens of Norfolk, Suffolk and Devon, and in the stalls of cathedral and collegiate church all over England. This is not the place to describe the elaborate tabernacles and canopies, but the art of the figure carver was called in to complete and give life to the rest.

The great wooden roods, flanked by statues of St Mary and St John on the beams which spanned the chancel of nearly every church, and the figures which must have decked many an altar have all been ruthlessly swept away by iconoclastic reformers, and only an odd fragment here and there remains to give any idea of what they were like.[1]

Stalls in England are remarkable for their rich and elaborate canopies, but these are not usually fitted with statuettes,[2] though late examples occur at Windsor. The large dorsal reliefs common on the Continent are conspicuous by their absence, though small figures occur among the foliage in the earliest of our fine stalls at Winchester (Fig. 526). The ends

[1] A series of statuettes at South Kensington, a Madonna at York, a repainted statue of a fourteenth-century queen in the Library of Queen's College, Oxford, and two figures forming an Annunciation in the Hall of the Vicars' Choral at Wells, a group of St Anne the Virgin and Child at South Kensington, and a much-worn Pietà at Battlefield may be cited as among the most important survivals of wooden images.

[2] Modern statuettes have been fitted in the niches in the canopies at Lincoln and reliefs at Ely.

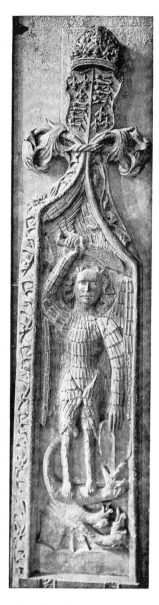 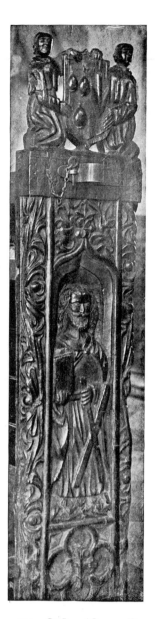

528. *Haverfordwest (Pemb).* 529. *St Ives (Cornwall).*
Bench end. St Michael *Bench end. St Andrew*

of benches are not infrequently richly decorated, as at Ripon and Chester and supports or brackets are carved with monster or animal subjects, as at Faversham (Fig. 527). Fine carved bench-ends also occur in smaller churches and we may take as examples the St Michael at Haverfordwest (Fig. 528) and the St Andrew at St Ives, Cornwall (Fig. 529). In these Cornish churches the Gothic tradition of the carving of benches lingered on well into the sixteenth century, and at Mullion we see Renaissance putti playing with wine casks in the midst of Gothic tracery and next door to reliefs of the Instruments of the Passion.

530. *Windsor. St George's Chapel. Stalls*

271

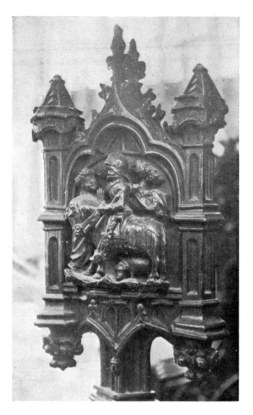
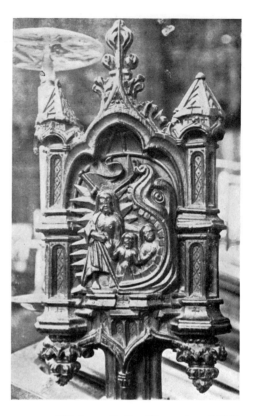

531. *Windsor. Stalls. St George* 532. *Windsor. Stalls. Harrowing of Hell*

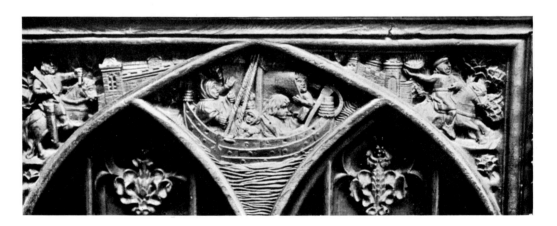

533. *Windsor. Stalls. Front of benches*

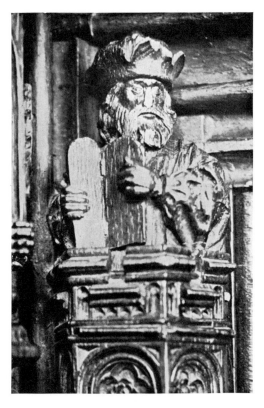

534. *Windsor. Stalls. Moses*

535. *Westminster. Henry VII's Chapel. Stalls*

At the very end of our period the stalls at Windsor (Figs. 530–4) present an astonishing wealth of sculptured detail, which has been described in full by Dr James, the late Provost of Eton. The so-called poppy-heads are developed here to include small reliefs dealing with New Testament subjects and the story of St George (Fig. 531), and the fronts of the benches have a varied series of subjects far too numerous to be detailed here (Fig. 533). There is a touch of Flemish influence to be detected here, as may also be found in the canopies of the stalls of Henry VII's Chapel at Westminster.

Stall arms frequently have animals crawling over them, as at Boston (Fig. 536), and bench-ends are usually carried up to form a foliated finial usually called a poppy-head.[1] Most of these are merely foliage, but figures are sometimes introduced as in the elaborate specimens we give from King's Lynn (Fig. 537), Walpole St Peter (Fig. 538), and Ludlow (Fig. 541). Sometimes little figures are perched on the arm beside them, as at Fressingfield (Fig. 540), and sometimes the whole poppy-head is replaced by a figure, as in the interesting set of the Seven Deadly Sins at Blythburgh (Fig. 539).

It is in the eastern counties that the carving of bench-ends reaches its highest perfection. Until the fifteenth century provision of seating accommodation for the congregation was very scanty and elaborate decoration was reserved for the stalls of the clergy in cathedral or

[1] Supposed to be derived from *puppis*, a poop. Some purists prefer to use an old form 'popey'.

273

536. *Boston (Lincs). Stall arm. c. 1400*

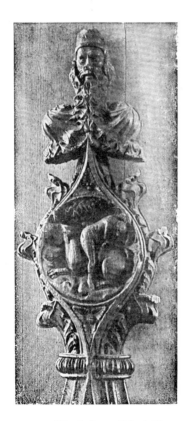

537. *King's Lynn (Norfolk).*
Poppy-head. St Michael.
c. 1415

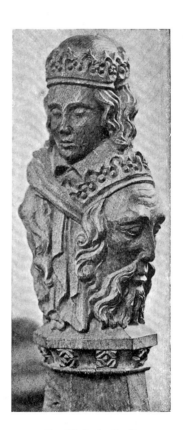

538. *Walpole St Peter*
(Norfolk). Poppy-head.
c. 1450

274

539. *Blythburgh (Suffolk). Figure*
on stall arm. Sloth

540. *Fressingfield (Norfolk).*
Figure on stall arm

collegiate churches. When, however, the increase of trade and manufacture brought wealth
to the middle classes of East Anglia it became the fashion to fit out the naves of many of
the fine new parish churches with a complete set of benches, and these were often enriched
with carving and poppy-heads. Perhaps the finest are the late fifteenth-century examples
at Wiggenhall St Mary the Virgin, where the bench-ends have a figure of a prophet or
saint in a niche and lively little figures are seated on each side of the poppy-head (Fig. 542).
There is a rather earlier set with standing figures and less elaboration of detail on the other
side of the church, and another interesting set at Wiggenhall St German, where an angel
is pointing to the usurer, drunkard, etc., descending into the mouth of Hell (Figs. 12, 13).
Others at Fressingfield, mentioned above, Dennington and St Nicholas, King's Lynn, are
among the richest examples.

Some Lincolnshire churches possess a great assemblage of fine wood-carving. Among
the most striking bench-ends are those at Addlethorpe and Winthorpe. The fine example
from the latter with the story of St Hubert (or Eustace?) is specially worth attention
(Fig. 543).

Some of these little wood carvings have a charm and freshness of treatment that is
lacking in the more conventional serious sculpture of the period. The poppy-heads at
Rettendon, crowned by the bear and ragged staff badge of Warwick and the child carried
off by an eagle of Stanley (the eagle unfortunately missing); the piper sitting beside that at
Honington may be cited as examples (Figs. 544, 545).

275

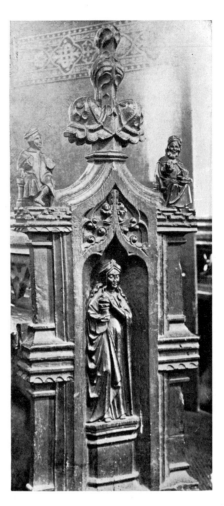

541. *Ludlow (Salop). Poppy-head* 542. *Wiggenhall St Mary the Virgin*
 (Norfolk). Bench end

In Devonshire and the west country benches are usually square-topped, and there is a tendency to cover the whole of the bench-end with tracery or foliage patterns.[1]

The early years of the sixteenth century witnessed a tremendous outburst of wood-carving in the west country churches of Devon, Cornwall and western Somerset. Besides elaborately carved screens and pulpits dozens of churches were fitted out with benches with richly carved ends. Unlike those of the eastern counties they are usually square-headed with panels filled with all kinds of emblems, heraldry, or initials. The Instruments of the Passion are very common, but the figure-subjects were seldom sufficiently developed to be treated here as serious sculpture. We illustrate however a Crucifixion from Abbotsham and a St Brannock from Braunton (Figs. 546, 547).

The finest sets in Cornwall are at Altarnun (Fig. 548), referred to in Chapter 1, St Winnow and Kilkhampton. The fine ship at St Winnow may be included in an account

[1] For illustrations of bench-ends and woodwork generally see Howard and Crossley's magnificently illustrated book on *English Church Woodwork*; also Dr J. C. Cox's *Bench Ends in English Churches*.

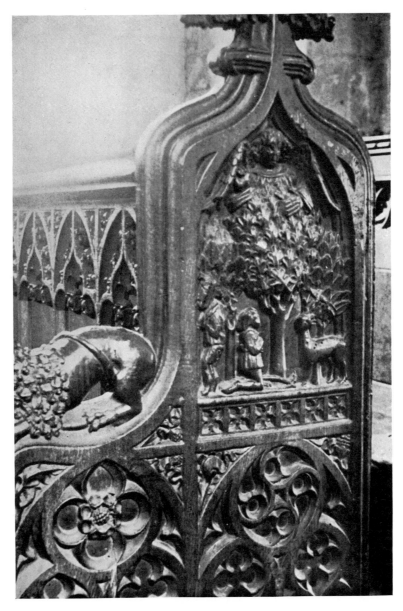

543. *Winthorpe (Lincs). Bench end. St Hubert*

of figure sculpture as the crew are on board (Fig. 549). There is another at Bishop's Lydeard as well as a windmill with the miller and his horse.

In the richly furnished churches of Somerset and Devon pulpits, both of stone and wood, were sometimes decorated with standing figures in niches, as at Trull and Harberton.

It is, however, in the *misericords*, as the seats made to turn up and form a bracket to give support during the long services were called, that the wood-carver found fullest opportunity for his art. There are more than two thousand of these little carvings in parish churches as well as cathedrals, and as they seem to have been less subject to clerical censorship and dictation than the more essentially religious sculptures they form a mine of inexhaustible

277

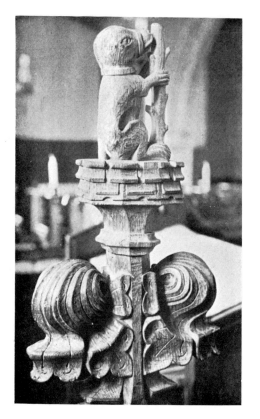
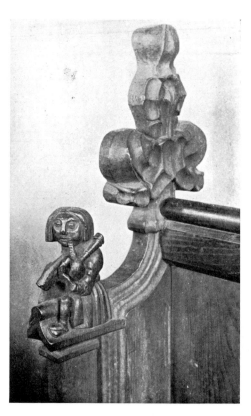

544. *Rettendon (Essex). Poppy-head* 545. *Honington (Suffolk). Bench end. Piper*

wealth for the researchers after medieval iconography. They display a liveliness of imagination, a sense of humour and power of composition that seems to have died out in the more formal productions of the stone-masons of the fifteenth century.

The subjects represented cover the whole field of medieval life and thought. From simple foliage and grotesques they pass on to heraldry and scenes from everyday life. We see the carver of the misericord himself at work (Fig. 21), the huntsman, the farmer, the tournament (Fig. 550). The schoolmaster with birch rod brandished holds his unfortunate pupil across his knees (Fig. 15), the scolding wife belabours her spouse with her distaff (Fig. 551), the boatmen put to sea and a passenger is sea-sick (Fig. 552), or undergraduates listen to a lecture at Oxford (Fig. 553). Agriculture is well represented in most of the big series, as in the vintage at Gloucester (Fig. 554), and the works of the various months, as at Worcester, etc. Satire even on the clergy is frequent, and we see the fox preaching to the geese (Figs. 555, 556), or an ass or an ape chanting the responses. Popular romances such as that of Reynard the Fox, or Alexander's flight to the ends of the earth supported by griffins (Fig. 557), or combats between lions and dragons occur again and again. Perhaps the most fruitful source of all was the Bestiary, a kind of medieval natural history book which described all kinds of beasts fabulous or otherwise, embellished with all sorts of old wives' tales, and ending up with a far-fetched moral. Thus the huntsman carrying off the young of the tiger at Chester (Fig. 6) is seen strewing mirrors in the way as described on p. 7. Fabulous creatures like the mermaid (Fig. 558) are grouped with real beasts like the

278

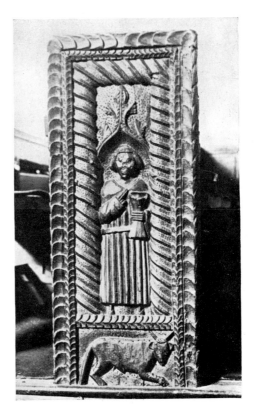

546. *Abbotsham (Cornwall). Bench end.*
The Crucifixion. c. 1530

547. *Braunton (Cornwall). Bench end.*
St Brannock. c. 1520

tiger, lion, elephant or whale, but the stories about them are hardly more incredible than those about the real creatures.

Bible stories, too, are frequent, the Old Testament being more common than the New. Samson carrying off the gates of Gaza (Fig. 559) and Jonah and the Whale (Fig. 560) at Ripon at the end of the fifteenth century are carved with as much spirit and verve as earlier work at Lincoln or Gloucester. The Crucifixion and such serious subjects do not occur, but at Sherborne there is a formidable Last Judgment with Christ seated on the rainbow and the dead rising from their tombs (Fig. 561).

New Testament scenes are found in some of the greater cathedrals like Ely and Lincoln. We illustrate the Resurrection (Fig. 562) and Ascension (Fig. 563) from Lincoln.

The saints are surprisingly rare. There are a few examples of the Evangelists, as at Worcester, St Martin and St Giles appear at Ely, and at Norwich and some other places there is a St George (Fig. 564), though in the latter case it is probable that we merely have a combat between a warrior and dragon.

In shape the English misericords follow a line of their own. On the Continent sculpture is always confined to the central support, but in England this is usually balanced by two supporters or 'ears'. In the earliest thirteenth-century examples these are sometimes omitted, as in the beautiful example we give from Christchurch (Fig. 565), or they are comparatively small and composed merely of a spray of foliage or dragon head, as at

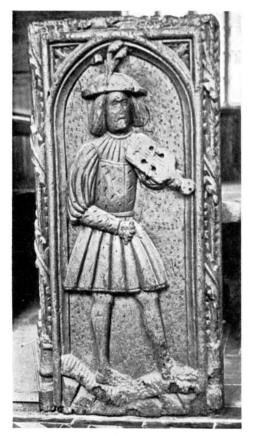

548. *Altarnun (Cornwall).*
Bench end. Viol player

549. *St Winnow (Cornwall).*
Bench end. Ship

Exeter (Fig. 566). Later they become larger, though a spreading leaf or grinning face is often used, and grotesques or animal subjects become common. Sometimes subjects subsidiary to the main theme are employed, like the extra pupils of the schoolmaster at Norwich (Fig. 15) or the geese listening to the preaching fox at Boston (Fig. 555), or else they form part of the group like the tigers at Chester (Fig. 6). Sometimes the ears are almost as important as the main bracket, as at Sherborne (Fig. 561), or in the elaborate Judgment of Solomon at Worcester (Fig. 567); more rarely the whole flat part of the seat is thrown into one design by cusping, as at Gloucester (Fig. 554).

The agricultural labours of the months and seasons are a favourite subject. There is a very complete set at Ripple (Fig. 568) and another at Worcester in addition to the series there from the Old Testament, which are boldly and vividly rendered.

It is remarkable what variety of handling is to be found in the different sets, and it looks as though each great cathedral developed its own local types. The earliest examples, like those at Exeter (Figs. 566, 569), are based on stone-mason's technique, and are not far removed from the little figures on the Wells capitals, but practice soon worked out a more distinctive wood technique. The very distinct mannerisms of Worcester or the special

280

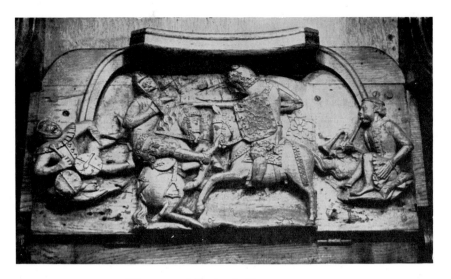

550. *Worcester. Misericord. Tournament. c. 1397*

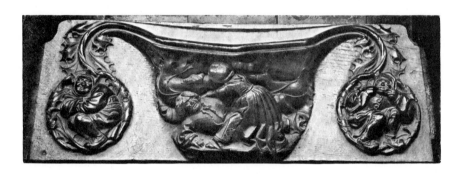

551. *Westminster. Henry VII's Chapel. Misericord. The scolding wife. c. 1509*

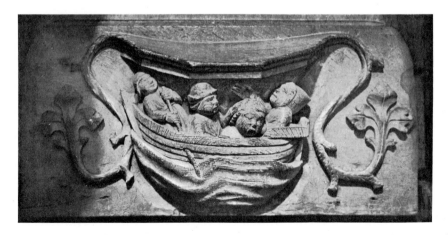

552. *St David's (Pemb). Misericord. The sea-sick passenger. c. 1470*

281

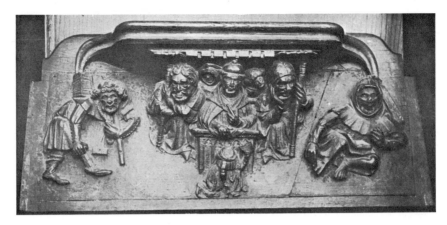

553. *Oxford. New College. Misericord. The lecture. c.* 1480

554. *Gloucester. Misericord. The vintage. c.* 1345

555. *Boston (Lincs). Misericord. Fox preaching to geese. c.* 1390

282

556. *Beverley Minster. Misericord. Fox preaching to geese. c.* 1520

557. *Wells. Misericord. Alexander's flight. c.* 1330

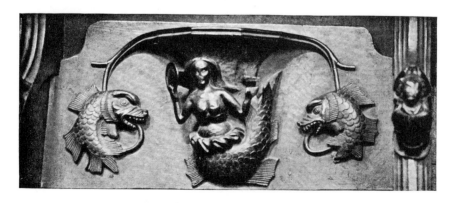

558. *Ludlow (Salop). Misericord. Mermaid. c.* 1435

283

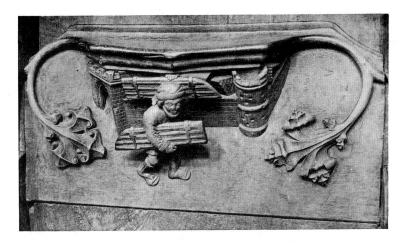

559. *Ripon. Misericord. Samson and the gates of Gaza. c.* 1490

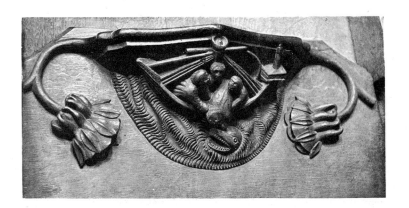

560. *Ripon. Misericord. Jonah. c.* 1490

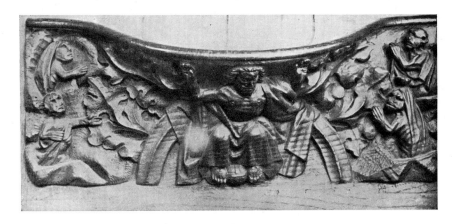

561. *Sherborne (Dorset). Misericord. The Last Judgment. c.* 1436

284

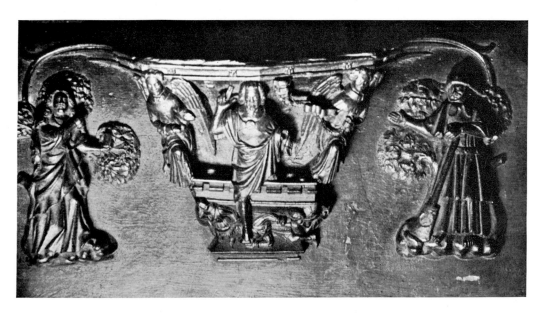

562. *Lincoln. Misericord. The Resurrection. c.* 1370

563. *Lincoln. Misericord. The Ascension. c.* 1370

285

564. *Norwich. Misericord. Combat. c. 1420*

565. *Christchurch (Hants). Misericord. Foliage. Thirteenth century*

566. *Exeter. Misericord. Foliage. Thirteenth century*

286

567. *Worcester. Misericord. Judgment of Solomon. c. 1397*

568. *Ripple (Worcs). Misericord. Works of months. c. 1480*

569. *Exeter. Misericord. Pipe and tabor. c. 1260*

570. *Tansor (Northants). Misericord. Heraldic falcon and fetterlock.* c. 1415

571. *Windsor. Misericord. 'He that sups with the devil....'* c. 1460

572. *Wells. Misericord. Pelican.* c. 1330

573. *Ludlow (Salop). Misericord. Lady with horned head-dress. c.* 1435

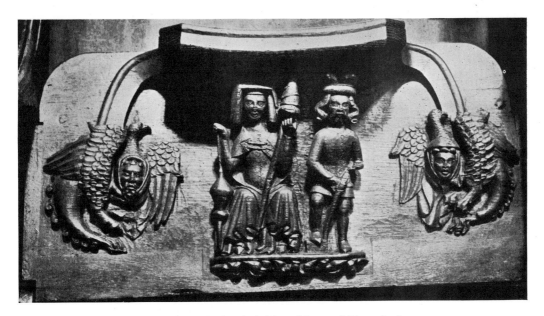

574. *Worcester. Misericord. 'Adam delves and Eve spins.' c.* 1397

designs at Gloucester distinguish them from an entirely different style at Lincoln, Ely, or Carlisle.[1]

Heraldry is introduced at times, as at Tansor, where the royal badges of falcon, fetter-lock and Yorkist rose are made use of as well as the Prince of Wales's feathers (Fig. 570).

Devils are much in evidence in the grand late series at Windsor, and some humour is displayed in one which illustrates the proverb 'He that sups with the devil must have a long spoon' (Fig. 571).

[1] For a more complete treatment of the subject the reader must be referred to F. Bond's *Misericords*, containing numerous photographs. Miss E. Philipson's *Choir Stalls and their Carvings* is also a useful collection, though the drawings are not so good as photographs in more modern books.

Accurate dating of these misericords is not always easy unless some record of the erection of the stalls in which they occur has been preserved. Details of the foliage or head-dresses sometimes help. Thus the stiff-leaf convention of the thirteenth century is decisive as to the date of those at Christchurch (Fig. 565) and Exeter (Fig. 566),[1] the naturalistic type of the early fourteenth century is to be seen at Wells (Fig. 572), and the coarse leaves at Ripon indicate late fifteenth-century work.

The armour of the warriors at Exeter is that of the thirteenth-century crusaders, and that of the huntsman at Chester (Fig. 6) is of the 'Camail' period of the second half of the fourteenth century, as illustrated in our chapter on the monumental effigies. The horned head-dress of the lady at Ludlow is that of mid-fifteenth-century date (Fig. 573). At Worcester Adam and Eve condemned to labour are difficult to recognise in fourteenth-century fashionable costumes (Fig. 574).

Bond in his *Misericords* reports that dates of 1489 and 1494 are carved on those at Ripon and that one at Beverley Minster has that of 1520. The shape of the seat varies so much from place to place that it gives little evidence as to date, but speaking generally the later examples are usually more pointed in front.

(7) BRONZE AND ALABASTER, ALTAR AND TOMB, 1360–1540

So far we have examined the sculpture of screen and chantry, and it remains to review that of the altars or tombs which were the centre of these erections. The art of the imagers was transformed after the Black Death not only by the new social conditions and consequent commercial development of the trade, but also by the introduction of a fresh and beautiful material. The Derbyshire alabaster is a form of gypsum, and differs from continental or oriental alabaster, and it is found near Tutbury and Chellaston, a few miles south of Derby. It does not stand exposure to the weather, but is easy to work, suitable for fine detail and takes colour well. Its earliest use is in one of the inner orders of the rich late Norman doorway of Tutbury Priory (Fig. 619). There was a royal castle at Tutbury, largely rebuilt by John of Gaunt, and it is not unlikely that as Purbeck marble came into favour owing to royal patronage, the same may have been the case with alabaster. There is a record that John of Gaunt gave instructions to his agent at Tutbury to send six cartloads of alabaster for the tomb of his wife in 1374, and his own monument in old St Paul's appears to have been in this material. There seems good reason, therefore, to suppose that London, having no stone of its own, imported alabaster along with other materials for the use of its school of imagers.

(a) Bronze

Before discussing the output of the alabaster men, it will be best to describe the later bronze tombs erected for royal or very distinguished persons, as they to some extent served as a model for all the others to follow.

The first of these to be made after Henry III and Queen Eleanor was that of the Black Prince, d. 1376, at Canterbury (Fig. 575). In his will he directed that 'an image shall be placed in memory of us all armed in steel for battle', and the sculptor has taken the utmost

[1] Single examples of thirteenth-century date remain at Hemingborough (Yorks) and at Westminster one misericord, survivor from the choir stalls, has been incorporated in those of Henry VII's Chapel.

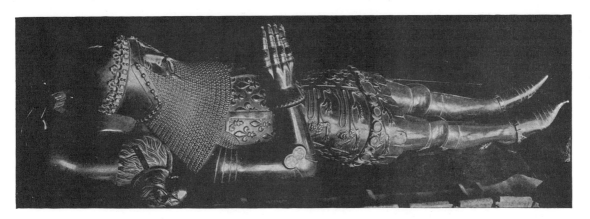

575. *Canterbury. The Black Prince. d. 1376*

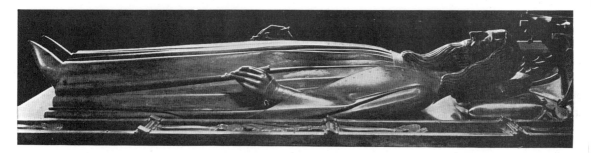

576. *Westminster. Edward III. d. 1377*

pains to render every detail of the armour. The armour is typical of the last quarter of the fourteenth century, when plate is beginning to replace mail on arms and legs. The prince wears the pointed bascinet, from which the camail depends, and there is a coronet round it. The jupon, which was probably still of leather, worn over mail, is blazoned with the royal arms. The legs are straight, as the cross-legged attitude would no longer be comfortable in steel plate, and the hands are clasped in prayer. Little of the face is exposed, and we can hardly call this a portrait, nothing more than a general typical warrior being intended. The bronze technique has been thoroughly mastered, but the stiff pose necessitated by the growing elaboration of the armour prevents the variety of action or the more romantic attitudes of the previous generation.

Edward III's own effigy is rather severe in its straight lines and balanced pose with a sceptre in each hand to represent England and France. The individual features and long beard give this figure a better claim to be a portrait than anything we have yet seen (Figs. 576, 577). No account of the making of this tomb has been preserved, but we know that John Orchard, 'latoner', was in the king's employ at this time and supplied railings and six angels for Queen Philippa's tomb, and he was very likely responsible for the bronze work of Edward III's tomb. The tomb-chest is of Purbeck marble, and on it stand as weepers six little bronze figures of his family (Figs. 578, 579). These are excellent specimens of the fashionable costume of the time, the tight bodice with large buttons and stiff-framed

291

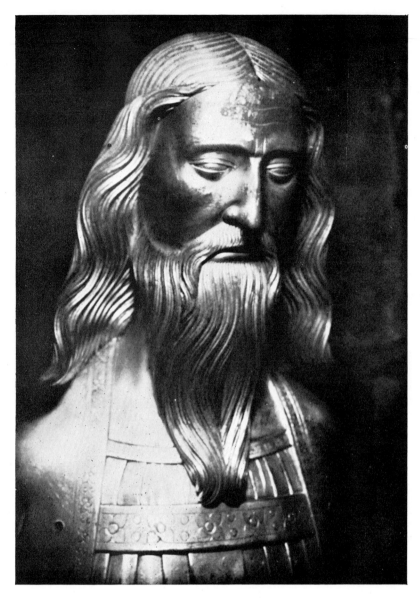

577. *Westminster. Edward III*

head-dress of the princess being most characteristic. The same costume with the hair in tight cauls on each side of the head is worn by Queen Philippa, whose effigy appears to be of white marble, not alabaster. It was made by a foreign artist Hawkin (or Hennequin) of Liège (Fig. 580).

The effigies of Richard II and his Queen Anne were made in 1395 after the death of the queen (Figs. 581, 582). In that year a contract was signed with Nicholas Broker and Godfrey Prest, citizens and coppersmiths of London, for two gilt images crowned and clasping their right hands. Details of all accessories were set out and instructions for engraving the table on which they were set. All was to be performed in two years according to a 'patron' which Nicholas and Godfrey had shown the king, and they were to receive

292

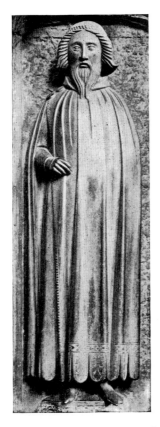

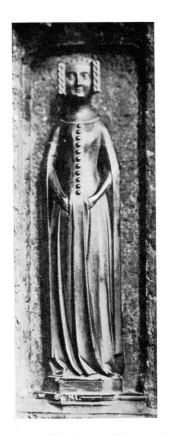

578. *Westminster. Weeper of*
Edward III's tomb. The Black Prince

579. *Westminster. Weeper of*
Edward III's tomb. Princess Joan

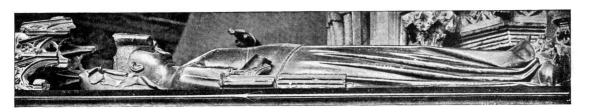

580. *Westminster. Queen Philippa. c. 1370*

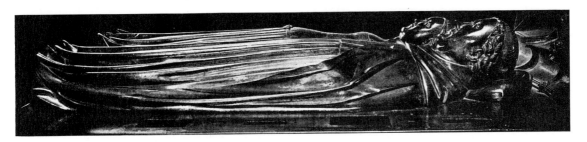

581. *Westminster. Richard II and Queen Anne. c. 1395*

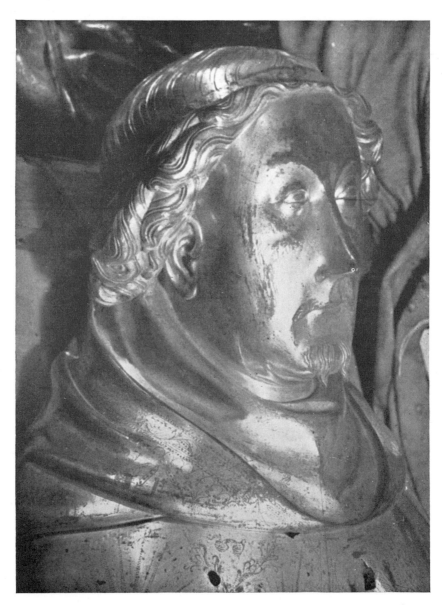

582. *Westminster. Richard II. c.* 1395

£400. Precious stones were set down the middle of the queen's bodice. The arms were cast separately and have been lost. As the king was still alive and taking an interest in the work there was probably some attempt at portraiture. If the work as ideal sculpture does not compare with Torel's figures of a hundred years earlier, these effigies at least were splendidly finished with elaborate accessories and presented a sumptuous appearance.

Henry V's effigy was of oak plated with silver, but only the battered core of wood remains. One other magnificent bronze, however, survives on the tomb of Richard Beauchamp, Earl of Warwick, and here again the contract has been preserved, as stated in our introductory chapter (see p. 17).[1] William Austen's figure (Fig. 583), in spite of its

[1] P. B. Chatwin, 'Monumental Effigies in Warwickshire' (*Birmingham Arch. Soc. Trans.* 1921).

peculiar visage, can hardly have been a portrait as it was made in 1454, and the famous earl died in 1439. Austen undertook to make the 'image of a man armed according to patterns', and he evidently took the greatest pains to represent the splendid armour of the earl in every detail. It is finished on the back as carefully as on the front, and the whole execution is masterly, even down to the veins on the hands. The tomb is of Purbeck marble, and in the niches are placed little figures of angels and weepers alternately. The weepers are clad in heavy mourning cloaks (Fig. 584), following the fashion set by the magnificent tombs of the Dukes of Burgundy at Dijon by the school of Claus Sluter,[1] and are master-pieces of their kind.

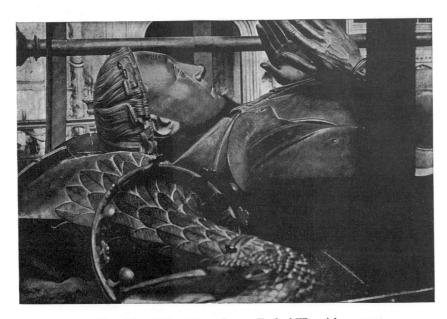

583. *Warwick. Richard Beauchamp, Earl of Warwick. c. 1454*

Henry VII's tomb and that of the Lady Margaret at Westminster were made by the Italian Torrigiani, but the superb grate enclosing the tomb is English work, and may with some probability be attributed to Laurence Ymber,[2] who competed with Drawswerd of York for the original design which was never carried out. On the grate are several small bronze statuettes of considerable power and beauty. We illustrate two of them representing St James and St George (Figs. 585, 586) to show that native craftsmen were able to make figures fit to stand beside the masterpieces of the countryman and contemporary of Michelangelo without looking foolish.

Although this magnificent tomb marks the introduction of Italian style into England, we may include it here as the general idea continued the old English tradition; the form

[1] See the author's *Medieval Sculpture in France*, Figs. 421, 422, 423.
[2] J. Harvey in his *Gothic England* thinks it probable that Ymber may be identified with Lawrence Ember, a native of Swabia naturalised in England. He provided the wooden patterns to be cast by Nicholas Ewen.

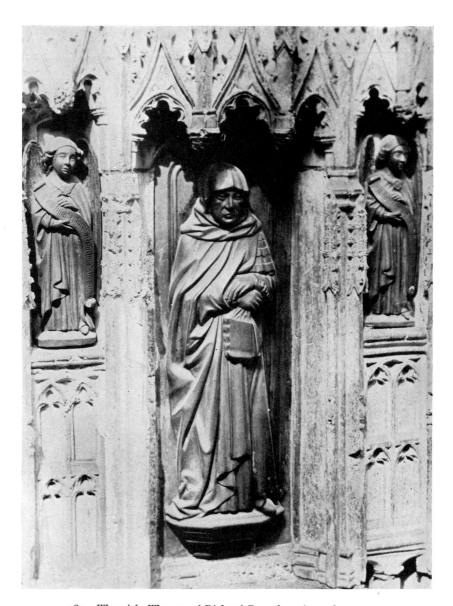

584. *Warwick. Weepers of Richard Beauchamp's tomb.* c. 1454

of tomb with effigies lying side by side with hands clasped in prayer, the costumes worn at the English court, and the pedimental head-dress of the queen were all taken over by Torrigiani. The new features he introduced were the roundels at the side of the tomb, the boy angels seated at the corners, the more scientific rendering of the folds of the drapery and the more realistic portraiture in the faces (Figs. 587, 588).

The effigy of Lady Margaret Tudor, Countess of Richmond and Derby, and mother of Henry VII must also be attributed to Torrigiani. It is a striking and lively portrait of that noble old lady, and a masterpiece of early Renaissance sculpture, though still enshrining the old Gothic ideals in the general pose and lay-out of the tomb (Fig. 589).

The brasses, or flat incised plates of laton, which were such a popular form of memorial

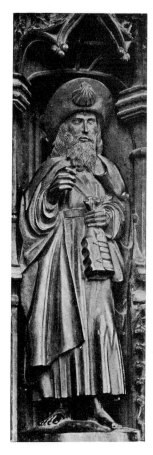

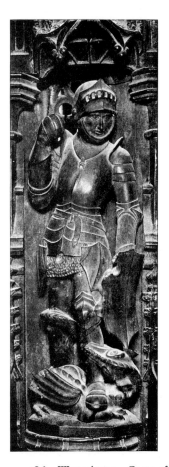

585. *Westminster. Grate of*
Henry VII's tomb. St James

586. *Westminster. Grate of*
Henry VII's tomb. St George

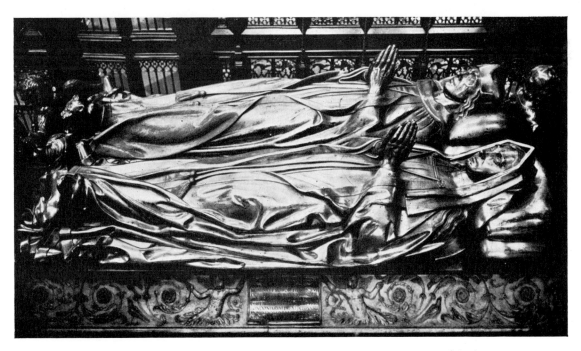

587. *Westminster. Effigies of Henry VII and Queen Elizabeth of York by Torrigiani.* 1512–19

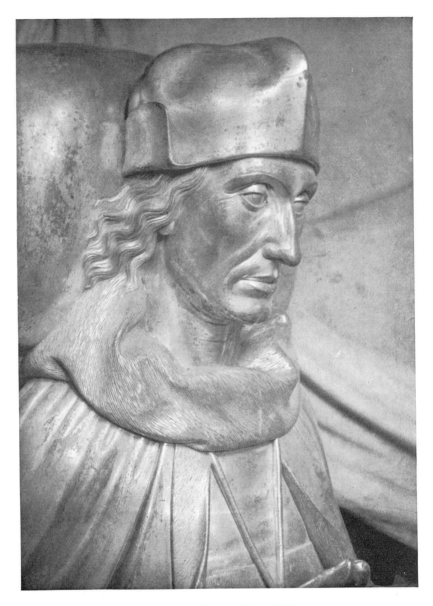

588. Westminster. Henry VII

in our churches, are more drawings than sculpture and cannot be described here. They are useful for comparison and for settling points of costume and date, but for these the reader must be referred to the excellent monographs which deal with the subject.[1]

[1] The most convenient is probably H. W. Macklin's *Brasses of England*, 1907. The Victoria and Albert Museum *List of Rubbings of Brasses* contains a very valuable series of illustrations from the rubbings.

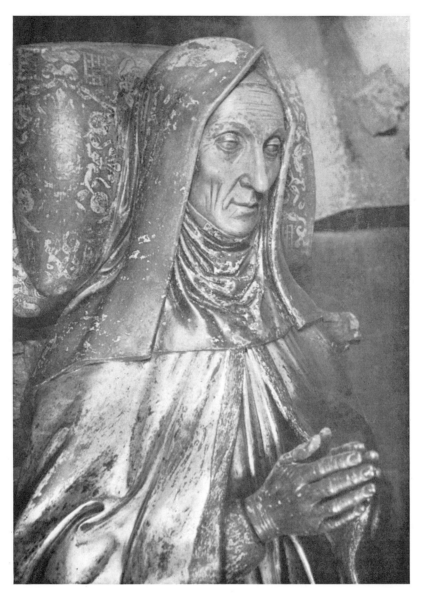

589. *Westminster. Lady Margaret by Torrigiani. c.* 1515

(b) Alabaster

Alabaster[1] seems to have come into general use during the second quarter of the fourteenth century, and after the Black Death its use increased rapidly until it set the fashion for all the other trades in religious and monumental sculpture. In the fifteenth century its reputation was so great that there is evidence of a considerable export trade to various

[1] A very valuable paper 'On the Early Working of Alabaster in England' was published by W. H. St John Hope, in the *Archaeological Journal*, 1904. Much of this was reprinted together with an article on 'The Sculpture of Alabaster Tables' by E. S. Prior in the *Illustrated Catalogue of the Exhibition of English Medieval Alabaster Work* held at Burlington House, 1910.

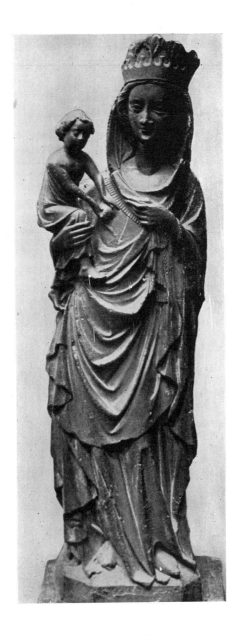 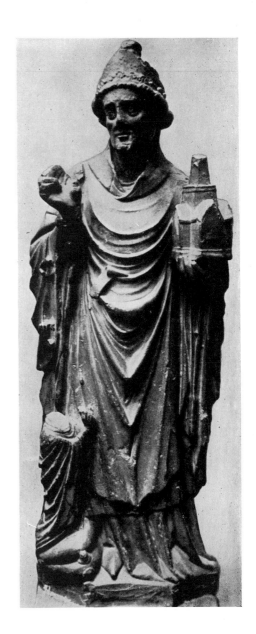

590. *Flawford (Notts). Alabaster Madonna* 591. *Flawford (Notts). Alabaster St Peter*

parts of the Continent. For instance, Queen Joan, after her marriage to Henry IV, ordered an alabaster tomb for her first husband, John, Duke of Brittany (d. 1399), to be erected at Nantes. This was made by Thomas Colyn, Thomas Holewell and Thomas Poppehowe, and completed in 1408. A drawing of it exists,[1] made before its destruction at the Revolution. In 1382 the king gave orders to the Customs officials at Southampton to allow the Pope's representative Cosmato Gentilis to export three images of alabaster, of the Virgin, St Peter and St Paul and a small one of the Trinity. Three small statues were discovered

[1] F. H. Crossley reproduces this in his *English Church Monuments* (from Lobineau's *Histoire de Bretagne*, 1707, p. 27).

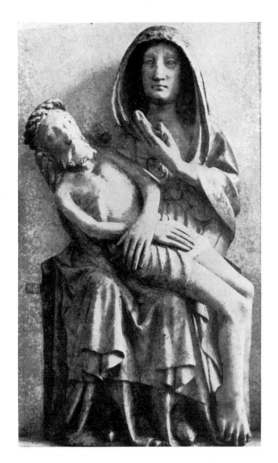

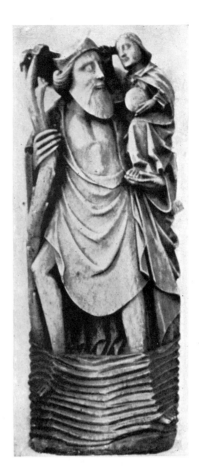

592. *Victoria and Albert Museum.*
Dead Christ on mother's knees

593. *Victoria and Albert Museum.*
St Christopher

not long ago beneath the floor of the church at Flawford, and are now in the Nottingham Museum. The two finest of them, a Madonna, some 28 inches high (Fig. 590), and a St Peter in the garb of a medieval pope, a few inches higher (Fig. 591), still retain much of the elegance of early fourteenth-century style and have not developed the mannerisms of fifteenth-century commercial production. Later figures were mostly made in connection with the retables, of which they formed part, and display coarser handling and mass-production mannerisms. Examples of later and rather less refined statuettes may be found in the magnificent collection presented to the Victoria and Albert Museum by Dr Hildburgh. We illustrate a Magdalene (Fig. 594), a St Christopher (Fig. 593) and a striking example in a Pietà with the dead Christ resting on his mother's knees (Fig. 592), a St James of better quality (Fig. 595) and the group of the Holy Trinity (Fig. 597) with the crucifix in front of the crowned and bearded figure of God the Father, the Dove being often added in metal or other material and frequently missing. This subject is often used as the centre piece of a reredos as in our example from South Kensington (Fig. 599).

An enormous number of little reliefs about 15 inches high by about 11 inches broad, together with a number of larger panels, are scattered all over Europe in churches and museums, and until recently their origin was not realised. They are found as far away as

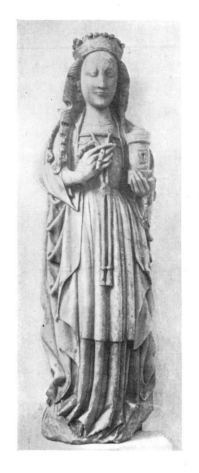

594. *Victoria and Albert Museum.*
Magdalene

595. *Victoria and Albert Museum.*
St James

596. *Victoria and Albert Museum.*
St Jude

Iceland and Italy, and beside those exported complete before the Reformation there is no doubt that a great number were sold abroad when they were turned out of our own churches by the reformers.[1] These were grouped in wooden frames to form reredoses or retables. None of these remains in England in its original position, but a few complete specimens in their original settings remain in France, Germany, Italy and elsewhere, and the South Kensington Museum has acquired a complete specimen (Fig. 599), which preserves much of its colouring as well as the wooden frame, and helps to give a notion of the rich and gorgeous effect attained. Many of these panels, or tables as they were called, are crude in execution, and the harsh cutting and shop mannerisms are not attractive on close inspection, but when looked at from a distance, as they were intended to be, the rich and mellow colouring, the gilded hinges and Gothic lettering of the inscriptions between the tables produce a very beautiful impression, and the hard lines serve to bring out the subject-matter in a way which finer sculpture would have failed to attain. We illustrate

[1] Sir William St John Hope found a letter from France in 1550 complaining that three or four ships laden with images had arrived and that the contents had been sold in Paris, Rouen and other places.

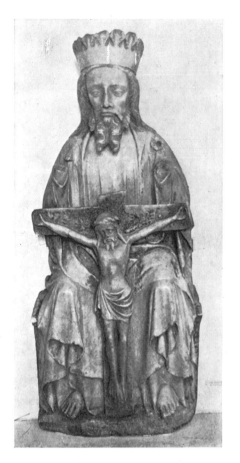

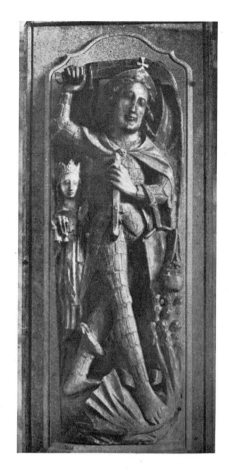

597. *Victoria and Albert Museum.*
Holy Trinity

598. *Victoria and Albert Museum.*
St Michael

two examples from France to show how these retables were made up. They were usually composed of five or seven tables, the middle one being taller than the rest, and a single figure was often placed at the ends (Figs. 600, 601). Sometimes more elaborate erections were made with two tiers, and a number of small single figures between them. These are all late examples, but there is a record of very large sums being paid to Peter 'maceon' of Nottingham for a large retable to be placed in the chapel of St George at Windsor, *c.* 1370, and in 1372 John Lord Nevill of Raby ordered a magnificent reredos of alabaster for Durham Cathedral.

In 1456 an English parish priest on pilgrimage to Santiago de Compostella took with him an alabaster reredos illustrating the story of St James, the greater part of which still exists. It has the crested heading which is characteristic of the later types.[1]

For these retables the panels were grouped in sets of suitable subjects. Thus the Annunciation, Nativity, Magi, Circumcision, Coronation of the Virgin with a tall central panel of the Assumption would make a Virgin set, or a central panel of the Crucifixion would have the various Passion scenes, the Betrayal, Flagellation, Entombment and Resurrection, grouped round it. These are the commonest, but panels devoted to the Baptist and other

[1] Dr Hildburgh in *Antiq. Journ.* 1926.

599. *Victoria and Albert Museum. Part of elaborate reredos in original frame*

600. *Issac-la-Tourette (Puy-de-Dôme). John the Baptist retable. c. 1450*

saints, a number of martyrdom scenes and many other interesting subjects appear, though the exact grouping is a matter of conjecture as the examples in England have mostly been dug up one by one from beneath the floors of churches or picked up separately by collectors all over Europe.[1]

[1] Several papers by Dr Hildburgh and Dr Nelson have been published in *Archaeologia*, the *Archaeological Journal* and the journals of other antiquarian societies on these tables and give examples of unusual subjects.

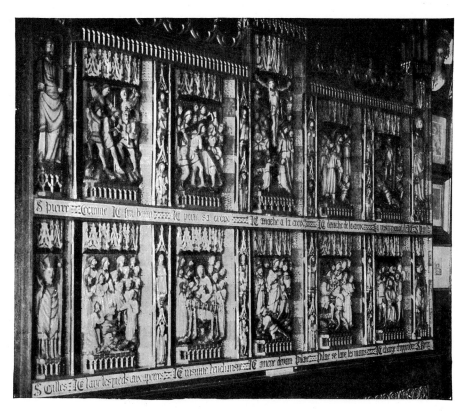

601. *Compiègne Museum. Alabaster reredos. c. 1480*

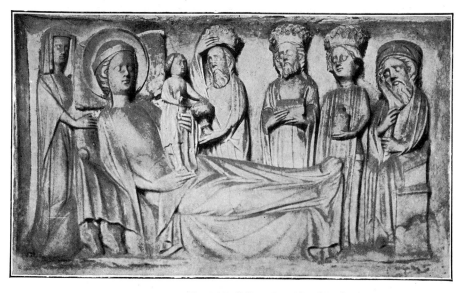

602. *Long Melford (Suffolk). Retable. Magi*

305

603. *British Museum (from Kettlebaston). Coronation of the Virgin*

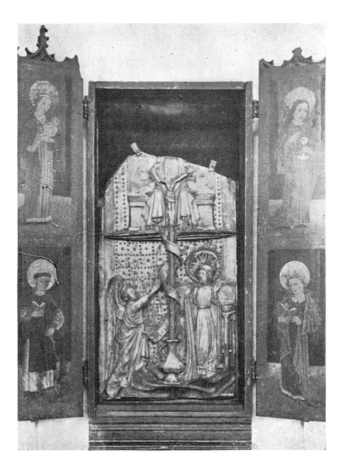

604. *Victoria and Albert Museum. Alabaster table set in triptych*

306

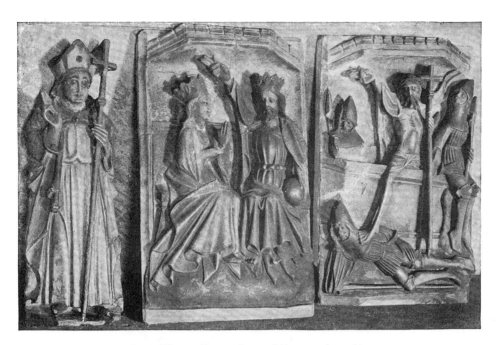

605. *Ripon. Coronation and Resurrection tables*

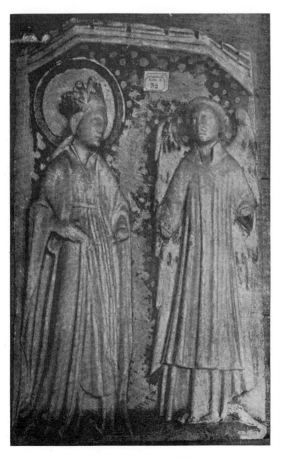

606. *Beauvais. Panel. Annunciation*

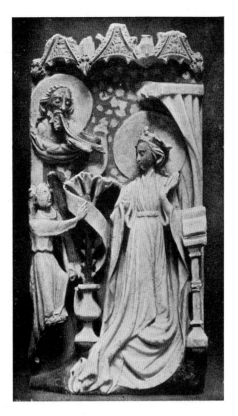

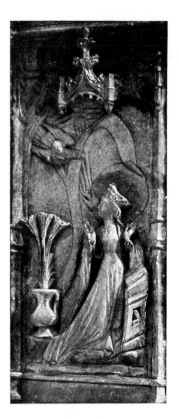

607. *British Museum. Panel.*
Annunciation

608. *Wells. Tomb chest.*
Annunciation

The earliest tables may not always have been framed up to form retables as they are finished off smoothly with a kind of edging all round, as if for individual exhibition. Thus there is a long wide panel in Long Melford Church representing the Magi, which would not have fitted into the scheme of any complete reredos which has survived (Fig. 602). Some broken slabs from Kettlebaston in the British Museum are of exceptionally refined handling with the graceful overlapping draperies of the middle of the fourteenth century. One of these has the Coronation of the Virgin (Fig. 603) treated in a novel way: she kneels to receive the crown instead of being placed on a throne beside her Son, as in the thirteenth century, and this contrasts also with a later fifteenth-century version where she sits in front in the middle and is crowned by the three persons of the Trinity.

Single figures or panel scenes were sometimes framed up separately for private use. They might be placed in a wooden cupboard with doors to open and form a triptych on the lines of one in the Victoria and Albert Museum, which is now placed in a painted setting of this kind (Fig. 604). Another of St Jude (Fig. 596) like the St John's heads to be mentioned presently, are more or less finished completely in the alabaster and were evidently meant for separate exhibition. The vast majority, however, were meant for employment as part of a retable framed up in wood. The collection of these alabaster carvings presented to the Victoria and Albert Museum by Dr Hildburgh enables them to be studied in detail better there than anywhere else.

308

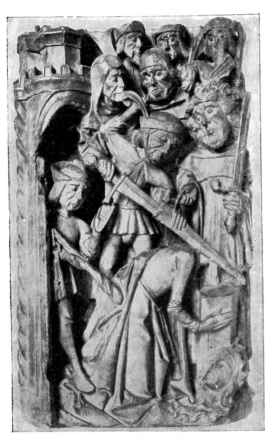

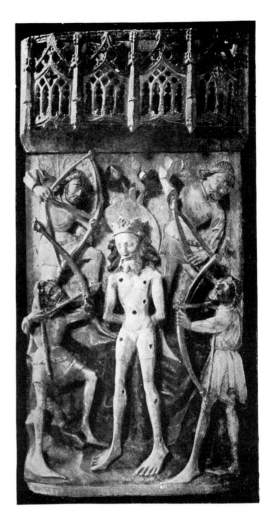

609. *Society of Antiquaries. Table.*
Martyrdom of St Catherine

610. *Private collection. Table.*
Martyrdom of St Edmund

Another group of panels may be separated as being fairly early, as the costume of the figures and camail and jupon worn by the soldiers points to a date in the fourteenth century. These are distinguished by having an embattled canopy worked in the same piece as the rest of the slab, as shown in a Coronation of the old type and a Resurrection at Ripon (Fig. 605). In the latter Christ steps from the tomb with arm outstretched, whereas in the late versions his arm is bent and held close to the shoulder. An Annunciation now at Beauvais (Fig. 606) has the embattled canopy and the angel is advancing quietly from the right instead of from the left, as usual. The quiet dignity and delicate drapery mark this as retaining fourteenth-century style. The later treatment of this subject is more dramatic. The angel kneels and holds out a scroll, while the Virgin starts back with a gesture of surprise: between the two is a lily pot, and a bust of God the Father appears at the top with a dove descending from his mouth (Fig. 607). In the example we show[1] there is a gabled canopy which serves to introduce the later fashion of making a kind of cresting

[1] As, however, this panel is rather small it is possible it came from a tomb and not a retable.

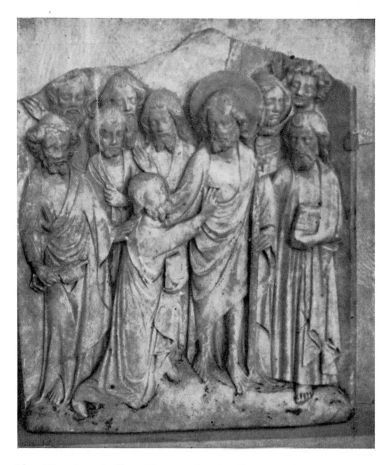

611. *Victoria and Albert Museum. Panel. The Incredulity of St Thomas*

in the shape of a row of little traceried windows in a separate block to be fixed above the tables, as shown in the complete sets at South Kensington (Fig. 599) and elsewhere.

These later fifteenth-century tables are not finished off so carefully at the edges, and the vast majority of our surviving specimens have lost the cresting. They show an increasing tendency to coarser handling and mannerisms as time goes on, though some of the uglier features, like the bulging eyeballs, would have been modified when the eyelids and lashes had been filled in with colour. The armour of soldiers and executioners is of a later type and a kind of sallet replaces the bascinet, but as these are usually only men-at-arms exact dating is not so easy as in the case of the effigies of the knights whose armour enables them to be dated very closely. In the martyrdom scenes the executioners are given hideous faces, which seem sometimes to have been painted black, and the onlookers wear large hats (Fig. 609). In the St Edmund table (Fig. 610) the traceried cresting has been preserved and is well seen.

The Victoria and Albert Museum has several panels from a reredos of the early and more refined type which can be assigned to the fourteenth century. We illustrate the Incredulity of St Thomas from a Passion series (Fig. 611). Other fine panels have the Descent from the Cross and the Last Supper.

310

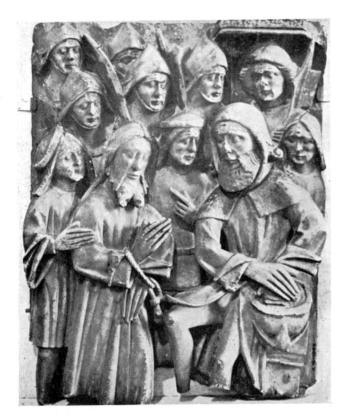

612. *Victoria and Albert Museum. Panel. Christ before Pilate*

Among the later examples there is considerable variety of handling indicating different workshops. Standing out from the rather coarse and overloaded scenes of the end of the fifteenth century there are a number of tables from another Passion reredos of a bolder design and with larger figures. They include a Christ before Pilate, a scene in the garden after the Resurrection, an Agony in the garden, and a Descent from the Cross (Figs. 612, 613, 614).

In the latest examples the scenes become crowded and workmanship careless; exaggerations of anatomical details and affected attitudes show the last degradation to which the shop-carvers came (Fig. 615). Certain tables with a large head of John the Baptist in a charger, a Resurrection below and saints on either side, seem to have been made for private worship, and were hawked about the country (Figs. 616, 617). In 1491 Nicholas Hill, an image-maker, brought an action against his salesman for the value of 58 heads of St John the Baptist, which shows the wholesale nature of the trade. The three small statuettes in Fig. 618 are excellent specimens of the small figures ranged between the tables in the reredoses.

The chief centre of the alabaster trade was in Nottingham and round the quarries, though at first it seems likely that the alabaster was sent to London to be carved. The great Durham altar-piece was to be sent in boxes from London. Alabaster-, or 'alablaster-men', as they are sometimes called, have left records at York, Lincoln, and later at Burton, and probably also existed at such important centres as Bristol and Norwich. It is,

311

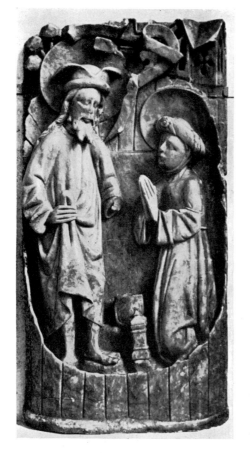

613. *Victoria and Albert Museum. Panel.*
Scene after the Resurrection

614. *Victoria and Albert Museum. Panel.*
Agony in the garden

however, purely a matter of conjecture to try to assign definite types of panels to any special centre. Our only fixed point is the tomb at Lowick, where the contract with Chellaston workers has been preserved, but this has no special feature in common with the retables.

Besides the retables the alabaster shops were kept busy in providing the *tombs* which survive in great numbers, and which set the fashion for such monuments for nearly 200 years. Two wall-tombs exist at Bakewell and Youlgreave. The first (Fig. 620) is a monument to Sir Godfrey Foljambe, d. 1376, and he and his lady are shown as half figures looking out from beneath an ogee canopy, as from a window, and the top of the slab is embattled like the earlier tables. The Youlgreave slab is much later and commemorates Robert Gylbert, d. 1492, who kneels with his wife on each side of the Madonna, while his numerous sons and daughters fill the sides of the panel (Fig. 621).

These, however, are exceptions. The usual form of tomb consisted of a tomb-chest surmounted by the effigy of the deceased laid flat on his back with his head resting on cushions, or on a tilting helm if a knight, and his feet against a lion or other beast. Little angels sometimes sit beside the head, as on the earlier Westminster tombs, and pet dogs

312

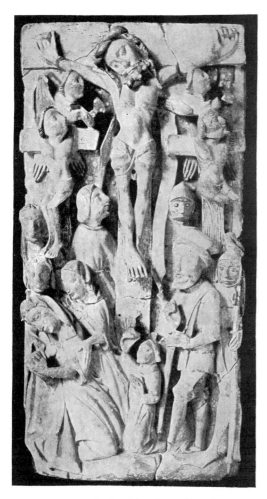

615. *Oxford. Ashmolean. Panel.*
Crucifixion

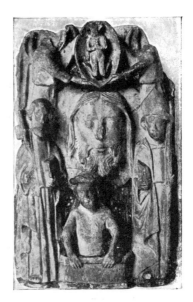

616. *Oxford. Ashmolean. Table.*
John the Baptist's head

617. *Private collection. Table.*
John the Baptist's head

often take the place of lions at a lady's feet, and sometimes play with the hem of her skirts. There is little variety in pose, and we miss the more romantic handling of the stone and wood effigies of *c.* 1300, but this is to some extent made up for by the changes in costume and armour, which are very carefully studied, and the effigies give us a most interesting series illustrating the changes of fashion and accoutrements.

The tomb-chest was either set against a wall (Fig. 622), usually under an ogee canopy, or was standing free in the shape of what is called a table tomb. This might not always be of alabaster, any more than the canopies occasionally erected over it, but when alabaster was used the sides were sometimes panelled, but more frequently decorated with niches or later divided up by miniature buttresses with crocketed canopies joining them, and in

618. *Alabaster retable. Statuettes. c. 1450*

these niches were placed rows of 'weepers', as they are called. These might be relatives, like the bronze sons and daughters of Edward III at Westminster, or they might be saints, or angels carrying shields blazoned with the family arms (Fig. 623). Sometimes religious scenes like those on the tables were introduced as on a tomb of an ecclesiastic at Wells (Fig. 608), where an Annunciation might have come straight from the same workshops as the retables. A later Annunciation with cresting very like that given to some of the later tables may be found on a tomb at Abergavenny (Fig. 624) and shows that the production of reredos and tomb was going on side by side in the same workshops. In the splendid tomb of the Earl at Arundel the weepers are the Canons of the College he had founded (Fig. 625). The tomb of Prince John of Eltham, son of Edward II, who died in 1334, has lost its superb canopy, but is remarkable as one of the first of the alabaster tombs. The weepers are cut out of alabaster, and the background pierced and backed up with a dark stone, this mixture of materials suggesting that it is a London work. The little weepers, who are mostly kings and queens, are lively and charming, though they lack the dignity of the earlier stone weepers on Crouchback's tomb. There are exaggerations of hands and other features to give emphasis, and they are full of life (see Fig. 362).

Alabaster weepers do not become common until after about 1370. Those on the tomb of Thomas Beauchamp, Earl of Warwick, who died in 1371, are excellent examples of the costumes of the period (Fig. 626). The short jerkin of the men, tight bodices and long cloaks of the women, produce rather a jaunty effect, though the framed or reticulated head-dresses of the ladies sometimes make them look somewhat grim. In the North the

314

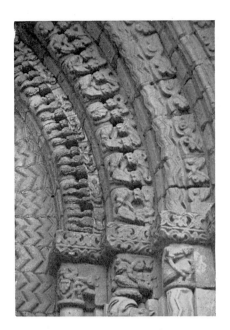

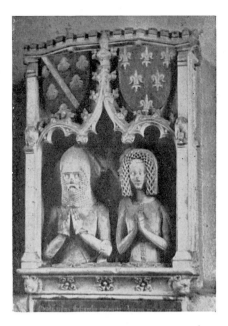

619. *Tutbury (Staffs).*
Earliest use of alabaster

620. *Bakewell (Derby). Wall-tomb.*
Sir Godfrey Foljambe and his lady.
d. 1376

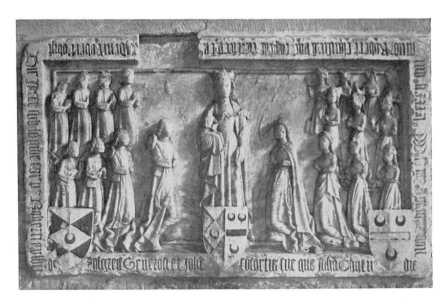

621. *Youlgreave (Derby). Wall-tomb. Robert Gylbert and his lady*
with Madonna. d. 1492

315

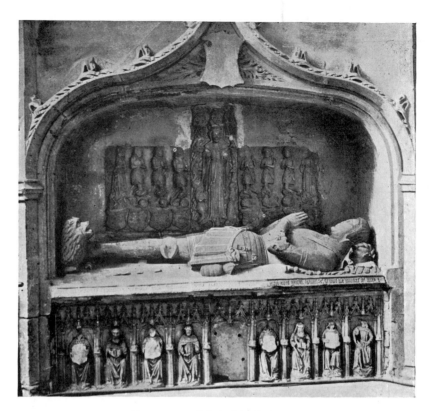

622. *Abergavenny (Mon). Tomb-chest.* c. 1500

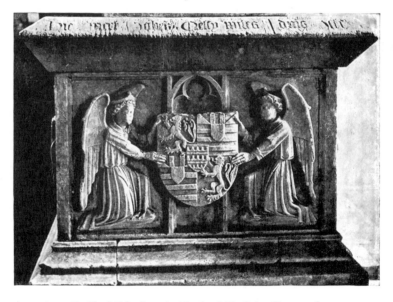

623. *Dodford (Northants). Tomb of Sir John Cressy.* d. 1444

316

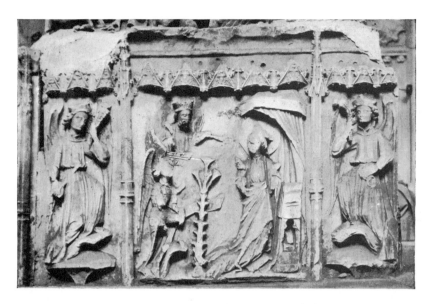

624. *Abergavenny. Tomb end. Annunciation*

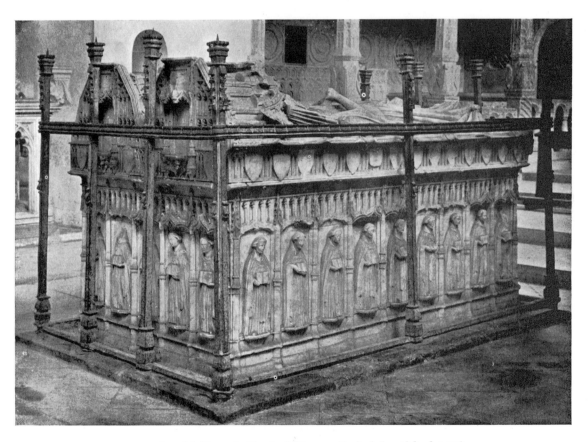

625. *Arundel (Sussex). Tomb of Thomas, Earl of Arundel. d.* 1416

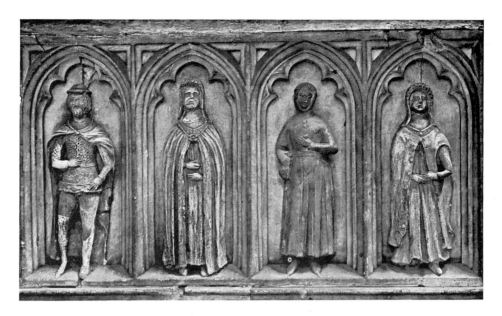

626. *Warwick. Weepers of Thomas Beauchamp's tomb. d.* 1371

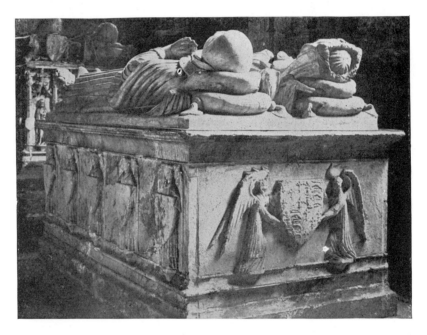

627. *Harewood (Yorks). Tomb of Sir William Gascoigne. d.* 1419

housings are sometimes omitted altogether, and angels holding shields, as at Harewood and Swine (Figs. 627, 628), kneeling in pairs on little footstools, are carved upon plain flat slabs. At Merevale they have a plain background (Fig. 631), and at Bottesford they occupy oblong framed panels (Fig. 630), but at Lowick the contract stipulated for 'tabernacles', and we accordingly find the angels placed between little buttresses with a flat ogee canopy over them (Fig. 629). They usually wear albs and a flat cap with the hair brushed

318

up on each side of it, and the primary wing feathers are carved with tips turned up, the smaller feathers being left for insertion by the painters. The later angels usually wear low mitres with a cross set in the apex. In the second quarter of the fifteenth century a more formal system of panelling on the lines of Perpendicular window tracery makes its appearance, as at Ashbourne (Fig. 632), and in the third quarter the usual arrangement was that with a loftier ogee canopy richly crocketed between the little buttresses, as at Norbury (Fig. 633). These later tomb-chests are often very elaborate; one favourite design was to have two little canopies over each figure with a pinnacle between them cut off above the heads and not carried down, as at Ewelme (Fig. 634). Here the shield-bearing angels are alternately clad in albs and in feathered tights like the big wooden roof angels.

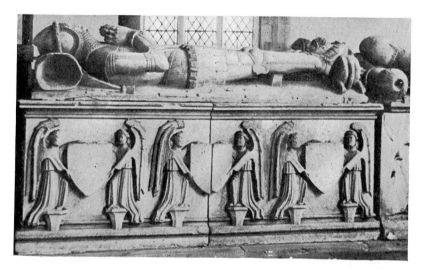

628. *Swine (Yorks). Alabaster tomb. c. 1410*

In the latest tombs the weepers are often grouped in twos and threes, sometimes standing hand in hand, as at Ashover (Fig. 635), or else pose in mimic attitudes of grief, as at Kinlet (Fig. 636). In this last tomb, that of Sir John Blount, d. 1531, the first signs of Renaissance influence begin to appear. The scrolls forming the canopies are decidedly Flemish in type, but the figures themselves are still purely Gothic, though possibly rendered with slightly more delicacy than some of the later fifteenth-century figures.

In a late wall tomb at Abergavenny (Fig. 622) the weepers appear to be seated, and in the recess under the enclosing canopy an Annunciation slab, of the type made for the retables, is set with kneeling knights and ladies on each side, whose costume and armour is so exactly like that of the main effigy that these seem to be in their right position.

In some of the latest monuments the elaboration of the canopies is carried to an extreme and imitation vaulting is placed underneath them, while twisted shafts at the corners are heralds of the Renaissance. It is a curious fact that in one of the last pre-Reformation tombs, that of Sir Richard Knightley at Fawsley, the alabaster weepers are cut out and set against a black background, very much as those of John of Eltham had been placed at the first introduction of alabaster for tomb making.

319

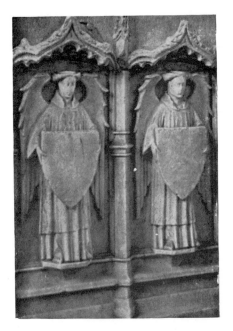

629. *Lowick (Northants). Angel weepers*

630. *Bottesford (Leics). Angel weepers*

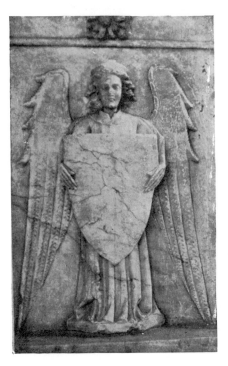

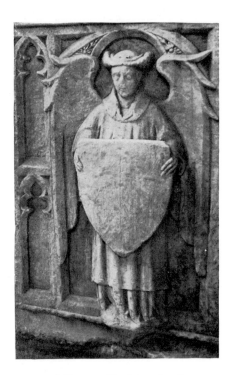

631. *Merevale (Warwick). Angel weeper*

632. *Ashbourne (Derby). Angel weeper*

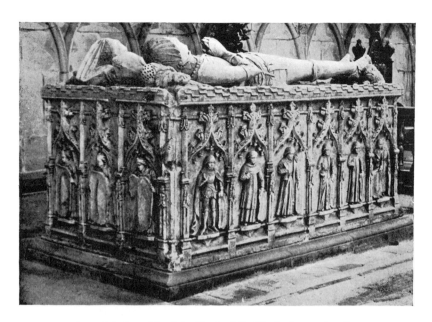

633. *Norbury (Derby). Tomb of R. Fitzherbert. d.* 1483

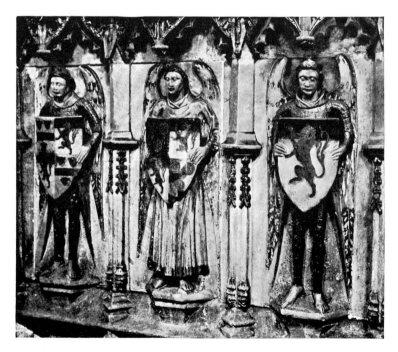

634. *Ewelme (Oxon). Tomb of Duchess of Suffolk.*
Shield-bearing angels. d. 1477

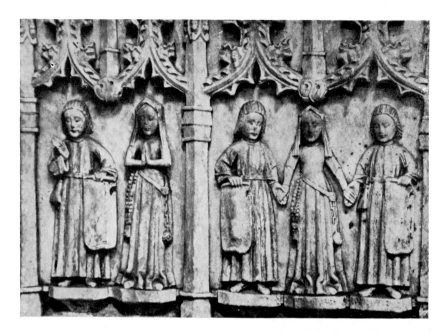

635. *Ashover (Derby). Weepers of Thomas Babyngton's tomb. d.* 1518

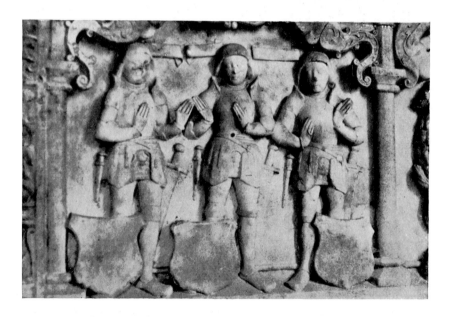

636. *Kinlet (Salop). Weepers of Sir John Blount's tomb. d.* 1531

322

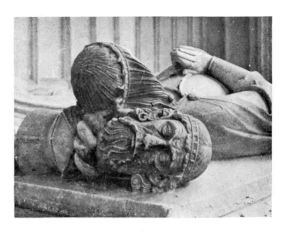

637. *Harewood (Yorks). Bedesman at foot of effigy*

638. *Wingfield (Suff). Effigy with head rested on tilting helm*

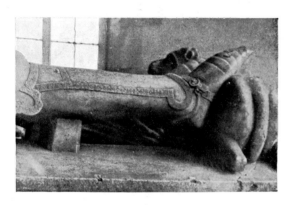

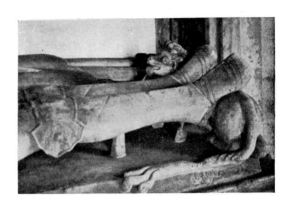

639. *Swine (Yorks). Effigy with foot-rest*

640. *Ratcliffe-on-Soar (Notts). Effigy with foot-rest*

(c) Effigy Types

Turning to the *effigies* themselves, it is impossible to give more than a few typical examples in the space at our disposal.[1] If a line is drawn somewhere about 1535–40 there are something like 500 alabaster figures remaining in various states of preservation. We no longer have to describe the varied and romantic attitudes of the preceding period as all are laid flatly on their backs, mostly with hands folded in prayer. Now and then husband and wife clasp hands, as in the Earl of Warwick's tomb at Warwick (Fig. 657), and an early knight at Wantage and an almost unrecognisable fragment at Burton have the legs crossed. Knights usually rest their heads upon a tilting helm with crest (Fig. 638), and their feet on a lion or occasionally on some other beast if it is a family badge, like the bear of Warwick. Civilians and ladies usually have pillows and sometimes little angels are seated on the slab beside the cushion. Ladies almost always have dogs at their feet and often two little pet

[1] For fuller illustration the reader is referred to F. H. Crossley's splendidly illustrated *English Church Monuments*, to Stothard's drawings, and to A. Gardner's 'The Alabaster Tombs of the Gothic Period'. *A Short History of Costume and Armour*, by F. M. Kelly and R. Schwabe, is also a useful summary of the subject.

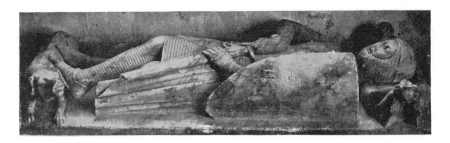

641. *Hanbury (Staffs). Earliest alabaster effigy*

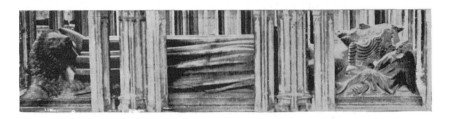

642. *Gloucester. Effigy. King Edward II. d. 1327*

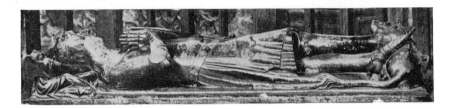

643. *Westminster. Effigy. Prince John of Eltham. d. 1334*

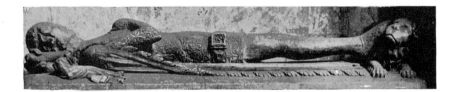

644. *York. Effigy. Prince William of Hatfield. d. c. 1346*

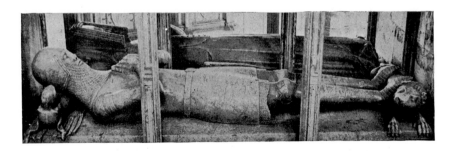

645. *Tewkesbury (Glos). Effigy. Sir Hugh Despenser. d. 1349*

terriers are worrying the hem of their skirts. In some of the later effigies little figures of bedesmen are placed against the sole of the foot to hide the ugliness of the square-toed sabaton, as at Harewood, where the tail of the lion is twisted up over the second foot (Fig. 637). In one or two cases, as at Kinlet and Harewood, ladies have little figures of children placed in the folds of their cloaks.

The chief interest lies in the constant changes in armour and costume, which were always carefully rendered, and which must form the basis of any classification.

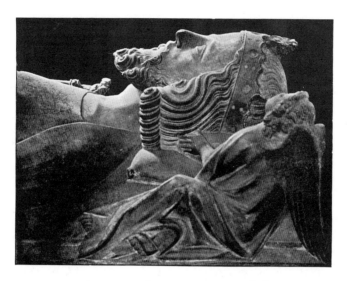

646. Gloucester. Edward II. Detail of Fig. 642

The earliest alabaster effigy is a knight at Hanbury, Staffs, near the quarries at Chellaston. It hardly belongs to the series as it is a typical cross-legged sword-drawing warrior of *c.* 1300 (Fig. 641). It must have been made in the ordinary way by the local carvers from the local material. The first real initiation of the alabaster trade must be traced to the royal tombs of the first half of Edward III's reign; those of his father Edward II, d. 1327; his brother John of Eltham, Earl of Cornwall, d. 1334; his young son William of Hatfield, d. *c.* 1346 (Figs. 642, 643, 644, 646); and the later one of two infant children of the queen, at Westminster, William and Blanche, for which John Orchard was paid 20 shillings.

Edward II's effigy at Gloucester lies under a magnificent canopy of freestone on a Purbeck marble tomb, and this mixed use of material suggests the work of the royal masons from Westminster. It follows the type of the bronze Henry III, and has the little Westminster angels supporting the cushion. The face is of an ideal type rather than an accurate portrait, and is strikingly beautiful (Fig. 646). The Earl of Cornwall's effigy at Westminster (Fig. 643) also had a fine canopy now destroyed, and the charming little weepers of the tomb-chest have already been described (Fig. 362). The prince lies with crossed legs in the easy manner of the earlier Westminster effigies. His armour is of mixed mail and plate, and he wears the short fronted surcoat. Prince William of Hatfield at York (Fig. 644) is represented as a young boy in a richly embroidered tunic and fringed cloak. An early figure of a knight may be found in the Sir Hugh Despenser, d. 1349, at Tewkesbury

325

(Figs. 645, 647). The round-topped bascinet is worn with the camail and jupon then coming into fashion.

Ecclesiastic vestments were stereotyped, and changes were merely in treatment and detail. The earlier bishops are perhaps more refined; Archbishop Stratford, for instance, at Canterbury, d. 1348, is delicately rendered with an ascetic face and elaborate details of the vestments (Fig. 648). Bishop Ralph of Wells, d. 1363, is still a refined figure, but there is an increasing dryness in the handling of the drapery (Fig. 649). Bishops of *c.* 1400 have bigger heads and fuller features, and seem to lose the ascetic look of their predecessors. We may instance Archbishop Courtenay at Canterbury, d. 1396 (Fig. 650), or the splendid

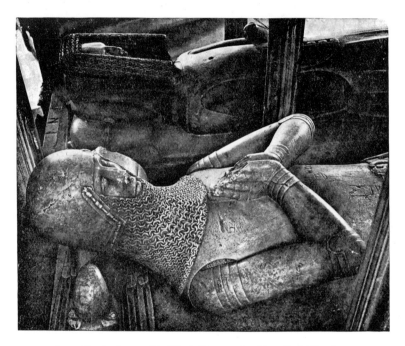

647. *Tewkesbury. Sir Hugh Despenser. Detail of Fig.* 645

figure of William of Wykeham, d. 1404, at Winchester (Figs. 651, 652). This last has escaped mutilation owing to the pious protection given by old members of the college he founded, and as much of the colouring survives may give us a better idea of the gorgeous effect of these alabaster figures than most others. Three charming little figures of clerks (probably his executors) are seated at his feet, whose striking features mark them out as masterpieces of early fifteenth-century sculpture (Fig. 652).

Later ecclesiastics, like Bishop Shirburne of Chichester, d. 1536 (Fig. 653), are bold and perhaps rather more florid figures, raised well above the slab. Bishop Shirburne has been repainted and is possibly touched up in other ways, but is an imposing figure, and may serve to give a better notion of what these effigies were meant to look like than more dilapidated, if more genuine examples.

A few priests occur without mitres, and in some cases wear the choir habit instead of mass vestments. The figure called William Canynge, a great merchant who took orders at the end of his life, in the church of St Mary Redcliffe, Bristol, is a striking example of this

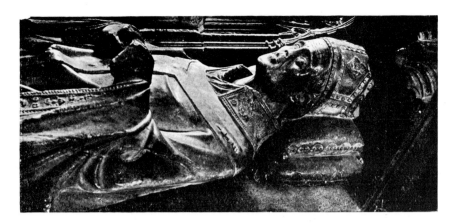

648. *Canterbury. Effigy. Archbishop Stratford. d.* 1348

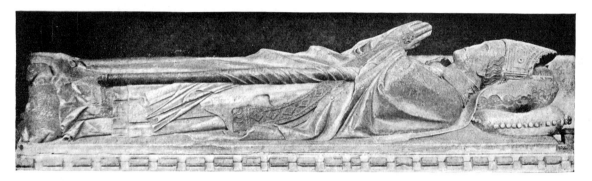

649. *Wells. Effigy. Bishop Ralph of Shrewsbury. d.* 1360

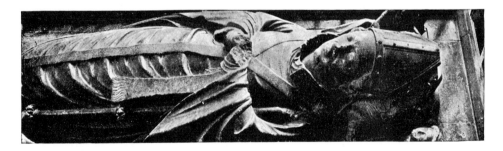

650. *Canterbury. Effigy. Archbishop Courtenay. d.* 1396

327

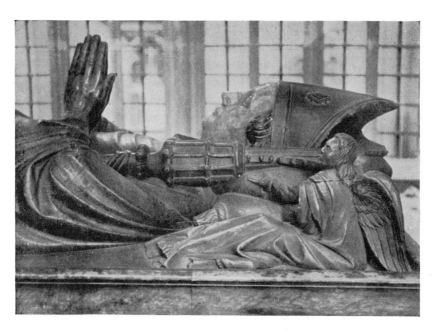

651. *Winchester. Effigy. Bishop William of Wykeham. d.* 1404

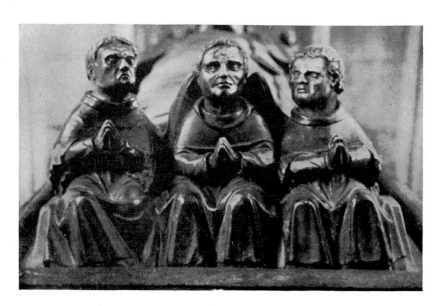

652. *Winchester. Clerks at the feet of William of Wykeham*

kind. The clean-cut features and bald forehead suggest a portrait (Fig. 654), but it must be pointed out that the features of a judge at Yatton, not far away, bear a strong resemblance to our Bristol priest, and the type may only be a model adopted in a common workshop.

The knights and ladies may be roughly divided into four categories, the main distinctions being governed by the changes of fashion in the armour of the men and head-dresses of the women. The four periods may be called the Edwardian, Lancastrian, Yorkist and Tudor,

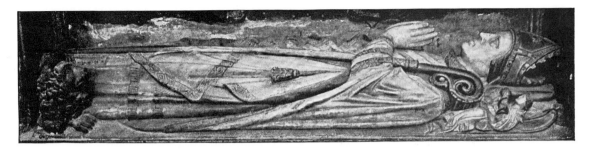

653. *Chichester. Effigy. Bishop Shirburne. d.* 1536

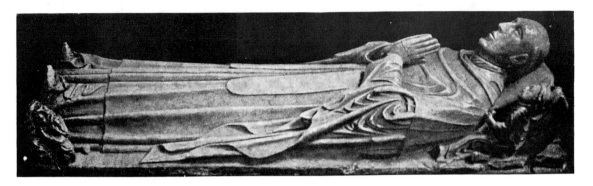

654. *Bristol. St Mary Redcliffe. Effigy. William Canynge. d.* 1490

though there are, of course, transitional examples between each. These titles may not be strictly accurate, as the Edwardian lasts on into the reign of Henry IV, but they have the advantage of being simple and easy to remember.

(i) *The Edwardian, c.* 1350–1420

This is sometimes called the camail and jupon period, from the characteristic military accoutrements. This is the style already described in the bronze effigy of the Black Prince; a pointed steel bascinet with the camail,[1] or curtain of mail, hanging from it to protect the neck is the characteristic feature. The jupon is a tight-fitting sleeveless garment coming down to the hips, and apparently made of leather worn over the mail shirt. It usually ends at the bottom in a scalloped fringe and is often decorated with armorial bearings. An elaborate sword-belt is worn low on the hips, and arms and legs are protected by plate. In the later examples, usually after 1400, the jupon appears to be swelling out as though worn over a steel breastplate, and the bascinet is surrounded by a jewelled circlet, called an orle, which is a very decorative feature.

The ladies wear the framed, or 'nebuly', head-dress, composed of closely placed frills and either square or round, with a plain cap behind. The camail of the knight and framed head-dress of the lady can best be seen by turning to our illustrations from East Harling in Norfolk (Figs. 655, 656). The complete figures may be illustrated by the Earl of Warwick,

[1] This was called 'aventail' in old English, but the French form 'camail' has been so much used that it is retained here.

329

655. *East Harling (Norfolk). Nebuly head-dress*

656. *East Harling. Camail*

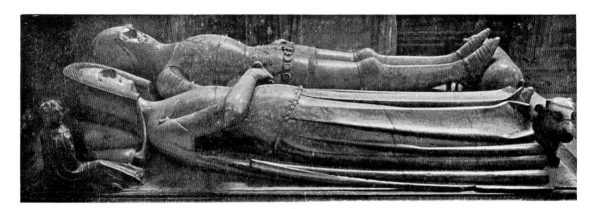

657. *Warwick. Effigies. Thomas Beauchamp, Earl of Warwick, and his lady. d. 1371*

d. 1371 (Fig. 657), or from the earlier of the tombs at Swine (Fig. 658). In this last the lady has a simple veil over her head with a 'barbe' of thin material over her chin, indicating that she was a widow, having survived her lord. A tight bodice, usually in the shape known as the sideless cote-hardie, is the regular dress with large buttons down the front and cloak thrown well back or even omitted altogether. In the later examples, after 1400, the framed head-dress begins to give way to something more akin to the elaborate convention of the next period. The hair is confined in a 'crespine' or jewelled net and bunched over the ears in what are called 'cauls', which are joined by a straight band, also jewelled, across the forehead. For convenience we may call this the 'crespine' head-dress, though there may not be much authority for this use of the term. A good example of this in its earlier and

330

658. *Swine (Yorks). Effigies. Sir Robert Hilton and his lady. d.* 1372

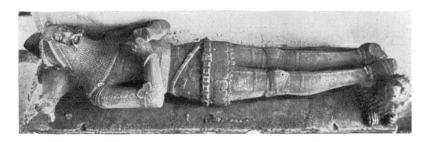

659. *Swine. Effigy. Sir Robert Hilton (?). d.* 1410

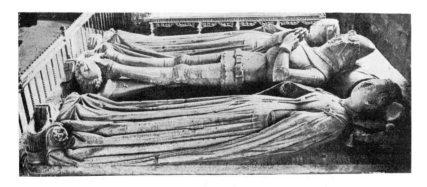

660. *Staindrop (Durham). Effigies. Ralph Nevill, Earl of Westmorland, and his lady. d.* 1425

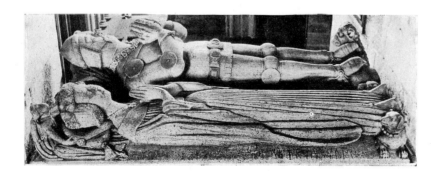

661. *Harewood (Yorks). Effigies. Sir R. Redman and his lady. c.* 1425

331

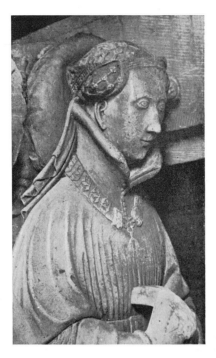

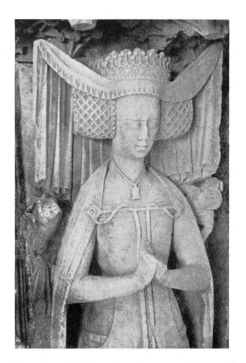

662. *Over Peover (Ches). Lady Mainwaring.*
Crespine head-dress. c. 1410

663. *Arundel (Sussex). Countess of Arundel.*
Crespine head-dress with cauls. c. 1416

more moderate shape may be found in Lady Mainwaring at Over Peover, Cheshire, *c.* 1410 (Fig. 662). She also wears the 'houppelande', a cloak with a high collar introduced from Burgundy,[1] and also sometimes worn by men, and about her neck is the famous SS collar, the badge of the Lancastrians, the exact meaning and derivation of which is still a matter of controversy.[2]

Later types of the camail and jupon armour may be seen in another knight at Swine (Fig. 659) and in the great tomb of Ralph Nevill Earl of Westmorland, d. 1425, at Staindrop, where he lies between his two wives (Fig. 660). Unless this effigy was made a few years before his death his armour is not quite up-to-date, as the camail was by this time beginning to be abandoned. He has the latest type of bascinet with a rich orle, and his wives have the earliest form of crespine head-dress; all three wear the SS collar.

Wealthy merchants, besides the old nobility, begin at this time to be commemorated by elaborate tombs and we find Sir William de la Pole, d. 1367, in Holy Trinity Church, Hull, represented in a long gown, beside his wife who wears a veil stretched over a square frame. He was the founder of the family which married into royal circles with disastrous results to his descendants. There is also the tomb of John Oteswich, *c.* 1400, in St Helen's Church, London. He wears the houppelande with a high collar, and a large purse or scrip at his side (Fig. 664). He has a short beard and his facial features follow the type of the earlier Edward II. His wife has the sideless cote-hardie with buttons down the front and a simple veil over her head.

[1] There is a very similar effigy at Northleigh, near Oxford, and both knight and lady are so much alike in both places that the two must have come from the same workshop—probably in Nottingham.
[2] The earliest noted instance of this is the effigy of Sir John Swinford at Spratton, who died in 1371. He seems to have been a follower of John of Gaunt.

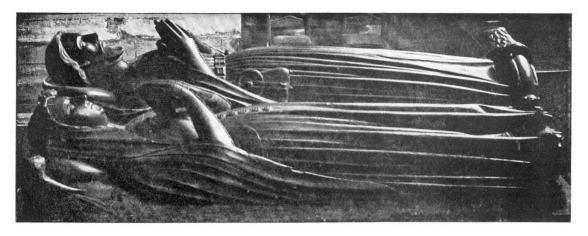

664. *London. Great St Helen's. Effigies. John Oteswich and his lady. c.* 1400

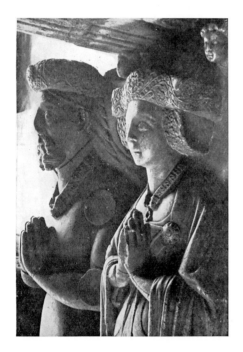

665. *Methley (Yorks). Lady Waterton.*
Crespine head-dress. c. 1425

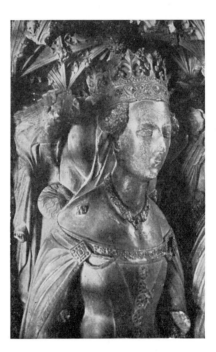

666. *Canterbury. Queen Joan.*
Crespine head-dress. c. 1437

(ii) *The Lancastrian, c.* 1415–50

About the time of the battle of Agincourt the mixed type of armour goes out and knights appear in full plate.[1] The camail is replaced by a gorget of plate and the jupon disappears; instead a cuirass or breastplate is worn and the thighs are protected by a series of

[1] Several big works have been published on armour. Perhaps the most convenient handbook at a reasonable price is C. ffoulkes' *Armour and Weapons*, 1909. The most up-to-date account may be found in Kelly and Schwabe, *A History of Costume and Armour.* See also C. Boutell's *Arms and Armour.*

333

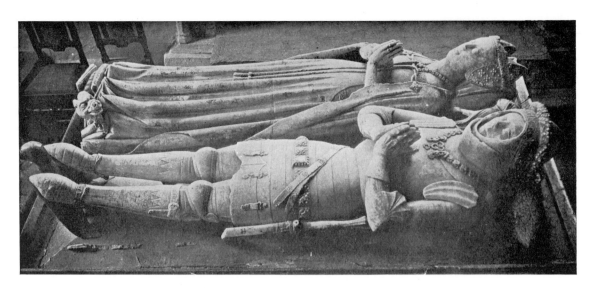

667. *Dennington (Suffolk). Effigies. Lord Bardolf, K.G., and his lady. d.* 1441

overlapping plates called a 'fauld' or skirt of lames. A slanting 'bawdrick', or sword belt, is used and the ornamental horizontal one appears to be used only to support the dagger. The orle is usually a very striking feature, and the front of the bascinet is sometimes inscribed with the sacred monogram IHS. Small plates called 'tassets' are buckled on to the lowest lames of the fauld, and more elaborate elbow cops and shoulder plates are added. Ladies bring their cloaks more over the shoulder and support them by cords and richly carved brooches. The crespine head-dress becomes more elaborate and more widely extended with a wealth of jewellers' work, as at Methley (Fig. 665) or Canterbury (Fig. 666). The most elaborate of these erections is worn by the Countess of Arundel (Fig. 663), who has wide-spread cauls and a splendid coronet perched on the top with a veil stretched out on wires to a great distance, anticipating the butterfly head-dress of the next period. Towards the middle of the century the cauls instead of being spread widely are brought up to two points above the head, forming the horned or mitred head-dress of which we have an example at Dennington (Fig. 667).

The Green tomb at Lowick, of which we know the sculptors, may be taken as an early example of this type (Figs. 20, 668). Ralph Green, d. 1419, holds his wife's hand and there is a canopy, referred to as a 'gablette' in the contract, over their heads. Another early pair may be found at Harewood (Fig. 661) where there is one of the finest collections of well-preserved alabaster tombs in the country. Later examples are Lord Bardolf, d. 1441, at Dennington (Fig. 667) and Sir Richard Vernon, d. 1451, at Tong (Fig. 669). These last are among the most imposing of the whole series and must rank high as specimens of fifteenth-century sculpture. They wear the SS collar, and Lord Bardolf also wears the Garter strapped round below his left knee. A comparison between the Lowick and Tong figures shows the advance made in the scientific construction of the plates protecting shoulder and elbow.

One magnificent royal tomb belongs to this series, that of Henry IV and his queen Joan at Canterbury (Figs. 666, 670). The jewels of the crowns, the splendid clasps of the mantles and richly carved borders of the royal robes are finely worked, and display the

334

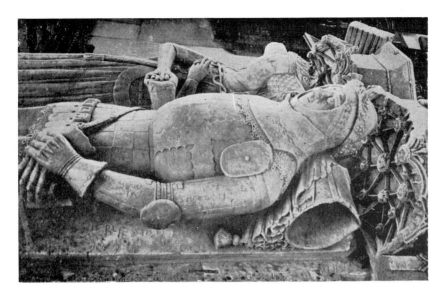

668. *Lowick (Northants). Effigies. Ralph Green and his lady.* d. 1419

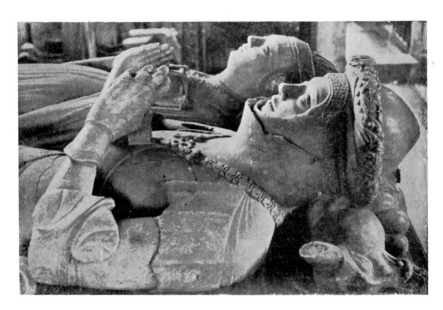

669. *Tong (Salop). Effigies. Sir Richard Vernon and his lady.* d. 1451

suitability of the material for elaborate detail. The king has a short beard, but his hair is short and worn in a kind of roll, while his cheeks and the back of his head up to above the ears are shaven. Henry V seems to have been clean-shaven and wore his hair short, and beards become very rare after his time until they were reintroduced by Henry VIII. Henry IV certainly gives the impression of being a portrait; the 'gablettes' over his head remind us of those of the Earl of Arundel and of the Green monument at Lowick, so that it is tempting to regard this group as all being the work of the Chellaston firm of Prentys and Sutton.

335

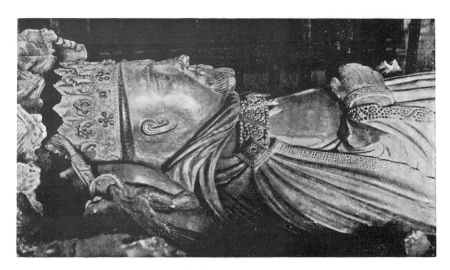

670. *Canterbury. Effigy. King Henry IV. d. 1413*

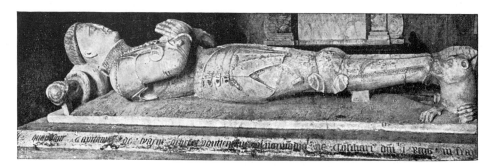

671. *Dodford (Northants). Effigy. Sir John Cressy. d. 1444*

An interesting civilian tomb of this period is that of Chief Justice Sir William Gascoigne, d. 1419, at Harewood (Fig. 627). He was described by Shakespeare as the judge who dared to commit Henry V, when Prince of Wales, for unruly conduct, and was afterwards promoted by Henry as one who would administer justice without fear or favour. He wears the judge's coif, which was originally painted red, and his lady shows a good example of the crespine head-dress.

(iii) *The Yorkist, c.* 1440–85

As explained already the dynastic names are used here somewhat loosely. Edward IV did not gain the throne till 1461, but though the most characteristic specimens of what we are calling Yorkist armour may be dated *c.* 1460–80 the changes began rather earlier. It is a remarkable thing that before 1440 the bare-headed warrior is practically unknown, but after 1455 the helmeted knight is almost equally rare. The head still rests on the tilting helm, but the bascinet disappears, and the four or five helmeted knights wear the 'sallet', a light fighting helmet with a back projection, resembling the shape of a fisherman's sou'wester. In all other instances the head is bare, and the hair is worn short, frequently cut above the ears in what has been termed a 'bowl crop', as at Dodford (Fig. 671). The

336

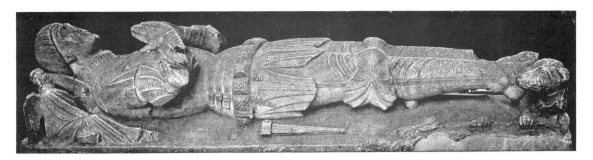

672. *Salisbury. Effigy. Lord Hungerford. c.* 1460

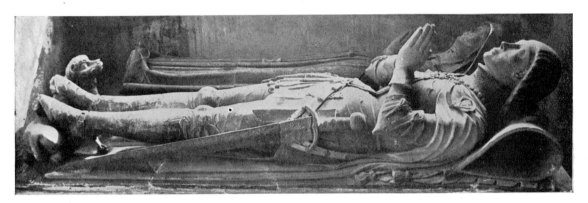

673. *Stanton Harcourt (Oxon). Effigies. Sir Robert Harcourt, K.G., and his lady. d.* 1471

armour assumes most elaborate and ornate forms with flutings and ridges designed to turn away the point of a lance; elbow and knee cops develop large wings and are laced on with carefully wrought straps and the gorget is replaced by a mail collar called the 'standard of mail'. Tassets become long and pointed, and the whole effect is extremely rich and varied. Ladies begin by wearing the horned head-dress, but the horns were soon brought more together and lengthened by a sort of wire framework, over which a veil was thrown, forming the famous 'butterfly' head-dress. As the fluttering veil could not be easily rendered in a recumbent figure these are usually more moderately rendered in the effigies than in the brasses. In some cases a broad turned-up flap covers the front of the receding horns, and sometimes a kind of truncated pyramid replaces the horns, though the tall steeple caps of the manuscripts never occur on the tombs, being perhaps more a French or Burgundian than an English fashion. Towards the end of the period ladies sometimes wear the hair long and loose with a coronet or something like the knightly orle round the brow. The Yorkist collar of suns and roses replaces the Lancastrian SS collar after 1461.

Sir John Cressy at Dodford, d. 1444 (Fig. 671), may be taken as one of the earlier examples of the type, and Lord Hungerford, d. 1459, at Salisbury (Fig. 672), as a more typical example of the elaboration of detail described above. In the later examples the hair is worn a little longer, as in the effigy of Sir Robert Harcourt, d. 1471, at Stanton Harcourt (Fig. 673). He wears the Yorkist collar and Garter robes over his armour, and his lady, who was also one of the few women to belong to the order, wears the Garter on her left arm. She is represented as a widow in veil and barbe.

337

We have no royal effigy of this period, but the tomb of the Duchess of Suffolk, d. 1477, at Ewelme (Fig. 674), may serve as a satisfactory substitute. We have already illustrated her weepers (see Fig. 634), and now show the wan face of the Duchess in a coronet over her widow's weeds. She also wears the Garter on her left wrist. She was grand-daughter of the poet Chaucer and widow of the unfortunate Duke whose murder at sea is told in the Paston Letters.

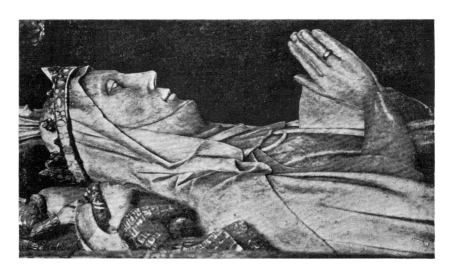

674. *Ewelme (Oxon). Effigy. Alice de la Pole, Duchess of Suffolk. d. 1477*

(iv) *The Tudor, c. 1485–1540*

During our last period workmanship becomes uneven, especially during the latter part of the fifteenth century. As we found in the case of the architectural sculpture first-class work was available for those who could pay for it, but some of the effigies were decidedly poor. The earlier years of the sixteenth century brought an increase in technical skill, and some of the tombs of *c.* 1495–1540 are very imposing. The more fantastic and florid features of the Yorkist armour disappear, and a smoother, more workmanlike effect, was sought. Tassets become larger, and in the latter part of the period huge neck-guards make their appearance. The 'sabatons', or shoes protected by laminated steel plates, which hitherto had been pointed become blunted and square-toed, and sometimes little bedesmen are carved seated against the sole of the foot (Fig. 637). The SS collar is reintroduced and hangs down lower over the breast, and the 'tabard', a kind of heraldic apron, is not unfrequently worn over the armour. Hair is worn longer, down to the shoulders, and in the sixteenth century is usually cut straight across the forehead and the back of the neck, like the 'bobbed hair' of little girls of to-day. Ladies, especially after 1500, wear what is known as the 'pedimental' head-dress, which is shaped like a gable with a point in the middle. At first it has long side-pieces, but later these are cut off below the ears. Loose hair with coronets or the orle-like circlet are still sometimes found, and widows still have the veil and barbe. The flapped caps are still used at the beginning of the period.

These details are more clearly brought out by a reference to the illustrations than by description. Sir Richard Redman at Harewood (Fig. 675) is a well-preserved and very

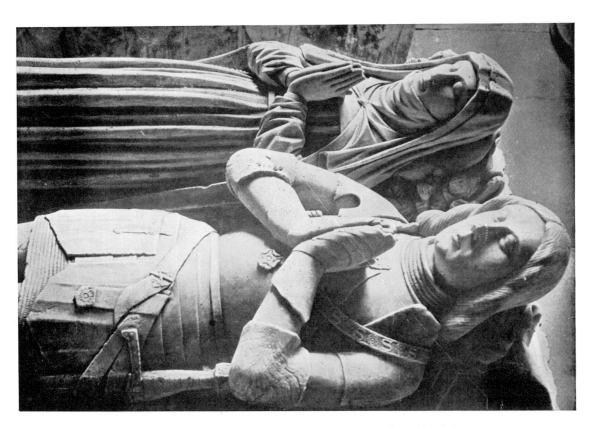

675. *Harewood (Yorks). Effigies. Sir Richard Redman (?) and his lady. c.* 1500

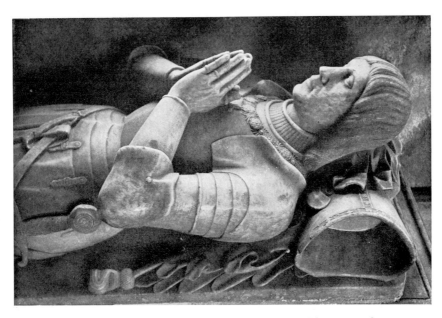

676. *Holme Pierrepont (Notts). Effigy. Sir Henry Pierrepont. d.* 1499

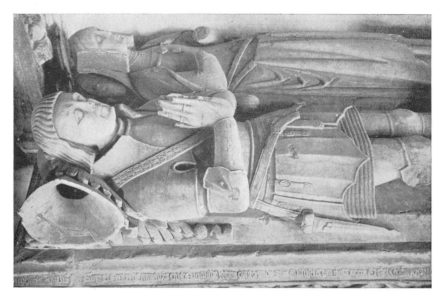

677. *Ratcliffe-on-Soar (Notts). Effigies. Ralph Sacheverell and his lady. d.* 1539

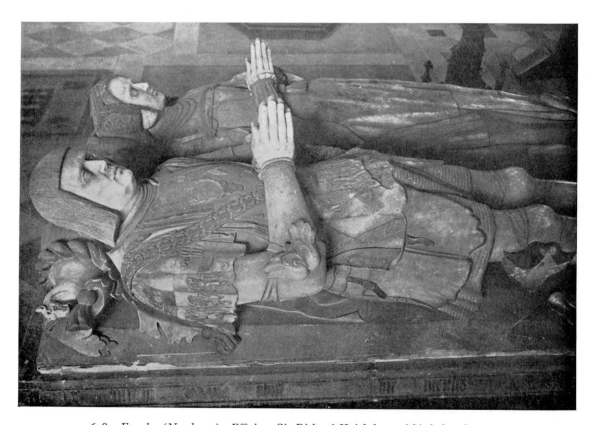

678. *Fawsley (Northants). Effigies. Sir Richard Knightley and his lady. d.* 1534

340

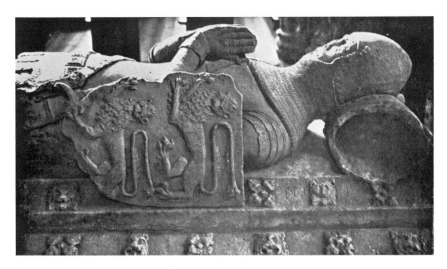

679. *Holbeach (Lincs). Freestone knight. c. 1360*

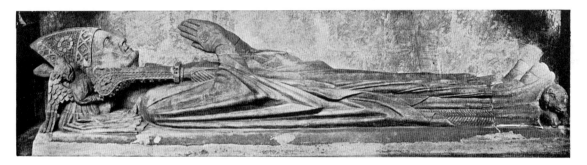

680. *Bristol. Freestone effigy. Abbot Newbury. c. 1475*

pleasing figure of the end of the century. He wears the Tudor collar combining the Lancastrian SS with the Yorkist roses. Lady Redman looks modest in her widow's weeds. The little bedesman sitting on the lion against his foot has already been illustrated (see Fig. 637). Another well-preserved knight of this period at Holme Pierrepont (Fig. 676) is identified with Sir Henry Pierrepont, d. 1499, though he still wears the Yorkist collar. The armour, however, is of the later type. The tomb of Ralph Sacheverell, d. 1539, at Ratcliffe-on-Soar, is also typical of the last phase of Gothic armour. He has the bobbed hair, high shoulder-guard and drooping SS collar, while his wife wears the pedimental head-dress (Fig. 677).

The monument of Sir Richard Knightley, d. 1534, at Fawsley (Fig. 678), is perhaps the most imposing of the later tombs. It is perfectly preserved and retains much of the original colour. Sir Richard wears a very ornate specimen of the heraldic tabard, and the quilted sleeves of his lady are the first sign of the coming change of costume which was carried to such extremes under Elizabeth. Certain details common to this and to the fine late tombs at Aldermaston and Windsor distinguish this group from the regular Nottingham type exemplified by the Ratcliffe figures. Possibly they were London productions.

341

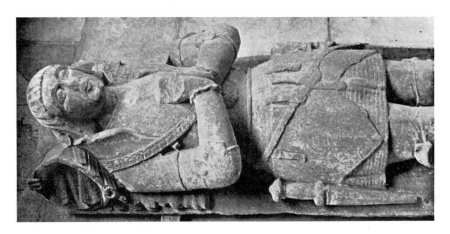

681. *Gaddesby (Leics). Freestone copy of alabaster. c. 1500*

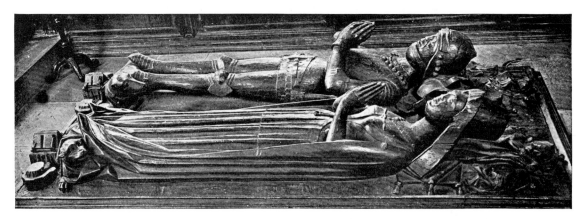

682. *Brancepeth (Durham). Wooden effigies. Earl of Westmorland and his lady. c. 1484*

The *freestone effigies* of the fourteenth and fifteenth centuries need not detain us long. They followed the fashions of the alabaster models with a necessary coarsening due to the rougher material, and seldom introduced any new features of their own. A fine knight of *c.* 1360 at Holbeach, Lincs (Fig. 679), proves that the Ancaster masons still retained something of their pristine skill, and could produce tombs of distinction; and at Bristol, where the oolite masons had managed to compete with the Purbeck marblers in the thirteenth century, the effigy of Abbot Newbury, *c.* 1475 (Fig. 680), shows that their fine-grained stone was capable of detail which could be set beside that of the alabaster-men. Elsewhere, however, the stone effigies are mainly copies of the alabasters, and one has only to look at such a figure as we show from Gaddesby (Fig. 681) to see its close resemblance to the late alabaster knights like the Sacheverell at Ratcliffe-on-Soar. The wooden effigies of the Earl and Countess of Westmorland at Brancepeth follow the alabaster types so closely that it has been suggested that these were the patterns submitted by the tomb-makers for approval before reproducing them in the more expensive material (Fig. 682). The weepers also follow the alabaster patterns, but it is worth while to illustrate a fine Resurrection (Fig. 683) from the tomb of Bishop Morgan, d. 1504, at St David's, which exhibits a liveliness of

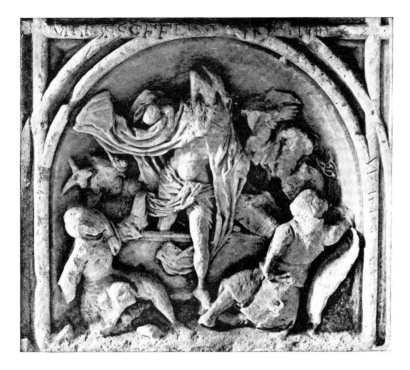

683. *St David's (Pemb). Tomb of Bishop Morgan. Resurrection. d.* 1504

action outside the stock models. This is possibly due to suggestions coming from the Flemish tomb-makers, whose productions were introduced into England on a large scale in the following generation.

This has necessarily had to be a somewhat sketchy description of the monumental trade which provided such a large proportion of our late Gothic sculptures. It was found convenient to fix a limit to our studies of the architectural sculpture at about 1535–40, by which time the monasteries had been suppressed and images removed from the churches. Tombs in alabaster and other materials continued to be made for many years which retained much of the Gothic feeling, even if combined with Renaissance details.[1] The fine effigy of the Earl of Huntingdon, d. 1561, at Ashby-de-la-Zouch, might for instance have passed for a much earlier figure if it had not been for his long beard. A line must, however, be drawn somewhere, and the Reformation is probably the most distinctive point at which it can be fixed.

[1] These have been ably dealt with by Sir James Mann in an article on 'English Church Monuments 1536–1625', published in the Walpole Society's 21st volume, 1932–3.

SELECT BIBLIOGRAPHY

I. WORKS, GUIDES AND CATALOGUES

J. ROMILLY ALLEN. *Christian Symbolism in Great Britain and Ireland*. Whiting, 1887.

M. D. ANDERSON. *Animal Carvings in British Churches*. Cambridge University Press, 1938.

—— *The Medieval Carver*. Cambridge University Press, 1935.

—— *Design for a Journey*. Cambridge University Press, 1940.

M. AUBERT. *La Sculpture française du Moyen Age et de la Renaissance*. Paris, Van Oest, 1926.

E. BLORE. *Monumental Remains of Noble and Eminent Persons*. Harding, 1824–5.

F. BOND. *Fonts and Font-covers*. Oxford University Press, 1908.

—— *Wood-carvings in English Churches:* (1) *Misericords*. Oxford University Press, 1910.

—— *Dedications and Patron Saints*. Oxford University Press, 1914.

C. BOUTELL. *Arms and Armour*. Reeves, 1907.

J. BRØNDSTED. *Early English Ornament*. Hachette, 1924.

BALDWIN BROWN. *The Arts in Early England*. Murray, 1925; Vol. VI, *Anglo-Saxon Sculpture*. Murray, 1937.

C. J. P. CAVE. *Roof Bosses in Medieval Churches*. Cambridge University Press, 1948.

Sir A. W. CLAPHAM. *English Romanesque Architecture before the Conquest*. Oxford University Press, 1930.

—— *English Romanesque Architecture after the Conquest*. Oxford University Press, 1934.

C. R. COCKERELL. *Iconography of the West Front of Wells Cathedral*. Oxford, 1851.

W. G. COLLINGWOOD. *Northumbrian Crosses of the Pre-Norman Age*. Faber, 1927.

A. H. COLLINS. *The Symbolism of Animals and Birds in English Church Architecture*. Pitman, 1913.

J. C. COX. *Bench Ends in English Churches*. Oxford University Press, 1916.

F. H. CROSSLEY. *English Church Monuments*. Batsford, 1921.

JOAN EVANS. *English Art, 1307–1451*. Oxford University Press, 1949.

A. C. FRYER. *Wooden Monumental Effigies* (2nd ed.). Elliot Stock, 1924.

A. GARDNER. *Medieval Sculpture in France*. Cambridge University Press, 1931.

—— *Alabaster Tombs*. Cambridge University Press, 1940.

S. GARDNER. *English Gothic Foliage Sculpture*. Cambridge University Press, 1927.

DOROTHY HARTLEY. *Medieval Costume and Life*. Batsford, 1931.

JOHN HARVEY. *Henry Yevele*. Batsford, 1944.

—— *Gothic England*. Batsford, 1947.

W. H. ST JOHN HOPE and E. S. PRIOR. *Catalogue of Exhibition of English Alabaster Work*. Society of Antiquaries, 1913.

F. E. HOWARD and F. H. CROSSLEY. *English Church Woodwork*. Batsford, 1917.

M. R. JAMES. *The Sculptures of the Lady Chapel at Ely*. Nutt, 1895.

—— *St George's Chapel, Windsor—The Woodwork of the Choir*. Windsor, 1933.

F. M. KELLY and R. SCHWABE. *A Short History of Costume and Armour*. Batsford, 1931.

C. E. KEYSER. *Norman Tympana and Lintels* (2nd ed.). Elliot Stock, 1927.

D. KNOOP and G. P. JONES. *The Medieval Mason*. Manchester University Press, 1933.

W. R. LETHABY. *Medieval Art*. Duckworth, 1904.

—— *Westminster Abbey and the King's Craftsmen*. Duckworth, 1906.

—— *Westminster Abbey Re-examined*. Duckworth, 1925.

M. H. LONGHURST. *English Ivories*. Putnam, 1926.

E. MALE. *L'Art religieux du XIIe Siècle en France*. Paris, 1922.

—— *L'Art religieux du XIIIe Siècle en France*. Paris, 1902.

—— *L'Art religieux de la Fin du Moyen Age en France*. Paris, 1908.

A. MASKELL. *Wood Sculpture*. Methuen, 1911.

A. MICHEL. *Histoire de l'Art*. Armand Colin, 1905/9.

345

EMMA PHIPSON. *Choir Stalls and their Carvings*. Batsford, 1896.

L. LEFRANÇOIS PILLION. *Les Sculpteurs français du XIIe Siècle*. Paris, n.d.

—— *Les Sculpteurs français du XIIIe Siècle*. Paris, n.d.

E. K. PRIDEAUX. *Figure Sculpture of the West Front of Exeter Cathedral*. Exeter, 1912.

E. K. PRIDEAUX and G. R. HOLT-SHAFTO. *Bosses and Corbels of Exeter Cathedral*. Exeter, 1910.

E. S. PRIOR. *History of Gothic Art in England*. Bell, 1900.

E. S. PRIOR and A. GARDNER. *Medieval Figure Sculpture in England*. Cambridge University Press, 1912.

H. H. HAMILTON ROGERS. *Ancient Sepulchral Effigies of Devon*. Exeter, 1877.

G. G. SCOTT. *Gleanings from Westminster Abbey*. Henry and Parker, 1863.

C. A. STOTHARD. *Monumental Effigies of Great Britain*. 1817. (New edition, ed. J. Hewitt, 1876.)

R. E. SWARTWOUT. *The Monastic Craftsman*. Heffer, 1932.

The volumes published by the Royal Commission on Ancient Monuments, especially *London—Westminster Abbey* (1924).

The Little County Guides.

Local guides and monographs.

II. JOURNALS

Antiquaries Journal
 (various dates). Dr W. L. Hildburgh, a number of 'Notes on English Alabaster Tables'.

Archaeologia
 XXIV (1842). Accounts of Ellinor Trustees.
 XLVII (1883). J. T. Mickelthwaite, 'Notes on the Imagery of Henry VII's Chapel'.
 LIX (1904). Sir W. H. St John Hope and W. R. Lethaby, 'The Imagery and Sculptures on the West Front of Wells Cathedral'.
 LXV (1914). Sir W. H. St John Hope and W. R. Lethaby, 'The Funeral Monument and Chantry Chapel of Henry V'.
 LXXVII (1927). P. B. Chatwin, 'The Decoration of the Beauchamp Chapel at Warwick'. Sir A. W. Clapham, 'The Carved Stones at Breedon-on-the-Hill'.

Archaeologia Cantiana
 L. G. C. Druce, 'Stall Carvings at Faversham'.

Archaeological Journal
 (various dates). Dr W. L. Hildburgh, a number of 'Notes on English Alabaster Tables'.
 (various dates). Dr T. Nelson, several papers on 'Alabaster Panels'.
 (1904). Sir W. H. St John Hope, 'On the early working of Alabaster in England'.
 (1910). County P. Bissen, 'Tombs of the School of London at the beginning of the fourteenth century'.
 (1921). M. P. Perry, 'Bristol Cathedral Stalls'.
 (1920–34). A. C. Fryer, 'Fonts'.
 (1923). A. Gardner, 'Alabaster Tombs of the Gothic Period'.
 (1930). C. C. Oman, 'Medieval Brass Lecterns in England'.

Birmingham Archaeological Society Transactions
 (1921–3). P. B. Chatwin, 'Monumental Effigies in Warwickshire'.

Bristol and Gloucestershire Archaeological Society Transactions
 XXVI–XXXIV. I. M. Roper, 'Effigies'.
 XLVIII. A. C. Fryer, 'Gloucestershire Fonts'.

Derbyshire Archaeological Journal, 1925
 H. E. Lawrance and T. E. Routh, 'Military Effigies of Derbyshire'.

Historical Society of Lancashire and Cheshire Transactions
 (1925 sqq.). F. H. Crossley, 'Medieval Monumental Effigies remaining in Cheshire'.

Somerset Archaeological and Natural History Society
 (1915–26). A. C. Fryer, 'Monumental Effigies in Somerset'.

Walpole Society
 (1911–12). E. S. Prior, 'A Sketch of English Medieval Figure Sculpture'. Sir James Mann, 'English Church Monuments, 1536–1625'.

INDEX

[The numbers in italics refer to the illustrations, those in ordinary type to pages in text]

349

351